Modern Painters

Peter Fuller's Modern Painters

Reflections on British Art

Edited with an introduction by

John McDonald

Methuen

First published in Great Britain in 1993
by Methuen London
an imprint of Reed Consumer Books Ltd
Michelin House, 81 Fulham Road, London sw3 6rb
and Auckland, Melbourne, Singapore and Toronto

Reprinted 1993

A CIP catalogue record for this book
is available at the British Library

H/B ISBN 0 413 67460 6
P/B ISBN 0 413 68480 6

Typeset by Deltatype Ltd, Ellesmere Port
Printed and bound in Great Britain by
Mackays of Chatham plc, Chatham, Kent

To Peter's children,
Laurence and Sylvia

Contents

Illustrations

8a Graham Sutherland, *Black Landscape*, 1939–40
© The Tate Gallery, London
8b Francis Bacon, *Self-Portrait*, 1973
Courtesy of Marlborough Fine Art Ltd, London

Colour (between pages 122 and 123)

9a Patrick Heron, *December 4 1983: II*, 1983
Courtesy of the artist and Waddington Galleries, London
9b Stanley Spencer, *Apple Gatherers*, 1912–13
© The Tate Gallery, London
10a Ivon Hitchens, *Flower Group*, 1943
© Sheffield City Art Galleries
10b David Blackburn, *A Mystical View of the Sea*, 1988
Private collection, courtesy of the artist
11a John Bellany, *The Storm* (triptych), 1991
Courtesy of the artist and the Glasgow Art Gallery and
Museum
11b Maggi Hambling, *Minotaur Surprised while Eating*, 1986–87
Courtesy of the artist and the Tate Gallery, London
12a John Hubbard, *Sub-Tropical Garden*, 1987
Courtesy of the artist
12b William Tillyer, *The North York moors, falling sky*, 1985
Courtesy of the artist and the Bernard Jacobson Gallery,
London

Black and white (between pages 218 and 219)

13 L. S. Lowry, *Head of a Man with Red Eyes*, 1938
© City of Salford Museums and Art Gallery
14a Alfred Wallis, *The Blue Ship (Mount's Bay)*, c. 1934
© The Tate Gallery, London
14b Peter Lanyon, *Tatra*, 1964
Courtesy of the Bernard Jacobson Gallery, London.
Photograph courtesy of the Gimpel Fils Gallery, London.
15a Frank Auerbach, *J. Y. M. Seated III*, 1992
Courtesy of the artist and Marlborough Fine Art Ltd,
London

Acknowledgements

As editor of this collection I am indebted to the Estate of Peter Fuller, without whose kind permission these essays and lectures could not have been reproduced. I owe another debt to Nicholas Serota, director of the Tate gallery, and Tate staff, Juliet Nissen, John Corr and Chris Webster, for their generous assistance with illustrations. Many thanks also, to those artists and public and private gallery people who responded so promptly to my requests for particular images.

John McDonald

Details of first publication

Details of first publication or delivery of the essays and lectures is as follows:

The Journey: A Personal Memoir: first published in a slightly different form in *Modern Painters*, Vol. 3, No. 3, September 1990

The Ruskin Lecture: presented in many varying forms, this version a distillation of several variant manuscripts, never previously published

British Romantic Landscape Painting from Turner to Maggi Hambling: a lecture given at the National Gallery, London, in April 1990, never previously published

But is it Art?: a lecture given on many different occasions in the UK and Australia and never previously published

Rocks and Flesh: An Argument for British Drawing: a catalogue essay for the exhibition *Rocks and Flesh – An Argument for British Drawing*, Norwich School of Art Gallery, 30 September to 26 October 1985

The Last Romantics: *Modern Painters*, Vol. 2, No. 1, spring 1989

Joshua Reynolds: Visions of Grandeur: *New Society*, 31 January 1986

George Stubbs: *New Society*, 25 October 1984

Alfred Munnings: a combination of articles in the *Independent*, 18 December 1986 and *Sunday Telegraph*, 4 February 1990

L. S. Lowry: *New Society*, 30 October 1987

St Ives: *Artscribe*, No. 53, May/June 1985

Winifred Nicholson: *Studio International*, Vol. 200, No. 1018, 1987

David Bomberg: *The Burlington Magazine*, Vol. CXXX, No. 1021, April 1988

Nature and Raw Flesh: Sutherland v. Bacon: *Modern Painters*, Vol. 1, No. 1, spring 1988 and *The Cambridge Guide to the Arts in Britain*, Vol. 9, edited by Boris Ford

Ivon or Andy: A Time for Decision: *Modern Painters*, Vol. 2, No. 3, autumn 1989

Auerbach's 'Kerygma': *Art Monthly*, No. 98 July/Aug. 1986

John Bellany: a catalogue essay for an exhibition at the Compass Gallery, Glasgow, 5 to 31 May 1990

Adrian Berg: a catalogue essay for the exhibition *Adrian Berg: Paintings 1977–86*, Serpentine Gallery, London, 21 June to 20 July 1986

David Blackburn: a catalogue essay for the exhibition *David Blackburn: Light and Landscape*, Yale Center for British Art, 28 March to 28 May 1989

Anthony Caro: *The Age Monthly Review*, Melbourne, Australia, Vol. 2, No. 7, 1982, with additional material from an article in the *Sunday Telegraph*, October 1989

Alan Davie: *New Society*, 27 September 1985

Lucian Freud: *The Burlington Magazine*, May 1988, Vol. CXXX, No. 1022

Maggie Hambling: a combination of a review in the *Burlington Magazine*, Vol. CXXIX, No. 1016, November 1987, and a catalogue essay for the exhibition *Maggi Hambling: Paintings, Drawings and Water-Colours*, Serpentine Gallery, 17 October to 22 November 1987

Patrick Heron: The Innocent Eye?: *Artscribe*, No. 52, May/June 1985

David Hockney: All the World's a Stage: *New Society*, 26 July 1985

John Hubbard: a catalogue essay for the exhibition *John Hubbard*, Yale Center for British Art, 3 September to 26 October 1986

R. B. Kitaj: *Art Monthly*, No. 91, December 1985 to January 1986

John Piper: *Modern Painters*, Vol. 1, No. 2, summer 1988

William Tillyer and the Art of Water-Colour: a catalogue essay for the exhibition *William Tillyer: English Landscape Water-Colours*, Bernard Jacobson Gallery 1987

Introduction

Art critics are generally little known outside their profession, but Peter Fuller's death in a car accident on 28 April 1990 triggered an avalanche of public tributes from friends, colleagues and even opponents. This response showed how far Fuller had succeeded in changing the direction of contemporary art debates, and in bringing those debates before the general public. The Tate Gallery has acknowledged Fuller's importance by taking on a huge archive of his papers, putting them alongside those of Roger Fry and Sir Kenneth Clark. With Fuller's death, British art lost its most energetic and provocative commentator, its greatest catalyst for change and renewal. It was widely mooted, in the obituaries, that Fuller was irreplaceable. So it has proved. In his absence, it is only too plain that the quality of art commentary in this country has settled back into the torpid and self-satisfied slumber he worked so hard to disturb.

The writings collected in this book are representative of Fuller's developing views on art over the last decade of his life. The story of his career up to that point has been told many times, most often by Fuller himself, whose autobiographical instincts were held on a long leash. He speaks most candidly about his life and thought in the meditative diary notes of *Marches Past*. In a large number of late essays, Fuller approached an artist's work by detailing the history of his own changing responses, showing in what ways he was able to empathise with another's vision. This was partly a response to the sheer quantity of writing he was doing at the end. He drew more heavily on his subjective responses as he had less time to do detailed research. At the same time, he became ever more

conscious of his growing status and authority, ever more confident in his opinions. The autobiographical preambles allowed him to 'discover' what he felt about a particular artist by reconstructing the growth of his sympathies and taste as a detective might reconstruct a crime. Neither is this metaphor so far-fetched, as Fuller often championed neglected artists in a way that deliberately went against the grain of received critical opinion. He delighted in transgressing the unspoken laws of art fashion.

This reached its culmination in *The Journey*, the piece which prefaces this collection. *The Journey* was written to accompany an exhibition of contemporary art held in Lincoln Cathedral in the summer of 1990. Fuller had been asked to discuss the general topic of the spiritual in art, and more particularly, the works of those artists included in the show. The result was a stately piece of autobiography, peppered with scathing assessments of artists such as Richard Long and Gilbert and George – who were, in Fuller's opinion, artists who only served to debase the spiritual aspects of aesthetic experience. The organisers of the exhibition were not pleased with this response and decided not to include the essay in the catalogue. It was, however, post-humously published in the *Guardian* and in Fuller's own journal, *Modern Painters*.

The story told in *The Journey* still needs a little fleshing out. Like Edmund Gosse, whose *Father and Son* was a favourite book and the inspiration behind *Marches Past*, Fuller endured a devout Baptist upbringing leavened by an interest in science and natural history. At Cambridge he traded in Christianity for Marxism, and was no less fervent in pursuing this new faith. His enthusiasm was reflected in the contents of his bookcases. To the hundreds of mouldering tomes on nineteenth-century theology, picked up in market-stalls and second-hand book-shops, Fuller added the works of Marx and Engels, Lenin and Mao Tse-tung. In search of a materialist aesthetics, he began to read writers such as Walter Benjamin, Christopher Caudwell and Sebastiano Timpanaro. However, the major influence on

Fuller's early writings was John Berger, whose example and encouragement provided a blueprint for his views on art throughout the 1970s. These were collected in the anthologies, *Beyond the Crisis in Art* and *The Naked Artist*.

Fuller's other abiding theme during the 1970s was psychoanalysis. Characteristically, this interest had grown from personal experience. Fuller had been a compulsive gambler since his student days, eventually joining Gamblers Anonymous to cure his addiction. This experience had led to his first book, *The Psychology of Gambling*, co-edited with Jon Halliday. Soon after came *The Champions*, a study of the psychology of leading athletes and sportsmen.

From 1972 to 1977, Fuller underwent an analysis with Dr Kenneth Wright, referred to simply as 'W' in *Marches Past*. With the same obsessive energy he brought to bear on everything, he became absorbed in psychoanalytical theory, particularly in the works of the British object-relations school, which he felt had been unjustly neglected. Inspired by analysts such as D. W. Winnicott, Charles Rycroft and Marion Milner, he began to investigate the psychological roots of creativity. This resulted in *Art and Psychoanalysis*, which remains his best-selling book, and the television film, *Naturally Creative*. As with Marxism, the influence of psychoanalysis was far-reaching, permeating every corner of Fuller's thought. Almost every essay that he wrote at the time contains references to 'transitional objects' and other items of the psychoanalytic vocabulary.

Although Fuller often declared himself an empiricist and expressed admiration for Karl Popper's critical rationalism, it would be surprising if Popper found much to approve in Fuller's choice of over-arching, explanatory theories. Fuller's historical materialism, his psychoanalytical ideas, and finally, his obsession with the spiritual dimension of art, seem equally 'unfalsifiable' and anti-empiricist. While he was certainly no *less* rational than any of the apologists for contemporary art who write such convoluted prose in the leading journals, Fuller was a subjectivist from start to finish. He seems much closer to the

mark when describing criticism as a kind of 'art form' in itself, as a useful fiction which allows us to look at works of art with fresh insight. In these late writings, one cannot ignore the grand narrative that lies behind most of Fuller's specific value-judgements. As opposed to the standard histories of twentieth-century art, which chronicle the rise and triumph of Modernism, Fuller concentrates on the survival of the British Romantic tradition. He finds the Romantic legacy – bruised and forced into hiding by Modernism's assaults – passed down from Constable and Turner to the Pre-Raphaelites, then to the Neo-Romantics of the 1930–40s. He insists that acclaimed 'Modernists' such as Graham Sutherland, Paul Nash and Henry Moore can more accurately be considered Romantic artists, who used Modernist devices to reinvigorate a longstanding, indigenous tradition.

As such thoughts gestated in Fuller's mind, he signalled his break with John Berger and historical materialism in his 1980 essay, *Seeing Berger* – a riposte to Berger's influential television programme and book, *Ways of Seeing*, of 1972. Returning to this study with the wisdom of hindsight, Fuller found it to be in unwitting complicity with the Thatcher government's ongoing demolition of England's art schools and museums. He argued that Berger's book tended to reduce art works to little more than documents of unequal power relations, or commodities to be sold and resold at ever higher prices. For Fuller, this now seemed a violently reductive way of treating art and aesthetics. Surely, a great work of art had an intrinsic *aesthetic* value over and above its commercial or ideological value. By denying this 'aesthetic dimension' Fuller felt that *Ways of Seeing*, with its critique of 'elitist' fine art values, played into the hands of Mrs Thatcher's economic rationalists who believed the arts should pay their own way. It was, for instance, considered more useful that art schools should turn out commercial designers rather than fine artists. Museums, instead of putting on shows which might interest only a small, 'elite' audience, should concentrate on block-buster exhibitions which would draw the crowds and generate revenue.

By the time Fuller was invited to Australia, to deliver the 1982 Power lecture at the University of Sydney, his thinking had undergone a revolution. The left-leaning academics of the Fine Arts department had originally asked John Berger to present this lecture, but accepted Fuller as a replacement on Berger's recommendation. He scandalised his audience almost immediately. 'Have you ever heard anyone say that William Butterfield – Victorian master of "constructional polychromy" – was a greater architect than Mies van der Rohe? Well, you have now.' He continued, '. . . You will be hearing a lot more such judgements in the near future. The great pariahs are coming in from the cold!'

That lecture, *Aesthetics After Modernism*, was published as a pamphlet, and collated with other essays into *The Australian Scapegoat*, a collection which reflected the impact Fuller's Australian experiences had had upon his thought. Taking his cue from John Berger's ideological opponent, Sir Kenneth Clark, Fuller hailed the work of modern Australian artists such as Arthur Boyd and Sidney Nolan, as pictorial equivalents of T. S. Eliot's *Waste Land*. For Clark, the Australian desert seemed a more appropriate metaphor for the twentieth century, scarred by war and the ongoing legacy of the Industrial Revolution, than the romantic image of the English country garden. For Fuller, the Australian wilderness – as painted by Boyd and Nolan, Drysdale and Fred Williams – provided an important chapter in the grand narrative he was composing. He argued that, by ignoring these Australian painters, art historians were condemning themselves to a partial and inadequate view of twentieth-century art.

The new spiritual guides Fuller identified in *Aesthetics After Modernism* were William Morris and John Ruskin. Morris was important because of his emphasis on the usefulness and pleasure of handicraft. His defence of individual creativity offered an antidote to what Fuller perceived as the soulless machine-aesthetic of Modernism. Ruskin's thought came to exert a deeper, more wide-ranging influence. Although Fuller

claims, in *The Journey*, that his enthusiasm for Ruskin was a symptom of his new-found interest in the traditions of British art, rather than the cause, it would be hard to overestimate Ruskin's significance to his late work. This was already evident in Fuller's 1985 anthology, *Images of God*. It found full expression in his last book, *Theoria – Art and the Absence of Grace*, in which a full-scale study of Ruskin's work was combined with a critique of the spiritual aridity of so much contemporary art. For Fuller, Ruskin's work was of the utmost relevance to our present condition. He set out to prove this claim in deeds, as much as words.

In a 1991 piece in the *Guardian* which noted that *Modern Painters*, the magazine Fuller started in 1987, had 'lost its way' without him, Tim Hilton – another Ruskinian – paid Fuller an extraordinary tribute. He was, said Hilton, 'entitled to underline his assertion that he was Ruskin's successor'.

Fuller probably never put this 'assertion' in writing, but he acted the part with singular determination. In his recent biography of Ruskin, Wolfgang Kemp writes:

> His literary output was immense; but even more impressive was the way in which he kept expanding the range of his influence. Until 1853 he was a writer on art known only to a small public, but in the following years he successfully mastered the roles of teacher, travelling lecturer, and pragmatic reformer. These functions, and the way he interpreted them, are so typically mid-Victorian that Ruskin seems never more a man of his times than in the 1850s. These were his best years, despite the painful break-up of his marriage, despite his fits of despair, and his unsettling conversion experiences. He had not yet frozen into a wise man, he had not yet acquired the freedom of the known eccentric, and he had not yet been forced to attack publicly things that were the wellsprings of his own identity. He still had to fight for a public and a position, and he did so by making the most of every opportunity – usually with supreme grace and charm and occasionally with unbearable

arrogance – while maintaining his independence as always. He was still living for the future.

For Ruskin in the 1850s, read Fuller in the 1980s. Perhaps the only substantive difference is that the painful break-up of Fuller's first marriage was followed by a happy second marriage, in which he was able to reassess some of the more manic aspects of his own personality. Fuller never got the opportunity to 'freeze' into a wise man, although he was not short of eccentricities. His 'unconversion' from Marxism echoed Ruskin's unconversion from Christianity, while his apostasy with John Berger lost him the friendship and respect of many former colleagues on the Left. Aptly enough, they tended to abuse Fuller for his 'Victorian' values. Nevertheless, he relished any opportunity for a public lecture or debate, never doubting that he had a sacred mission to educate and influence public taste.

By the end of his life, Fuller's timetable was so crowded that he was due to be in several different parts of the country on the same day, and two different countries simultaneously. His correspondence was voluminous. He had so many articles, reviews, essays, book and film projects in the pipeline that he wrote from early one morning to the small hours of the next. A typical lecture in his collected papers begins as a neat, orderly typescript written on his word processor in Bath. It changes to handwriting as he continued the piece on the train to London and ends in a mad scrawl, finished while sitting on the steps of the gallery where he was soon due to speak.

If Ruskin was notorious for his 'purple passages', Fuller's prose was similarly prone to delinquent punctuation and syntax. He could not be described as a great stylist, and the Ruskinian flourishes of his late writings often strike an archaic note. Fuller is occasionally repetitive, but this is because he believed, with evangelical passion, that when he had hit upon a truthful observation, it was worth repeating to anyone who would listen. Like Ruskin, there is more than a little of the

preacher in his make-up, fuelled by an unwavering belief in the need to make moral judgements about works of art. He saw art appreciation as more than a game of intellectual fencing, invoking Ruskin's statement: 'Tell me what you like and I'll tell you what you are.' For Fuller, the type of art one liked revealed a great deal about one's intellectual and moral fibre. When he inverted Hannah Arendt's famous phrase and said that Andy Warhol or Gilbert and George represented 'the evil of banality', he was not simply playing on words.

With *Modern Painters*, Fuller paid another homage to Ruskin: not merely to Ruskin's own mammoth work of the same name, but to *Fors Clavigera*, the personal newsletter that he published from January 1871 until December 1884, apart from a two-year break because of illness. Fuller started *Modern Painters* because, like Ruskin, he was increasingly dissatisfied with existing venues, which either refused to publish his work or expected him to modify his views. In his opinion, all existing art magazines showed a lack of conviction and combativeness. By contrast, *Modern Painters* was outspoken in its opinions. It took the British art world by storm, provoking extremes of admiration, anger and scorn. More than anything, it revealed Fuller's genius as an editor. He had a talent for making mischief and a deep-seated hatred of art-world complacency. Leading always from the front, he stimulated ferocious debates and revelled in the controversy, getting the media and the general public interested in art in a way that had scarcely seemed possible before. He also tried to stir up patriotic feelings for national art traditions in a traditionally apathetic audience. He was accused of being a 'little Englander' and a bigot as he fought to stem the tide which had so often reduced England to a provincial outpost of the latest 'international' movement – first from America, and later the Continent. If Clement Greenberg's name appears in a surprising number of these late essays, it indicates Fuller's respect for this most influential of Modernist critics, but also his burgeoning desire to cut off the head of the king and steal his crown. As Greenberg helped launch American art into world

prominence, Fuller was determined to do the same for British art – even if he had to do it single-handedly.

Without Fuller, the entire temper of art debate has resumed a more even, monotonous tone, and art itself has been pushed back to the margins of British public and intellectual life. Such a climate of sleek mediocrity undoubtedly assists many who are carving out careers as contemporary artists, critics or administrators, since it is easier to conform to the unargued dictates of fashion than to account for tastes and judgements in the way Fuller demanded. It is also simpler to award artists ticks and crosses in a piecemeal way rather than judge them by the standards of a thoroughly-developed aesthetic philosophy. Such a standpoint may have often led Fuller to apparently distort or caricature the work at hand – his characterisation of Modernism itself is highly questionable – but this is surely preferable to that lukewarm professional reflex, which never looks beyond the next pay-cheque to consider the wider aesthetic and political issues in which every art work is imbricated. It is rare for critics and artists nowadays to be anything but cynical. Fuller was never guilty of this offence. In its passionate conviction and breadth of argument, his writing was most appealing when it was most infuriating.

John McDonald
1992

The Journey: a Personal Memoir

I hope that I will not sound unnecessarily cussed if I begin by saying that I regard the exhibition, *The Journey*, with unease and even rank scepticism. At the time of writing, I have not seen any of the works which will be on show, but, with a few notable exceptions, the list of names of those artists who are taking part does not inspire much confidence in me. I am aware that this sounds arrogant and, no doubt, discourteous to the artists concerned, but then serious criticism is often that way. After all, such criticism is itself the result of a personal 'journey'. As it happens, I agree with Gilbert, one of the contributors to Oscar Wilde's famous dialogue, *The Critic as Artist*, who argues that higher criticism is 'the record of one's own soul'. He goes on to describe it as 'the only civilized form of autobiography, as it deals not with the events, but with the thoughts of one's life; not with life's physical accidents of deed or circumstance, but with the spiritual moods and imaginative passions of the mind'.

Before I spell out my objections to *The Journey*, I want to say something about how I arrived at such a view of criticism. I have written often enough about how I grew up – in an intellectual sense, at least – at a time when materialism of one kind or another was the orthodoxy in critical theory. In the late 1960s and throughout the 1970s, 'serious' critics invariably seemed to pride themselves on the thoroughness with which they renounced the idea of the transcendent in art. Words like 'soul', 'grace', 'spirit' and even, unbelievable as it now seems, 'imagination', were taboo.

At that time such an intellectual ambience was congenial to me – not least because I was reacting against the somewhat claustrophobic religious atmosphere I had inhabited as a child.

Inevitably, I was drawn towards the intellectual ambience of Marxism, then a great deal more prevalent and persuasive in Britain than it is today. Indeed, it was among Marxists that I acquired much of my aesthetic education.

John Berger was, in an unofficial sense, my teacher in criticism. In his book, *Ways of Seeing*, he associated aesthetic valuing with 'bogus religiosity'. As far as he was then concerned, the spiritual dimension of art was an anachronism, a sort of penumbra of the function of art as property and in the market-place. Berger had, of course, nailed his colours to the mast of 'Realism', but almost all the rival theories of art also presented themselves as thorough-going materialisms. Indeed, Formalists, Structuralists and Post-Structuralists alike justified their respective viewpoints on the grounds that they were more materialist than those of the next man, or very occasionally, woman.

I cannot claim to have been an exception. My early books on art were also attempts to elaborate a materialist aesthetics. In *Beyond the Crisis in Art*, I drew what I could from sociological and political theory. To this day, this is the only one of my books which has ever been regarded as even worthy of attention by the Left. It amuses me that there are critics such as John Roberts, who, in a recently published book called *Postmodernism, Politics and Art*, argue with the texts in *Beyond the Crisis in Art* as if they contained my final positions. Roberts simply isn't prepared to entertain any greater doubts about left-wing theories of art than the modest questionings of that early book.

Marxism, of course, endeavoured to see every aspect of human culture as determined exclusively by historical circumstances. But, in my own writing about art, I was already beginning to emphasise the relative constancy of the human body, indeed, of the human being itself, from one historical moment to the next. Nothing propelled me in that direction faster than my belief in the universality of great art. I brooded upon the fact that the greatest works of art transcend those moments of history in which they were made and appear to

'speak' directly to those who lived in quite different historical circumstances. The explanations offered by Marx and the Marxists for this seemed to me inadequate – special pleading of the least convincing sort. I can still remember with what excitement I read Herbert Marcuse's posthumously published essay, *The Aesthetic Dimension*, in which he assailed orthodox Marxist aesthetics. 'By virtue of its trans-historical, universal truths,' he wrote, 'art appeals to a consciousness which is not only that of a particular class, but that of human beings as "species beings", developing all their life-enhancing faculties.'

Marcuse wrote that 'art envisions a concrete, universal humanity (*Menschlichkeit*), which no particular class can incorporate, not even the proletariat, Marx's "universal class" '. Such ideas struck a receptive chord in me. My own book, *Art and Psychoanalysis*, plunged into a terrain which was simply out-of-bounds for orthodox Marxist aesthetics. I explored psychoanalytic ideas, especially those of the British School of 'object relations' analysts, in an attempt to say something about the pleasure, wonder and mystery which I derived from the experience of art. In particular, I was interested in the possibilities of psychoanalytical understanding of form itself. In *The Naked Artist* I tried to take these ideas still further and draw upon natural history and biology too.

Nowadays, despite having changed my views on many of the ideas of these books, I would not disown any of them. *Art and Psychoanalysis* still commands a steady readership and has been translated into Portuguese, Greek and Chinese. Therein I argue that the formal dimensions of painting are themselves symbolic. Although this will seem perfectly obvious to anyone with psychoanalytical experience, it is hardly common currency in the art world, even today.

Nonetheless, I came to believe that *Art and Psychoanalysis* was imperfect and partial. The great New Testament scholar, Rudolf Bultmann, once complained about the way in which modern theology had ended up with a 'God-shaped hole'. It seemed to me that deconstructive and semiotic approaches to art

criticism had disappeared into an 'art-shaped hole'. But was my own brand of materialist criticism bringing me any closer to the palpable and yet mysterious presence of art itself? I could describe the 'psychodynamics' which informed a Rothko painting, but my critical vocabulary could not say much about the hair's breadth which divided one of Rothko's successes from his most abject failure. Was that vocabulary worth having at all? I came to feel that all I had written failed to give any explanation of the central question of *evaluation* in our response to art.

There was only one critic who called himself a Materialist who seemed to be grappling with this vital aspect of aesthetic experience, and that was Clement Greenberg. This is not the place to enter into any detailed discussion of the influence which he has had over my development. Suffice to say that I regard him as, without doubt, the greatest critic of art that America has produced or is ever likely to produce. I have nothing but contempt for his detractors. Invariably they rail loudest against those aspects of Greenberg's taste for which I have the greatest admiration, especially his willingness to test irony against judgement.

The irony, for me, is that I cannot agree with all, or even with many, of the specific evaluations Greenberg has made. For example, when I visited him in 1989, he was insisting that Jules Olitski was the greatest living painter. I have never seen a painting by Olitski which I regard as major, and I find his recent pictures vulgar and tasteless. Yet I continue to admire Greenberg because he has the courage of his aesthetic and moral convictions. He knows that the values which great art proposes are trans-historical. He understands that taste is the only means we have for the apprehension of such values, and he realises that individual taste itself is never invested with the authority of those absolutes in whose name it aspires to speak.

If, in the end, I found myself parting company with Greenberg too, it was because his approach seemed to me to be positivist, by which I mean that he assumed that there was nothing more to aesthetic experience than that which is

immediately given to the senses. I realised that, if this was true, then the sort of emotion to which a beautiful red scarf gave rise in me would be indistinguishable from that which I felt when contemplating the ceiling of the Sistine Chapel.

The simplest way of describing the changes which took place in my taste from about 1979 onwards, would be to say that I developed an ever-deeper sympathy for the Romantic, the Gothic, and the spiritual dimensions of art. I have read that the reason for this was my growing interest in the writings of Ruskin, but I am not sure that this is true. Indeed, I think that I became ever more involved with Ruskin because my taste was changing anyway.

For example, I developed a passionate interest in the great Gothic cathedrals and the medieval parish churches of Suffolk, where I acquired a cottage in 1981. It seemed to me that no 'materialist' culture – certainly not the high Modernism celebrated by Clement Greenberg – had ever remotely approached the aesthetic glories of these churches. I was very much aware that their splendours and their intricacies were dependent upon a faith which I could not share and which was not even shared by contemporary Christians. Although the Catholic Church in post-second world war Britain might inspire a building as shoddy as Liverpool's Catholic Cathedral, it could never give rise to the harp-playing pigs and evil old women which spring up from the early fifteenth-century bench-ends in Stowlangtoft church.

When, in the early 1980s, I wrote the essays gathered together in *Images of God*, I felt that I was being tremendously daring and even perverse in reviving the idea that aesthetic experience was greatly diminished if it became divorced from the idea of the spiritual. What I responded to in Ruskin, above all else, was the distinction he made between 'aesthesis' and 'theoria', the former being merely a sensuous response to beauty, the latter what he described as a response to beauty with 'our whole moral being'. My book, *Theoria*, was an attempt to rehabilitate 'theoria' over and above mere 'aesthesis'. I also tried to

communicate my feeling that the spiritual dimensions of art had been preserved, in a very special way, within the British traditions.

In my critical writing I came to emphasise how British artists appeared to have faced up to the aesthetic consequences brought about by the spiritual dilemmas of the modern age. In particular, I became interested in the links between natural theology and the triumphs of British 'higher landscape', and those beliefs about nature as divine handiwork which were held with a peculiar vividness and immediacy in Britain.

The experience of Matthew Arnold's 'long-withdrawing roar' of the Sea of Faith, and the exposure of 'the naked shingles of the world' created a great crisis for art, as for every other dimension of cultural life. However, the best British artists of the twentieth century faced up to that spiritual crisis. I interpreted the work of David Bomberg, Paul Nash, Stanley Spencer, Henry Moore and Graham Sutherland as differing responses to the phenomenon of 'Dover Beach'. I argued that all these artists were imperfectly modern, and that this imperfection was a source of their strength. Unlike true Modernists they did not deny the spiritual and aesthetic calamity brought about by the ever-present weight of God's absence. They did not merely tease aesthesis, but appealed to theoria, regardless.

When I first put these ideas forward, they seemed to me to be very much against the grain of the times. After all, the 1980s witnessed a terrible debasement of art. I have often enough described how, in the 1980s, a kind of Biennale Club Class Art took over in the art institutions and smothered any real response to the strengths of our national tradition. The decade saw the rise of rampant commercialism of a crassness and vulgarity never before encountered. Sadly, many younger artists turned to the anaesthesia of the mass media rather than the world of natural form for inspiration. At times, it seemed as if there was a general indifference to aesthesis, let alone theoria.

Of course it was not as simple as that, nor was I so alone in my tastes and views as I sometimes felt. I began to realise that the

very baseness of the decade has created a counter-current of reaction. One instance of this was the resurgence of interest in the work of a painter such as Cecil Collins. Another was the great number of painters of real calibre who insisted upon pursuing higher landscape, regardless of art world fashions. They were, unsurprisingly, very much in tune with the wider 'ecological' concerns of the day. Everyone, it seemed, *except* the art world, was insisting upon the need to re-create an imaginative and spiritual response to the world of nature.

I am sure that, in retrospect, the 1980s will be seen as a period almost as rich in visionary landscape painting as the 1940s. Just look at the work of some of the older painters such as Norman Adams or John Piper; or take the work which Adrian Berg, Maurice Cockerill, Christopher Cook, Maggi Hambling, Derek Hyatt, David Leverett, Terry Shaves, Len Tabner and William Tillyer did in the 1980s. What a pity that not one of those artists was included in *The Journey*.

Equally exciting for me was the discovery that criticism too was beginning to emerge from its 'dark night of the soul', regardless of the fact that for much of the decade the dreary progeny of the 1960s continued to rule the roost. What a baleful influence was exerted over criticism of both literature and art by figures such as Norman Bryson, T. J. Clark and, worst of all, Terry Eagleton. The art institutions and magazines, academic art history and journalistic criticism alike became dominated by modes of 'discourse', which obscured the view of pictures and sculptures *as art*. Indeed, the dark shadow of cultural material- ism seemed to hang heavily over any attempt to revive interest in the only dimensions of art which counted for anything at all – those of aesthesis and theoria.

As the decade came to a close, all that began to change. In large part, I am sure, events in Eastern Europe, and indeed throughout the world of organised Communism, contributed to the shift of critical emphasis in the West. Quite quickly, Marxism, and indeed historical materialism itself, began to lose whatever claims they may have once possessed over ethical and

aesthetic life. The foundations of much of the 'higher criticism' of the 1980s were shown to have been built on sand.

For me, one of the most important books of recent years has been George Steiner's *Real Presences*, a bold essay in which he argues that the chatter of secondary discourse – whether academic or journalistic – is just a defence against an encounter with that real presence which great art has to offer. Steiner argues that even in a secular culture such as ours, great art is necessarily 'touched by the fear and ice of God'. He affirms that even, or perhaps especially, in an era of unbelief the artist must make 'a wager on transcendence'. Needless to say, these words had great resonance for me.

But not all recent talk of the transcendental dimension of art has been as convincing as *Real Presences*. Almost every day, it seems, we receive further news of an escalating 'spiritual revival'. *The Journey* is only the latest in a swelling spate of books, seminars, conferences and other projects on some aspect of the transcendental experience in art. My own scepticism dates back at least three years, to the exhibition, *The Spiritual in Art: Abstract Painting 1890–1985*, which was held at the Los Angeles County Museum of Art in 1987. In this show a whole range of erstwhile American Modernists – deeply implicated in the reduction of art to the vulgar materialism of Pop or the sterile vacuity of Minimalism – were rehabilitated as founders of the new spirituality. Examples of every sort of foolishness from the recent history of art were suddenly kitted out with new 'transcendental' critical robes. As usual, much of the best art of our time, including every one of the British painters and sculptors I have referred to above, was ignored altogether.

The late Cecil Collins told me, more than once, of his own mixed feelings about the revival from which his own reputation so greatly benefited. Cecil, too, was sceptical about the loose and superficial invocation of the terms 'romantic', 'visionary' and 'spiritual'. Here in England, I believe that exhibitions like *A Spiritual Dimension* and *New Icons* have only served to exacerbate the problem. While there was some good work in both shows,

there was also much which was merely fashionable, sentimental or worse. The truth is that very little in either of these exhibitions could be said to be touched by 'the fear and ice of God'. Chatter about transcendence is not qualitively different from chatter about the framing edge, 'proletarianisation', signifying practices or post-modern radical eclecticism. Indeed, the appropriation of the language of the spiritual to defend work which is trivial or banal, is perhaps the saddest twist in the present-day shrouding of the transcendent potentialities of art. My heart sinks, for example, when I hear my friend Sister Wendy Beckett defending the reductionist ethic of Minimalism.

It is now more than seventy years since Rudolf Otto wrote so revealingly in *The Idea of the Holy*, about the part played by the void, or emptiness, in Chinese painting. We could understand this, Otto believed, through a comparison between the 'nothingness' and the void of the mystics and the enchantment and spell exercised by 'negative hymns'. 'For "void",' he wrote, 'is like darkness and silence, a negation, but a negation that does away with every "this" and "here", in order that the "wholly other" may become actual.' It seems to me that there is every difference in the world between this spiritually replete emptiness and the numbing vacuity of works by artists such as Carl Andre, Agnes Martin, Ellsworth Kelly or Brice Marden.

The trouble with so much recent art and criticism of the spiritual revival is that it has got hold of a new, and these days increasingly trendy, way of talking about art. Spiritual terms are deployed regardless of whether the art in question has struck that perilously risky 'wager on transcendence' or not. No attention at all is paid as to whether the wager has actually been won.

In 1989 I contributed to the colloquium, 'The Church and the Visual Arts today: partnership or estrangement?', organised at Winchester Cathedral by Canon Keith Walker. I was appalled to see men of the church apparently nodding in agreement when a member of the staff of the Tate Gallery encouraged them to believe that Gilbert and George and Andy Warhol were among

the greatest spiritual artists of our time. I had a vision of lurid stained glass windows with titles like *Marilyn* and *Dick Seed* rising above the altars of parish churches and cathedrals throughout the land.

When my turn came to speak I tried to tell the assembled clerics about the ethical, aesthetic and spiritual bankruptcy of the institutions of contemporary art. I argued that it was up to the churches to rehabilitate the idea of the transcendent in art. It was not their task to condone the ubiquitous symptoms of anaesthesia and spiritual bankruptcy which pass for art in the modern world. I don't think my words counted for much. In fact my worst fears seem to be coming true much sooner than I expected.

It is, I believe, a tragedy that consideration was given to inviting an artist such as Richard Long to create a piece within Lincoln Cathedral. His work, for me, is symptomatic of the loss of both the aesthetic and the spiritual dimensions of art. He shows little trace of imagination, of skill, of the transformation of materials. Seen in contrast to the greatest achievements of the British tradition in art, Long's relationship to the world of nature is simply regressive. His work is sentimental and fetishistic. By contrast, 'the Cathedral of Lincoln,' as Ruskin once wrote, 'is out and out the most precious piece of architecture in the British islands, and – roughly – worth any two other cathedrals we have got'. It is the greatest monument this country possesses to what, in aesthetic terms, can be achieved through work, faith, worship and praise. Elsewhere Ruskin proclaimed:

> Go forth again to gaze upon the old cathedral front where
> you have smiled so often at the fantastic ignorance of the
> old sculptors: examine once more those ugly goblins, and
> formless monsters, and stern statues, anatomiless and rigid;
> but do not mock at them, for they are signs of the life and
> liberty of every workman who struck the stone; a freedom
> of thought, and rank in scale of being, such as no laws, no

charters, no charities can secure; but which it must be the first aim of all Europe at this day to regain for her children.

Richard Long's chips and pebbles are evidence that she has not yet done so. Claims that his work is worthy of 'spiritual' attention are preposterous, but they do not surprise me. 'What I affirm,' writes Steiner, 'is the intuition that where God's presence is no longer a tenable supposition and where his absence is no longer a felt, indeed overwhelming weight, certain dimensions of thought and creativity are no longer attainable.' Under these circumstances, there is perhaps nothing to be done except to fall back on the consolations of lost illusions, in art, if not in faith. These we can find more readily in the ancient fabric of the west front of Lincoln Cathedral itself, than in anything an artist like Richard Long may place within it.

1990

A National Art?
The Legacy
of Romanticism

The Ruskin Lecture

When I was 'Critic-in-Residence' at an art school in Newcastle in the late 1970s, I returned to work after the Easter break and was told about a terrible and awesome spectacle to be seen in the Life Room. I went along to investigate. As usual, a small group of students stood behind their easels, drawing. But they were ranged in front of a young man mounted in the crucified position upon a large wooden cross. His hands grasped pegs at the extremities of the cross-beam; his head sagged towards the left, his knees were bent and his feet rested on a small platform. He was wearing a white loin cloth and his arms were decorated incongruously with tattoos.

Even for an unrepentant atheist like myself this was a disturbing sight. Not only did the lithesome banality of the young man's body jar against 2,000 years of religious iconography, I also felt jolted because this picture seemed to epitomise the way in which the great epic of Modernism has collapsed. If you'll pardon the expression, not so long ago, no self-respecting art student – least of all in Newcastle, sometime centre of the 'Basic Design' approach to art education – would have been caught dead in the Life Room with a crucifix.

There is, however, a change of sensibility sweeping through the visual arts. Modernism taught that the only truth was 'truth to materials', but more and more artists are again seeking a truth in the visible forms of nature. This is why they are flocking back into the Life Room or out into the landscape.

Modernism also maintained that the only symbolic framework that mattered was that of 'Art' itself, but today artists are seeking to create images which appeal to far more widely-shared 'structures of feeling'. Until recently, much art criticism

and art practice has had its nose pressed so closely to the surface of the canvas that it has tended to ignore the world of natural form, the human spirit and imagination. If some are returning to the traditional iconography of Christianity, it is not necessarily because of their religious beliefs, but because they feel they have nowhere else to go.

In such a climate it is inevitable that John Ruskin's contribution will be revalued too. Ruskin was not just British literature's first major art critic, he was, I believe, the greatest critic the world has yet seen. He has been much neglected throughout this century, but now Ruskin is attracting attention again because of the way he scrutinised the evidence of his senses and sought to connect what he saw with the moral and cultural issues of his day.

Indeed, Ruskin's work seems constantly to raise the question: 'Can the arts flourish outside a shared framework of affective and symbolic beliefs – a religion, in fact?' One might like the answer to be an unequivocal 'yes', but it is by no means certain that this is so. The recent history of Modernism suggests rather the opposite.

This problem was implicit in the very first piece of Ruskin's writing that I encountered. When I was a student at Peterhouse, Cambridge, in the mid-1960s, I came across a copy of *The Political Economy of Art* in the college library. This book was quite unlike anything I had read before, consisting of lectures Ruskin gave in Manchester in 1857, when he was invited to speak on the occasion of a major 'Art Treasures' exhibition. Manchester was at that time the mecca of *laissez-faire* capitalism and the headquarters of the economic 'Liberals' who believed that everything should be left to the operation of market forces. No doubt, the worthy manufacturers and their wives who crowded into the Manchester Athenaeum expected some edifying aesthetic sentiments from the protagonist of Turner, the fashionable author of *Modern Painters*.

This work, with which Ruskin made his name, began as a brochure replying to scoffing criticisms of Turner's art. It

subsequently swelled to five volumes, with Ruskin changing his views on art and much else, during its writing. When he set out, his intention was to show that Turner had paid greater attention to nature and depicted it more truthfully than any of the masters of the past or any of his contemporaries. For Ruskin this did not mean that Turner was locked into physical and empirical realities which other painters overlooked, but that he could transcend these things more effectively than they. At this stage of his thinking, Ruskin saw 'nature' as little more than a synonym for the handiwork of God. Linking this with Turner's achievement, he wrote that 'each exertion of his mighty mind' might be 'both hymn and prophecy; adoration to the Deity, revelation to mankind'.

But 1857, when Ruskin visited Manchester, was a time of transition in his thinking. It was one year before his 'unconversion' in Turin, after which he came close to adopting a sensualist aesthetics, arguing that 'a good, stout, Self-commanding magnificent animality is the make for poets and artists'.

His thoughts were also shifting from the kingdom of God to the society of men, and the lectures he delivered to the good citizens of Manchester amounted to a teasing indictment of Victorian, mid-century capitalism. Ruskin criticised unbridled economic competition and promoted the principles of co-operation, while attacking the indifference of government to the quality of life endured by the governed. How, he wanted to know, was *laissez-faire* theory and practice compatible with, say, the employment of artists, the education of workmen, the elevation of public taste and the regulation of patronage? Ruskin was especially concerned about the way in which *laissez-faire* capitalism was destroying the aesthetic dimension in human life. Contemporary society was such that it seemed to be squeezing out all room for art whatsoever. He pointed to things like the tasteless luxury of the rich, ignorant patronage, the destruction of ancient buildings, and the decline of artistic work in ornament, furniture and dress.

These lectures are scattered with suggestions about what the

Government might do to make things better. For example, Ruskin thought it would be a good idea if the Government set standards and regulated the production of artists' materials, such as brushes and paper, to ensure the maintenance of quality. His audience, committed as it was to *laissez-faire* ideas, seems not to have objected too much at the time, and applauded frequently while he was speaking. Perhaps they were misled by the tone of profoundly anti-democratic paternalism which stamped even Ruskin's most utopian imaginings. Yet when the press had a chance to study the lectures, they realised something of their significance. *The Manchester Examiner* dismissed Ruskin's pleas for the involvement of the state in the arts as 'genius divorced from common sense' and 'arrant nonsense'.

So when I chanced upon these lectures in 1967 – a mere 110 years after they were first delivered – I set out to study Ruskin for my next undergraduate essay. My supervisor suggested I should entitle it, 'Ruskin's social, economic and aesthetic teaching was confused by puritanical prejudice. Discuss.' I dug out that old essay recently, and was not surprised to find that it was a highly ambivalent text. I wanted to say that, however eccentric and bigoted Ruskin may have been, he was also right in the emphasis he placed on the aesthetic elements in human life – on what he called 'the qualitative channel of human experience' – and in his critique of work under industrial capitalism. But I also berated him, not just for his religiosity and evangelical ethics, but for his 'blindness' towards what I then took to be the aesthetic potentialities of the new age. I could not endure his preference for Gothicism, over and above engineering; for wood and stone, rather than iron; for ornament, as against structure; for the arched, rather than rectangular, window frame. I wrote as if there was no real difficulty in separating a Ruskinian kernel from the husk of his 'archaic' religious thought, and assimilating the former to Modernism while quietly flushing away the latter.

The ambivalence of my views at that time was probably less surprising than the fact that I chose to write about Ruskin at all.

Although Raymond Williams had argued, in his influential study, *Culture and Society*, of 1958, that Ruskin should be taken seriously, I doubt if this had much effect. Indeed, when Kenneth Clark published his anthology of selections from Ruskin in 1964 he prefaced it with the remark that no other writer had suffered so great a fall in reputation. In the mid-1960s, one could easily buy copies of Ruskin's works for a shilling from book stalls in Cambridge market place. At that time, while there was plenty of academic scholarship focused upon the pathetic details of Ruskin's biography, as a cultural force he was not even an echo, let alone a voice.

My generation of revolting students were preoccupied with issues such as anti-capitalism and 'art and society'. After all, in the years immediately preceding 1968, it seemed to many of us that the world might be about to undergo a change for the better. We were infatuated with the ethic of Modernism; we believed that – in all sorts of strange and complex ways – the Modernist movement in art prefigured the great historical transformations we felt to be imminent. In those days the colleges were in ferment, but – with our eyes glued to television sets watching events across the Channel – it never occurred to us to refer to a rich, British tradition of political and aesthetic thought, a tradition which finds its roots in Ruskin's fertile prose.

Instead, in 1968, Walter Benjamin's now-famous essay, 'The Work of Art in the Age of Mechanical Reproduction', became easily available in English translation for the first time. Benjamin spoke about how modern means of producing and reproducing images were shattering the 'cultic' associations and the 'aesthetic aura' which had once surrounded works of art. He claimed that this process was part of progress and proletarianisation. He saw traditional literary, musical and artistic forms streaming into 'an incandescent liquid mass' out of which new forms would be cast. Naturally, all this was much more congenial to those of us concerned with art and revolution, than whatever puritanical prejudices might be found in

those olive-green, second-hand volumes of old fuddy-duddy Ruskin.

Upon reading my undergraduate essay, a colleague felt that even such an ambivalent and half-hearted endorsement of Ruskin amounted to a kind of betrayal – not just of the Modernist movement, but of the revolutionary politics to which we were committed without reservation. Any refusal to go along unconditionally with what I would now describe as the philistinism of the so-called 'avant-garde', was read as a sign of incipient political 'conservatism'.

When I left university and went to London in 1968 to work as a professional art critic, no one ever suggested that I should read Ruskin, even though discussions of social issues dominated the art community throughout the 1970s. If Ruskin was ever mentioned it was usually to imply that much of what angered him about nineteenth-century capitalism had been rectified. What he said about art was presumed to be wrong or, at best, irrelevant. Maybe the Government doesn't put its seal of approval on every sheet of cartridge paper, but we do have public museums and an Arts Council. Aesthetically, Ruskin had not even been able to stomach Whistler, so what could he possibly have to say to the heirs of Cézanne? Besides, didn't he have terrible sexual problems and eventually go mad?

In one sense such attitudes are understandable. We no longer live under the kind of *laissez-faire* capitalism that so appalled Ruskin, although it appeared for a long time that the Thatcher Government wanted to return us to those days. For better or worse, through books like *Unto This Last*, Ruskin had a profound influence on the British labour movement and the emergent ideology of the welfare state. Again and again in his late work one finds ideas that would have appalled his Manchester audience but which, at least until the rise of Thatcherism, have been considered political common sense in our century, supported by both Government and opposition. This includes the proposal that the Government must intervene

to mitigate the effects of market forces and to provide educational, health and cultural facilities.

A few years ago I started reading Ruskin again, and now I see him neither as I did in 1967, nor as a tame prophet of the modern welfare state. To set out to read Ruskin's work today is to begin climbing an unknown mountain. Admittedly, it is a deeply flawed mountain, and it is easy to lose one's way among all that granite stubbornness, those dangerous crevices, valleys clogged with the silt of dead ideas, and endless strata of categories. It is a mountain upon which one encounters strange fossils of thought, glacial drifts of verbiage, springs of brilliant insight and frequent glints of an almost preternaturally acute perception. Despite the arduous, rocky passages where the going gets so tough that one wants to give up, it is also an infinitely varied mountain, fascinating for its dappled surface, rich in filigreed rocks and luminous hoar-frost. It offers spectacular changes of view and mazes of argument at every turn. Above all it is a majestic mountain, with its foothills and lower slopes rooted firmly in the common-or-garden facts of nature and physical being, but soaring up towards those giddy and sublime heights, swathed in clouds of rapture, where non-believers must leave Ruskin to tramp on to meet with his maker.

Above all, Ruskin is not, as some of his anthologists would have it, simply a quarry for paradoxes and purple passages. What he is saying, and the way he says it, is all of a piece – that kind of unity in profusion and contradiction which one finds in the Gothic cathedrals whose beauties he did so much to popularise. This kind of unity was at odds not just with the *laissez-faire* capitalism of mid-nineteenth-century Britain. It emerges from the thirty-nine volumes of the Library Edition of Ruskin's work as an even more formidable indictment of twentieth-century monopoly capitalism and its sad, technist apology for a human culture.

Ruskin, I believe, is far more radical than many of his commentators allow, but his radicalism is of a deeply *conservative* kind. In the 1870s Ruskin began to issue his eccentric

monthly letters for working men, *Fors Clavigera*. In the seventh
number he announced, 'Indeed, I am myself a Communist of
the old school, reddest also of the red.' Three issues later, he
was saying, 'I will tell you plainly. I am, and my father was
before me, a violent Tory of the old school.' This contradiction is
much less inscrutable than it at first appears if one remembers
that Ruskin believed a significant potentiality of human life
which had been realised in the past, was being suppressed in
the present, but might be brought to life again in a changed
future. What was that potentiality, or rather, cluster of related
potentialities? It was everything Ruskin came to express
through his notion of 'the Gothic', which, insofar as it was a
purely historical category, might be described as the conditions
under which the aesthetic dimension in human culture could
flourish. This aesthetic potentiality was denied by
nineteenth-century capitalism, but it has also been ignored by
many of those who opposed themselves to it. Herein lies the
importance of Ruskin for the present day.

However, one must be careful in attributing an interest in 'the
aesthetic dimension' to Ruskin, if only because he himself
distinguished between what he called *aesthesis*, or the response
to merely sensuous pleasure (about which he was dismissive),
and *theoria*, the response to beauty of one's whole moral being.
In using the term 'aesthetic dimension' as a synonym for
Ruskin's concept of the Gothic, I was clearly referring to the
latter category rather than the former. Because he made this
distinction, Ruskin has been much criticised in the twentieth
century for his allegedly 'moralistic' approach to art, but one
must remember that this appeal to morality meant something
richer than mere ethical considerations. For Ruskin 'morals'
encompassed everything we would identify as human affection
and emotions, sentiments, 'structures of feeling', and the whole
terrain of imaginative and symbolic thought. He attacked 'the
general tendency of modern art under the guidance of Paris',
because he thought it was in pursuit of *aesthesis* in isolation from
theoria. This was the basis of Ruskin's notorious quarrel with

Whistler. In denouncing the search for mere sensation, he wrote, 'I take no notice of the feelings of the beautiful we share with spiders and flies.'

Had Ruskin been able to see the Minimalist and Pop art made in New York during the 1960s and 1970s, he might have thought that his fears about 'the general tendency of modern art' had been realised. It is hard for us to imagine just how revolted Ruskin would be, because his discussion of the 'response to beauty with one's whole moral being' is entirely enmeshed with his thoughts about nature and God. Such things are likely to prove impenetrable to contemporary readers who were fortunate enough to escape a theologically-infected childhood. One can get some idea about Ruskin's way of seeing things by thinking about St Hilary's question: 'Who can look on nature and not see God?' The immanence of God within his creation was a traditional element of Christian teaching which acquired unprecedented importance in nineteenth-century Protestant thought. Gregory the Great had regarded 'the wonders of a visible creation' as 'the foot-prints of the Creator', but a Victorian divine, such as Charles Kingsley, could detect 'the finger mark of God' even in a rock pool.

Ruskin was the heir to this universe of thought. Just as the evangelical preachers he had heard in his youth sermonised from the 'Types' they perceived in the natural world, Ruskin saw 'Typical Beauty' in organic forms which he believed to be the handiwork of God. In Ruskin's early writing, the natural world is seen as a work of art produced through the supreme imaginative and creative activities of the Creator, and therefore the model for all artistic creativity. Since God seemed to have created diversity in unity, Ruskin looked for such features in art and architecture. He attends to nature in such obsessive detail in his extraordinary passages on mountains and clouds partly because he wanted to know how God went about making things. In *Modern Painters* he imagines the Alps as a 'great plain, with its infinite treasures of natural beauty, and happy human life, gathered up in God's hands from one edge of the horizon to

the other, like a woven garment, and shaken into the deep falling folds, as the robes droop from a king's shoulders'. As late as 1870 he could compare the splendours of the vault of Chartres Cathedral unfavourably with nature – that is, with 'the work of His fingers' and 'the stars of the strange vault which He has ordained'.

But what if there was no God? Unlike St Hilary or Gregory the Great, Ruskin could never be sure. He studied the Bible, but confessed to hearing the chink of the geologists' hammers at the end of every sentence. Indeed, the year before he found Chartres a poor comparison with God's work, he had concluded that there was 'no Eternal Father . . . man has no helper but himself', and admitted that this conclusion brought with it 'great unhappiness'. For Ruskin, if God did not exist, the human response to nature risked becoming meaningless, and art a futile pursuit. This was the root of Ruskin's revulsion at Poussin's great grey painting, *Winter* or *The Deluge*. He believed not only that Poussin's atheism had rendered him unable to paint wetness, but that it had led him to a 'sense of spiritual destitution' which had fastened onto his mind 'together with the hopeless perception of ruin and decay in the existing world'.

In later life, despite attempts to retrieve the consolations of religious belief, Ruskin was dogged by a sense of *the failure of nature*, by the feeling that nature had been reduced to the grey, lifeless monotone that had so repelled him as a young man in that late Poussin picture. Soon after he first admitted there was no God, Ruskin began to detect 'the Storm Cloud of the 19th Century', and its accompanying plague wind. This led to the conviction that the failure of nature, brought about by the evil actions of men, was leading to annihilation; to 'blanched Sun, – blighted grass, blinded man'. At such times, even Turner lost all meaning for him.

It is often said that all this was a result of Ruskin's religious delusions or his growing madness, but I believe that some of his most significant insights are to be found in the writings of this period. We live in a world in which both nature and art seem to

have lost their way. We live in an anti-aesthetic or anaesthetic environment, whose emblem is the grey monochrome. As I have argued on many occasions, Ruskin's perception that the actions of men might be leading to a real natural catastrophe and the annihilation of human life, is turning out to be grimly prophetic in this era of nuclear confrontation and ecological crisis.

For Ruskin, large-scale industrialisation was an environmental and aesthetic disaster. He saw an aesthetically healthy society as one in which each individual could express him or herself through imaginative, creative work, made meaningful by a shared framework of values and beliefs. 'The Gothic' was a paradigm of that dimension of life which he felt industrial capitalism was destroying. One finds examples of such systems in non-industrial societies such as Bali, where, as Margaret Mead noted, 'the arts are a prime aspect of behaviour for all Balinese, and literally everyone makes some contribution to the arts, ranging from dance and music to carving and painting. Nonetheless, an examination of artistic products from Bali shows a wide range of skill and aesthetic quality in artistic production.'

Ruskin, as far as I know, never took serious notice of the artistic productions of so-called 'primitive' cultures, but, as Kristine Garrigan has put it, in discussing Amiens Cathedral Ruskin argues that 'a great architectural masterpiece stands not only figuratively, but also literally for the spiritually unified society, in which each member's creativity is respected and welcomed. This is how Ruskin "sees" a building in its entirety: not as a structural enclosure of space but as a symbolic shelter for mankind's noblest aspirations.'

Gothic architecture, in its perpetual variety within unity, not only resembled divinely inhabited nature, but also allowed each individual workman to bend the eye of his soul upon the finger-point in a necessarily feeble imitation of the way God left his finger-marks in creation. Because the Gothic cathedral was, for Ruskin, the place in which all human skills and arts

could unite in the creation of this great symbolic vision, he was led on to those emphases which have so scandalised architectural theorists of the twentieth century. Chief among these is Ruskin's idea that 'the principal part of architecture is ornament'. Ruskin's attitude to ornament only makes sense in the context of his attitudes to work. He insists that the pleasure we take in a building – beyond simple, functional considerations – is in some way related to the pleasure the workman invested in his labour. Ruskin's theory of ornament is, in effect, a theory of labour. Ornament is not a sensualist 'optional extra', but the guarantee of creative work. It is the means by which the workman expresses his individuality and enters fully into the affective and symbolic life of his community. Ruskin railed against the mechanisation of ornament and against the 'degradation of the operative into a machine'.

'We have,' he wrote, 'studied and much perfected, of late, the great civilized invention of the division of labour; only we give it a false name. It is not, truly speaking, the labour that is divided; but the men: – Divided into mere segments of men – broken into small fragments and crumbs of life; so that all the little piece of intelligence that is left in a man is not enough to make a pin, or a nail, but exhausts itself in making the point of a pin or the head of a nail.' Ruskin saw such points and heads as being polished with the 'sand of human soul'. Under such conditions, the aesthetic dimension all but disappeared from the everyday life and work of ordinary men and women.

Since Ruskin holds up true Gothic as a paradigm of excellence, one can hardly avoid asking whether his view of this form was historically accurate. Well, it was and it wasn't. John Harvey, a medieval scholar, could be echoing Ruskin when he describes late Gothic buildings as 'the climax of European art' and points out that 'not only had individual buildings acquired artistic unity, but every part and detail was so subtly proportioned to the whole, and to human scale, that it gives the impression of a work of nature rather than of human striving'. Or, as George Henderson argues, Gothic was something

beyond and above architecture or building techniques. It was, he says, an intellectual, spiritual and decorative principle which was applied equally to all the major and minor arts, and by which they were blended into one Total Art.

Ruskin was absolutely right about these aspects of the Gothic. But if Gothic was for him much more than a matter of style – almost a way of life, in fact, – it is significant that both he, and William Morris after him, misunderstood the conditions under which the artists and craftsmen of that period worked.

Ruskin did not know much about how the cathedrals were built, or the division of labour upon which their construction depended. Chartres or Lincoln did not spring, fully-formed, from collective imagination and collective work. They were designed by architects who, as we now know, were men of distinction and reputation. The specialist craftsmen who built them were much more like early 'professionals' than everyday labourers, as Ruskin and Morris supposed. Furthermore, the late Middle Ages underwent its own 'industrial revolution', and its architectural feats were, at least in part, made possible by the mechanical innovations of the time.

Ruskin liked to believe that the rot started with the Renaissance, and would probably have been horrified to learn about the role of professionalisation, division of labour and mechanisation in his beloved Gothic era. And yet there is an important sense in which these recent historical discoveries only strengthen his argument. In many so-called 'primitive' societies, the aesthetic dimension permeates every aspect of life and work – from personal adornment, through manufacture of bowl, dagger or sculpture, and into ritual preparations for the hunt and celebrations of the harvest. The arts barely exist as separate categories, and the aesthetic dimension is a component of all human skills. But in Gothic Europe, the aesthetic has been displaced from the appearance and everyday work of the body onto certain buildings. The aesthetic dimension becomes lodged, largely though not exclusively, in a space set apart: the space of the great cathedral.

These cathedrals – unrivalled human achievements as they remain – represent the beginnings of the *displacement* of the aesthetic dimension; its isolation from life, as much as its consummate expression. This separation of the aesthetic dimension accelerated during the Renaissance, which saw the emergence of a division between intellectual and affective life, and the consequent decline of ornamental and architectural arts. From the Renaissance onwards, architectural style in Europe tended to be pillaged from the symbolic orders of the past, rather than arise from the spiritual life of the present.

As the aesthetic dimension was forced to retreat still further out of actual life, it came to reside in that 'other reality within the existing one', the illusory space of the painter, who, through the invention of perspective, ceased to be a decorator of architectural space and became the creator of his own painted world. The arts thereby ceased to be synonymous with all human skills. Art acquired a capital 'A' and became the special and unique province of the privileged creators of that other reality. By the nineteenth century, the artist was one whose imaginative work was distinct from all other kinds of work. This was not, as some have argued, simply a change in the ideology of art, it was the consequence of a profound change in the nature of work. Ruskin saw this clearly when he wrote, 'the English school of landscape, culminating in Turner, is in reality nothing else than a healthy effort to fill the void which destruction of Gothic architecture has left'.

This is a good moment to return to that conventional wisdom I cited earlier that Ruskin is irrelevant to us because the social conditions about which he complained have been put right by the emergence of the welfare state, while his attitudes to art are inappropriate to the modern age. Even though the conditions of labour have improved since Ruskin's day, its divorce from the aesthetic dimension has been rendered more complete. We live in a culture which is infinitely more 'anaesthetised' than that of the Victorians. In our society, not many artists could credibly be said to be filling that void left by the destruction of Gothic

architecture. Too many painters have been content with the pursuit of *aesthesis* alone, while the very notion of *theoria* is forgotten or mocked.

Take the case of the Modern movement in architecture. Almost every book on the subject will tell one that Ruskin's attitude to new building practices was 'negative and reactionary', as Nikolaus Pevsner puts it. Again and again, Ruskin is depicted as having been merely stubborn and stupid in his refusal to celebrate such feats of architectural engineering as the Crystal Palace. But, as it happens, Ruskin was never against functional constructions for the new age. He repeatedly argued that, say, railway stations and bridges should not be ornamented. He was a functionalist to the extent that he believed buildings should be well-proportioned, stand up and do the jobs for which they were designed. Nevertheless, he drew attention to the 'difference between a wasp's nest, a rat hole, or a railway station', *and* architecture, which, through ornament, entered into the affective and symbolic order, and was expressive of an aesthetic dimension. The new steel and glass buildings he saw as 'eternally separated from all good and great things by a gulf which not all the tubular bridges nor engineering of ten thousand nineteenth centuries cast into one great bronze foreheaded century will ever over-pass one inch of.' He foresaw the dehumanising sterility of those 'machines for living in' produced by modern architectural functionalists. 'You shall draw out your plates of glass,' he predicted, 'and beat out your bars of iron till you have encompassed us all . . . with endless perspective of black skeleton and blinding square.'

Isn't that exactly what has happened? Ruskin's views on art and architecture are only irrelevant to those – and there are fewer and fewer of them – who remain happy with black skeletons and blinding squares. Today, at the other end of the disastrous Modernist experiment, should we not begin to reconsider what Ruskin had to say about the role of ornament, symbolism and *work* in architecture? Perhaps he was not so foolish when he declared, 'the highest nobility of a building

does not consist in its being well built, but in its being nobly sculpted or painted.'

In recent years, many architects have reassessed the problem of ornament. However, given the divorce between architecture and the fine arts, and the absence of any shared system of affective belief, such as that provided by a religion, it is hard to see how contemporary ornament can be more than mere 'aesthesis'. It acts largely as a stimulus to sensuous pleasure or participates in the debased symbolic orders of advertising, resulting in spectacles such as the neon profusion of Piccadilly Circus. It may well be that we are living in the kind of society in which all that Ruskin understood by 'the Gothic' and I understand as 'the aesthetic dimension', has become impossible.

In trying to find a way out of this impasse, one must ask whether or not there aren't some components of religion which our secular culture must recuperate in order to redeem itself. Perhaps Ruskin, given his time and place in history, was compelled to express in theological terms what we can discuss more easily in psychological or even ecological terms.

Ruskin was certainly one of the first to understand the importance of play and symbolism in every individual's life, and to perceive the ways in which art and architecture could minister to those needs. He was the first to perceive that there was a vital relationship between a child's playful desire to model animals out of pastry and the adult pursuit of sculpture, indeed of culture itself. He was mocked for such views at the time. Heedless of the mockers, he also foresaw that the advance of capitalism, mechanisation and unbelief – all the great triumphs of Modernism – were combining to seal over that area which psychoanalysts like D. W. Winnicott have called 'the potential space'. That is, the unchallenged imaginative domain between objective and subjective, in which the ego finds its earliest definition. This state is sustained, writes Winnicott, 'in the intense experiencing that belongs to the arts and to religion and to imaginative living'.

It is easy enough to see how, in less-developed cultures, the aesthetic element in work constituted one of the most signifi-cant ways in which this 'potential space' between individual and society was held open. Ornamentation, and the interplay between tradition and innovation, provide a significant arena for this exploration of union and separation. This is also relevant to the emotional power of the great Gothic cathedrals, which, as George Henderson has put it, not only 'blur the distinction between the inside and the outside of a building' but express formally the interconnection of all the members of Christ's Church in the supreme unity of the new Jerusalem; as well as allowing those opportunities for individual, expressive work which so impressed Ruskin.

Green politics also finds a progenitor in Ruskin – an environ-mentalist who realised that when a man's spiritual and imagina-tive response to the world waned, he risked destroying himself. Here he is entirely in agreement with modern biologists such as E. O. Wilson, who has spoken of man's 'biophilia': his need to affiliate with other forms of life. He sees this urge as being violated by the development of technology and the destruction of the natural environment.

Although I believe Ruskin has an important role to play in the growing reaction against the reductionism of the modern age, there is probably not much future in the reversion to Christian iconography I described at the beginning of this essay. One must attend to the secular implications of Ruskin's views about art and imagination, particularly his belief that 'Fine Art must always be produced by the subtlest of all machines, which is the human hand.'

'Thoroughly perfect art,' he continued, 'is that which pro-ceeds from the heart, which involves all the noble emotions; – associates with these the head, yet as inferior to the heart; and the hand, yet as inferior to the heart and head; and thus brings out the whole man.' The real importance of Ruskin today lies in the image he presented of the whole man, living within a society which permitted him to imagine, think, feel and work

creatively; and to transform his immediate physical environment through his non-functional or 'aesthetic' work, informed by the dictates of the spirit. Even though Ruskin's dream has not been realised in any present-day society, I see no reason to believe that we have any less need for such a dream.

British Romantic Landscape Painting from Turner to Maggi Hambling

A few years ago, British painters and sculptors were always being encouraged to take their aesthetic values from New York. The rapid succession of fashions and styles which poured out of this metropolis turned it into the Mecca, whose radiance would somehow replenish ailing provincial cultures like ours. Only by imitating American artists could the British hope to redeem themselves. Now no one thinks like that. American art – at least that favoured by the institutions of contemporary art – does not lie dying; it is already dead. Here, in England, there is a welcome re-awakening of interest in the achievements of our national school, and signs of an efflorescence in the painting of nature which defies the infantile involvement with the trivia of the mass media which pre-occupies the American art world. So much so, that they sent an unspeakably awful artist such as Jenny Holzer, with her electronic messages flashed on LED screens, as their representative to the 1990 Venice Biennale.

As an antidote to this kind of art, I must begin by reiterating the argument I put forward in my book, *Theoria*. It is necessary to discuss the rise of English landscape painting, beginning with Turner, and the crisis this movement suffered in the mid-nineteenth century. It is a crisis with which those artists of today who refuse to be seduced by the easy solutions of a Holzer still need to grapple.

In the massive work he published in defence of Turner, *Modern Painters*, John Ruskin argued that Turner's greatness resided in his realism. This did not mean that Turner had simply attended to the appearances of natural forms, but rather that he had studied them so closely that he perceived the way in which

they had revealed God, or the infinite, in the same way in which we believe that the chisel marks in the stone reveal something about the man who carved the sculpture. As he drew towards the end of the first volume of this great epic of art criticism, Ruskin braced himself to find the concluding sentences which would resonate as a fitting memorial to Turner's greatness. 'He stands,' Ruskin wrote, 'upon an eminence, from which he looks back over the universe of God and forward over the generations of men. Let every work of his hand be a history of the one, and a lesson to the other. Let each exertion of his mighty mind be both hymn and prophecy; adoration to the Deity, revelation to mankind.'

Now there are many objections to this line of reasoning, the least being that it is doubtful whether Turner worshipped any God other than – as he is supposed to have admitted on his death-bed – the sun. Even Ruskin's own belief in the idea of God's immanence within a divinely created nature was soon to falter, but it has always seemed to me that, whatever Turner's or Ruskin's reticences about the God of Christendom, Ruskin was on to something fundamental when he argued that what Turner reveals about nature does not stop at appearances but reaches through and beyond them to a spiritual vision of nature itself.

In fact, Ruskin's aesthetic theories fitted rather more perfectly the work of a painter for whom he had much less respect – John Constable. Constable may have seen himself as a 'natural painter', as he put it, driving a nail to secure realism, but he was convinced that such a 'realistic' view of nature would ultimately reveal the divine activity out of which it sprang. Art historians have sometimes emphasised Constable's empiricism and the scientific dimensions of his work, but they tend to forget that orthodoxy in Constable's day – to which he himself subscribed without reservation – viewed science as a branch of Natural Theology. It wasn't just clergymen, but also most scientists (and the two often co-existed within the same individuals), who believed that the ultimate knowledge which science was revealing was religious truth. Indeed, one of the many

meanings of the dark and compelling pictures of Constable's later years, on which so much critical attention has recently come to focus, is that they show his struggle to maintain belief in the face of great personal tragedy. From the brink of despair he was led to glimpse the desolate vistas of unbelief.

The point I am making is really a very simple one: the truths which the higher landscape painting of the early nineteenth century struggled to express were not simply 'natural', let alone merely 'visual'. They were religious and spiritual, they depended upon a belief in the immanence of God within his creation. All this makes perfect sense of an argument of Ruskin's which has long perplexed modern art historians, used to thinking about painting solely in terms of the evolution of style rather than sensibility. I am referring to Ruskin's view that the Pre-Raphaelites were trying to carry on where Turner had left off, whereas Whistler – whose *Nocturnes* seem to us to bear some superficial 'art historical' resemblance to Turner – was anathema to him.

Ruskin's view was perhaps more consistent than it seems. In the 1850s, that 'dissociation of sensibility' which was so to trouble T. S. Eliot in the following century, began to become acute. The old natural theology was breaking down; science (or empirical observation) and spiritual belief seemed to be prised apart. The Pre-Raphaelites struggled manfully, if not always successfully, to hold them together. This was the great drama upon which the subsequent history of British painting came to depend. It is why so much writing about the Victorian art world in terms of patronage, social and political circumstances, just misses the point.

One of the many virtues of Nicholas Serota's 1990 re-hang of the Tate Gallery was that instead of tucking the Pre-Raphaelite pictures of the mid-nineteenth century away downstairs, he put them where they belong, at the very centre of the history of British art. Holman Hunt, in particular, began by painting landscapes in which he depicted the English countryside as a garden of Eden made by God for man. But as the decade

progressed, Hunt felt compelled to make his impetuous trip to the Holy Land, in the hope that there, if anywhere, he would find the 'Types' of God Incarnate within the physical landscape.

He did not discover material evidence of his Redeemer. Instead, he found a mangy goat which dropped dead on him, and, as he put it, 'so extraordinary a scene of beautifully-arranged horrible wilderness'.

'It is black,' he wrote, 'full of asphalte scum – and in the hand slimy, and smarting as a sting – no one can stand here and say it is not accursed of God.' Similarly, William Dyce's *Pegwell Bay, Kent – A Recollection of October 5th 1858* [*see plate 3a*] shows women and children hunting for fossils – evidence against the idea that nature was divine handiwork – on a bleak, grey, godless shore. Donati's comet shoots, unnoticed, and yet portentously, through the sky above. Under the glowering clouds of the new science, secularism, unbelief and industrialisation, Nature no longer seemed to be God's creation.

As Matthew Arnold listened to the 'long, withdrawing roar' of the Sea of Faith, he glimpsed the 'naked shingles' of the world; while in Tennyson's *In Memoriam*, the idea of nature as Eden was replaced by the fallen imagery of 'iron hills' and 'desert dust'. In later life, John Ruskin became obsessed with the failure of nature itself. He detected, or thought he detected, the Storm Cloud of the nineteenth century and its accompanying Plague Wind, and he warned of 'blanched Sun – blighted grass, blinded man'. Gazing at the world from the windows of Brantwood, overlooking Lake Coniston, he complained, 'The darkness gains upon the day and the ashes of the Antipodes glare through the night.'

As Tennyson had asked, 'Are God and Nature then at strife / That Nature lends such evil dreams?' Perhaps not surprisingly – with some notable exceptions such as Millais's *Chill October* or his *Lingering Autumn* of 1890 – British landscape painting fell into precipitous decline. But, for Ruskin, emergent Modernism, in the guise of Whistler, offered no alternative. Ruskin believed that Whistler was simply evading this deep spiritual crisis by a

retreat into an art of mere sensation. He was advocating aesthesis rather than theoria. Or, as Whistler himself put it, in words which were to be echoed again and again by the theorists of Modernism: 'Art should be independent of all clap-trap, should stand alone, and appeal to the artistic sense of eye or ear.'

Now I don't want to sound as if a form of higher landscape painting developed only in England. In front of a picture such as Caspar David Friedrich's *Winter Landscape* in the National Gallery in London, one does not doubt that the sentiments the artist wished to convey had more to do with the redemptive promises of Christianity than with his feelings for snow, trees, moonlight and mountain scenery, *per se*. This is a work drenched in symbolic allusions. Indeed, one of the many reasons for supporting the authenticity of the National Gallery's picture in preference to another version in the Dortmund Museum is that the former contains innumerable details, such as the blades of grass which prick the snow, or the hints of warmer pink tones in the sky, which seem more suggestive of the restorative power of the redeemer and the whole Christian narrative of salvation.

It is interesting to compare Friedrich's *Winter Landscape* with *The Scapegoat* [*see plate 2a*], which Hunt painted forty years later. The spiritual subject matter is very similar, and yet it must be said that if Ruskin had reservations about *The Scapegoat* he would have detested Friedrich's work. While he never mentions Friedrich by name, on every possible occasion Ruskin heaped scorn upon 'that school of modern Germanism which wears its pieties for decoration as women wear their diamonds, and spreads the dry fleeces of its sanctities between its dust and the dew of heaven.'

When he visited Germany in the summer of 1859, Ruskin unleashed a stream of vitriol about German art in his letters to his friends. To George Richmond he wrote, 'The intense egotism and ignorance of the modern German painter . . . is unspeakable in its offensiveness. The eternal vanity and

vulgarity mistaking itself for Piety and poetry – the intense deadness to all real beauty, puffed up into loathsome caricatures of what they fancy to be German character – the absorption of all love of God or man into their itch of applause and Fine-doing, leave me infinitely more sorrowful than the worst work of the French or Italians.' He even said that his 'intense disgust with German art', of which he had seen great quantities in Munich, acted on him 'like a real poison', making him feel ill. He was still feeling thoroughly poisoned by German art months after he returned home. Indeed, he wrote to the Brownings that he had been so depressed by German painting that he was only then returning 'to something like tranquillity of mind – by ceasing to read the papers, and taking desperately to buds of trees and wreaths of clouds.'

It must be recognised that, as so often with Ruskin, this wasn't simple prejudice. Behind the rhetoric there were very real aesthetic and spiritual differences between the German and the British schools. Ruskin was objecting to a quality which he called 'idealism' in German philosophy and art. Certainly there is nothing comparable to the natural theology of the British school in German romantic painting. For Friedrich, and those who came after him, the world of nature was a symbol or a shadow of the infinite world which lay beyond. As von Schubert, Friedrich's friend and admirer, wrote of his pictures: 'At last the mind understands that the abode of that longing which has guided us so far is not here on earth. Speed on then, river, down on your way! Where your waves flow into the infinite sea on a far distant shore we have heard of a last place of rest. There indeed the inner fire shall cool, the deep wound shall heal . . .'

Friedrich's most famous picture, *The Monk by the Sea*, depicts in vivid form the 'blissful dissolution' of the self, its absorption into that mystical void which is God. In this sense, Robert Rosenblum was absolutely right to see Friedrich's pictures as precursors of the transcendent vacancy of Mark Rothko. One might even say that the transition from Friedrich to Rothko

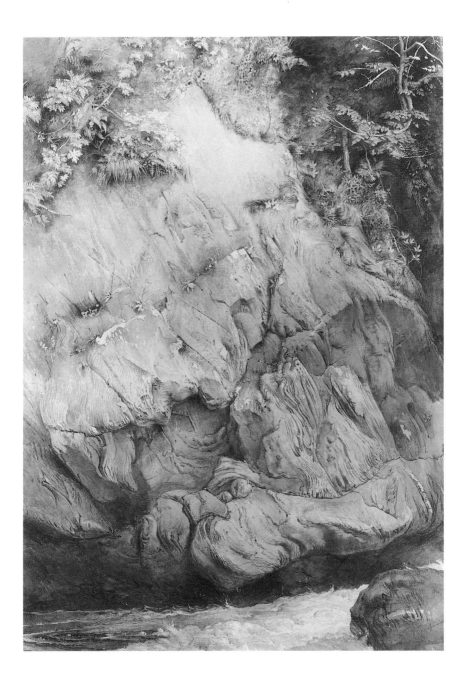

1 John Ruskin, *Study of Gneiss Rock, Glenfinlas*, 1853

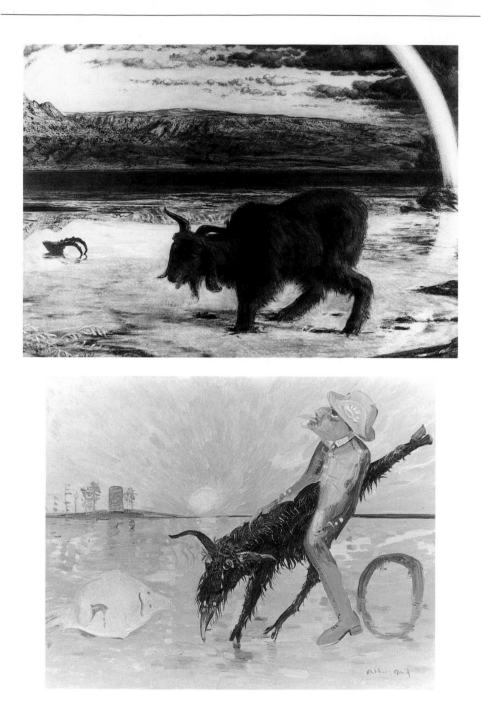

2a Holman Hunt, *The Scapegoat*, 1854
2b Arthur Boyd, Study for *The Australian Scapegoat*, 1988

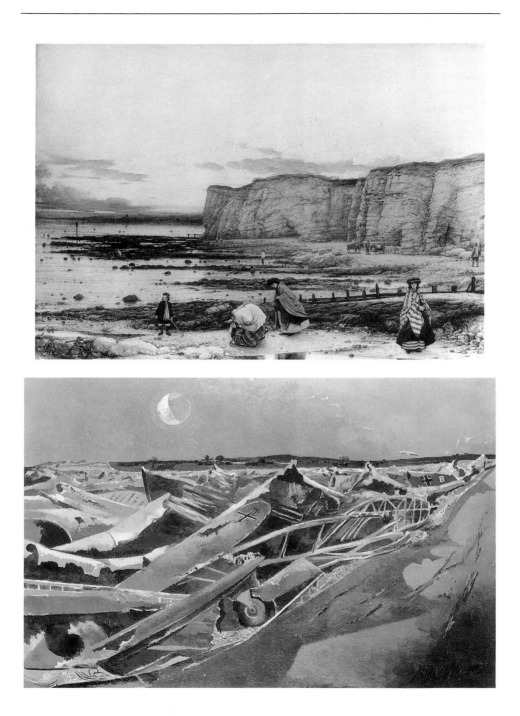

3a William Dyce, *Pegwell Bay, Kent – a Recollection of October 5th 1858*, 1858–60

3b Paul Nash, *Totes Meer*, 1940–41

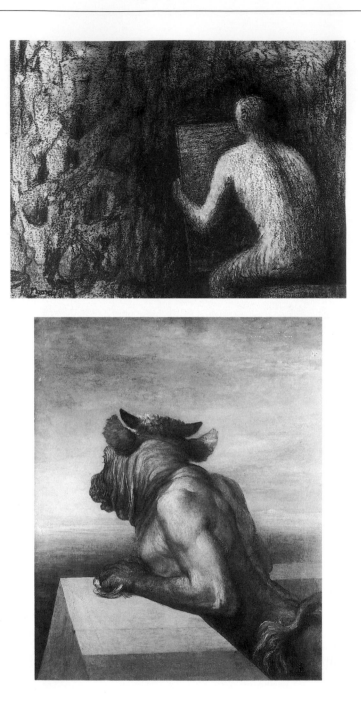

4a Henry Moore, *Man Drawing Rock Formation*, 1982
4b G.F. Watts, *The Minotaur*, 1885

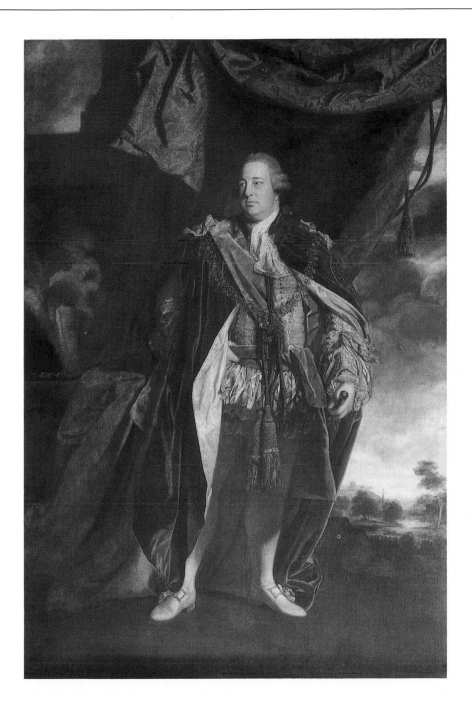

5 Sir Joshua Reynolds, *Portrait of William, Duke of Cumberland*, 1758

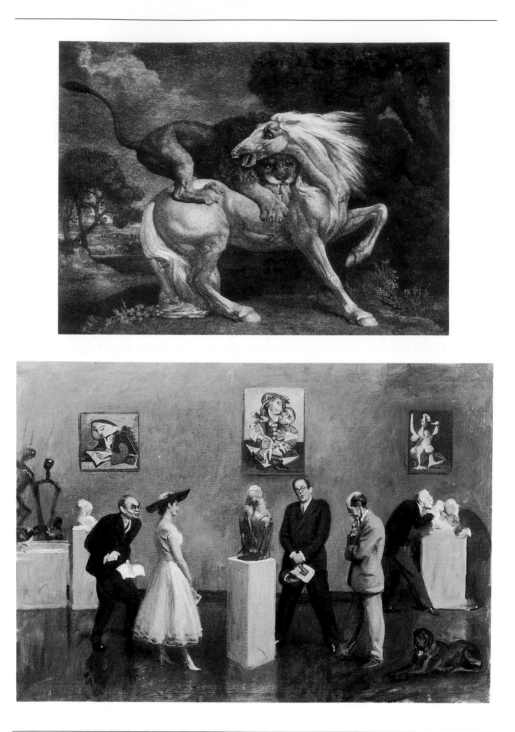

6a George Stubbs, *Horse Attacked by a Lion*, 1763
6b Sir Alfred Munnings, *Does the Subject Matter?*, 1956

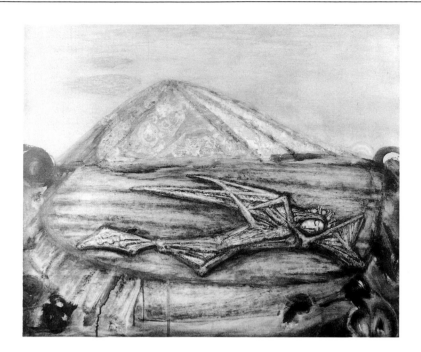

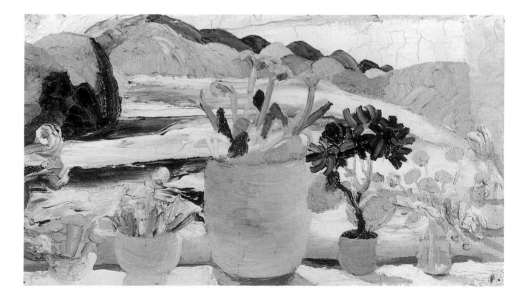

7a Cecil Collins, *The Wounded Angel*, 1967
7b Winifred Nicholson, *Window-Sill, Lugano*, 1923

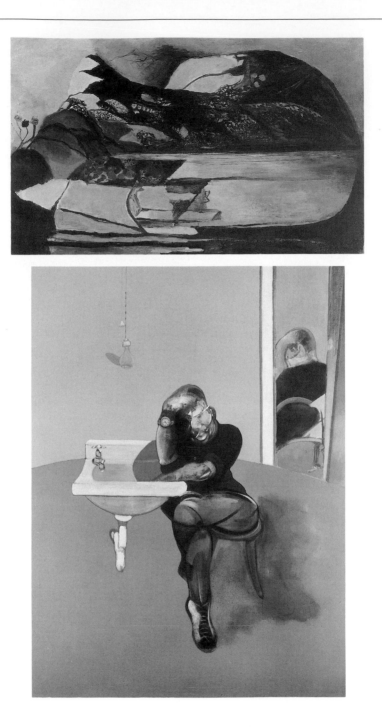

8a Graham Sutherland, *Black Landscape*, 1939–40
8b Francis Bacon, *Self-Portrait*, 1973

represents that transition from pantheism to nihilism in art, about which the Catholic theologian, Hans Kung, has written so vividly. For Kung, this nihilistic background enables us to raise the question of art and meaning today in a wholly new, ultimate radicalness.

'The sea drunk up (a bleak emptiness),' he writes, 'the horizon wiped away (a living space without prospects), the earth unchained from its sun (an absymal nothingness); with these three powerful metaphors Nietzsche a hundred years ago clear-sightedly announced the advent of nihilism – today often so banal, ordinary, superficial – in order to ask, "Is there still any up or down? Are we not straying through infinite nothing? Do we not feel the breath of empty space? Has it not become colder? Is not night continually closing upon us?" '

And yet Ruskin did not want to do away with every 'this' and 'here'. He detested this kind of Germanic nihilism. Indeed, he even refused to follow his master, Turner, into the vortex of his closing years. For Ruskin clung to the idea of nature, not as a veil, dimly reflecting the radiance of a God who resided 'beyond' and who was reachable only through the abnegation of death. Rather, for him, nature was 'God's second book', a concrete incarnation of His glory and His beauty, a physical revelation of Himself. When his faith was shaken, Ruskin did not experience the absolute silence of the void, but rather Arnold's 'naked shingles'. The idea that obsessed him was that of the wilderness, the desert – a place of desolation. I believe that the image of a wasteland and its redemption, its transformation into new images of paradise, has been the subject of the best British painting ever since.

For better or worse, this spiritual crisis in landscape painting has been largely ignored by the protagonists of the Modern Movement. When Roger Fry tried to introduce the values of European Modernism to a reluctant British public in the early part of this century, he felt that it was incumbent upon him to denigrate that older 'theoretic' tradition of British landscape painting. It is a sobering experience to read Fry's reflections on

British art and remind oneself just how hostile he was to Turner's achievement. 'Turner has not probed further than the first gasp of wonder,' he wrote, calling him 'Poussin at second hand'. Fry was intent upon opposing the Ruskinian idea that attention to natural form could give rise to transcendent experience in art. For Fry it was all a matter of Significant Form, that is, of 'lines and colours combined in a particular way'. In the hands of his followers, though not in those of Fry himself, this soon became an argument for the idea of aesthetic effect as mere sensation, for aesthesis and the severance of the idea of beauty in art from any relationship to the world of nature or that of the spirit.

Nowhere was such reductionism pursued with greater fervour than in America. These are the chilling words of Alfred Barr, the first director of the Museum of Modern Art in New York, the prototype for modern art museums throughout the Western world: 'Since resemblance to nature is at best superfluous and at worst distracting, it might as well be eliminated.'

Clement Greenberg went further. 'There is,' he wrote, 'nothing left in nature for plastic art to explore.' He even criticised Van Gogh for becoming 'too obsessed with the pattern glimpsed in nature'. Greenberg questioned whether the impact of Van Gogh's paintings had as much to do with art as with that emotion or quality of 'strikingness' which Kant distinguishes as analogous to the beautiful, 'in that its presence makes us linger on the object embodying it because it keeps arresting our attention'. Needless to say, Greenberg regarded the Neo-Romanticism which began to flower in Britain in the 1930s and 40s as 'the enemy of modern art' and 'the fag end of a boring, very great and violent war'. As for Henry Moore, he was just another example of what the Americans dismissed as 'the English country garden of the soul'.

In spite of Roger Fry and, for a time at least, in spite of American art and criticism, most of the British public could not bring themselves to see things in this way. Neither did our best painters and sculptors, nor our most perceptive critics. In a

remarkable essay called 'Art Since 1939', published in 1947, Robin Ironside described the way in which 'the undisputed greatness of Constable and Turner' was no longer seen to reside 'in the prophetic impressionism of their vision', nor even in Constable's responsiveness to subtle changes of weather or Turner's to sunlight, but rather in 'the manifestation of a poetic attitude analogous to that of Wordsworth and . . . Shelley'. Ironside even went so far as 'to prefer in Cézanne the artist who was passionately at the rigid but invaluable mercies of nature – the Cézanne of the water-colours and the final oil-paintings – to the laborious architect of the three-dimensional pattern whose structural peculiarities fathered, in this country, so many fruitless ambitions.'

It might be said that all the best British artists of the twentieth century had more Romanticism than Modernism in their blood. Just consider the pantheon of our greatest painters and sculptors: Paul Nash, David Bomberg, Stanley Spencer, Henry Moore, Graham Sutherland, John Piper, Cecil Collins. Are they not, each and every one, more involved in telling us spiritual narratives than in pursuing formal objectives? Or, to be more precise, don't their formal innovations serve those narratives rather than the onward march of Modernist styles? Sometimes formal ingenuity was not even necessary. As far as I can see, there was nothing at all original, in a pictorial sense, in the work of the greatest British painter this century has yet seen – Stanley Spencer. He has been called, with reason, 'the last of the Pre-Raphaelites'.

Take, too, the case of Paul Nash. I know that Nash liked to present himself draped in the rhetoric of Modernity, and was sometimes associated with Surrealism, but one must still think of him within the tradition of British Romantic landscape. Nash wrote of his experiences on the Ypres Salient in phrases reminiscent of Holman Hunt's description of the shores of the Dead Sea: 'the black, dying trees ooze and sweat and the shells never cease. It is unspeakable, godless, hopeless.'

Nash survived to paint the second world war as well. Perhaps

his most compelling image was *Totes Meer* [*see plate 3b*] – literally a Dead Sea of wrecked German aircraft. Unlike Hunt or Ruskin, however, Nash's vision was not despairing. He surveyed the charred, injured and god-forsaken landscape and brought about what I would call 'a redemption through form'. This is why, perhaps, his *Totes Meer* lacks the compositional awkwardness of Hunt's vision of the Dead Sea in *The Scapegoat*. All this flowered into the great visionary landscapes of Nash's later years.

A visit to the Holy Land also formed a pivot in the career of David Bomberg, allowing him to finally break with the ethic of Modernism. I see Bomberg's famous search for 'the spirit in the mass' as an attempt to resolve those dilemmas which Holman Hunt confronted on the shores of the Dead Sea. In Bomberg's work and that of some of his followers, one finds a dogged refusal to accept that the naked shingles of the world are quite as naked as they seem.

Another key image is Cecil Collins's *The Wounded Angel* [*see plate 7a*]. Collins himself used to explain this picture by saying that it represented an angel, injured through its contact with strife on earth, who had returned to rest in Paradise. Behind the purple mountains in the background, the sun rises. In Collins's later work there is a similarity with Turner in his use of colour, light and the imagery of the sun.

Collins used to object to the pursuit of transcendence through abstraction, saying it was a form of puritanism and that the Divine Reality should be reflected in the wholeness of human experience, in nature and in man himself. 'The divine reality,' he wrote, 'should be everywhere – in an insect, in an ant, in a fly on a window pane, in a speck of dust.' Like Ruskin he insisted that paradise was in 'the minutiae of life, the minute details of life, in the particulars'.

I am convinced that in the late 1930s and early 1940s there was a renaissance of British art which had much to do with the revival and efflorescence of an indigenous Romantic tradition. Immediately after the second world war, the standing of the

best British artists throughout the Western world could hardly have been higher. In the late 1940s and early 1950s it was argued that, although Britain had lost much of her political and economic power, she was in a position to exert cultural leadership.

As we know, that was not to be; at least not for several decades. From the mid-1950s onwards the reviving Romantic tradition was swamped, as British artists looked increasingly to America. Our national schools were rendered invisible by a succession of vacuous fashions, each more empty, more anaesthetic, than the last: Post-Painterly Abstraction, Pop art, Conceptualism, and every sort of mixed-media prank. All these gimmicks were buoyed up by the tastes of modern art museums and injections of public funds from bodies like the Arts Council, administered by bureaucrats who lacked the faith, vision and taste of those like Kenneth Clark and John Maynard Keynes who brought such organisations into being.

While the 1980s saw the rise of European art and the fading of American hegemony, it is somewhat ironic that so much of the painting we imported from Germany was merely regressive. Mired in the nihilism of the Dead Sea, it proposed no alternative, no glimpse of beyond, as in the work of the most creative British landscape painters.

No artist has had more adulation showered on him than Anselm Kiefer. *Scarab*, a vast work shown at the Anthony d'Offay Gallery in 1989, consisted of actual salt and caustic soda, implanted on a bed of heavy, funereal lead. Other works contained fragments of thorn bush, more lead and more salt. They were indeed the Dead Sea of the world. Gone are all hints and traces of redemption, of resurrection, of the ghost of a redeemer. Kiefer's works consist of nothing but inert matter. Not even that last and most tenuous transformation of all – aesthetic redemption, redemption through form – has taken place. In Kiefer's work, light and colour play no part; night has subsumed all. Dissolution is no longer blissful. It does not open up into the transcendent spaces of *Monk by the Sea*, but collapses into the absolute stillness of the grave.

Kiefer's *Scarab* might be compared with Cecil Collins's *The Dream of an Angel*, a tempera work of 1987. This shows a sleeping angel enfolded in its own wings. The picture stands in some relation to the nihilistic voids of Rothko or Kiefer, and yet it differs from them. It isn't simply that image of the rising sun – so important in many of Collins's works – it is also that, in the blue-greyness of the paint itself, he evokes a tremulous light that reinstates the promise of transcendence.

Throughout the 1960s and 1970s, Collins's work was in eclipse, but in the 1980s he benefited from an upsurge of interest in the spiritual aspects of art. Official taste, however, has still not begun to appreciate the 'spiritual narratives' in the best recent Australian painting. Kenneth Clark was one of the few to recognise that 'in Australian landscape painting, as in all great landscape painting, the scenery is not painted for its own sake, but as the embodiment and expression of the imagination and spiritual values'. The fact is, the image of the desert as wasteland was the *reality* of much Australian landscape, and a much more potent metaphor for men and women in the twentieth century than say the tilled and manicured fields of Constable's Suffolk.

I believe that the Australian artist, Arthur Boyd, is one of the finest painters at work in the world today. He has lived, for much of the last thirty years, in England – most of the time at Ramsholt, near Woodbridge, north of Constable country – but most of his subject matter is drawn from visits to his homeland. One of Boyd's most important early paintings was *The Expulsion*, which shows Adam and Eve banished from Eden into the fallen and desolate world of the Australian bush. Boyd begins where Holman Hunt gave up in despair. In 1985, he painted a massive picture, *Bathers with Skate and Halley's Comet*, which I can't help seeing as a modern version of Dyce's *Pegwell Bay*. One finds the same suggestion of man set apart from the nature he inhabits; even the same ominous imagery of the unnoticed comet, passing overhead.

In his paintings of *The Australian Scapegoat* [see plate 2b],

modelled explicitly on Holman Hunt's themes, Boyd speaks compellingly of our isolation within the world we inhabit. The only relief from our fallen condition comes through the terrible beauty of an aesthetic transformation, on which Boyd, unlike Kiefer, insists. That aesthetic transformation is made even more explicit in the late works of another Australian painter, Fred Williams, whose searing imagery of the hot red desert becomes a sort of paradise. In his work the colour field is not one of Rothko's voids, but the physical world itself.

Another British artist, Maggi Hambling, has recently taken to painting pictures based on water-colour studies of the sunrise over Suffolk. These have soared into great mythic statements which celebrate the diurnal resurrection of the sun and, like Boyd, affirm the redemptive experience that art and nature can still offer us, even in the absence of God.

At present there are many other painters working within the tradition of British Romantic landscape whose work seems worthy of attention. There are the myths of damnation and new life which Terry Shaves finds in his memories of the burning stubble fields of Suffolk, or the paradise gardens of Adrian Berg; the strange landscapes of Maurice Cockerill, so reminiscent of Paul Nash; the pictures of Christopher Cook, Richard Kenton Webb, and David Leverett – who was once a very different sort of painter. The main point, though, is that British artists are once again making pictures in their own particular way, not simply following in the footsteps of the Americans or the Germans.

I am tempted to leave the last word to the unlikely figure of Jenny Holzer. In one of her electronic messages she reminds us: 'YOU MUST REMEMBER YOU HAVE FREEDOM OF CHOICE.' Mercifully, we do; the freedom to reject art like hers and to affirm a tradition which is infinitely richer, infinitely deeper, and, in an aesthetic if not a monetary sense, infinitely more rewarding.

1990

But is it Art?

In my time as a critic, considerable prominence has been given to 'works of art' of a kind previously unseen. That is, works which apparently embody no imaginative, nor indeed physical, transformation of materials; no sense of belonging to any of the particular arts, such as painting, sculpture, drawing, engraving, etc.; no sense of tradition nor of skill. Such works possess no identifiable aesthetic qualities and offer, in my view at least, no opportunity for aesthetic experience or evaluation.

The prototype for works of this kind was Marcel Duchamp's *Fountain* – a urinal signed 'R. Mutt', which he submitted to the 1917 Salon des Indépendants. Duchamp was the start of all the trouble and there is nothing I would wish to say in his defence. Even so, it must be stressed that, in its time, the urinal was a relatively isolated phenomenon, while an overwhelming proportion of the institutionally-approved art of our own time is of the same character.

Over the past twenty-two years I have been invited to attend to all manner of objects and events. They have ranged from a document entitled 'A Social Resource Project for Tennis Clubs' to folded blankets; a man seated in a bath of bull's blood; another who successfully amputated his sexual organs; used nappy liners and sanitary towels; a beach covered in polythene; thousands of old tyres arranged in the shape of a Polaris missile; a huge ceramic blow-up of a Pink Panther; a tray of cow brains and used fly-strips set in resin, and of course, the Tate Gallery's notorious *Equivalent VIII* – a stack of fire-bricks arranged by Carl Andre. All these things have been presented to me as 'Art'.

These are extreme cases, but many less bizarre works of recent years have no less tenuous affiliations with the recognis-

able arts of painting or sculpture. For example, I'd argue that there is little or no aesthetic content in much Pop art, Minimalism, New Expressionism, Neo-Geo or New Sculpture of the 1980s. A 'painting' these days tends to be identified with the mere presence of paint as a substance. A 'sculpture' can be anything. In a pamphlet accompanying the Hayward Gallery's despicable 1983 *Sculpture Show*, Norbert Lynton declared that 'sculpture is what sculptors do. No other definition is possible.' This is ludicrous. After all, sculptors get up in the morning, read the paper, take the dog for a walk, and so on. None of this is necessarily sculpture, although it's possible that it could all be designated as such. For Gilbert and George, life is sculpture.

This proliferation of anaesthetic art has been a problem. The temptation is simply to say, 'This is not art', and to pass on without hesitation to consider those things which appear more worthy of attention. That, after all, was the approach favoured by Bloomsbury. In his book, *Art*, Clive Bell's aesthetic hypothesis was that the essential quality of a work of art was 'Significant Form', which gave rise to aesthetic response and experience. Significant Form was 'the expression of a peculiar emotion felt for reality', and anything which did not possess Significant Form was not a work of art. For Bell, most of that which was presented as art was not art at all. 'I cannot believe,' he wrote, 'that more than one in a hundred of the works produced between 1450 and 1850 can be properly described as a work of art.'

Bell claimed that calling something a work of art, or not, was a 'momentous moral judgement'. He would have experienced no difficulty in dealing with the anaesthesia of late Modernism. He would simply have expressed the view that less than one in a thousand of the works produced between 1950 and 1986 were works of art.

It must be said, however, that Bell's concept of Significant Form (borrowed from Roger Fry), and his idea of aesthetic emotion, are rather unfashionable nowadays. More characteristic of current thinking is the view put forward by the

aesthetic philosopher, B. R. Tilghmann, in his book *But is it Art?*
Tilghmann is concerned with the inadequacy of traditional
aesthetic theories to deal with the sort of phenomena I have
been discussing, from Duchamp's urinal to Andre's bricks.
Tilghmann argues that the very idea of a theory or definition of
art is a confused one. This confusion, he believes, arises from
the fact that the language of aesthetic theory has simply lost
contact with the sort of everyday practice we engage in when
we look appreciatively at urinals, piles of bricks, muddy smears
or acts of castration. Instead of trying to stretch the old aesthetic
theories to accommodate these new kinds of artistic practice, we
should be elaborating new theories appropriate to the new sorts
of practice.

These, then, are two opposing approaches to the problem of
anaesthetic art objects: the Bell position, which dismisses those
objects which do not give rise to aesthetic effect – anaesthetic
objects – out of the category of 'Art' altogether; and the
Tilghmann position, which includes everything which anyone
ever designated 'Art' *as* art, but recommends a rejection of
traditional concepts of what is and what is not aesthetic
experience.

While most discussions of this issue tend to take up a position
somewhere between these polarities, I'd like to argue that this
whole line of reasoning should be refused.

From Baumgarten onwards, aesthetic response and
experience were never regarded as being synonymous with
what was called 'art'. The early philosophers of the aesthetic
recognised that a great many natural phenomena – flowers,
minerals, waterfalls, landscapes, forests and the song of the
nightingale among them – also gave rise to aesthetic response; a
disinterested response, unrelated to price, necessity or whatever.
It may well be that this view depended upon a 'Natural
Theology'. That is, the belief that the natural world was, in
some sense or other, a revelation of the handiwork of God. As
Friedrich Schlegel put it, 'As God is to His creation, so is the
artist to his own.'

Natural Theology is no longer very popular, even among Christians. And this may have something to do with the fact that most aesthetic theories do not even pay lip service to the 'non-artistic' aspects of the aesthetic experience. My own belief, however, is that the aesthetic faculty has its roots in our continuities with – and ultimately helps establish our differences from – the remainder of the animal kingdom. It can be understood in terms of our *specifically human* natural history. This aesthetic potentiality, though threatened by the decline of religious belief and the growth of industrial, and latterly, electronic production, is not necessarily destroyed by it.

Rather than see aesthetic theory rewritten in such a way that it incorporates anaesthetic 'Art', I think we should be attending to the independence of 'the Aesthetic Dimension' from 'Art'. If this implies that we should not go along with Tilghmann, I think it also means that we should not go along with Bell's argument. There is, perhaps, something inherently wrong-headed in the view that most works of art are not 'really' works of art at all. (It is reminiscent of that Left argument which accounted for repression in Socialist countries by arguing that most of these countries weren't *really* Socialist.)

I think one can, indeed *should*, concede to the Post-Post-Structuralist contextualisers that art is a category constituted within ideology and maintained by institutions, especially the institutions of contemporary art. But the same does not apply to aesthetic experience and aesthetic values, which are orders of innate and inalienably human potentiality. Aesthetic experience of an imaginative order is a terrain which we can enjoy because we are the sort of creatures that we are. Some art embodies aesthetic values and gives rise to aesthetic experience of the highest order, but much art does so only minimally or not at all.

This statement may seem like a platitude, but important consequences flow from it, since it implies a new – or, more accurately, an *old* – set of priorities. We must first of all recognise that the freedom to engage and develop innate aesthetic

faculties is being impinged upon by present social and cultural policies. Here I am not launching into a defence of 'artistic freedom', a catch-cry which has been used to justify so many contributions to the spread of General Anaesthesia, and which so often proves to be little more than a rallying cry for philistines. On the contrary, I see my practical task as a critic, as one of fostering those circumstances in which the aesthetic potential can thrive, even if it means opposing certain kinds of 'art'.

One question which I have left in brackets is 'Why, in our own time, has there been such a preponderance of anaesthetic art?' For a start, I believe that post-second world war theories of art education must bear much of the blame.

About fifteen years ago, Dr Stuart MacDonald, an historian of art education, referred to what he called 'articidal tendencies' among art teachers. In my language that would be 'aestheticidal tendencies', but that sounds even worse. He was, I think, concerned with counteracting the continuing effects of the 'Basic Design' approach to art education, which was effectively debilitating the idea of Fine Art.

'Art educationalists,' he wrote, 'have been busy demolishing the subject which supports them . . . "Beauty" as a quality of an artefact was vaporised some years back. "Craft", with its connotation of old-fashioned hard work, has been given short shrift. "Artefact" is now being replaced by "museumart". Art education was deleted recently in favour of "visual education".' Dr MacDonald concluded that 'Art itself will go shortly', and he has since been proven right.

This is not to say that art itself has disappeared. Art remains in abundance, but aesthetic education, the nurturing of aesthetic intelligence and, inevitably, the creation of objects of aesthetic value, have all but gone. What is happening in our schools and colleges of art is a calamity of national proportions. Children in some schools receive lessons in 'Design Education' and 'Information Technology' but not in art. An education in art is becoming indistinguishable from an education in design, which is anything *but* disinterested.

However, it isn't simply education which is to blame for the general anaesthetisation of our culture. One must not forget how left-wing thinkers have long blamed everything on the market in art. This was, in essence, the teaching of my teacher, John Berger, who argued that there was a special relationship between oil painting and capitalism, and that pictures were 'first and foremost' portable capital assets. This led him to express hostility towards the very idea of 'true' aesthetic values, or of connoisseurship, which he saw as being merely derivatives of oil painting's functions in exchange and as property. Despite my respect for Berger I came to feel that there was something strangely circular in the argument that aesthetic discourse and connoisseurship were simply derivatives of the market. If they were, it was not at all clear what it was that the market could be said to be corrupting, distorting or infecting.

Indeed, there was a very real sense in which the left-wing aesthetic theories of the 1960s and 1970s provided the 'programme' for the right-wing governments of the 1980s; for that unholy alliance between philistines of the Left and the Right. For example, John Berger argued that photography had displaced painting as the uniquely modern, democratic art-form of the twentieth century. Margaret Thatcher's Government squeezed the Fine Arts courses and shifted everything towards design. Berger argued that museums were 'reactionary' middle-class institutions that should 'logically' be replaced by children's pinboards. Margaret Thatcher proceeded to pressurise every one of our art institutions in a way which the Director of the National Gallery likened to the destruction of the monasteries during the Reformation.

Berger led the assault on the idea of Fine Art values, which he dismissed as 'bourgeois' and anachronistic. Mrs Thatcher initiated a regime of stunning philistinism and destructiveness, which aimed to sweep away the last vestige in public arts policy of exactly those things to which the Marxists had objected. If the point is not to understand the world but to change it, then in England the palm must be awarded to Mrs Thatcher. She

'deconstructed' aesthetic values much more effectively than a thousand polytechnic Marxists and art school Post-Structuralists.

Nowadays, the philistine complicity of Left and Right is a fact of life for Britain's art institutions. Charles Saatchi, the advertising man (inventor of the slogan 'Labour isn't working', which did so much to bring Mrs Thatcher to power), has amassed a large collection of anaesthetic art, praised by many of the trendiest Left theorists of recent years. Meanwhile, Gilbert and George have become the salon artists of our times. Praised by Left critics for their hatred of unique objects, painting and 'elitist' aesthetic ideas, they are vociferous supporters of Mrs Thatcher.

Even though I believe that the left-wing thinkers have provided the best moral justification for the growth of institutional anaesthesia, there is also a ring-wing version of the 'corrupting market' theory, as put forward by Suzi Gablik in her slim and slight book, *Has Modernism Failed?* Here she suggests that the market somehow corrodes 'Higher Values' through the very nature of commercial activity. However, there remains strong empirical evidence against any such line of reasoning. Gablik does not mention Henry Moore, Graham Sutherland, Barbara Hepworth or Ben Nicholson, all of whom were enmeshed in the higher reaches of the art market but whose work embodies precisely those spiritual and aesthetic values which are so often absent from the work of those less commercially-successful artists of today's official, state-subsidised avant-garde. It also seems to me that the evidence of history is against Gablik's view. The market, in and of itself, did not corrupt the art of sixteenth-century Venice or seventeenth-century Holland. On the contrary, in these cases at least, intense activity in the picture markets seems to have been inextricably bound up with extraordinary efflorescences of aesthetic life.

But this observation must also be qualified, since I have no wish to draw any neat equations between the vitality of capitalism and aesthetics. While it is perfectly true that much

anaesthetic art involves an element of subsidy, both historically and in our own time public subsidy has also been associated with high aesthetic achievement. One doesn't have to look back to the heyday of Athens or the Gothic period to find instances of such successful uses of public funds. Not so very long ago, the Arts Council and the British Council helped foster an exceptional generation of British artists, including Henry Moore and Graham Sutherland.

While some dealers may prefer to deal in works of quality, rather than in trash, if the art institutions foster a demand for trash, then most dealers will happily service that taste. From this, all one can conclude is that the market clearly does not *cause* good art (i.e. art of high aesthetic value) or bad art (anaesthetic art, art of low aesthetic value). The operations of the market are, in a certain sense, neutral; neither implying nor eliminating aesthetic values. On its own, the market is simply insufficient or incapable of creating that 'facilitating environment' in which good art can be created. If the Left is wrong to blame the market for destroying art, the Right is equally wrong to suppose that art can be preserved and invigorated by the market.

So what does create a facilitating environment for high aesthetic achievement? Beliefs, faith and even will – but in a very different sense to the way those qualities were manifested in the culture of Modernism or in that of fashionable Post-Modernism.

Modernism resembled the other great styles of the past in at least one important aspect; it aspired to universality, and sought to become 'the genuine and legitimate style of our century' – to use Nikolaus Pevsner's phrase. In this sense, the Modern movement had to be rooted in the *Zeitgeist*, to be expressive of what Pevsner called 'faith in science and technology, in social science and rational planning, and the romantic faith in speed and the roar of machines'.

Or, as the scientific populariser, C. H. Waddington put it, from a slightly different angle, the artist who wished to paint, or

the architect who wished to build for a scientific and sceptical age, 'had to, whether he liked it or not, find out what was left when scepticism had done its worst'.

For a critic of American painting like Clement Greenberg in the late 1940s, 'Cubist and Post-Cubist painting and sculpture, "modern" furniture [as he called it], decoration and design,' were all part and parcel of the Modern Movement, which he described as 'Our Period Style'.

'The highest aesthetic sensibility,' Greenberg wrote, 'rests on the same basic assumptions as to the nature of reality as does the advanced thinking contemporaneous with it.' For Greenberg, as for Pevsner and Waddington, this 'advanced thinking' was a belligerent, scientific materialism, which, in terms of painting, meant an art of sensation and materials 'uninflated by illegitimate content – no religion or mysticism or political certainties'. Hence Greenberg's hostility to Neo-Romanticism and to the spiritual and humanist aspirations of a sculptor like Henry Moore, whom he accused of being 'half-baked'. (Even Jackson Pollock was reprimanded for his 'Gothickness'.) Hence, too, Greenberg's notorious talk about the ineluctable search for the material essence of the medium, and the pursuit of 'the minimum substance needed to body forth visibility'.

Greenberg's Modernism has had its day, but its passing entailed not merely the waning of a style of architecture or painting, it was bound up with the decline of those beliefs I have outlined above. It became sceptical of its own aspirations to triumph over nature, it began to recognise the limits of that rampant materialism embodied in Pevsner's 'faith in science and technology'. While we may make ever greater use of gadgets such as personal computers and car phones, who among us now believes that such things are initiating us into a brave new world? As for Modernist ideals of social planning, they are quite routinely despised, now that we can see the horrors to which they led. Modernism is, quite simply, no longer open to us as an option.

So what is Post-Modernism? The critic, Charles Jencks set out to answer this question in a pamphlet of that name, and numerous ancillary tomes on Post-Modernism in architecture and art. Jencks's *What is Post-Modernism?* essentially argues that Post-Modernism is the Counter-Reformation to Modernism. Jencks even contends that it involves 'a new Baroque'. This is disconcerting to those of us still trying to accommodate ourselves to the idea that Post-Modernism in painting simultaneously involves some kind of appeal to classicism, especially to Poussin, the opponent of the Counter-Reformation, *par excellence*. But matters become even more perplexing when Jencks declares that, unlike the real Counter-Reformation, Post-Modernism involves 'no new religion and faith to give it substance'. Where then is the parallel? A Counter-Reformation without faith? But this is precisely the point. Post-Modernism is the first of the world styles to have no spiritual content at all, not even the misguided faith of materialist Modernism. For what the Post-Modernists are saying is that the certainties of Modernism – its 'meta-narratives' in Jean-François Lyotard's overused phrase – can only be replaced by self-conscious incredulity about everything. Jencks echoes Umberto Eco, who says that Post-Modern man cannot say to his beloved, 'I love you madly', but must express his passion in such terms as, 'As Barbara Cartland would say, "I love you madly" '; or perhaps 'as Fuller said Jencks said Eco said Barbara Cartland would say "I love you madly".' Likewise, the Post-Modern sculptor cannot build a monument to his nation's dead, he can only build a structure which refers to what such a monument might look like if honouring the dead were what one did, any more, as it were.

Post-Modernism knows no commitments. It is the opposite of that which is *engagé*. Post-Modernism takes up what Jencks himself once described as 'a situational position', in which 'no code is inherently better than any other'. The west front of Wells Cathedral, the Parthenon pediment, the plastic and neon signs of Caesar's Palace, Las Vegas, even the hidden intricacies of a

Mies curtain wall: all these things are equally 'interesting'. We are left with a shifting pattern of strategies and substitutes, a shuffling of semiotic codes and devices varying ceaselessly according to audience and circumstances. This is authenticity dissolved. Historicity takes precedence over experience and knowingness is substituted for a genuine sense of tradition.

Speaking as an absolutist and a dogmatist, it has always seemed to me that this Post-Modernist stuff does not escape from the dilemma of all relativist, eclectic and pluralist positions; namely that they are constrained to exempt themselves from those strictures and limitations with which they wish to hem in every other position. For relativism is never able to turn back on itself, to view itself *relatively*. No relativist will ever proclaim his own position as being only an option, with no greater claims than rival dogmatisms. And so, by subsuming all other positions, relativism is doomed to re-establish itself on the pedestal of the very authoritarianism which it was its sole *raison d'être* to challenge. In other words, for all its shifting pluralism, like Modernism before it, Post-Modernist radical eclecticism wants us to know that it is 'the genuine and legitimate style of our century'.

Now I happen to believe, with John Ruskin, that the art and architecture of a nation are great only when they are 'as universal and as established as its language; and when provincial differences of style are nothing more than so many dialects'. I am not a Modernist because I don't believe in a style rooted in the values of triumphant, technist, scientific materialism, and I am not a Post-Modernist because I don't believe in the historical necessity of culture succumbing to a shabby, fairground eclecticism.

Perhaps to prove how all-encompassing Post-Modernism really is, at the end of *What is Post-Modernism?* Charles Jencks even mentions me. He writes: 'The atheist art critic, Peter Fuller, in his book *Images of God: The Consolations of Lost Illusions*, calls for the equivalent of a new spirituality based on an "imaginative yet secular response to nature herself." ' (This is a

bit Post-Modernist – quoting Jencks quoting me.) He continues by arguing that, like himself, Fuller is seeking 'a shared symbolic order of the kind that a religion provides, but without the religion'. He asks, 'How is this to be achieved?'

To answer this question I would like to emphasise three points: the human imagination, the world of natural form and the idea of national traditions in art. In these, I believe, lies the framework for a 'facilitating environment' in which the aesthetic dimension of life can still flourish.

To begin with the imagination, I think it is very important to resist the idea that Post-Modernism is 'the language of free-dom'. It would be more appropriate to see it as the language of corporate uniformity in fancy dress. A greater relativist than Jencks was Walter Pater, who, in the mid-nineteenth century, wrote vividly of the fragmentation of human experience into 'impressions' that seemingly did not add up into a coherent whole. Like the Post-Modernists he argued that one ought to take the best from Hellenic and Gothic or Christian traditions, and synthesise them. But, he added, 'what modern art has to do in the service of culture is so to rearrange the details of modern life, as to reflect it, that it may satisfy the spirit'. For Pater, unlike the Post-Modernists, 'a sense of freedom' was rooted not in stylistic eclecticism, but rather in the cultivation of what he called 'imaginative reason'.

To turn specifically to the case of British art, when Baudelaire wrote in the 1850s that British artists were 'representatives of the imagination and the most precious faculties of the human soul', I think that what he was referring to was the persistence in British cultural life of a Romantic tradition, whose twin characteristics were a belief in the human imagination and a close, empirical response to the world of natural form.

I believe that this tradition, a particular national version of a wider Romantic tradition, persisted in England and gave rise to some of our best art in the twentieth century – the work of such artists as Paul Nash, Henry Moore, Graham Sutherland, David Bomberg and Peter Lanyon – which was all created as much in

resistance to the ideas of Modernism as in acceptance of them. Moore, who has often been acclaimed as the greatest sculptor of the twentieth century, far from showing any faith in science and technology, turned his back on what he called 'synthetic culture'. Using a claw chisel, he carved stone into symbols of the unity of man and nature, in what was an essentially anti-Modern vision. In the spirit of Pater, Moore conjoined elements of the classical and the Gothic, but his work could never be considered 'Post-Modern' in that it affirmed the human spirit and, however fractured, the human subject. This was not an art in quotation marks or parentheses.

In Britain, in the late twentieth century, this powerful humanist and Romantic tradition persists, and may even be undergoing a renaissance comparable to that which it underwent in the 1940s. The stimulus this time is not war, but the collapse of the Modern movement and the spiritual bankruptcy of Post-Modernism. Here are the lineaments not of a new heroism – a triumph over nature – but rather of a new imaginative relationship to it.

'There is,' wrote Clement Greenberg, 'nothing left in nature for plastic art to explore.' This has been the tacit assumption of Post-Modernism too. But all human needs are ultimately dependent upon nature, in which and through which we have our being. The best British artists of this century continually set out to explore and reaffirm the primacy of the natural world.

This is not nostalgic, or not necessarily so. Modernism incorporated within itself a view of science as somehow a reduction to the rectilinear, the upright – the exposure of the essential simplicity of phenomena. Yet recent science, one might even say 'Post-Modern science', is very much concerned with the way in which complexity springs out of the combination and recombination of simple elements. I'm thinking, for example, of the fractal geometry of Benoit B. Mandelbrot, and his fascinating doctrine of 'self-similarity', which seems to have so much in common with the insights of poets and philosophers throughout the ages, who thought to see the whole world

reflected in a grain of sand. Now some artists in England, and elsewhere, are beginning to take on board the insights of this new science. This, I find far more exciting than more junky pilasters and shifting semiotic codes, intent on demonstrating the equivalence between Poussin and Disneyland. I'd like to think that true Post-Modernism will take on Post-Modern science and explore the immense imaginative possibilities and aesthetic potential which it proposes. This may even lead to an architecture which has more in common with the Gothic than the classical, although this is still merely speculation.

For the time being, I feel that, in Britain, the best chance of a national aesthetic revival lies in the improbable hands of Prince Charles, heir to the throne. The Prince has already – by virtue of his position, which is outside the political and economic arguments – challenged conventional Modernist and Post-Modernist wisdom in architecture. In his speeches he has criticised both the commercial imperatives of the free market and the utopian materialism of the Left, which have often suited each other so well. The Prince seems to echo Ruskin in his longing for an architecture which finds ways of 'enhancing the natural environment, of adding to the sum of human delight by appreciating that man is more, much more, than a mere mechanical object whose sole aim is to produce money'.

'Man,' he has said, 'is a far more complex creation. Above all he has a soul, and the soul is irrational and mysterious.' By his intervention in architecture, the Prince has helped change the fundamental terms of the leading debates. It is to be hoped that he may take a closer interest in the fine arts as well.

When one tries to sum up some of the elements that might sustain aesthetic life in the face of growing anaesthesia, I think the general principle that must be stressed is that the universal can be achieved only through a recognition of the particular. We must return to the 'sense of place' which international Modernism and contemporary Post-Modernism have done so much to devalue. This entails a return to nature and a reconsideration of national tradition for which there are a number of

useful guides, from Pater to secular pantheism, from Post-Modern science to the Prince.

Rocks and Flesh: an Argument for British Drawing

The road to *Rocks and Flesh*

It is now almost a year since Lynda Morris came over to our cottage in Stowlangtoft, Suffolk, and invited me to make an exhibition for the Norwich School of Art Gallery, to coincide with this year's Norwich Triennial Festival. Lynda gave me virtually *carte blanche* to select any show I wished within the physical and financial limitations of the Gallery. For some time, I had been thinking about the possibility of putting together an exhibition of British drawing, and so I had no hesitation about accepting her offer.

The original idea I had for the exhibition was rather different from the way it has in fact worked out. At first, I felt I wanted to choose five good drawings by each of twelve different artists and write a short essay on every work indicating its qualities. But as I looked – literally with an eye to my exhibition – I found I was following certain themes, without being entirely sure why I was doing so. I also came to feel I wanted the individual drawings just to stand without elaborate verbal justifications.

As it ended up, *Rocks and Flesh* was not an historical exhibition. By this, I mean I self-evidently did not attempt to trace the history of British drawing from Ruskin to the present day. But neither was it, strictly speaking, a 'thematic' exhibition – at least, not of the 'Hands' or 'Horses' variety which has suddenly become so popular in London's Cork Street. I left out innumerable drawings which my suggestive title might bring to mind, and I included others which, at first sight, might seem to have only a loose or tenuous connection with the chosen theme.

The exhibition remained, first and foremost, an exercise of

discriminatory taste. I held true to my original intention to select only drawings I believed to be of exceptional quality. I hope they were enjoyed – good drawing is hardly plentiful. But my intentions in putting together this exhibition were also pedagogic and instructional, for I do not regard taste as a faculty whose responses are necessarily arbitrary: that is, matters of whim, or merely personal preference. The exertion of taste always involves the affirmation of certain values and the implied or explicit exclusion of others. Ruskin once observed that no statement of his had been more earnestly or oftener controverted than that good taste is essentially a moral quality. But, he insisted, 'The first, and last, and closest trial question to ask any living creature is, "What do you like? Tell me what you like and I'll tell you what you are." ' These were all drawings which I liked.

I deliberately excluded various categories of tendentious and functional drawing such as cartoons, caricatures, architectural drawings, and all manner of illustrational and diagrammatic material. Such things can also be either well or badly done, but this was an exhibition about drawing as an imaginative and disinterested aesthetic activity.

A drawing is not so much the reproduction of the image of something seen, as a record of something made. Nonetheless, all the drawings I chose had a strong relationship to the pursuit of truthful perception – or, at least, to the memory system which functions as the storehouse of past percepts. I wanted the whole show to have a coherence, to amount to something more than the sum of its marvellous parts. I found that I was beginning to organise the exhibition around images of heads, mothers and children, couples, babies, stones, mountains, the nude female figure, quarries, churches, cathedrals, townscapes, and some-what less-than-heroic men. But not one of these drawings aspired to being a simple record of appearances. All the images I chose celebrated the power of the human imagination. That is, our capacity to see and to represent objects, people, and the world other than the way they are, or appear to be.

I believe that all good drawing is, to use a word of the psychoanalyst D. W. Winnicott's, 'transitional'. I will explain this more fully. Suffice to say that, at its best, imaginative drawing involves a mingling of subjective and objective experience in a way which transcends mere fantasy and the factual evidences of immediate perception, alike. The good draughtsman creates upon the flat support an illusion of a third area of experiencing – unattainable through say dreaming or photography – to which the word 'revelation' can legitimately be applied.

Inevitably, the formation of this exhibition was subject to vicissitudes and disappointments. The most significant of these was undoubtedly the fact that, after a prolonged exchange of letters, the Henry Moore Foundation finally felt unable to lend us a group of late drawings by Henry Moore. Moore's drawings of the last few years had been one of my major sources of inspiration when I conceived of this exhibition. I particularly wanted to see what his great studies, *Man Drawing Rock Formation*, 1982 [*see plate 4a*] and his *Two Figures Looking at Rocks No. 1*, 1982, would have looked like beside Ruskin's dazzlingly imaginative drawings of rocks and stones. I hope that one day this juxtaposition will be made. The absence of any work by Samuel Palmer was another significant omission, but we simply did not have the resources to gather together everything I wanted. Some sacrifices had to be made and, sadly, Palmer became one of them. Fortunately, certain Palmers were recently hung close to some of the English twentieth-century, Neo-Romantic landscapes which, in part at least, were inspired by them in Fischer Fine Art's pioneering exhibition, *The British Neo-Romantics*.

Drawing the line somewhere

The appreciation of drawing can be obstructed by an 'objective' fallacy, on the one hand, and a 'subjective' fallacy, on the other. According to the objective fallacy, learning to draw is nothing

more than acquiring a technique to record what you see. The objectivist tends to believe that there is *a* technique capable of capturing appearances, and that the more thoroughly one aspires to and masters that technique the better the drawing will be. There are both popular and professional versions of the fallacy. The latter is often associated with a particular strand of recent teaching at the Slade, which emphasises measurement, plumb-lines and rules of thumb.

One objection to this view is that drawing is not seeing. It is not even a way of seeing. A drawing consists of the traces left by a tool drawn across a surface with the intention of making a representation or an abstract pattern. Alternatively, drawing can be thought of as that element of a two-dimensional work of art which functions independently of colour. When we look at nature, it does not present itself to our eyes as static lines, rather the world renders itself visible as areas of colour.

'Everything that you can see in the world around you,' Ruskin wrote, 'presents itself to your eyes only as an arrangement of patches of different colours variously shaded.' We may like to think that lines and outlines are naturally given, and that all the draughtsman has to do is to read and record them. In fact, however, they are concepts of constructs, which no amount of looking can reveal. A drawing is always *created*.

The 'subjective' fallacy has its roots and history in an older, religious conception of drawing. Drawing began to be discussed and appreciated for its own sake (rather than as a sketch or preparation for some other artistic activity) in the fourteenth century. There was considerable consensus around the view, expressed by Giorgio Vasari himself, that drawing originated in the intellect of the artist. In the seventeenth century, Federico Zuccari characteristically argued that that which is to be revealed through art must first be present in the mind of the artist. For Zuccari, *disegno* – that is drawing or design – was synonymous with the term 'idea'. But Zuccari differentiated between *disegno interno* and *disegno externo* – the 'inner' and 'outer' design.

The *disegno interno*, 'inner design' or idea, preceded the act of creation and could, or so Zuccari thought, only be engendered in a man's mind by God. This imaginative 'inner design' was, if you will, a spark of divine, creative activity, manifesting itself through a human being. The *disegno externo* was, for Zuccari, the physical rendering of this divinely inspired intuition.

He conceived of the 'outer' design as the visible shape of the structured idea, or its actual artistic representation, through pencil, chalk, or whatever, on a support. And so, Zuccari saw drawing as a human corollary of divine creative activity:

> Since the human intellect, by virtue of its participation in God's ideational ability and its similarity to the divine mind as such, can produce in itself the *forme spirituali* of created things and transform the *forme* to matter, there exists, as if by divine predestination, a necessary coincidence between man's procedures in producing a work and nature's procedures in producing reality – a predestination which permits the artist to be certain of an objective correspondence between his products and those of nature.

It is true that, like the modern objectivist, Zuccari ended up with the claim that the artist should be certain of 'an objective correspondence between his products and those of nature', but the apparent relationship between drawn forms and those of nature is unrelated, in his view, to the act of visual perception. Rather, he accounts for it in terms of the artist's ability to, as it were, reproduce something of divine creativity in his work. And if we remove God or the divine from the account, we end up with a completely 'subjective' description of drawing, which owes nothing to its relationship with the world of things seen.

Roger Fry quotes approvingly the words of a small child who, when asked how she produced her drawings, said, 'I think, and then draw a line round my think.' Paul Klee called drawing, 'taking a walk with a line'. Philip Rawson has attempted a more sophisticated description of the modern subjectivist position at the beginning of his intriguing book, *Drawing*:

In a sense one can say that drawing is the most fundamentally spiritual – i.e. completely subjective – of all visual artistic activities. Nature presents our eyes with coloured surfaces to which painted areas of pigment may correspond and with inflected surfaces to which sculptural surfaces correspond. But nowhere does it present our eyes with the lines and the relationships between lines which are the raw material of drawing. For a drawing's basic ingredients are strokes or marks which have a symbolic relationship with experience, not a direct, overall similarity with anything real. And the relationships between marks, which embody the main meaning of a drawing, can only be read into the marks by the spectator, so as to create their own mode of truth.

Although the subjectivist view stresses important aspects of drawing which the objectivist cannot account for, I believe that it too involves us only in partial truths. In fact, Philip Rawson himself seems to recognise this when he attacks that 'modern academic' type of drawing which never has the slightest suggestion of three dimensions. He goes on to spell out the 'horrid implication' (in which he clearly delights) that this illusion of a third dimension, so necessary to good drawing, can only be produced by the appearance in the drawing of 'notional *bodies* of some sort'. 'Notional bodies'? It seems we have moved away from the idea of the marks creating 'their own mode of truth', towards some concept, however remote, of their resemblance to natural forms or at least physical forms in three-dimensional space. Indeed, drawings which contained no illusions of space nor bodies could hardly be expected to retain our interest for long.

Clearly both the objectivist and subjectivist accounts of drawing are inadequate. But in Britain there have long existed traditions first of landscape, and later of figure drawing, which make manifest the nature of a third position upon which, I believe, the theory and practice of good drawing depends.

The naked shingles of the world

Everyone knows Ruskin's famous advice to those who want to learn to draw: 'go to Nature in all singleness of heart,' he advised, 'and walk with her laboriously and trustingly, having no other thoughts but how best to penetrate her meaning, and remember her instruction; rejecting nothing, selecting nothing, and scorning nothing – believing all things to be right and good, and rejoicing always in the truth.' Now, at first sight, this may sound like an extreme version of the objective fallacy, and yet if we look at the context of Ruskin's advice, and indeed at his drawings themselves, we quickly realise that this is not the case.

In his advocacy of 'simple *bona fide* imitation of nature', Ruskin was concerned explicitly with the training of young artists for 'the scarlet and the gold' of the imaginative feats of their later years. The contrast between pedagogic exercises and fully realised imaginative work is illustrated by the difference between Ruskin's instructional drawing and his great and justly well-known studies, *Gneiss Rock, Glenfinlas*, of 1853 [*see plate 1*], and *In the Pass of Killiecrankie*, of 1857. Moreover, Ruskin's 'naturalism' was in no sense topographic or quasi-photographic, rather it was profoundly spiritual. He believed that the study of natural forms led men and women towards the highest of all revealed spiritual truths. In his view, nature was the visible handiwork of God.

In his early writing, Ruskin took these views absolutely literally. He believed that through the study of nature one came to see how God had made things. And God revealed himself in small things, as much as in big: 'the Divine mind,' Ruskin insisted, in the first volume of *Modern Painters*, 'is as visible in its full energy of operation on every lowly bank and mouldering stone, as in the lifting of the pillars of heaven, and settling the foundation of the earth.'

In holding such beliefs, of course, Ruskin was not alone. As Kenneth Clark once pointed out, even such an apparently empirical painter as John Constable was motivated by the belief

that since nature was the clearest revelation of God's will, the painting of landscape, conceived in a spirit of humble truth, could be a means of conveying moral and religious ideas. Ruskin tried to interpret all of Turner's work in this sort of way. He even went so far as to describe Turner as, 'sent as a prophet of God to reveal to men the mysteries of His universe'. Ruskin argued that Nature had a body and a soul like man, 'but her soul is the Deity'. Turner's great achievement was that through his exacting attention to the details of natural form – the 'body' of nature – he had rendered visible its soul.

In 1850 William Dyce, an Academician and friend, encouraged a reluctant Ruskin to look at John Everett Millais's work. Ruskin soon began to argue that, like Turner, the Pre-Raphaelite painters were taking truth to nature to such lengths that they revealed God.

In deriving his aesthetics from natural theology (that is teaching about God based on knowledge of nature), Ruskin was very much at one with the general intellectual climate of the first half of the nineteenth century. He had been deeply involved in the Geological Society, and was personally acquainted with eminent geologists, like William Buckland of Oxford, and Adam Sedgwick of Cambridge, whose theories (though widely divergent) assumed that nature was the principal source of divine revelation. They thought that the stones provided direct evidence of God's activity, just as we believe that in studying the material marks left on a piece of paper or a canvas we are dealing with evidence which leads us back directly to the aesthetic and spiritual activity, the imagination, of an artist.

But what if a stone was just a stone? The 1850s, the decade which saw the rise and fall of Pre-Raphaelitism, was also Ruskin's greatest period as a teacher of drawing at the Working Men's College, and I believe, as a draughtsman himself. This was a time of spreading doubts about God's relationship to his world, doubts which occasionally extended to questioning his very existence. The explanations of the older generation of geologists, though still the accepted orthodoxy, were coming to

sound increasingly inadequate. With the advantage of hind-sight it is possible for us to see that every advance of knowledge emphasised that the earth bore evidence of slow developmental processes rather than a sudden, single, creative act. The attempts made to accommodate the new evidence to the old biblical, creationist account were often ingenious, but many retreated fearfully into the ever more emphatic affirmation of old dogmas.

In 1856, Ruskin restated his view that the earth had been literally 'sculptured' by the hand of God. 'We should try to follow the finger of God,' he wrote, 'as it engraved upon the stone tables of the earth the letters and the law of its everlasting form; as, gulf by gulf, the channels of the deep were ploughed; and cape by cape, the lines were traced, with Divine foreknow-ledge, of the shores that were to limit the nations; and, chain by chain, the mountain walls were lengthened forth, and their foundations fastened for ever.' This is heavy stuff. Not even Buckland and Sedgwick had clung as closely to the scriptures as that. And yet we know from Ruskin's journals and correspon-dence that his doubting ran as deep as his mountain of dogma rose high. For struggle as he might to follow the earth-sculpturing finger of God in nature, it became harder and harder for him to do so. 'Hammers!' he complained in a letter to a friend in 1857, 'I hear the clink of them at the end of every cadence of the Bible verses.'

Ruskin's great rock drawings of the 1850s are, I believe, animated by just this mixture of rock-hard conviction and dissolving doubt. Ruskin wants to see the spirit in the mass, to perceive the stones as an avenue to revelation of the divine, but, with this intention, the ever-increasing scrutiny which he bestows on them ends up leading him only towards their blank facticity.

In 1857, Ruskin published his little book, *The Elements of Drawing*, in which he wrote:

Go out into your garden, or into the road, and pick up the
first round or oval stone you can find, not very white, nor
very dark; and the smoother it is the better, only it must not
shine. Draw your table near the window, and put the stone
. . . on a piece of not very white paper, on the table in front
of you. Sit so that the light may come from your left, else
the shadow of the pencil point interferes with your sight of
your work. You must not let the *sun* fall on the stone, but
only ordinary light: therefore choose a window which the
sun does not come in at. If you can shut the shutters of the
other windows of the room it will be all the better; but this
is not of much consequence. Now if you can draw the
stone, you can draw anything; I mean anything that is
drawable. Many things (sea foam for instance) cannot be
drawn at all, only the idea of them more or less suggested;
but if you can draw the stone *rightly*, everything within
reach of art is also within yours.

Now Ruskin has been often praised for the 'practical' tone of *The Elements*, for his refusal to engage in his customary preaching, and it must be said that here, more than anywhere, he comes close to naturalism, to the objective fallacy. For when Ruskin wrote *The Elements*, his faith was ebbing away. The following year he was to undergo his famous 'unconversion', or loss of belief, in Turin and, temporarily at least, to change from a 'spiritual' to a sensualist aesthetics.

Predictably, at this time Ruskin found that he could no longer draw as he once had done. He even began to sympathise with his father's indifference to mountains. Nor was Ruskin's case an isolated one. About the same time, Samuel Palmer's once visionary art became inert, topographic and lifeless. Similarly, in 1854, Holman Hunt, Ruskin's most comprehending disciple among painters, went against all advice to the Holy Land – in the mistaken belief that there, if anywhere, he would find God in nature.

Then, in 1859, Charles Darwin published *On the Origin of Species*. The aesthetic Ruskin had proposed to explain the

greatness of Turner, and upon which Pre-Raphaelitism and his own drawing had been based, was now in ruins. It became harder and harder to believe that meticulous attention to natural form would reveal the activity of the Great Artificer. If nature was the product of chance, and not God's handiwork, it seemed to be deprived of its exemplary beauty. Once the sea of faith had withdrawn, all men and women, including artists, came to feel they were standing on the naked shingles of the world where a stone is a stone. Henceforth, there seemed to be something quite arbitrary about the attempt to make truthful depictions of the appearance of given chunks of matter.

Beyond the darkling plain

All this is not, in my view, some strange and remote affair of relevance only to the middle of the last century. The 'discovery' that the natural world was unrelated to divine creative activity had the most profound effects on man's ethical and aesthetic life. The outside world, no longer seen as a garden made by God for man, came to be regarded as fit only for 'exploitation'. The artist tended to look upon it as something increasingly intractable, alien and other. 'Naturalism' became reduced to the attempt to reproduce appearances, to a *process* like photography.

Drawing declined in the later nineteenth century into a lifeless academic practice drained of even the aspiration to spiritual content, and largely dependent on delineation through outline. Modernism pursued the strange gods of mechanism, abstraction and subjectivism. But for the last ninety years or so, drawing in this country has been fostered by a diverse, and, for the most part, unacknowledged tradition of drawing masters and practitioners who have tried to find ways, in this secular and technologically blinkered society, of re-uniting vision and visionary imagination.

One man responsible for the revival of drawing was Henry Tonks, who taught at the Slade School from 1892 until 1930. (A

major exhibition, *Henry Tonks and Art of Pure Drawing*, was held at the Norwich School of Art Gallery early in 1985.) Tonks believed that drawing should be both 'poetic' and objective – but that only the latter could be taught. Tonks professed a great admiration for Ruskin, but, as he had been a surgeon, his system of teaching drawing was rooted in the human figure, which Ruskin effectively ignored. Certainly the 'Elementary Propositions in Drawing and Painting', which Tonks signed together with George Clausen, have a pedestrian feel today. Some of Tonks's propositions – especially the emphasis upon horizontal and vertical lines as a means of establishing an object's position in space – were to be turned into mere mannerisms by later Slade practitioners like Patrick George and Euan Uglow. Tonks's own drawings show little capacity for imaginative transformation. And yet there can be no doubt that he was an inspiring teacher whose passionate belief in draughtsmanship fired several generations of students including such artists as David Bomberg, Bernard Meninsky and Roger Hilton.

Bomberg was to emerge as a far greater figure in the revival of drawing than his master. He was involved in the Vorticist movement at the beginning of this century, but became, in effect, a pioneer Post-Modernist, who saw that the only possible redemption for art would come about through renewed imaginative contact with the world of natural form. Although Bomberg believed drawing always began in immediate perception, he also thought that, in itself, the eye was a 'stupid' organ. He emphasised the role of intuition in drawing which he once described as, 'the representation of form. Not the representation of appearance of Form, but more the representation of our feelings about form.'

He was no subjective expressionist. Rather, he argued that the way through to the depiction of feeling about form was through a restless and ceaseless search for the 'spirit in the mass'. For Bomberg, as for Ruskin, his way of drawing was inseparable from far wider values than the merely optical. As Roy Oxlade, one of Bomberg's pupils, has put it:

> Bomberg believed that . . . his own approach to drawing,
> involving an assessment of form leading through synthesis
> to what he called 'the spirit in the mass' was the answer to
> the problems of drawing, painting, sculpture, architecture
> and the *total* environment . . . it also became increasingly
> clear to him that the self-destructive impulses latent in
> materialistic and sophisticated societies could be avoided
> only by reappraising man's relationship with nature.
> Indeed, Bomberg's teaching concentrated on what he saw
> as an urgent collective need to reassess that relationship.

Drawing, for Bomberg, was the practical expression of this new 'approach to mass'. He felt that through learning to draw in his way, we could attune ourselves to the forces of nature and 'become initiated in the hidden integrations of its structures', and thereby be enabled 'to render our vision of its image in our fervour to make known what is'. Bomberg was shabbily treated by the art institutions during his lifetime. Between 1945 and 1953, however, he held classes at the Borough Polytechnic, where he gathered around him a remarkable group of students, including not only Roy Oxlade, but Frank Auerbach, Dennis Creffield and Leon Kossoff.

Bomberg's position was in some ways paralleled by that of Bernard Meninsky, who had also studied under Tonks. Meninsky's art depended entirely on the pursuit of drawing, and he taught evening classes in life-drawing at the Westminster School of Art. Unlike Bomberg, however, he constantly drew attention to the drawings of the Old Masters. He believed in the possibility of enthusing the 'classical' language of line with a new life. For him, too, drawing was not merely a technique. He insisted that it was an affirmation of values which went far beyond resemblance to 'the evocation and realisation of a dynamic impulse'. Meninsky's own drawings, which often reflect his concern with the mother-and-child theme, are filled with a sense of deep repose, and silent utopian mystery.

In the 1930s and 1940s, English Neo-Romantic artists began searching for ways of depicting the natural world which were

the modern equivalents for the visions of Turner, Palmer and Ruskin. The drawings of Graham Sutherland, John Piper, Paul Nash and John Minton can all be seen in this way. Graham Sutherland began as an etcher and immersed himself in the work of Samuel Palmer. Later, he looked at nature and transformed what he saw in a way which reflected his own sense of the immanence of spirit in the natural world. John Piper's great Welsh drawings of the 1940s are directly inspired by Ruskin's attempts to unify the geological and spiritual. But the Neo-Romantics were not nostalgic. They were looking for a contemporary vision which could affirm a sense of 'onement' between men and nature. Some of their most powerful imagery came about in response to the devastations of the second world war.

Henry Moore, too, produced some of his most compelling drawings in response to the war. I believe that Moore is the finest British draughtsman of this century, probably of any century. No one has come closer than Moore to creating a new aesthetic in which perception and imagination are reunited through a response to natural form which is at once perceptually accurate and involved with the most profound of symbols. Interestingly, Moore's main themes as an artist have always been the exploration of the infant-mother relationship, and the reclining female figure seen as a nurturing and sustaining landscape. (Ruskin's images of mountains metamorphosing into women may be usefully contrasted with Moore's images of women seen as mountain ranges.)

As Moore's early life drawings show, he has a tremendous sense of the construction of the human figure and a great feel for its variety of balance, size and rhythm. Moore can express all this with exemplary economy of line. He can evoke the massivity of a woman's back with just a few marks of a brush or a stick of charcoal. But at times, Moore has also made 'transformation' drawings, when he works with no preconceived object in mind, or in front of the eyes, to produce a series of variations on a theme. Nonetheless, Moore's greatest drawings – like his

famous studies of sleepers in the tube during war-time, or of miners working at the coal face – belong neither to the world of reconstituted impressions, nor yet to that of fantasy. They constitute a vital third area of experiencing.

Like Henry Moore, Cecil Collins was also briefly involved with the Surrealist movement in the 1930s. Like Moore, he also excelled at drawing from the figure. A source of inspiration throughout his life was a vision of onement with nature which he experienced as a child. He believed that the art schools will have to be reformed because they have wrongly taught that creativity can be rationalised, whereas he regarded it as a process of 'unveiling or revealing something'. Nonetheless, Collins insisted on the value of drawing from the casts:

> I would certainly bring the casts back for several reasons.
> First, the discipline in drawing from them, that can be a
> form of meditation. Secondly, because if the casts are
> rightly chosen they are bringing back the archetypal forms
> that the student should study. Contemplation of archetypal
> forms is one of the most important things that should come
> back to the art schools. Because what you contemplate you
> become.

He insisted that the technique of drawing should be learned unconsciously, because one creates unconsciously. Creation, he said, is a leap into the unknown.

> I don't know what's coming, and what's more, I'm not
> really very interested in what's coming, because then I
> would not get that very important surprise which is what
> creativity is about. It's always something being born in me
> and revealed.

Martin Bloch, too, believed that art should reveal. He did not arrive in England until 1934, when he was fifty-one years old. Yet his sensibility was of a kind which responded, immediately, to the landscape he encountered. In one sense, Bloch was a

European Expressionist, but he differed from, say, Oskar Kokoschka, in the closeness with which he studied the world of nature. Indeed, Bloch resembles Bomberg in the sense that we feel he is always searching for 'the spirit in the mass', rather than simply projecting his own subjectivity into the landscape. Bloch, too, established himself as a teacher of drawing at Camberwell in 1949. His work, for me, exemplifies the way in which the British tradition could be reinvigorated not just by a 'return' to the nineteenth-century insights of Turner, Ruskin and Palmer, but also through contact with a kind of empirically-anchored Expressionism.

Several of Bomberg's most talented pupils can be thought of as having combined expressionism with an emphasis on relentless, empirical questing to produce a new marriage of objective and subjective approaches which cannot adequately be described as being either. I have written extensively elsewhere about the work of Frank Auerbach and Leon Kossoff in these terms.

The work of Dennis Creffield and Roy Oxlade, also in Bomberg's illustrious class at the Borough, is perhaps less well-known. Creffield himself has perceived the links between the vision of Ruskin and that of Bomberg. He professes admiration for both, though his own work is quite independent of either. Certainly, Creffield has drawn mountain scenery and the great cathedrals but he also returns to the sacraments of the flesh, drawings of human embraces, pregnancy, child-bearing, and most recently his own baby son. His work exemplifies that sense of secular spirituality – of the discovery of new forms capable of expressing aspects of our haptic and affective life – which I believe to be essential for the creation of good art in our time.

Roy Oxlade has developed, and made his own, a different aspect of Bomberg's teaching. Although he is a traditionalist, in the sense that he emphasises the need for artists to assimilate the past in order to contribute to the present, Oxlade believes that old attitudes and methods cannot be kept alive artificially.

He is, for example, exceptionally critical of Tonks's legacy, and has stressed the need for a primitive sign language which breaks with conventional modes of depiction and thereby questions conventional ways of seeing. This sense of intuition and gesture, linked to a rigorous draughtsman's discipline, is the basis of his teaching at Tunbridge Wells. It has also enabled Oxlade to create some exceptional drawings, like a brilliant study of a male nude which has an ancestor in Mantegna's foreshortened Christ.

Roger Hilton also tried to make use of a 'primitive' gestural sign language in his reinterpretations of the figure. Nonetheless he often seems to lack Oxlade's Bombergian rigour and vision. He is, in my view, at his best in a superb drawing of a reclining woman, which retains more than a residue of Henry Tonks's objectivist approach.

My list could continue, but it must now be said that during the 1960s and 1970s, imaginative drawing of the kind I have been describing passed out of fashion. The legacy of Bomberg was largely ignored. Cecil Collins worked in obscurity; Moore, Sutherland, and Piper were regarded as being outside the critical debate. Auerbach and Kossoff had not yet begun to receive the attention they enjoy today. Part of the reason for all this is, as Lynda Morris notes, 'the failure of Public Patronage to withstand the pressure exerted by a powerful international network of avant-garde art dealers'. Most of the art produced and promoted over those years became drained of all sense of spirit. Late Modernism, with its emphasis on Pop imagery, bland and insensitive Minimalism, anti-illusionism, etc., was the order of the day.

It seemed that a shift was coming in 1975, when Patrick George selected the exhibition, *Drawings of People*, for the Arts Council. This contained some beautiful works, but George tragically argued that the artist's task was nothing more than to 'account for the bewildering state of appearance'. George maintained that all the artist does is to catch likenesses, like a photographer with antiquated equipment.

R. B. Kitaj's better known exhibition, *The Human Clay*, mounted the following year, certainly included a wider range of work – and left out some of the dead wood from the Slade. But Kitaj, too, often seemed to argue as if mere involvement with appearance, as against 'empty' abstraction, was sufficient. Over the last decade, we have seen a lot more vacuous figurative art. By and large, this has not been 'Georgian', 'photographic', or factualist; rather, it has tended to be New Expressionist, or Subjectivist. It has had no relationship to imaginative vision or revelation. All this seems to have played its part in leading Kitaj himself to realise that even for us unbelievers, art without a 'spiritual' dimension – whether abstract or figurative – is barely worth having.

Potential spaces

Throughout this essay, I have suggested that good drawing is 'transitional' in character, and that this might provide a clue to that quality of secular spirituality which I believe is the necessary ingredient of any genuine Post-Modernist aesthetic. The term 'transitional' I have borrowed from the late D. W. Winnicott, a great psychoanalyst, who talked about those 'moments of illusion' which occurred when the mother offered her breast at precisely the moment when the child wanted it, thus providing the illusion that there was an external reality which corresponded to the child's capacity to imagine, or to create.

In such moments, the baby's sense of what is self and what is other is literally not yet defined. The baby has still to develop a sense of his body as contained by a limiting membrane, or skin. The baby does not so much perceive objects, as apperceive subjective objects. Winnicott drew attention to the moments when the baby reaches out for the mother's mouth and feels her teeth, and at the same time, looks into her eyes, seeing her creatively. Winnicott felt that such primary 'transitional' experiences led on naturally to cultural experience, and indeed formed its foundation.

In his view, the 'potential space', originally between baby and mother, ought ideally to be reproduced between child and family, and indeed between the adult individual and society, or the world. He thought that this potential space was 'the location of cultural experience' itself. He wrote, 'The interplay between originality and the acceptance of tradition as the basis for inventiveness seems to me to be just one more example, and a very exciting one, of the interplay between separateness and union.'

Good drawing mingles perception and apperception, and involves just such an interplay. This helps us to understand why even – perhaps *especially* – in an advanced secular and technological society, the teaching and practice of drawing requires celebration and, where necessary, defence. Drawing involves a relationship between the self and objects and persons in the world, which is elsewhere often denied. Drawing involves an affectionate and creative gaze, a mingling of self and that which is seen or imagined, of a kind which an automatic process, like photography, immediately and inevitably excludes. Drawing involves heart, head, eye and hand in a relationship with objects which implies not just an aesthetic, but also an ethic, which is reconciling and re-binding – a redemption through form.

I have surely said enough at least to hint at the reason why images of the mother-and-child occupy a special place in my estimation, but the point of view from which the majority of these have been drawn can be distinguished from that of an independent observer, or the mother, alike. The good draughtsman, or woman, develops his or her inherited talents to the full; he absorbs and extends the living legacy of tradition. And yet, in so doing, he never loses touch – or at least not for long – with his child-like, 'transitional' vision. Rather, he presents others with a fully adult version of such a vision, a version created through the exercise of traditional skills, informed and transformed by a lifetime of personal looking, apperceiving, learning, and above all, creating. We need not be

surprised if the birth of a baby, close to home, often stimulates the draughtsman towards a replenishment and revitalisation of the intimacy of vision. There are drawings by Henry Moore, Peter Lanyon, Dennis Creffield, Martin Bloch, and Martin Murray which underline that point. But the subject matter of these artists extends out from re-creations of that primary, maternal environment to include the whole face, as in heads and portraits, and indeed the entire female body, male figures, rocks, stones, landscape, and architectural structures too. For as Roger Scruton once put it, architecture is 'the history not of engineering, but of stones in their expressive aspect'. Through his search for what Bomberg described as 'the spirit in the mass', the artist can create for us an illusion of a transitional environment – even when we no longer believe that the world is the literal handiwork of God.

1985

The Last Romantics

The exhibition, *The Last Romantics: The Romantic Tradition in British Art, Burne-Jones to Stanley Spencer*, at the Barbican Gallery in April 1989, added fuel to debates which have been simmering about the clash between Romanticism and Modernism, between 'national tradition' and 'internationalism', and between 'populism' and the 'avant-garde'. The argument which informed the exhibition was that Pre-Raphaelitism was not, as had so often previously been assumed, a cul-de-sac. On the contrary, John Christian, who brought together more than 300 works for the show, wished to demonstrate that even after the death of Burne-Jones in 1898, a Romantic tradition, deriving from Pre-Raphaelitism, persisted here, and gave rise to a great diversity of twentieth-century painting and sculpture.

Christian argued that this exhibition fills in the gap between the point where *The Pre-Raphaelites*, at the Tate Gallery in 1985, left off and the rise of Romanticism at the time of the second world war, as chronicled in the 1987 Barbican show, <u>*A Paradise Lost: the Neo-Romantic Imagination in Britain, 1935–1955*</u>. This amounts to more than a matter of academic art history. Christian sought to demonstrate that a Romantic tradition has been continuous in Britain, and that it persisted through the period when the Modern movement was supposed to have overthrown, or at least displaced it. What makes all this peculiarly urgent is the resurgence of a Romantic sensibility in painting in the 1980s, and the re-emergence of interest in Romantic, as opposed to Modernist, critical approaches.

The hostility of the protagonists of the Modern movement to Romanticism in general and to Pre-Raphaelitism in particular, is legendary. Christian quotes George Moore, the champion of

Impressionism and the New English Art Club, who described Burne-Jones as 'the worst artist that ever lived, whether you regard him as a colourist, a draughtsman, a painter or a designer'. This view was reiterated by Bloomsbury, for whom opposition to Pre-Raphaelitism was *de rigueur*. Clive Bell, notoriously, swept all Pre-Raphaelitism aside, declaring it was of 'utter insignificance in the history of European culture'.

In the 1920s, a derisory view of Romanticism in general, and of Pre-Raphaelitism in particular, became part of received opinion in 'progressive' artistic circles. (Late Turner remained virtually unknown; Constable was praised as the forerunner of Impressionism!) Clive Bell's son, Quentin Bell, has described how between 1900 and 1940, no one thought the Pre-Raphaelites were worth attending to, and so no serious historical studies of them were published.

All this changed with the rise of Neo-Romanticism in the late 1930s and 1940s, and the recovery of the Romantic sensibility by painters like John Piper and critics like Robin Ironside, who wrote, so vividly, about 'a reaction from the ideas of Roger Fry, a return to freedom of attitude more easily acceptable to the temper of our culture, a freedom of attitude that might acquiesce in the inconsistencies of Ruskin but could not flourish under the system of Fry'.

Ironside was largely responsible for the re-awakening of 'serious' interest in Burne-Jones – without which John Christian's work would never have been possible. Together with John Gere, Ironside also compiled the Phaidon Press volume, *Pre-Raphaelite Painters*, which appeared in 1948, on the centenary of the foundation of the Pre-Raphaelite Brotherhood. This book marked the beginning of the end of twentieth-century obscurity for the Pre-Raphaelites. One of the more singular features of contemporary cultural life since the second world war has been the seemingly unbounded efflorescence of interest in Romantic painting (*vide* the return of Francis Danby), and specifically in Pre-Raphaelitism among a large section of the public interested in the visual arts.

And yet advanced 'Modernist' opinion has remained scep-
tical and unconvinced. In 1944, Clement Greenberg, the archi-
tect of the new formalist criticism in the USA, wrote dis-
missively about the latest 'romantic revival' in painting and
poetry, in both Britain and America. Opposition to
Romanticism was a central plank of his early position.
Greenberg wrote that the new interest in, as he called it, 'Pre-
Raphaelism', and the literary aspects of painting, stood
historical Romanticism on its head. For this new Romanticism

> does not revolt against authority and constraints, but tries
> to establish a new version of security and order. The
> 'imagination' it favors seems conservative and constant as
> against the 'reason' it opposes, which is restless,
> disturbing, ever locked in struggles with the problematical.
> 'Reason' leads to convictions, activity, politics, adventure;
> 'imagination' to sentiment, pleasure and certainties. The
> new 'Romanticism' gives up experiment and the
> assimilation of new experience in the hope of bringing art
> back to society, which has itself been 'romantic' for quite a
> while in its hunger for immediate emotion and familiar
> forms. A nostalgia is felt for a harmony which can be found
> only in the past and which the very technical achievements
> of past art seem to assume.

This sort of view has persisted. Quentin Bell has described how,
even in the late 1960s, he had great difficulty in persuading his
colleagues and his students of the validity of his interest in the
Pre-Raphaelite movement; and only three years ago, John
Berger – as it happens disingenuously – asserted the reason he
had broken off relations with me was because of my interest in
Pre-Raphaelitism.

These sorts of unquestioning, fashionable Modernist views
were entrenched in, say, the rhetoric which surrounded the
exhibition *British Art in the 20th Century: the Modern Movement*,
which was held at the Royal Academy in 1987. It is that rhetoric
which John Christian was determined to challenge. 'Old ideas,'

he writes, 'die hard, as we saw in the exhibition . . . at the Royal Academy in 1987. Here again, with the single exception of Eric Gill, there was no overlap with our exhibition other than in the Slade area.'

So did Christian succeed in offering an alternative view of British art to that provided by Norman Rosenthal and his colleagues at the Academy? On the surface, the answer to that must be a resounding 'no'. Christian is, of course, a scholar of Burne-Jones, and was responsible for an exemplary exhibition of Burne-Jones's work at the Hayward Gallery in 1975. It was therefore disappointing to discover that Burne-Jones himself was so poorly represented in the Barbican show – *Vespertina Quies* is hardly the masterpiece of his later years. Minor, and less than minor, works by Burne-Jones's followers and studio assistants were also allowed to proliferate. *The Last Romantics* was cluttered with Birmingham Pre-Raphaelites; academic revivalists of Pre-Raphaelite genres, like Frank Dicksee and John Waterhouse; fey fairy painters; Viennese-inspired pictures by Charles Ricketts and Charles Shannon; illustrators of the Celtic fringe; and even with neo-classicists, from the British School in Rome in the 1920s.

When all is said and done, there was but one room of outstanding paintings and drawings in the show, namely by those painters whom Christian calls 'Slade School Symbolists', that is, artists who studied at the Slade just before the first world war, like Stanley Spencer, Paul Nash, Mark Gertler and David Bomberg. As Christian himself points out, these painters also featured prominently in the Royal Academy exhibition, where they were rightly and powerfully presented as among the century's greatest British artists.

And so, it must be admitted that the Barbican exhibition presented us with very little of real stature which had not also been represented in the Academy show. But the Academy exhibition also contained more than its share of phoney nonsense – especially in the rooms chronicling art from the 1950s to the present day. I would argue that, say, Richard

Hamilton's *Towards a definitive statement on the coming trends in men's wear and accessories (c) Adonis in Y-fronts*, 1962, is, roughly speaking, the 1960s equivalent of John William Waterhouse's slick and facile, *Echo and Narcissus*, 1903, included as an academic Pre-Raphaelite picture in Christian's show. (In fact, I much prefer the Waterhouse to the Hamilton. Seen 'in the flesh', Waterhouse's painting demonstrates verve and immediacy. Hamilton's necrophiliac touch and techniques always snuff out every semblance of life.)

Or take Stuart Brisley's *Survival in Alien Circumstances*, 1977–81. To my mind, this silly and sentimental work – photographs of the two weeks Brisley spent splashing about masochistically in the water at the bottom of a deep hole – is the contemporary equivalent of, say, Herbert Draper's set-piece, *The Golden Fleece*, which shows Jason in mortal peril on the high seas. Brisley and Draper are both institutional artists who have made use of fashionable techniques to trigger spurious emotions. Similarly, Gilbert and George's *Wanker*, *Prick Ass* and *Bummed* of 1977, can be compared, in their vacuity and vulgarity of feeling, to Frank Dicksee's *Chivalry*, which shows a knight, literally in shining armour, about to rescue a distressed maiden tied to a tree, in delectable disarray.

My point is that objections which Greenberg addressed to 'romantic' art in the 1940s, now apply much more aptly to Modernist art, the institutional art of our own time. Today, of course, it is Modernism which has given up 'the assimilation of new experience in the hope of bringing art back to society', which, we might add, has itself been 'modern' for quite a while in its hunger for immediate emotion and familiar forms.

The second, and to my mind more important point that needs making about the Academy show is that, the breathy rhetoric of the catalogue notwithstanding, much of the work on exhibition there in fact owed little to the Modern movement. To be more exact, many of the outstanding British artists of this century have simply incorporated elements of international Modernism

into their work as a way of furthering their Romantic concerns. Some have not even bothered to do that.

Take the case of Stanley Spencer who was represented at the Academy by six paintings, and at the Barbican by two. At least one of the latter, *Zacharias and Elizabeth*, 1914, is, in my view, a masterpiece. And yet everything about it involves an appeal, over the heads of both the academic Pre-Raphaelites and the insipid followers of Burne-Jones, to the attitudes of mind of Pre-Raphaelite painting in the mid-nineteenth century. Spencer was everything that – according to the Modernists – the twentieth-century artist ought not to be, and yet he was undoubtedly one of the greatest British artists of the twentieth century; far greater, I believe, than Francis Bacon. Spencer was narrow-minded and provincial; a man of biblical, rather than scientific vision; concerned with the past, rather than the future (which he conceived in terms of a second coming); an enemy of industrialisation, indeed of almost everything about the modern world. Spencer looked at nature with the intensity and longing of one who believed that he could find God there. [*See plate 9b.*]

Now one could say that such attitudes were what Fry and Bell sought to dismiss when they castigated Pre-Raphaelitism. (Although their antipathy to Englishness was perhaps stronger than their affiliation to Modernism, which was one reason why they responded to a thorough-going French Symbolist painter like Gauguin.) Fry could not, however, dismiss Spencer: he had too sharp an eye for that. He included him in the first Post-Impressionist exhibition.

For many Modernists who came after, one way of dealing with Spencer was to argue that he was 'unique' – a freak if not of nature, then of cultural life, who stood outside the laws of his time. But John Christian shows this just was not true. Spencer belonged to a tradition, a Romantic and Pre-Raphaelite tradition – an *English* 'Post-Impressionism'.

As I try to argue in my book, *Theoria*, what was true of Spencer was true of a remarkable number of our greatest contemporary

artists. Certainly, many of them recognised the pictorial failures of Pre-Raphaelitism, but they admired the desire of the Pre-Raphaelites, and of Turner before them, to paint pictures which were rooted in an imaginative and spiritual response to the world of nature.

Paul Nash, for example, begins with an admiration for Rossetti. The experience of the 'godless' landscapes of the first and second world wars reunites him with the earlier and tougher vision of Holman Hunt's *Scapegoat* and paves the way to his own luminous last landscapes, surely some of the greatest Romantic paintings since Palmer. Similarly, as I have argued at length elsewhere, Bomberg's search for 'the spirit in the mass', or Henry Moore's sculptural preoccupations, stand in direct and undeniable continuity with the aesthetic concerns of the nineteenth century. Both realised that the imaginative world of the arts necessitated, at the very least, a 'suspension of disbelief'. Whatever philosophy they may otherwise have espoused in the real world, in the illusory spaces of their art, these artists were vitalists rather than materialists. They were motivated by the desire to see beyond appearances, to depict the spiritual essences of things.

Greenberg had a sharper eye and a much finer critical mind than either his acolytes or his critics, and yet it seems to me that he was wrong on the most fundamental issue of all, when he argued that 'the highest aesthetic sensibility rests on the same basic assumptions . . . as to the nature of reality as does the "advanced" thinking contemporaneous with it'.

In Britain in the twentieth century our greatest artists have invariably shown a refusal of modernity, an unashamed preference for an older, romantic and spiritual tradition. This was also indubitably true of much of the best French painting, especially after Impressionism. (I write this as someone who himself remains an atheist and a materialist.)

John Christian's show fell apart because he included so much empty and academic work in which the high ideals of the Romantic movement were replaced by slickness,

commercialism, or imaginative ineptness. He also omitted much of real stature. Why, for example, were there no paintings by G. F. Watts, at his best a great, and unjustly neglected artist, whose work foreshadowed so much of what is best in the British achievement in the twentieth century?

Exactly the same criticisms can be raised against Norman Rosenthal and his colleagues at the Royal Academy. They, too, misunderstood the nature of the tradition with which they were dealing. Neither Christian nor Rosenthal have Baudelaire's understanding of what it was that made British art unique both in the last century, and, I believe, in our own. (Can it be an accident that both overlooked the work of Cecil Collins which was, I felt, triumphantly vindicated at his retrospective exhibition at the Tate, in May 1989?) In 1859, Baudelaire regretted the absence of a long list of British artists from the French salon, describing them as 'enthusiastic representatives of the imagination and of the most precious faculties of the soul'. Once, British art seemed hopelessly inferior to that of France. Yet, today, the British school is probably the liveliest and most creative in the world and French painting is nowhere.

1989

PART TWO

Past Masters

Joshua Reynolds:
Visions of Grandeur

It was surprising that Sir Joshua Reynolds had to wait until 1986 for his exhibition at the Royal Academy. Over the last fifteen years most of the major figures of British painting have been revalued in the light of recent scholarship. We have seen major museum shows devoted to – among others – Hogarth, Stubbs, Wilson, Gainsborough, Blake, Fuseli, Lawrence, Constable, Cotman, Cox, Turner, the Pre-Raphaelites, even Landseer and Sargent. Logically we might have expected Reynolds to have appeared early in this series. As the first President of the Royal Academy, Reynolds contributed more than anyone else, even Hogarth, to the establishment of British painting as a tradition, academic discipline and profession. Only Turner achieved a comparable stature in Europe.

And yet, though Reynolds usually receives respect and admiration, he has never been greatly loved. I have yet to meet a living painter who admitted to having been influenced or inspired by him. He fares little better with the great British public. It is virtually impossible to buy a popular book of reproductions of Reynolds's paintings.

In neither his person, nor his practice, did Reynolds have much in common with what the twentieth century expects of its artists. He was a man of method, who admired tradition and believed in civil institutions. He placed no faith in an innocent eye and did not put much value on the craft of art. Again and again in the famous *Discourses* which he delivered to students of the Royal Academy, he emphasised that it was not the eye but the mind 'which the painter of genius desires to address'.

All this comes out in the changing ways in which Reynolds depicted himself throughout his life. In what is probably the

earliest of his self-portraits painted when he was a 'face-painter' of twenty-five, Reynolds comes over as a stylishly dressed proto-Romantic, holding a brush and palette, and gazing out of the picture towards the viewer. He shades his eyes with his hand, like a ship's mate on the look-out. The picture owes a lot to Rembrandt, but Reynolds has made the device of the eyes-in-shadow his own. He was to use it to good effect in portraits of young women whose faces were darkened by the brims of their hats.

The convention crops up in another self-portrait which Reynolds painted some thirty-five years later. Here it is only the left eye which is plunged in shadow, much else has changed. The references to Rembrandt are more marked than before, but this time there is no sign of palette, nor brushes, nor any of the appurtenances of the painter's trade. Reynolds has decked himself out in the robe of a Doctor of Civil Law. The hint of passionate intensity apparent in the earlier self-portrait has disappeared. His face has the aloofness of an intellectual grandee.

A decade later, Reynolds painted himself almost for the last time in a self-portrait which provided a moving conclusion to the Academy's exhibition. The proud academic robes have gone. Bewigged, and bespectacled, Reynolds is an old man on the verge of blindness. The pathos of this portrait is underlined by the cracking and blistering of the paint, caused by the artist's disdain for his materials, and excessive use of bitumen.

These paintings tell us a good deal about how Reynolds saw himself and his work. 'The beauty of which we are in quest,' he once said, 'is general and intellectual; it is an idea that subsists only in the mind; the sight never beheld it, nor has the hand expressed it: it is an idea residing in the breast of the artist, which he is always labouring to impart, and which he dies at last without imparting.'

First and foremost an intellectual, Reynolds believed, 'He can never be a great artist who is grossly illiterate.' The Doctor of Civil Law simply provided a more appropriate model for what

he thought the artist ought to be doing than the visionary, the outsider, the craftsman, or the natural scientist – with whom Constable was to compare himself.

Reynolds was born in 1723, the son of a clerical schoolmaster, sensitively depicted in a posthumous portrait in the Academy exhibition. He served his apprenticeship with one Thomas Hudson, a fashionable, but uninspiring portraitist. In 1749 he went to Italy where he stayed three years, copying and studying prodigiously.

Back in England, Reynolds established himself as a portraitist by painting a picture of Commodore Augustus Keppel, son of the second Earl of Albemarle, in a pose reminiscent of the famous Greek statue, the *Apollo Belvedere*. Soon Reynolds was producing portraits of Keppel's many influential relatives including his mother, the formidable Anne, Countess of Albemarle, whom he depicted in lavish rococo silks and a 'furious passion', brought about by the elopement of one of her daughters. He also painted Anne's niece, Lady Caroline Fox, and the latter's sister, the extravagantly beautiful Lady Sarah Bunbury.

By the end of the 1750s, Reynolds had established himself as the most fashionable portraitist in London. The rich, the mighty and the famous passed through his studio. Reynolds painted their faces while his assistants filled in the drapery and backgrounds from models and props. He was fascinated by the courtesans of his day, especially by the notorious Kitty Fisher, whom he once portrayed as Cleopatra, in an idealised portrait executed for Sir Charles Bingham, later Lord Lucan.

Reynolds established a reputation as a master of the full-length portrait, intended to adorn the Great Hall or the Grand Staircase. For example, he was commissioned to paint William, Duke of Cumberland, known as 'The Butcher', because of his massacre of the Jacobites after the Battle of Culloden. The Duke was grossly overweight, prodigiously ugly and blind in one eye. He emerges from Reynolds's paintings as a splendid, almost majestic fellow, adorned in the sumptuous garments

of the Order of the Garter, and set off against an imaginary landscape [*see plate 5*].

Much has been made of the fact that, in his *Discourses*, Reynolds consistently elevated 'History Painting' over the portraiture which he himself practised. 'An History-Painter,' he said, 'paints man in general; a Portrait-Painter, a particular man, and consequently a defective model.' Portrait painting certainly provided Reynolds with a lucrative income: in real terms, he must be rated among the wealthiest of European painters. He is often seen as an artist who sold his soul to the devil, and yet the contradiction between theory and practice is not quite what it seems.

Reynolds believed in truth to nature, but in his *Discourses* he explains that, in his view, 'the whole beauty and grandeur of painting consists . . . in being able to get above all singular forms, local particularities, and details of every kind'. For Reynolds, the ultimate truth which revealed the good was general.

He says that what he means by History Painting ought to be described more as 'Poetical' painting, that is, painting which eschewed the defects of the particular. Agesilaus may have been 'low, lame, and of mean appearance', but 'none of these defects ought to appear in a piece of which he is the hero'.

When he painted the Duke of Cumberland Reynolds was trying to do something more than provide a massage for the ego of a mighty man. He wanted to transcend the meanness of particular nature and character. This intention is expressed clearly in his portraits of women – such as his painting of the three Montgomery Sisters 'Adorning a Term of Hymen', his famous representations of the ravishing Lady Sarah Bunbury sacrificing to the Graces, or Mrs Hale as Euphrosyne. It comes out, too, in his grand group portrait of the Marlborough family, generally acknowledged as among the most impressive of all his pictures. All this was not, as has sometimes been suggested, simply a matter of flattering his sitters. It often necessitated going against their wishes, for, as Reynolds put it, 'It is very

difficult to ennoble the character of a countenance but at the expense of the likeness, which is what is most generally required by such as sit to the painter.'

Reynolds was neither a fop nor a sycophant. His was an art of High Seriousness. His preferred *milieu* was not that of the great country houses, least of all the Court, where, despite his success, he was greatly disliked. It was the world of the tavern, the theatre and the literati – many of whom he counted among his friends. He not only painted fine portraits of Samuel Johnson and Oliver Goldsmith, but appointed them both as Professors in the Royal Academy.

Reynolds's portraiture was consistent with aesthetic beliefs which, in part, explain his fascination with courtesans and actresses. He liked to find refinement and sensitivity even in the features of Kitty Fisher; just as he revealed sublime beauty in Mrs Abington's rendering of Miss Prue, the thumb-sucking wanton from Congreve's play, *Love for Love*. In this sense, Reynolds's art was the opposite of that of the caricaturists who proliferated in eighteenth-century England. Caricature fed on exposure. It was, by its very nature, tendentious and sadistic, thriving in the space between public morality and private debauchery. The caricaturist committed himself to particular truths and defects, to the revelation of evil.

Reynolds was not so much engaged in an ignoble collusion as in the pursuit of noble sentiment. For the idea of Reynolds as a painter motivated by dry intellect and tradition can be over-stressed. The importance he placed on feeling is underlined by his preoccupation with maternal sentiment, something rightly accentuated in a special section of the Royal Academy exhibition. Reynolds was drawn to the theme of children and fascinated by the relationship between a mother and her child. He seems to have admired those noble women like the Duchess of Devonshire, who abandoned the use of wet-nurses, and nurtured their children themselves. He certainly painted many pictures of them.

There may be something inherently absurd in the depiction of

the British nobility as the gods and goddesses of ancient Greece, but we should not underestimate the element of irony that entered into many of Reynolds's portraits in 'The Grand Style'. We live in an era when the portrait has generally been reduced to the transcription of appearance or, at best, the pursuit of merely psychological insight. Portraiture has become a form of 'face-painting' once again. Alternatively, in the work of a painter like Francis Bacon, the portrait may aspire to the revelation of general truth, but, like the caricature, the truth it reveals turns out to be tendentious, mean and degrading.

Although Reynolds lived in a time when kings were corrupt and the nobility less than noble, he contrived to see beyond these particular defects, to create a Grand Style of elevating characters and noble sentiments. The preconditions for the elaboration of this ideal vision were swept away by successive Reform Bills, and a better understanding of nature in its infinite variety. That brand of secular Platonism in which Reynolds believed hardly remained tenable. And yet, as I wandered round the rooms of the Academy and gazed upon the remote and unfashionable pictures painted by its first President, I felt compelled to agree with something Darwin said in defence of his own vision, 'There is grandeur in this view of life.'

1986

George Stubbs

Among George Stubbs's most beautiful paintings are the arrangements of *Mares and Foals* he began in the early 1760s. Several of these were shown at the Tate Gallery in 1985, in an exceptional exhibition of Stubbs's work which forced a major revaluation of his contribution to British art. He was commissioned to produce these canvases by aristocrats of the recently established Jockey Club, such as the Dukes of Richmond and Grafton, and Earl Grosvenor. They expected him to furnish them with portraits of their valuable live-stock, but they also wanted something more than that. One of the most successful of these paintings is the Tate's own *Mares and Foals in a River Landscape*. Though made for Viscount Midleton, the picture consists of an elaboration of a group of horses previously depicted in a painting commissioned by the Marquess of Rockingham. The catalogue suggests that although Viscount Midleton did not have brood mares of his own, perhaps he just 'liked the subject'.

The pedigrees and provenance of these mares and foals, their feats on the track and in the stud farm, have long since been forgotten even by *aficionados* of the turf. But Stubbs was never much interested in such matters, only more general concerns. Like Jonathan Swift's Houyhnhnms, his horses were one of the means through which he tried to reveal his vision of the natural order. That vision – at once highly original and profoundly conservative – was always his true subject.

George Stubbs was born in Liverpool in 1724, the son of a prosperous currier. As a boy of eight he showed a precocious interest in anatomy, and seven years later was briefly apprenticed to a now-forgotten painter. By 1745 he was living in York, where he painted portraits and studied and taught anatomy.

At this time, he acquired a 'vile reputation', apparently because he dissected the corpse of a pregnant woman and supplied the plates for a treatise on midwifery by John Burton, the model for Laurence Sterne's disreputable Dr Slop. In 1754, Stubbs made a short trip to Rome. Two years later he went to live in the Lincolnshire village of Horkstow, with his common-law wife, Mary Spencer.

For sixteen months, Stubbs put all his energy into the dissection of horses, devising a contraption of hooks and iron bars for hoisting the horses' corpses into a 'standing' position. A friend of Stubbs's described how they 'continued hanging in the posture Six or Seven Weeks, or as long as they were fit for use'.

Stubbs employed the latest dissection techniques, involving wax injections. He cut away layer after layer, making meticulous notes and drawings of what he saw. Only Mary encouraged him in his arduous and unsavoury work. No publisher was interested, and Stubbs eventually engraved all the plates himself.

What he learned, however, advanced his career indirectly. Early in the 1760s, he began exhibiting at the Society of Artists. His prestige as a painter of horses steadily grew. He moved to London. There he produced not only *Mares and Foals*, but many of his most famous pictures, like *Gimcrack on Newmarket Heath*, or the life-sized portrait of *Whistlejacket*, the Marquess of Rockingham's fiery stallion. When *The Anatomy of the Horse* was finally published in 1766, it confirmed Stubbs's by-then-established reputation.

At this time, too, Stubbs made his first pictures of imported wild animals, such as a zebra and a cheetah. By the end of the decade, he had developed a new obsession: painting in enamel on copper and ceramics, in pursuit of which he enlisted the aid of Josiah Wedgwood, the industrial potter.

But Stubbs's position was no longer secure. Basil Taylor, an acknowledged authority on the painter, has described how, in the 1780s, fashion swung away from smooth finish towards a dramatic sense of tone and a richness of *matière* in the handling

of paint. Stubbs's pursuit of a 'bland, unemotive surface' was considered *passé*. As we shall see, his unique vision was also beginning to seem obsolete.

The lavish patronage the lords of the turf had bestowed on him fell away. Increasingly, Stubbs worked for professionals – men like William and John Hunter, comparative anatomists and natural history collectors, for whom he painted a moose, nylghau, rhinoceros, yak, macaque monkey, and many other creatures. Then, in 1795, at the age of seventy-one, Stubbs began a massive *Comparative Anatomical Exposition of the Structure of the Human Body with that of a Tiger and a Common Foal*. Occasionally, he would produce a *tour de force* painting, like his enormous picture of the race-horse, *Hambletonian*, intended to show a younger generation how it was done. But for most of the time, he was once again absorbed in his lonely anatomical work. When he died in 1806, neglected and in dire financial straits, he had issued fifteen plates of the *Comparative Exposition* and written down more than a quarter of a million words of anatomical description.

Stubbs became embittered by the reception of his work. The details of his quarrel with the Royal Academy remain obscure, but he certainly disliked being known as just a horse-painter, and wanted to be 'considered as an history portrait painter'. These days, Stubbs is referred to as a 'scientific naturalist', and it is often suggested that he was simply an empirical realist who recorded what he saw with neither style nor moral intent. He is unlikely to have been happy with these interpretations either. Formally, his *Mares and Foals* are rhythmically composed into patterns or friezes. In the Tate version, they are stretched out across an idyllic vista, organised according to the classical, pictorial mathematics of the Golden Section.

The force of these pictures certainly owes something to the empirical facts Stubbs learned from his dissections, but his discoveries have been absorbed into a thoroughly eighteenth-century conception of natural harmony. Indeed, it is surprising that, as far as I know, no Stubbs scholar has tried to relate

Stubbs's vision of natural order to the conception of the
universe as a 'Great Chain of Being', governed by principles of
plenitude, continuity and gradation. As Arthur Lovejoy, the
American historian, has demonstrated, ' "The Great Chain of
Being" was the sacred phrase of the eighteenth century, playing
a part somewhat analogous to that of the blessed word
"evolution" in the late nineteenth.'

The theory was that nature consisted of a continuous,
hierarchic gradation, stretching from molluscs to God. This
'wonderful chain' was expressive of God's goodness. Though
characterised by an infinite variety, it was not subject to change
or development. The idea of the creation of new species was
often specifically rejected because it implied an imperfection in
the 'goodness' of the previously existing order.

Soames Jenyns tried to describe how 'the divine artificer' had
formed this gradation. He likened it to the way a skilful painter
uses his colours. The qualities of adjacent orders and classes 'are
so blended together and shaded off into each other, that no line
of distinction is anywhere to be seen'. The biologists tried to
assimilate the new facts they were constantly gathering about
the world into these models. Such thinking permeated the
Comparative Exposition on which Stubbs was working when he
died. We know he envisaged expanding his work to cover the
entire animal and vegetable kingdoms.

This idea of 'A Great Chain of Being' not only affected the
emergent sciences, it permeated every aspect of aesthetic,
cultural, and indeed social life. Just as Stubbs is often incorrectly
credited with the detached empiricism of modern science, so he
is, equally wrongly, depicted as a proto-Social Realist. It is true
that Stubbs invested as much attention in the depiction of
servants, grooms, and jockeys as in that of the noble lords they
served, but it is nonsense to suggest, as the Tate catalogue does,
that he was thereby trying to give a voice to those who were 'yet
to speak the great unspoken'. The idea of social becoming
would have been as alien to Stubbs as that of natural evolution.
He depicted the 'lowly' in detail because he would have agreed

with Jenyns that the universe resembles a large and well-regulated family, 'in which all the officers and servants, and even the domestic animals, are subservient to each other in a proper subordination'. Each, claimed Jenyns, 'enjoys the privileges and prerequisites peculiar to his place, and at the same time contributes, by that just subordination, to the magnificence and happiness of the whole'.

In those great paintings of Stubbs's later years, *The Reapers* and *The Haymakers*, the figures are integrated as in the *Mares and Foals* into harmonious, rhythmic friezes. In effect, they were, even at the time they were made, anachronistic celebrations of 'The Great Chain of Being' in both the natural and the social world – and of that 'just subordination' upon which the concept depended.

But there were problems in sustaining such a vision. The most conspicuous was the fact of competition and conflict between individuals, species and classes. Competition implied a threat to the divinely-ordained harmonious order. Even though he was a painter of race-horses, Stubbs tried to evade the facts of competition. His *Mares and Foals* are shown without any of the appurtenances of the race track; without saddles, bridles, whips, colours, jockeys or crowds. The favourite theme of horse-painters who came before and after Stubbs, like Wooton or Sartorius, was 'The Finish', as great thoroughbreds raced against each other for the winning post. Stubbs only once shows us a race in progress, and even then it is a frozen, crowdless, dream-like event, forming the background to the portrait of Gimcrack on Newmarket Heath. More generally, Stubbs simply averted his eyes from the facts of the industrial revolution and all the impingements into the natural order, all the conflict of the classes which that implied.

But the great eighteenth-century theodicies could not be sustained on denial alone. Stubbs, too, was obsessed with the weak link in his great chain. Much has been written about his preoccupation with the theme of a lion attacking a horse: about twenty versions of this subject exist in his *oeuvre* [*see plate 6a*]. It

used to be said that he had witnessed an incident in which a lion savaged a horse in Italy, but Basil Taylor contends that this story is apocryphal. Today, art historians are content to point out that Stubbs must have seen a celebrated antique sculpture on this theme in Rome. A copy of the sculpture was included in the Tate exhibition.

Why, though, did this particular sculpture have such a deep effect on Stubbs? After all, he must have seen literally thousands of other works of art in Italy, but it is not possible to trace the influence of any of them on him, except this one. The answer, perhaps, is to be found in a book called *De origine mali*, by William King, Bishop of Derry. This work was first published in 1701; an English-language version appeared thirty years later, with copious notes and additions by Edmund Law, Master of Peterhouse, Cambridge. The translation proved more influential than the original, and had a deep influence on Alexander Pope.

Essentially, King and Law wanted to show how the conspicuous facts of conflict and evil could be made compatible with the concept of divine harmony and 'The Great Chain of Being'. For example, they enter into a long discussion about the problem presented by predatory animals. They argue that such creatures contribute to the 'goodness' of creation by being the sort of creatures that they are. It is the nature of animals to delight in the exercise of their particular faculties. 'Nor can we have any other notion of happiness even in God himself,' King writes. 'If you insist that a lion might have been made without teeth or claws, a viper without venom . . . then they would have been of quite another species, and have neither the nature, nor use, nor genius, which they now have.' And that would have implied a gap, or fault, in the 'goodness' of 'The Great Chain of Being'. As for the lion's victim, if it were a rational animal, it would doubtless rejoice, as does God – in the thought of the agreeable exercise which it is affording to the lion in allowing it to fulfil its nature, or 'genius'.

As Lovejoy points out, this is hardly a convincing line of

argument. Faced with the fact of the lion and its prey, King and Law are compelled to subject the idea of 'divine goodness' to a confused and unsustainable transformation. The God of *De origine mali* is made to love abundance and variety of life more than he loves peace and concord among his creatures and more than he desires their exemption from pain.

Perhaps this accounts for Stubbs's preoccupation with the theme of the lion and the horse. He knew there was something here which did not fit in with his vision of nature. Perhaps, too, it accounts for the ambivalent qualities of so many of these pictures. Stubbs freezes the whole scene, giving it the *unnatural*, dream-like quality of his one depiction of an actual race. Often he endows his great beasts of prey with the benign expression one sees today on children's cuddly toys. It is as if, in this theme, Stubbs dimly glimpsed the idea of the struggle for life and the survival of the fittest – evolutionary ideas which were to dominate the following century. But he drew back, and assimilated the terrible scene to a model based on the harmony and divine goodness of nature, which simply could not accommodate it. The threat of a world ruled by competition, blind chance, and a malevolent nature was neutralised as soon as he allowed himself to glimpse it.

Meanwhile, we turn back to those images of mares and foals and derive as much pleasure from them as did the Augustan, Viscount Midleton. This has little to do with Stubbs's 'scientific naturalism', and less with his social realism. His acute perception, anachronistic beliefs, and supremely skilful artistry combine to create an intact vision of perfected natural harmony. This was already scientifically and socially obsolete in his own day, and it is even more so in ours. Yet that obsolescence does nothing to diminish its compelling aesthetic power.

1984

Alfred Munnings

No one had expected Sir Alfred Munnings, the retiring President of the Royal Academy, to steal the show at the Academy banquet in 1949. But long after that evening's speeches by Churchill and Lord Montgomery have been forgotten, Munnings's is still remembered. 'I find myself a President of a body of men who are what I call shilly-shallying,' he told the distinguished guests. 'They feel there is something in this so-called modern art.'

Their one-eyed President proceeded to disabuse them. 'If you paint a tree – for God's sake try and make it look like a tree,' Munnings urged, 'and if you paint a sky, try and make it look like a sky.' He then laid into the 'experts who think they know more about Art than the men who paint the pictures'. They saw so many pictures, he said, 'that their judgement becomes blunt, yes, blunt!'

That, inevitably, reminded him of Anthony Blunt, Surveyor of the King's Pictures, who was among the guests. Munnings had once heard Blunt say that Reynolds was not as good as Picasso. 'What an extraordinary thing for a man to say!' Next in line was Henry Moore's *Northampton Madonna*, which had recently been unveiled. 'My horses may be all wrong . . . but I'm damned sure that isn't right!'

By the time Munnings had finished, he had confirmed his position as the pariah of the emergent Modern Art establishment. Since that speech we have seen thirty-five years of proselytisation, exhibitions and patronage in favour of Modern Art, but Munnings was considered almost a folk hero for the rest of his life. Even today, Castle House in Dedham – Munnings's home for forty years, and now the Sir Alfred

Munnings Museum – still reflects the aesthetic preferences of more middle-class people than does, say, the Hayward Annual.

Back in 1928, when Munnings held a retrospective of 300 pictures at Norwich Castle Museum, he attracted 80,000 visitors. At the time, the show was the century's second most popular art exhibition in Britain. Only Rembrandt had managed to draw bigger crowds. Castle House still manages to draw large crowds on summer afternoons. On my first visit there, for Munnings's centenary exhibition in 1978, I was foolish enough to present my press card and to request the customary complimentary admission. 'An art critic. . . ?' the attendant asked with a smile. 'We charge them double.'

But now that it is once again intellectually respectable to assault Modernism, Munnings has been undergoing a 'revaluation'. Manchester City Art Gallery was first to seize the moment with a major Munnings retrospective at the Manchester Athenaeum in 1986. Round the corner, in the Gallery itself, there was *Munnings versus the Moderns*, a complementary show featuring many of the works against which the artist vented his spleen. A recording of the notorious speech was played on a bakelite wireless.

These days, however, Munnings's connections are keen to play down his role as a polemicist. A 1990 exhibition at Norwich Castle Museum, largely of paintings on loan from Castle House, put the emphasis firmly on his painterly qualities and his working methods. Most of the official horse portraits, the lucrative bane of Munnings's later years, were excluded. But so too was *Does the Subject Matter?* [*see plate 6b*], the excoriating picture in which he caricatured John Rothenstein, then director of the Tate Gallery, and other defenders of the Modern movement in the mid-fifties.

As Rothenstein's memoirs reveal, the director of the Tate and the President of the Royal Academy fought bitterly over matters of taste. Today all is forgiven. In the illustrated guide which accompanied the 1990 rehang of the Tate, the current director, Nicholas Serota, regretted the way in which the contributions of

Munnings and others were 'overlooked', and made good his promise to rectify this omission in the following year's rehang.

Now I hate to introduce a sour note into this new climate of genial tolerance, but I am inclined to wonder whether such Post-Modern ecumenicity is all to the good. Could it be that the cooling of those passions and prejudices which art once aroused is not so much a sign of deepening artistic sophistication as of a general thinning of aesthetic commitment?

Munnings certainly lived by both his passions and his prejudices. He was born in 1878. Like Constable, he was the son of a successful East Anglian miller. He trained at Norfolk School of Art, where he got to know and admire the local collection of Cromes and Cotmans. He was not, however, an artistic provincial. As a young man he painted in Paris, and later visited Cornwall, where he knew and was greatly influenced by the *plein air* painters of the Newlyn School. Whatever his style was, it could not be described as academic. The art critic of the *Eastern Daily Press* wrote of Munnings's contribution to the RA exhibition of 1899: 'The artist would do well to avoid a tendency to paintiness.' It is just that which now seems his principal redeeming feature.

Before the first world war, Munnings painted bucolic studies of the life and light of rural Suffolk, in which his legendary facility is everywhere in evidence. But these early works are richer, fresher, and pictorially more complex than one expects. Munnings was steeped in the English tradition. He knew his Stubbs, and from Constable inherited an obsession with the passing effects of light and weather.

However, Munnings's vision was his own, and there was always a darker side to his romantic landscapes. His finest picture, begun in 1910, was *The Coming Storm*. This ambitious work shows a gypsy boy on a stallion leading an agitated herd away from the tents of a distant horse-fair as a black storm is about to break. In Munnings's words: 'The sky dark; calamitous! Anything might happen.'

If gypsies, white horses, bucolic country-folk, sunny skies,

and ominous storm clouds seem like tired symbols of English Romanticism, Munnings imbued such stock imagery with a freshness and vitality which came from his knowledge of new continental techniques, loosely called Impressionism, and from his acute observation of nature itself. Charles Wheeler, who was to succeed Munnings as President of the Royal Academy, exaggerated only a little when he said that Munnings 'drank so deeply of the visible world that he became at times, quite intoxicated with it'.

All the same, he was often intoxicated in a more conventional way. Munnings found it easier to relate to men and horses than to women. His first wife attempted to poison herself on their wedding night and succeeded a few years later. Their marriage was unconsummated. One suspects that, as with Frans Hals, the relentless cheeriness of his paintings, and indeed his addiction to clubs and tipsy bonhomie, masked an enduring sense of loneliness and frustration.

His second marriage – also childless – was only superficially better. The exhibition at Norwich featured *My Wife, My Horse and Myself*, 1932, and its preparatory studies. The picture shows Violet, his second wife, seated sidesaddle on an elegant stallion outside the bay windows at Castle House. Munnings cuts a jaunty figure beside her, with his cocked hat, cravat and palette. In fact, the marriage came close to destroying him as an imaginative artist, and both parties knew it. Violet insisted that he accept lucrative commissions which he detested. She would say, 'He never painted so well after he met me.'

As Munnings grew older, his sense of frustration, both personal and artistic, spilled out in crotchety boorishness or worse. He scandalised the Garrick Club with his anti-Semitism, and waged a relentless war against modern art. He looked forward to the day when 'young art boys, glad of good, easy jobs on the Press, Arts Councils and such like, would wag their beards for the last time on the wireless'.

Those days have yet to come, but what was it that Munnings hated so much? Was it simply, as we are often told, a matter of

academicism versus the Modern movement, of British in-
sularity versus cosmopolitan internationalism? I suspect not.
Munnings paid lip-service to Reynolds, but owed him nothing
aesthetically. All his emotional identification was with
Constable, who could hardly have been treated worse by the
Academy. In his youth Munnings was a moderately innovative
English Romantic, but he allowed himself to be strapped to the
wrong harness. As he later told his young friend, the writer
Adrian Bell, nothing he painted 'was ever so satisfying as that
horsey hurly-burly under the huge East Anglian weather of
those gypsy themes'.

That, I think, is why he directed his invective not at the most
extreme Modernists – Vorticists, Abstractionists, Constructivists
– so much as against those like Picasso, Cézanne and Matisse,
who, as he put it, 'distorted' the visible world. His deepest
hatred of all was reserved for those close to home, such as
Stanley Spencer, Henry Moore and Graham Sutherland, who
succeeded where he had failed. None of these artists were
'Modernists'. They simply used some of the devices of conti-
nental Modernism, as Munnings himself had tried to do, in
order to replenish the British Romantic tradition and make it
relevant for a new century. Despite Kenneth Clark's admiration
for Moore, his view of Picasso did not differ substantially from
Munnings's.

After the first world war, things were never the same for
Munnings. In the 1920s he cashed in on the success of his
wartime study of Major General Seely on a horse, becoming a
fashionable painter of equestrian portraits and racecourse
scenes. But perhaps Munnings's real problem was that, after
1918, the image of a menaced arcadia on which his vision had
depended was no longer possible. His rambling autobiography
is an old man's lament at his inability to sustain a romantic
vision of England in the post-war world.

About the time of Munnings's death, in 1959, a new and
aggressive brand of abstract, commercial, 'international'
Modernism, emanating from America, swamped the British

institutions of contemporary art. This brash work flaunted that renunciation of nature first prescribed by the influential New York critic, Clement Greenberg.

Now, the annual Turner Prize for British Art, hosted by the Tate, celebrates the 'Post-Modern' coda to all that. It is a sobering fact if they were alive today, all the main protagonists in the so-called 'Munnings v. the Moderns' controversy – Clark, Blunt, Sutherland, Moore and Munnings himself – would probably agree that this sort of thing was a betrayal of a tradition which, in their different ways, they had sought to defend. We can hardly be surprised if the middle classes stubbornly prefer the taste of Castle House to that of Millbank or the South Bank.

1986/90

L. S. Lowry

It was ironic that the centenary of L. S. Lowry, who was born on
1 November 1887, should have been celebrated at a time when
stock markets around the world were slumping and economic
commentators speculating whether the Great Crash of 1987
would be followed by a global recession in industrial production
and a devastating depression in economic and social life. For, as
anyone who visited the exhibition of Lowry's paintings at the
Salford Art Gallery would immediately have realised, Lowry's
vision, for much of his life, seemed almost trapped within the
ethos of the Great Slump.

Yet Lowry did not become popular until after that era was
over, until relative prosperity had returned and the artist's own
work was, arguably, in decline. There is still controversy about
why such pictures have proved so inordinately popular in the
years following the second world war. Can the enthusiasm for
Lowry be explained, as John Berger argued in the 1960s, as part
of a deep cultural resentment against the 'grim heritage' of the
industrial revolution; part of a longing for a change and 'an
alternative plan'? Or was it rather, as I believe, because Lowry
found in the imagery of industrial decline, a secular equivalent
for the religious idea of the Fall, and, through his painting
techniques, reinstated hints of paradise into this dismal reality?

One of the most harrowing pictures Lowry ever painted was
Head of a Man with Red Eyes, 1938 [*see plate 13*]. The man bears a
look of physical dereliction and emotional despair. The fearful
symmetry of the painting seems to emphasise that this is
someone who is standing on the very brink. *Man with Red Eyes* is
best described as an imaginary self-portrait, since Lowry put a
great deal of himself into it. He painted this and other deeply

troubled images as his mother was dying. Lowry was then more than fifty years old. An only child whose father had been inadequate, all Lowry's hate and affection had been directed towards his mother. 'The more I came to know him,' the painter James Fitton commented, 'the more I became aware of his mother's dominance of him.' She was a snobbish, unloving and unappreciative hypochondriac. Lowry, who never married, lived with her and nursed her through her final illness. When she died in 1939, he complained that all meaning seemed to have drained away from his life.

In the same year that Lowry painted *Man with Red Eyes*, he was 'discovered' by the art dealer Alex Reid, and offered an exhibition at the Lefevre Gallery in London. In fact, during the 1930s, Lowry had had more success among Manchester collectors than he later liked to admit. But the scale of the recognition that was accorded him after the war was of quite a different order. He himself used to say that it had come too late.

The prices of the industrial scenes Lowry had painted in the 1930s, and 1940s, began to soar. He became a national celebrity. He was made first an associate, then later a member of the Royal Academy. Universities began to offer him honorary degrees. The Queen Mother bought one of his paintings. Harold Wilson used another as a Christmas card. Politicians of all parties sought to confer official honours upon him. Characteristically, Lowry demurred. He refused an O.B.E. from Macmillan, a C.B.E. and a knighthood from Harold Wilson, and the rank of Companion of Honour from Edward Heath.

The politicians courted this eccentric and obstinate old painter because they were well aware of his enviable popularity in the country. Indeed, as Marina Vaizey reveals in the book which accompanied the Salford exhibition, the attendance at Lowry's memorial at the Royal Academy in 1976 was the record for any one-man show by a twentieth-century artist, easily outstripping Picasso and Stanley Spencer. Mass reproduction of Lowry's paintings meant that his crowds of 'stickmen' in industrial settings were almost as well-known as Van

Gogh's sunflowers or Constable's scenes on the banks of the Stour.

While this was happening Lowry continued to confuse the art world, since he did not belong to any of the camps which proliferated after the war. In both a social and an aesthetic sense Lowry always felt out of place at the Royal Academy. 'I must congratulate you on your pictures,' Lowry once said to Sir Alfred Munnings, the irascible President, horse-painter, and hater of modern art, 'I admire them immensely.' To which Munnings replied, 'I wish I could say the same about yours but I dislike them intensely.'

Lowry received but cold comfort from Munnings's opponents, the avant-garde. Such hostility on the part of 'advanced' taste persists until this day, as shown by Lowry's conspicuous omission from the Royal Academy's 1987 blockbuster exhibition, *British Painting in the 20th Century*. Nor did the Neo-Romantic artists have any more sympathy with Lowry's urban aesthetic. Michael Ayrton, protagonist of Neo-Romanticism in painting and criticism, was one of his most vociferous and outspoken critics.

In the 1950s, the reception of Lowry's work used to be put down to the fact that he was 'untutored' and 'unsophisticated', the implication being that Lowry's pictures appealed to those with an equally naive eye. But Lowry was not completely unschooled. As Mervyn Levy has pointed out, he was an art student for the best part of twenty years, achieving competence in both academic drawing and impressionistic painting. He accepted some aspects of what he had learned and quite consciously refused others.

In the 1960s, interpretations of Lowry's work shifted away from discussion of his forms and looked towards his content. For example, John Berger condemned the patronising tone of Kenneth Clark and others when they spoke of Lowry. He went on to argue that the real significance of Lowry was that he had to 'paint the historic'. According to Berger, Lowry's paintings were 'about what has been happening to the British economy since 1918, and their logic implies the collapse still to come'.

For Berger the pictures expressed stoicism in the face of continuing industrial decline. They reflected the vision of those who always voted Labour because they believed in an alternative plan – those who, in Berger's line of reasoning, had been let down first by Ramsay MacDonald and later by Harold Wilson. The *cognoscenti* of the art world were blind to all this because it was hard to reconcile 'a life devoted to aesthetic expositions with the streets and houses and front doors of those who live in Bury, Rochdale, Burnley or Salford'.

Despite the Great Crash of 1987, Berger's interpretation of Lowry seems implausible. Lowry was certainly one of the first artists in the twentieth century to paint the industrial scene, but he had little or no interest in the 'historic'.

'I think I must have been what they call a "cold fish",' Lowry remarked in old age. 'Even now, I usually prefer to be by myself. I didn't even notice there was a Great Slump. It didn't come into my curriculum. My mother died in 1939, and, I know it sounds ridiculous and sentimental to say so, but I've never felt much interest in life since then.'

For Lowry, such things as the 'historic', the 'economy' and 'alternative plans' were merely intrusions into what can best be described as his vision of 'The Golden Age of Industrial Squalor'. He was, according to those who knew him best, 'a staunch Tory' throughout his life – largely because he erroneously believed that the Tories would put up the strongest resistance to change of any kind, which he hated.

It has often, and rightly, been noted that almost all Lowry's industrial scenes – even those painted after the second world war – seem to belong to the 1920s. For Berger, Lowry's anachronisms were no more dated than 'certain English cities and towns'. They formed part of his social insight, his observation of desolation and his desire for change. But this was not how Lowry himself explained it. 'I was happiest in the twenties,' he said, 'and I don't see why I should take leave of them! Not in my painting at any rate.'

The truth about Lowry was more shocking than Berger

suggested. 'When I was young,' Lowry told Maurice Collis, 'I did not see the beauty of the Manchester streets. I used to go into the country painting landscapes and the like. Then one day I saw it. I was with a man in the city and he said, "Look, it is there." Suddenly I saw the beauty of the streets and crowds.'

Lowry told several versions of this story – some of them contradictory. But, like Ruskin's famous encounter with an aspen leaf, these anecdotes bear witness to a moment in his life when that which he had seen as being indifferent or ugly suddenly acquired an intense aesthetic and spiritual beauty. Only, for Lowry, this response was not directed towards the world of natural form. The industrial scene – with its crowds of fusing ant-like figures, half-seen, half-remembered, engulfed in blankets of milky white smog and snow – appeared to him to be transfigured and redeemed. He was at pains to stress that this discovery of beauty had little, or nothing, to do with perceptions of social or economic reality. He answered back sharply to those who attributed to him a sense of 'pity' for the people he depicted, denying that he had any such feelings for them. 'They are symbols of my mood,' he said. 'They are myself . . . Natural figures would have broken the spell of it, so I made them half unreal . . . Had I drawn them as they are, it would not have looked like a vision.'

The way in which Lowry wanted to use the mundane facts of the external world as symbols of a spiritual vision immediately relates him to a long tradition of English art. For example, Lowry has something in common with Constable, who must have seemed equally eccentric to his contemporaries when he tried to construct a vision of the divine in nature out of the 'green slime' of the banks of the Stour, and the tackle and trim of the barge-men's trade. The waning of the belief that nature was God's handiwork brought an end to this aesthetic possibility. We can see it falling into disarray in the work of the Pre-Raphaelites, one of Lowry's abiding obsessions. When he felt depressed, he would spend long hours brooding in front of the Pre-Raphaelite pictures in the Manchester Gallery. He

developed a taste for Ford Madox Brown and, especially, Rossetti, as Paul Nash had done. Even when Lowry became a wealthy man, he clung to the frugal, lower-middle-class habits of a lifetime, refusing to travel abroad, or to own a car or a telephone. He appeared to have but two indulgences. One was the fact that he used taxis, even for long-distance journeys. The other that he began to buy Victorian pictures, especially Rossetti's. By the time he died his house was stuffed full of the languorous women Rossetti referred to as 'stunners'.

Lowry seems to have recognised, intuitively, that the central problem for the Pre-Raphaelites was how to find beauty in the world, when you had glimpsed its fallen character. Lowry abandoned painting in the fields and among the hills even though he possessed, as Mervyn Levy said, 'a tenderness and an affection for nature' which could have led him to become a landscape artist. No one, in a psychological or spiritual sense, could have had a stronger conception of the Fall. Lowry found his own solution to the Pre-Raphaelite impasse when he experienced a revelation of aesthetic and spiritual 'beauty' where it might least have been expected.

The 'visionary' or 'poetic' quality of Lowry's painting was enhanced by his use of flake-white as a ground for the painting of murky industrial scenes – a device surely derived from the early Pre-Raphaelite paradisical landscapes. Lowry's rhythmical patterns of little men are like waves on the surface of what Kenneth Clark once called a 'milky pool'. Even smog becomes transfigured into something comforting, embracing, and swaddling. The return to Eden, for Lowry, is expressed not in the imagery of a garden, but rather through a transformed vision of the process which, in the nineteenth century, had seemed to be driving men and women out of paradise: the polluting effects of industrialisation.

Like all dreams of Eden, Lowry's vision seems to have been born, on the one hand, out of his intense and unremitting sense of loneliness and isolation, and on the other, out of some half-remembered dream of mergence with his mother. It is, perhaps, not too

ridiculous to glimpse in those incongruous milky backgrounds hints of that longed-for infantile fusion.

One of the many young women on whom Lowry doted his 'innocent' yet tortured adult affections once revealed that, after the war, the artist required her to buy tubes of flake-white for him because, he said, the woman in the art supply store had taken a dislike to him and would not let him have any. She also said, 'Mr Lowry was very fond of milk and enjoyed a warm glass before retiring at night.' She went on to describe how, when Lowry went on holiday with her, they persuaded two ageing landladies to heat up milk for him in the evenings, on the pretext that she needed it for her baby. 'We felt it quite a conspiracy putting one over on the little old ladies in this way.'

The strength of Lowry's vision, as expressed through his finest paintings of the 1930s and 1940s, seems to have had at least something to do with his capacity to rediscover this land flowing with milk and honey not in some estranged vision of utopia, but in the smoky heart of the city itself. The consolatory power of such beauty, which has little to do with the desire for social change, ensured Lowry's popularity among those usually untouched by the desire for aesthetic experience. Whether Lowry's works will continue to remain popular if, in reality, the Great Crash of 1987 gave rise to a Great Slump is, of course, another matter.

Enjoyment of the 'beauty' of industrial decay depends – as Lowry was aware, even if Berger was not – upon our capacity to regard it as somehow unconnected with social and economic reality. Lowry's greatest popularity, after the second world war, was among those who neither knew, nor wanted to know, what industrial recession was 'really' like. In Lowry's later work his vision failed him. He never really recovered from the emotional effects of his mother's death. The bleak perspectives of the *Man with Red Eyes* took over, tempered only with a wry and sometimes almost cruel sense of ironic detachment. Lowry became obsessed with the odd, the eccentric, the crippled and the lonely, glimpsed now in an isolation from which there was

no escape. He began to caricature that state in which he had previously sought, and found, a degree of aesthetic redemption. Personally, I find these later works weaker than the great pictures of the 1930s and 1940s, but I would not be surprised if, in a more 'realistic' climate, they underwent a critical revaluation.

1987

St Ives

I was not really aware of St Ives as a place of importance in the history of British taste until, as an undergraduate at Cambridge in the late 1960s, I started to visit Kettle's Yard, which, at that time, was still very much Jim Ede's private home. Jim was not, himself, a St Ives person, but his house quietly celebrated the sort of subtle pleasures – well-washed pebbles, scrubbed driftwood, white limestone and gentle pictorial illusions – which St Ives, at its best, had embodied. Kettle's Yard also contained rows and rows of Alfred Wallis's Cornish sea-scapes stacked up against the walls like crates of fish on the quay-side. Jim would loan these to undergraduates.

No sooner had I gone down from Cambridge than I forgot about this gentle whiff of a modern sea breeze emanating from the West country. Most of us who were interested in art forgot too. We were far more concerned about the merits, or demerits, of, say, Morris Louis's stained, stripe paintings, and we didn't believe that what came out of buckets of acrylic in Washington had anything to do with distant events in a remote English fishing town. The stripes and stars began to slide from my eyes after I heard a cry from the Eagle's Nest, by which, I refer not to Ruskin's book of that name, but rather to the Cornish house from which Patrick Heron sent a long article to the *Guardian*, which was published in three instalments in 1974. Heron argued that American painting of the 1960s and 1970s was only understandable if it was seen in conjunction with British painting as it existed by the year 1960. He showed how American post-painterly abstraction of the 1960s was deeply indebted to St Ives.

Although, on most subjects, I take a different aesthetic

position from Heron, I share his concern about historical truth.
His text was one of the most revealing art-critical essays of the
last decade, and yet it has been insufficiently studied and
digested on either side of the Atlantic. Where, one wonders, is
the considered response from an American critic or art his-
torian? After all, chaps, you've had more than eleven years
now. When Heron's article first appeared, the dogma of 'The
Triumph of American Painting' was still so widespread that his
arguments were met with a thunderous silence. Today, how-
ever, who really believes that there was anything so very special
about the American 'achievement' in painting after 1958? We
are witnessing a healthy renewal of interest in, and appreciation
of, the best aspects of British taste, tradition, and sensibility, as
these things existed before becoming defiled by imported
Made-in-USA anaesthesia . This is what made the Tate's 1985
exhibition, *St Ives, 1939–64*, such an exciting experience. St Ives
is a remote coastal town on the south-western extremity of the
British Isles which economic stagnation and geographical
isolation preserved – as we cultural conservationists like to put
it – 'unspoiled'. In other words, St Ives escaped some of the
most destructive and intrusive aspects of modern industrial,
commercial, and architectural 'progress.'

Achievement in art almost always involves an element of
refusal of modernity. Even in the nineteenth century, artists like
Whistler and Sickert saw the attractions of St Ives, and by the
late 1880s, a gallery and arts club had opened there. Later,
traditional British landscape painters, like Borlase Smart and
John Park, established themselves in the town. And in 1920,
Bernard Leach set up his pottery in St Ives, thus making it the
mecca for his magnificent hand-thrown protest against the
dehumanisation of modern technological processes.

One day in 1928, Ben Nicholson and Christopher Wood were
walking back from Porthmeor Beach when they chanced upon
the 'studio' of Alfred Wallis, a retired fisherman. Wallis painted
on flotsam and jetsam of wood and cardboard, in a limited
range of household and ships' paints [*see plate 14a*]. Eleven

years later, with the war clouds gathering over Europe, Nicholson and his wife, Barbara Hepworth, and their triplets, moved in with Adrian Stokes at his cottage in nearby Carbis Bay. They were joined soon after by Naum Gabo, the Russian Constructivist.

After the war, other artists poured in to the area, among them John Wells, Bryan Wynter, Sven Berlin, and Denis Mitchell. Some, like the painter Peter Lanyon, had grown up in St Ives. The artistic community thus embraced a range of aesthetic positions from traditional and academic painters, to Primitives, Romantics, Constructivists, and those struggling seriously, like Lanyon, to find a new kind of symbolism in natural forms. Nonetheless, all these artists were, in a sense, united, for as Peter Davies put it in a moment of rare perception, their work invariably involved them (even when they were barely aware of it) in 'a particular response to the distinctive, irresistible, local landscape'. This was even true of Gabo and Hepworth, whose abstract forms evoked the morphology of waves and hills.

It was, perhaps, inevitable that tensions would erupt – and in 1949, the Modernists broke away from the St Ives Society and set up their own group, the Penwith, under the presidency of Herbert Read. With a characteristically British sense of compromise this new organisation – perhaps following the lead of the British Psycho-Analytic Society – divided itself formally into three sections, each with its own jury of selectors. A was for figurative, B for non-figurative, and C for crafts. Predictably, the centre did not hold. As David Lewis has put it: 'Peter [Lanyon] felt strongly that the B section was not only dominant but that Ben [Nicholson] and Barbara [Hepworth] were manipulating the Penwith to promote their own direction. Sven [Berlin] felt that romantic work of his kind in sculpture and painting could never get a proper evaluation from either an A jury that had a figurative bias and [*sic*] a B jury that had a hard-edge bias: and Peter was upset at Sven for writing a book about Alfred Wallis when Wallis was a Cornish man and Sven wasn't. Meetings became stormy and humour became cutting.'

Lanyon resigned from the Penwith, but soon after, Hepworth and Nicholson became personally estranged, and the aesthetic position for which they had fought together was weakened. In any event, a new generation of Abstractionists – including Terry Frost, Bryan Wynter and Patrick Heron – was becoming increasingly prominent within the society. Lanyon was friendly with this younger grouping and sympathetic towards at least some of their artistic aims, although he never lost faith in the idea of an aesthetic rooted in natural form. Lanyon was also developing a reputation in New York. He got to know Mark Rothko well and brought the American over to St Ives in 1958. Patrick Heron, too, helped strengthen St Ives's transatlantic links. Up until 1958, Heron practised as a critic, writing extensively on the British response to New York painting, often for American magazines. His American editors were not much interested in articles about developments in British painting. Meanwhile, under Heron's auspices, American painters and critics – including Helen Frankenthaler, Jack Bush, Hilton Kramer and Clement Greenberg – beat a path to St Ives. They looked, but they tended to keep very quiet about what they had seen going onto English canvases, when they got back home.

No one who has studied Heron's evidence could doubt that through their contact with the British, the Americans picked up many technical and formal innovations. In particular, they plagiarised various devices – including rows of stripes – for re-complicating the picture surface. Now all this may sound, to some, like the thin tittle-tattle of academic art history. But the experiments, battles, shifting alliances and international cross-currents which splashed across and within the Penwith art community were, I think, rather more important than that. Unwittingly, St Ives became a crucible in which so many of the significant issues affecting the fine arts in the post-second world war period were tried and tested.

The history of painting in St Ives could not be written without discussing the conflict between traditional and modern painting; the opposition of nature and mechanism; primitivism; naturalism versus abstraction; the role of the decorative; Fine

Art versus craft; regionalism versus internationalism, and the impact on indigenous cultures of America's overweening cultural expansionism. What may have sometimes seemed to be nothing more than petty squabbles were often, in fact, attempts to resolve issues which remain unresolved for us, years later.

In particular, I believe Lanyon was right to leave the Penwith when he did. Lanyon was often right, and the Tate show revealed him as a painter of exceptional stature. His work was not especially well presented, but it manifested a depth, strength and character lacking in, say, the repetitive out-pourings of Wynter and Frost. [*See plate 14b.*]

Lanyon was one of the last major British artists to attempt a *Higher* Landscape painting. That is, to engage the pathetic fallacy and produce pictures rooted in the imaginative transfor-mation of the perception of nature; pictures which are capable of expressing deep human sentiments. Lanyon's experiences when gliding – both affective and visual – helped him to reach ever more complex and original pictorial equivalents for these sentiments. His work can, perhaps, be compared with the pictures Sidney Nolan produced after flying over the Australian desert. Lanyon depicts a nature which seems in danger of disappearing from him – and us – into a void of meaningless sensation, but it is still a nature out of which he can, if only just, extract a compelling sense of aesthetic order and consoling harmony. We need not be surprised if Lanyon, the figurative painter of the vanishing field, found a soul mate in Rothko, the great abstract painter of the absent figure. Both were struggling for that 'Higher Symbolism' in painting, and both, in different ways, were aware of its virtual impossibility – of the risk of losing everything, including themselves, in the void of sensa-tion and 'pure' abstraction.

The generation that followed Lanyon in St Ives took the much easier route of accepting this 'impossibility'. Instead of the quest for a Higher Painting, they produced pictures which purported to rely on visual sensation alone. They set out in search of an art which, in Ruskin's terms, was one of pure *aesthesis* rather than

theoria. In the 1950s, Heron successfully elaborated a critical practice – 'as descriptive of the visual facts as we can make it' – and a manner of painting which he believed to be based on precisely such a 'pure' aesthetic of sensation. Before he encountered Heron's work, Greenberg had already moved some way towards this aesthetic, but, awkwardly for him, he was stuck with the symbolist tendencies of the great generation of Abstract Expressionists. Greenberg criticised Pollock himself for his Gothickness, and aspiration to symbolism. He largely ignored the achievement of Rothko, who denied he had any interest in abstract forms or colour harmonies, except as vehicles for the expression of deep emotion.

Heron once described to me his first meeting with the ambitious and immature Clement Greenberg. He was struck by just how thoroughly Greenberg seemed to know even the exact phrasing of Heron's articles. I am convinced that the essays Heron eventually collected in *The Changing Forms of Art*, of 1955, were a significant influence on Greenberg's development. They showed the American the extreme to which an aesthetic of pure 'aesthesis' could be pushed. Greenberg successfully transported these ideas back to America. There the superficiality of the new aesthetic, its reliance on visual sensation divorced from natural form, spiritual values or, come to that, any deeply rooted sense of cultural tradition, was a positive advantage. In the thin and ugly climate of modern American 'cultural' life, this art of mere sensation flourished as it could never hope to do in the English countryside.

There are many ironies in this situation which only much longer investigations than this may hope to unravel. Suffice to say that despite what he wrote, Heron was, in practice, an artist who aspired beyond the exploration of merely visual effects. His best pictures are informed by intentions much closer to those of Lanyon or Rothko than he himself is prepared to admit. Heron has, at times, hinted that even his most abstract works may indeed contain residues of natural form derived, for example, from his experience of nature around Eagle's Nest.

This opens up the question of an underlying 'pathetic fallacy', or at least an unacknowledged symbolism of colour and form, informing and enriching his whole project as a painter.

Personally, I do not believe in the possibility of articulating 'purely visual' forms or colours, stripped of all symbolic resonances. Neither do I think the pursuit of this unattainable goal is likely to prove a fruitful path in aesthetic theory or painting itself. Charles Rycroft, the psychoanalyst, has written perceptively of the 'capacity of the mind to endow all its perceptions with additional symbolic meanings'. He has argued that although it would be rational to be immune to the pathetic fallacy and to perceive scenery as only geological formations, buildings as only bricks and mortar, paintings as only pigments on a canvas, 'something important is lost if one cannot react to them in terms of the symbolism and metaphor that can be read into them – and that in the case of artefacts such as paintings has in fact been written into them'.

Repression, whether psychologically or socially determined, impoverishes appreciation of the sensory world by reducing the symbolic resonances and meanings that can be read into sensations. Art, if it is any good, affirms, increases, celebrates and intensifies such resonance. In David Bomberg's phrase, it pursues 'the spirit in the mass', of rocks, flesh or pigment. Heron fails as a critic of painting because he does not understand this, and his critical failure was exported and writ large in American post-painterly practice. In New York there was no redeeming residue of the pathetic fallacy, nothing to thicken the thin vibrations emitted by a Louis, Noland or Olitski. Tragically, this virtually anaesthetic painting was watered down still further and re-imported into Britain, where it spread like a virus through the trashy 'pigment-on-a-canvas' painting of artists such as Gouk, Abercrombie, McLean and Rigden. Happily, all that may now be history.

1985

Winifred Nicholson

Winifred Nicholson painted *Mughetti*, the earliest picture in her 1987 Tate Gallery exhibition, in about 1922. (She was never very precise about dates.) She was almost thirty years old, and she regarded it as her first mature work. 'Mughetti' is the Italian for lily of the valley, and the painting shows a pot of the flowers given to her by her husband, Ben Nicholson, enveloped in a white tissue-paper wrapper which, she wrote later, 'held the secret of the universe'. The flowers are standing on a window-sill. The blue in the background is the Lake of Lugano, or rather, lake, sky and mountain fused together.

The picture, according to Winifred, painted itself, 'and after that the same theme painted itself on that window-sill, in cyclamen, primula, or cineraria – sunlight on leaves, and sunlight shining transparent through lens and through the mystery of tissue-paper' [*see plate 7b*]. When Winifred's marriage to Ben Nicholson broke down, she wrote to him that the idea of marriage she had when they married had been expressed in *Mughetti*. 'I remember thinking of it while I painted. Love and the secret lovely things that it unfolds.'

From the early 1920s until the end of her long life in 1981, Winifred Nicholson worked with remarkable consistency. The pictures she produced in the months before her death remained among the most impressive of all, none more so than *Eigg, Candle* (1980). This haunting painting shows a candle burning on the window-sill in a cottage on a dark day. The window creates a frame of iridescent light at the centre of the canvas, almost like a gateway leading into some unseen world. Her last picture was, in fact, *The Gate to the Isles* (1980) – an image of a swinging picket-gate opening onto a shimmering

vista, which may have been intended to suggest the legendary Isles of the Blest.

Winifred Nicholson was born Rosa Winifred Roberts in 1893; her grandfather was George Howard, Earl of Carlisle, an associate of many of the Pre-Raphaelite painters. Winifred's mother, Lady Cecilia, was a painter of water-colours, her father an Under-Secretary of State for India in Asquith's Liberal Government. Winifred grew up in the fading world of the English upper classes. She studied at the Byam Shaw School of Art, and began exhibiting at the Royal Academy Summer Exhibition.

In 1920 she met Ben Nicholson and they were married later that year. In the early years of their life together the couple spent their winters in Villa Capriccio at Castagnola and their summers in London. As they travelled to and fro, they stopped in Paris, becoming deeply involved in the activities of the Modern movement. The Bombergs once visited them in Switzerland, but the trip proved a disaster. Their contacts with Paul and Margaret Nash, and Ivon Hitchens, were more successful. In 1925, Winifred began her association with the 7 and 5 Society. But of all the painters of her generation, she was especially close, in both a personal and an aesthetic sense, to Christopher Wood.

By the late 1920s, Winifred's work had begun to receive some recognition, but in 1930 Christopher Wood died, and the following year Ben Nicholson left Winifred, after the birth of their third child, and went to live with Barbara Hepworth. Winifred took the children to a rented house on the Isle of Wight, where she painted pictures of a quivering and melancholic poignancy, like *Berries in Sea Window, Night*, of 1932. 'I like your idea of our new relationship,' she wrote about this time to Ben, 'clear and true, in complete freedom and unexclusiveness, no sense of the divisions of people. I see it clear in the high skies – I feel it clear in the subconscious spaces where all picture ideas, all vision comes from.' But, she added, 'How it works on earth I do not see.'

In fact, it did work. The couple retained their respect and affection for each other until the ends of their lives. When Ben left Hepworth, Winifred, always his confidante and adviser, wrote to him, 'my experience is that the living part of any human experience, the love in it, never dies, and never ends, even if it can't flower; all that goes is something that is not worth keeping, something that is part of human change and flow'. (An edited selection from the letters they exchanged after they were no longer a couple forms one of the most moving parts of *Unknown Colour*, an anthology of work by Winifred Nicholson which was published to coincide with the Tate Gallery retrospective.)

But how are we to assess Winifred Nicholson's work as a painter? John Ruskin once bemoaned the fact that no modern English painter, not even his beloved Turner, seemed able to paint flowers any more. For Ruskin, those who looked to flowers simply for decoration, or for botanical research, were to blame. He recalled the 'entire, exquisite, and humble realization' of the early Italian painters. 'The rose, the myrtle, and the lily,' he wrote, 'the olive and orange, pomegranate and vine, have received their fairest portraiture where they bear a sacred character.'

I do not know if Winifred Nicholson's grandfather ever drew her attention to Ruskin's views on flowers and painting, but if the good Earl had done so, I suspect she would have understood at once. 'Flowers,' she once wrote, 'mean different things to different people – to some they are trophies to decorate their dwellings (for this plastic flowers will do as well as real ones) – to some they are buttonholes for their conceits – to botanists they are species and tabulated categories – to bees of course they are honey – to me they are the secret of the cosmos.'

Winifred Nicholson took her faith in Christian Science and the teachings of Mary Baker Eddy as seriously as Kandinsky took his beliefs in theosophy and Madame Blavatsky. Like Kandinsky, and indeed like Ruskin or like Mondrian, whom she knew well, she wanted to see beyond the veil of

appearances into the spiritual essences of forms and things. But for Nicholson, it was never a matter of the eye or the intellect on their own. The literal symbolism of the flowers she depicted was important to her. For example, she herself wrote of *Mughetti*, 'Without a name it is the beginning of heaven and earth. With a name it is mother of all things.' Colour was always the means which she hoped would carry her beyond the mundane barrier of mere appearance. She became fascinated by unknown colour, those hues which lay just beyond the range of the visible spectrum. She seems almost to have believed that if she could find a way of realising them in paint, then she could reveal the presence of God in the world.

At the Tate, Winifred Nicholson's exhibition was held simultaneously with the Mark Rothko retrospective. Winifred Nicholson was undoubtedly not such a 'great' painter as Rothko, but her lack of a sense of self-importance gave her strengths which he did not possess. She once told her friend, Kathleen Raine, the poetess, that she felt she had never painted a 'masterpiece'. Such a thing would have been quite alien to her. Nicholson's sense of the spiritual was at once more English, more resolutely plastic, and more immediately bound up with particular and common-or-garden things: a pot of irises, a burnished jug, a flock of birds, sunlight on a wall, the expression in 'Kit' Wood's face, or her children's party hats. Perhaps if Rothko had suffered less from a need to create masterpieces and had shared Winifred Nicholson's love of the blooms of particular things, he would have drawn even closer to the expression of those fundamental truths which preoccupied them both.

1987

David Bomberg

Of all twentieth-century British painters David Bomberg remains among the most difficult to assess. These days, he is sometimes freely described as the greatest British artist of this century – a once neglected genius, who is, at last, receiving his due. Others see him as an interesting, if inconsequential, *petit maître*, a man whose influence was greater as a pedagogue than as a painter, and whose significance remains parochial.

The Tate Gallery's comprehensive 1988 retrospective, organised by Richard Cork, author of a monograph on Bomberg's life and work, provided a welcome opportunity for a fresh evaluation. The selection was made from the whole range of Bomberg's achievement. [*See plate 15b.*] It ranged from his days as an accomplished Slade draughtsman, evident in his pencil study of a *Head of a girl*, of 1911; through his short-lived association with Vorticism; into the 'topographic' pictures of Palestine and Toledo; the second world war studies of an underground bomb store; then the dense pictures of the rocks of Ronda, the burning landscape of Cyprus, and the forceful charcoal drawings of St Paul's and Chartres, stamped by his legendary quest for 'the spirit in the mass'. It ended with that extraordinary, and harrowing, series of pictures created as his life limped towards its tragic close in 1957 -- depicting Ronda again, and also himself.

What can be concluded from this, the most comprehensive showing of Bomberg's work ever held? First, that the accepted narrative of Bomberg's development is inadequate. Again and again, we have been told (on occasions, by the present writer), that Bomberg began his professional career as a Vorticist and a Modernist who celebrated the machine age; that the first world

war led to his disillusionment; that he passed through a period of confusion, when he endeavoured only to reproduce the appearance of things; and that he arrived finally at a painterly vitalism which developed into an Expressionist style in his later years.

But the most immediately striking thing about this exhibition was its unity in diversity, for, despite all the changes of Bomberg's stylistic clothes, there was an underlying continuity running through the show. Such a continuity of sensibility may not be of a kind which immediately suggests itself to art historians, used to the analysis of stylistic devices, but it is present in both the precocious Slade *Self-portrait* of 1909, and in the shimmering magnificence of *Evening light, Ronda*, of 1956, a drawing which Bomberg produced the year before his death.

Although Bomberg explored many avenues, there was something unswerving and uncompromising about the way in which he did so. He always knew where he wanted to go. Take that strange picture, *Island of joy*, and the stranger *Vision of Ezekiel*, with its accompanying studies, all of which were produced around 1912. These works have frequently been interpreted as Bomberg's first excursions into a mechanical and Modernist vision, yet their subject matter is profoundly un-Modern. The comparison with, say, Stanley Spencer's scenes of resurrection is self-evident. Bomberg appears to have resorted to an abstraction of form not in order to stake his claim to 'progress' and Modernity, but in the hope of intensifying his eschatological, even biblical, motifs.

Modernity, it might be said, thwarted him by hijacking such forms for its own, very different, ends. This, I think, provides the clue to the paintings of Bomberg's middle period, which have so often seemed problematic. These pictures have been seen as a 'reactionary' attempt to pin down appearances like so many butterflies. But the group of such works at the Tate – and Cork undoubtedly chose well – displayed a quivering power which had little to do with tame, Slade empiricism. They confirm that Bomberg reacted to the failure of Vorticism by reverting to a full-blown Pre-Raphaelite aesthetic.

It is a tragedy that *Mount of Olives*, of 1923, was destroyed by fire and is now known only through photographs, for Cork rightly compares this lost masterpiece of Bomberg's middle period with Thomas Seddon's *Jerusalem and the valley of Jehoshaphat*, painted in 1854. Seddon was a landscape painter influenced by the Pre-Raphaelites, who accompanied Holman Hunt on his trip to the Holy Land. An important black chalk study for *Mount of Olives*, and enough of Bomberg's finished pictures from Palestine and Toledo – including the outstanding *Toledo from the Alcazar* – were included at the Tate to confirm the nature of Bomberg's project at this time.

The spectre which haunts Bomberg's middle phase is that of Ruskin. Many of Bomberg's preoccupations – including rocks, cathedrals and flowers, or even his reluctance when confronted with the human body – were uncannily Ruskinian. At this time, Bomberg seems to have hoped that scrutiny of the appearance of things, if carried out with a relentless and unremitting intensity, would reveal their spiritual essence. Indeed, his trip to the Holy Land seems to have been motivated by similar impulses to those which drove so many nineteenth-century British painters to that parched, injured and yet resonant terrain. Bomberg hoped that, there at least, he would be able to find traces of the divine in the rocks and sands – that he might, in Palestine of all places, stumble upon the key which would enable him to paint pictures which, though rooted in the impressions of the senses, would reach beyond them to give material expression to a transcendent reality. In one sense he failed, as the Pre-Raphaelites had failed before him. The mark of his failure is that so many regard these pictures as simply 'topographic' in their intentions, even today. But, in his relentless way, Bomberg recognised this. In the late 1930s, he began to find a solution to his quest for the transcendent which involved neither the formalisation and abstraction of his earlier work, nor that fidelity to the outer appearance of things so characteristic of his work in the 1920s.

Certainly, Bomberg was influenced by Cézanne; not Cézanne

as the 'Father of Modern Art', but Cézanne as a painter who
believed in a natural theology of sorts. Cézanne provided the
sign-post which pointed Bomberg back beyond Pre-
Raphaelitism, to retrieve an aesthetic which – though more
modest in its scale and restricted in its means – bears compari-
son with that of Turner. This proximity between Bomberg and
Turner is immediately visible in an important transitional work,
Picos De Europa, Asturias of 1935, which was included in Gillian
Jason's outstanding exhibition of Bomberg's works on paper,
held at the same time as the Tate retrospective. The relationship
was even more obvious in *Sea, sunshine and rain* of 1947, shown
at the Tate.

At the core of Bomberg's thinking was an idea derived from
George Berkeley, Bishop of Cloyne, which amounted to the
belief that 'gravitational forces' somehow bore witness to the
existence of God. In this most mundane and physical of
phenomena – the force of gravity – we find the very evidence we
are seeking for the existence of the transcendent. Bomberg's
'Spirit in the Mass' was, in other words, close to Turner's 'Angel
in the Sun' – 'the indefinable in the definable', as Bomberg once
put it. And it was this strange philosophy, quite alien to the
concerns of the modern world, which Bomberg made the core of
his pedagogy and his practice as a painter in the later years of his
life. Nowhere did these ideas find more convincing plastic
expression than in Bomberg's studies of an underground bomb
store, during the second world war. Here the potentially
explosive subject matter seemed to give added credibility to
Bomberg's pursuit of dynamic structure rather than superficial
appearance.

It is, of course, absurd to enquire as to the 'truth' or otherwise
of Bomberg's doctrine of a quest for 'the spirit in the mass'. In
aesthetic terms – like the theosophy of Mondrian and
Kandinsky, or the Christian Science of Winifred Nicholson –
this was an enabling belief. Bomberg and his most talented
followers were able to develop an aesthetic stance which
evaded the limitations of abstraction, with which Bomberg had

experimented in his youth; or empiricism, in which he had come close to being trapped in his middle years. It was his unremitting emphasis on the necessity, but insufficiency, of the eye – he was a seer in every sense of the term – that ensured his escape from the solipsism of an Expressionism rooted solely in the angst of the individual psyche.

The measure of his success is to be seen in the remarkable group of drawings and paintings he produced in the final years of his life, after his troubled return to Ronda. In pictures like *Hear O Israel*, and *Last Self-Portrait*, Bomberg seems literally to be painting his own self-effacement. Yet this loss of self is synonymous with a new and terrible sense of the sublime; of unity with the world of nature, manifest in such rock drawings as *Ronda bridge, the Tajo*, or the mysterious, luminous clouds of the Turneresque drawings – especially, perhaps, *La Casa de la Virgen de la Cabeza*. This late group finds the forms for a more compelling 'Vision of Ezekiel' than Bomberg was able to attain through the abstractions of his youth.

Spread out at the Tate, Bomberg's life's work confronted us with a talent greater than his detractors are prepared to allow. But that talent was not, perhaps, as singular as Bomberg and his followers liked to imply. Bomberg himself insisted upon his uniqueness, demanding that his art be seen and his ideas heard, as phenomena unrelated to any other. However, the dilemmas which he faced were those of the Romantic artist living in the twentieth century, and before we can justly assess him, we need to return him to the mainstream of the continuing Romantic tradition. For Bomberg's incessant questing for 'the spirit in the mass', his concern with structure rather than surface, certainly led him to plastic and formal solutions which evaded the illustrative superficiality which was the bane of so much English Neo-Romanticism. But there was also something ultimately confining about his aesthetic temperament. I left the Tate wondering what Bomberg thought about the rich archetypal resonance of Moore, the graceful facility of Sutherland, the idyllic vision of the late Nash, the malignant

grandeur of Bacon's figuration, or the Gothic generosity of Piper. In his pedagogy and his writings, Bomberg seems to have said nothing about such things. Presumably, he came to regard all such qualities as expendable in the relentless search for the spirit in the mass. His art was undoubtedly compelling and his teaching charismatic; but they were of such a kind that one feels almost duty bound to protest that Bomberg possessed no monopoly over these aesthetic means through which the 'spirit' is revealed.

1988

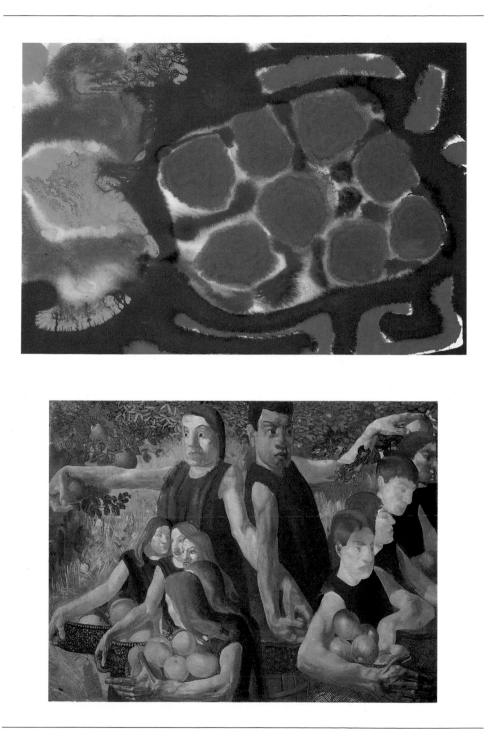

9a Patrick Heron, *December 4 1983: II*, 1983
9b Stanley Spencer, *Apple Gatherers*, 1912–13

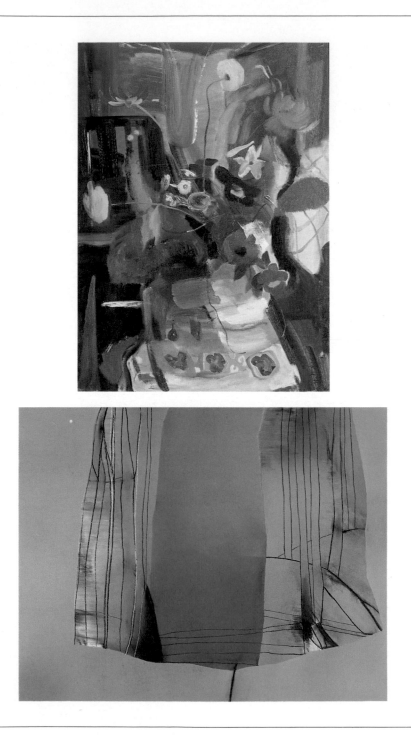

10a Ivon Hitchens, *Flower Group*, 1943
10b David Blackburn, *A Mystical View of the Sea*, 1988

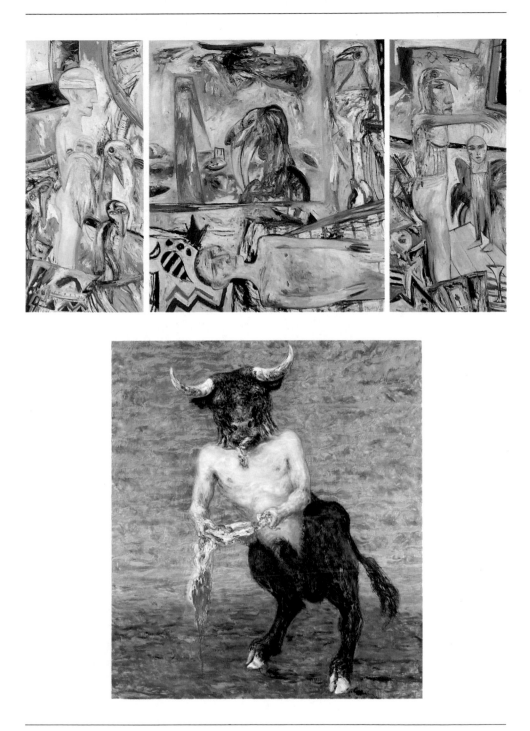

11a John Bellany, *The Storm* (triptych), 1991
11b Maggi Hambling, *Minotaur Surprised while Eating*, 1986–87

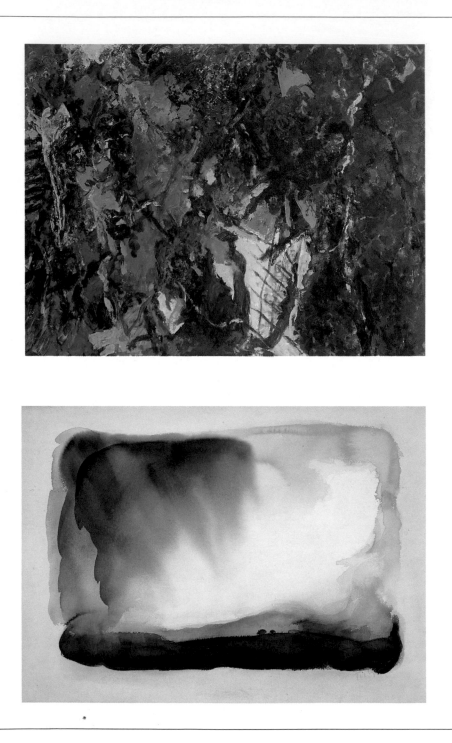

12a John Hubbard, *Sub-Tropical Garden*, 1987
12b William Tillyer, *The North York moors, falling sky*, 1985

Nature and Raw Flesh:
Sutherland v. Bacon

'Graham Sutherland is the most distinguished and the most original English artist of the mid-twentieth century.' With these words, Douglas Cooper opened his 1961 monograph, in which he concluded that Sutherland was recognised in European artistic circles as the only significant English painter since Constable and Turner. Cooper certainly intended to imply Sutherland's superiority to Francis Bacon, but Sutherland's critical reputation was already on the wane and Bacon's was still rising. At the time of Bacon's second retrospective at the Tate Gallery in 1985, Alan Bowness, the Director, wrote, 'His own work sets the standard for our time, for he is surely the greatest living painter; no artist in this century has presented the human predicament with such insight and feeling.' But how just is the contemporary evaluation of the relative achievements of Britain's two major post-second world war painters?

For a time, Sutherland and Bacon were friends, and, in the 1950s, shared more than a taste for roulette. They had a direct influence on each other, and their work has much in common. Both artists refer constantly to a vanished tradition of European painting, for which religious symbolism and belief were of central importance. The work of both men is eccentric to Modernist concerns; their subjects are landscapes, animals, portraits, and crucifixions. Although their imaginations constantly seem to touch upon each other's, they also diverged widely. It isn't simply that Sutherland was a 'nature' painter, whose principal subject was landscape, whereas Bacon is, first and foremost, a painter of the human figure. Sutherland's paintings are haunted by a yearning for spiritual redemption, and he is the last serious artist who has practised an aesthetic rooted in natural theology.

As John Hayes has written, 'For Sutherland, landscape, and all its elements, bears the impress of the divine creation, of which he seeks to catch a reflection.' Indeed, no painter this century seems closer to the sensibility of Ruskin, who once wrote, 'the Great Spirit of nature is as deep and unapproachable in the lowest as in the noblest objects'. In Pembrokeshire in the 1930s (and again in the 1970s), Sutherland studied 'sea-eroded rocks', and noted how precisely they reproduced in miniature 'forms of the inland hills'. For Sutherland, as for Ruskin, 'the Divine mind is as visible in its full energy of operation on every lowly bank and mouldering stone, as in the lifting of the pillars of heaven, and settling the foundations of the earth'. But Bacon acknowledges only sense and sensation, and can affirm no more than a mundane sense of damnation.

Graham Sutherland was born in 1903. After a false start as an engineer, he trained as an etcher at Goldsmiths College, and converted to Catholicism in 1927. Throughout the 1920s he was greatly influenced by Samuel Palmer. 'It seemed to me wonderful,' he wrote later, 'that a strong emotion, such as was Palmer's, could change and transform the appearance of things.' Sutherland's earliest etchings were idyllic images of rural England – unfashionably 'overbitten' in technique. In *Pastoral*, of 1930, Sutherland's imagery began to change. A note of menace became apparent in his twisted root and branch forms, but he gave up etching a few years later. He made a living as a designer and commercial artist, and then in 1934, visited Pembrokeshire, where, in his words, he began to learn painting. He immediately responded to 'the exultant strangeness' of the place, which, despite its 'magical and transforming' light possessed 'an element of disquiet'. It was, he wrote, 'no uncommon sight to see a horse's skull or horns of cattle lying bleached on the sand'. He noted, too, 'the twisted gorse on the cliff edge . . . twigs, like snakes, lying on the path, the bare rock, worn, and showing through the path, heath fires, gorse burnt and blackened after fire' and 'mantling clouds against a black sky'.

In one sense Sutherland remained faithful to what he had seen in Palmer: he continued to transform appearances with powerful emotions, but Pembrokeshire encouraged him to develop the twisted imagery hinted at in his last etchings. In pictures like the ominous *Gorse on Sea Wall* of 1939, Sutherland revealed a rocky, spiky, and even hostile Nature, a fallen world, rather than a garden created by God, for man. This feeling was only heightened by the onset of war. Sutherland became an official War Artist in 1940. He drew first in the East End of London and around St Paul's, making compelling images of damage and devastation, for example, of burnt-out paper rolls in a warehouse. Later, he produced infernal drawings of men at work in a steel furnace and in the womb-like caverns of the Cornish tin-mines. In France he drew caves with, as he put it, 'a terrible sweet smell of death in them'. The war enabled Sutherland to incorporate images of mechanical destruction into his ominous vision. But paintings like the Tate's *Black Landscape* of 1939–40 [*see plate 8a*] and Southampton Art Gallery's fiery *Red Landscape*, of 1942, underline the imaginative continuity between his response to an injured and injurious nature, and his war work.

In 1944, Canon Walter Hussey invited Sutherland to undertake an 'Agony in the Garden' for his church, St Matthew's, in Northampton. But Sutherland had set his mind on another religious subject. Although he had never seen the concentration camps, he received a black-covered American Central Office of Information book containing photographs of Belsen, Auschwitz and Buchenwald. As a result, the idea of the depiction of Christ crucified became more real to him. As he put it, 'it seemed possible to do this subject again'. In 1945, while brooding on his crucifixion, Sutherland started to draw thorn bushes, attending intently to their structure as they pierced the air. As he did this, 'The thorns rearranged themselves, they became, whilst still retaining their own pricking, space-encompassing life, something else – a kind of stand-in for a Crucifixion and a crucified head.'

Sutherland's fine paintings, like *Thorn Tree* of 1945–6, were, in

effect, preparations for a crucifixion. In 1946, he tied himself up with ropes on a make-shift, packing-case cross, and sketched his reflection in a mirror. After months of experiment, he returned to his original conception of a tortured, symmetrical rendering of a Christ distanced from us by a small tubular railing round his feet – to emphasise the dreadful otherness of the event depicted. Sutherland wrote later that the Crucifixion interested him because 'It is the most tragic of all themes yet inherent in it is the promise of salvation.'

In the spring of 1945, Sutherland contributed to an exhibition at the Lefevre Gallery which included Bacon's *Three Studies for Figures at the Base of a Crucifixion*. Bacon, the son of a Dublin race-horse trainer, was six years younger than Sutherland. He had left home early after an incident in which he was discovered wearing his mother's clothes. He had no formal training in art, but began painting in the 1920s – without success. He worked as an interior designer, which may explain the hints of tubular, Bauhaus furniture which recur, often as a sort of space-frame, in much of his later work. Although Herbert Read reproduced a Bacon *Crucifixion* in his book, *Art Now*, Bacon destroyed almost all his early painting. *Three Studies* was his first mature painting, and it prefigured many of the characteristics of his later work. These included the use of extreme anatomical and physiognomic distortion as the principal means of expression; a general tenor of violence and relentless physicality; and iconographic and formal allusions – through reference to the Crucifixion, and the triptych format – to an abandoned tradition of Christian religious painting.

The *Three Studies* was followed by a *Figure in a Landscape*, 1945, but Bacon soon moved his mutilated creatures indoors where they have tended to remain. In the late 1940s came a series of macabre, isolated heads which reflected an obsession with the mouth and teeth. These merged with a series of screaming popes, based on Velasquez's portrait of Innocent X. Further studies of caged animals, enclosed figures, and grinning popes in front of carcasses of beef followed. Many of these indicate

Bacon's preoccupation with the incidents and accidents of photography. *Two Figures*, 1953, depicted a violent act of buggery, and declared Bacon's predilection for sadistic, homosexual imagery. Towards the end of the 1950s, his palette briefly lightened: the studies he made for a portrait of Van Gogh even contain suggestions of borrowed sunlight. But the 1960s saw his return to more characteristic themes and moods.

Three Studies for a Crucifixion, 1962, is a massive triptych in virulent reds, oranges, purples and blacks. Characteristically, the centre panel displays a naked and bleeding figure splayed upon a bed, while the right-hand panel illustrates Bacon's view that Cimabue's great *Crucifixion* is no more than an image of 'a worm crawling down the cross'. Bacon insists, however, that his interest in the subject has nothing to do with its symbolic resonances – least of all with any hint of salvation. The explanations he gives for his involvement with the Crucifixion have always been formal: 'The central figure of Christ is raised into a very pronounced and isolated position, which gives it, from a formal point of view, greater possibilities than having all the different figures placed on the same level.'

After the second world war, it seemed, briefly, that Sutherland's painting was about to assume a central role in the nation's cultural life. In 1950, Sutherland was commissioned to paint a massive mural for the 'Land of Britain' pavilion at the Festival of Britain. He conceived of *The Origins of the Land* on the scale of a cliff-face, suggesting geological strata, and incorporating a pterodactyl. Sutherland represented Britain at the Venice Biennale in 1952, and he and Gainsborough were the artists selected for retrospectives at the Tate Gallery the following year, during the Coronation summer. Philip James explained that they were both 'incontestably English in their style and vision'.

But that same year, Sutherland painted one of the most pessimistic of all his paintings, *Christ Carrying the Cross*. Jesus is depicted at his moment of collapse, falling to the ground amid strange architectural ruins. An odious thug, with grinning teeth

– explicitly recalling similar figures by Francis Bacon – boots him mercilessly. In this picture, at least, we are offered no hint of a resurrection. It is tempting to read the work as an allegory which expresses Sutherland's growing doubts about the Baconian culture which was emerging in post-war Britain.

If so, it was prophetic. In 1951, Sutherland had been invited to design a vast tapestry of the Risen Christ to form the centrepiece of Basil Spence's new Coventry Cathedral. This absorbed much of his time over the decade. Working within tight theological constraints, Sutherland conceived a bold, frontal image of the Christ, whose face fuses the power of Egyptian sculpture, the hieratic stillness of the Byzantine Pantocrator, and elements drawn from the artist's own physiognomy. Both the design and the weaving of the tapestry were subject to delays and prevarications, and there were misunderstandings between the artist, the architect and the Cathedral authorities. By the time it was unveiled, in 1962, both British culture, and Sutherland's position within it, had changed.

The ethics of hope and 'reconstruction' had been replaced by the callous banalities of consumerism, and the shallow concerns of the Pop art movement were booming. Despite – and in some degree because of – Cooper's impassioned advocacy, Sutherland's reputation had collapsed among artists, critics and the cultural *cognoscenti*. Sutherland lived for much of the year in France, where the tapestry had been woven, but he was becoming an exile in something more than a physical sense. His *Risen Christ* seemed like an iconic survival from a forgotten age of faith.

Churchill's rejection of Sutherland's portrait of him seems to have brought home to the artist his displacement from the mainstream of British cultural life. The following year, he bought a house at Menton, in France. Soon after, he became embroiled in a bitter struggle with the Tate Gallery, which he rightly perceived to be falling away from its former high ideals. But cut off from its roots in the landscape and traditions of Britain, Sutherland's art did not prosper. His palette had been

lightening and brightening before he moved to France –
partially as a result of his study of Picasso and Matisse. But
something repetitive and stereotyped entered into Sutherland's
handling in the 1960s. At its worst, his painting seemed to have
lost its way, to have made too many concessions to accepted
Modernist styles. His virtuosity as a graphic designer seemed to
be inhibiting his development as a painter, and at times he was
in danger of producing pastiches of Picasso or Matisse. Two
groups of work must be exempted from these general criticisms:
in the 1960s, Sutherland painted a number of animal pictures,
and a series of related prints known as *A Bestiary*. Like his
landscapes, these works involved intense, imaginative trans-
formation – or 'paraphrase', as he called it. In some of them, he
imbued an established genre with new layers of symbolism and
imaginative resonance. The other and more significant excep-
tion to his general decline was Sutherland's portraiture.

In 1949, Somerset Maugham suddenly and unexpectedly
invited Sutherland to paint his portrait. Eventually, Sutherland
agreed to do so, and the startling result opened a new chapter in
his art. He has often been criticised for painting the rich and
famous, even for accepting portrait commissions – as if these
were things that 'serious' modern artists did not do. But
Sutherland was drawn towards those who were creative,
powerful, influential or successful – in life and in art. He liked
sitters whose faces were, in effect, social masks, etched with the
lines of history and experience, which revealed as much as they
hid. Lord Beaverbrook, Kenneth Clark, and the neurotically
hyper-sensitive Edward Sackville West, he knew well, but his
portraits of Helena Rubinstein, Konrad Adenauer and Lord
Goodman are also compelling.

Although, as John Hayes has put it, 'likeness has always been
the essential ingredient in Sutherland's portraiture', he has
treated 'likeness' as a means to an end, rather than an end in
itself. The point has often been made that if Sutherland's
landscapes suggest human and divine presences, his portraits
recall landscape, and reveal the depths of the *human* spirit.

Nowhere is this more evident than in the creased and craggy features of Sutherland's *Somerset Maugham*. Sutherland argued that if you falsified physical truth, you were in danger of falsifying psychological truth, and so he did not caricature, flatter or idealise. Portraiture, Sutherland insisted, 'is a matter of accepting rather than imposing'.

He once explained that it was 'an art of letting the subject gradually reveal himself unconsciously so that by his voice and gaze as well as by his solid flesh your memory and emotions are stirred and assaulted, as with other forms of nature'. Or, in Douglas Cooper's words, Sutherland waited while the sitter 'composes his own portrait'. This, one feels, the ageing Churchill did for him, then complained that he had been depicted as 'a gross and cruel monster'. What would he have thought if the 'greatest living painter', whose work (according to the former Director of the Tate Gallery) 'sets the standard for our time' had attempted his likeness?

In the early 1960s, Bacon's work began to change too. It took on a more personal – one hesitates to say 'intimate' – character. He made increasing use of those in his personal circle as models, though he usually worked from photographs rather than life. He preferred 'low-life' characters, who accompanied him on his drinking and gambling bouts. The distorted faces and figures of Muriel Belcher – the owner of a Soho drinking club Bacon frequented, Isabel Rawsthorne, Lucian Freud, and George Dyer – Bacon's lover, recur time and again.

Andrew Forge, the distinguished British critic, has argued that the 'scandal' of Bacon's painting resides in the fact that he has rejected the conventions that have dominated the art of his lifetime. Not only does Bacon dismiss abstract painting as fashionable pattern-making, but he also makes a claim for a traditional art of the human figure which takes its stand on likeness: 'The gap between Sargent and Cézanne, between Sir William Orpen and Matisse was unbridgeable. Dimples, moist eyes, half smiles were taboo. Bacon affronts this taboo.'

It is certainly true that Bacon appeals exclusively to a system

of 'expression', dependent upon the anatomy, gesture, and physiognomy of the depicted subject. But so did Sutherland, in his portraiture, and so do many lesser artists whose work holds no 'scandal' for us. The scandal of Bacon's work must lie elsewhere – in his particular way of handling likeness. I used to argue that Bacon caricatured his subjects. Caricature is a tendentious portrayal of character based on the distortion of specific features. It is an intentionally biased rendering of the 'social mask' through which all men and women – especially those with a public persona – present themselves to the world. But caricature depends on *difference*, it accentuates specifics. Forge is surely right when he says that Bacon has no interest in 'social masks'. Unlike the traditional portrait painter, he would never paint an individual 'as' an admiral, faithful wife, scholar, statesman or whatever. Bacon seems barely aware that such people exist. Whether he is depicting Isabel Rawsthorne, Muriel Belcher, George Dyer or himself, the brutal 'revelation' is always the same.

Bacon has often suggested that his distortions clear away veils and screens, revealing his subjects 'as they really are'. But before one assents to this, one must first go along with Bacon's judgement on his fellow human beings. In this sense, his approach is the opposite of Sutherland's. Bacon would *never* let the sitter 'compose his own portrait'; there is only one aspect of human being to which he attends, and one has to go back a long way to find something similar. Reynolds, too, rejected the psychologically revealing portrait and caricature alike, and pursued a policy of edifying idealisation. He believed that by painting even the ugliest subjects in a noble way, he was revealing the universal good. Manifestly, Bacon does not idealise, but in a similarly universal way, he *denigrates*. It does not matter whose likeness he exploits, their face will emerge as that of 'a gross and cruel monster . . . *and nothing else*'. For Bacon, an individual's face is no more than an injured cypher for his own sense of the irredeemable baseness of man.

In 1967 Sutherland went to Pembrokeshire for the first time

since the war, to take part in a television film. He believed he had exhausted the imaginative possibilities this landscape offered him, but once there, the country exerted its old attraction. He returned for a longer visit the following year and then again, frequently, until his death in 1980. The paintings Sutherland produced throughout the 1970s are more than an old man's spiritual home-coming. He fused his English nature Romanticism with what he had learned from the best twentieth-century French art, to produce some of the most original and elegiac British paintings of recent years. *Conglomerate I*, 1970, bears witness to Sutherland's Ruskinian capacity to see in a pebble the grandeur and scale of a mountain range. The troubled root forms of *Picton*, 1971–2, are heavy with presentiments of a return to the earth, of impending death; whereas *Forest with Chains II*, 1973, suggests the eventual triumph of the organic over the mechanical, though Sutherland denied conscious symbolic intent. *Bird over Sand*, 1975, based on a bird flying over Sandy Haven at low tide, brings to mind the desolate and historic imagery of *The Origins of the Land*. It also reveals the relationship between Sutherland's vision of an alien nature and that put forward by the Australian painters, Arthur Boyd and Sidney Nolan. In 1978, Sutherland painted *Thicket: with Self-Portrait*, a picture which has been justly described as his 'testament'. It shows the artist, aged, and almost wizened, drawing intently, while above him soars a mass of vegetable and organic forms, which, like the monsters in Goya's *Sleep of Reason*, seems about to absorb him into itself – except that in *Thicket* there is no terror. Only one more major work followed: *Path through Wood*, 1979. The figure of the artist has disappeared, but the vegetable forms are now frozen into a monumental stasis. The silence of eternity replaces the rushing urgencies of growth. Ruskin seems almost to have had Sutherland's last paintings in mind when he praises the 'infinite wonderfulness there is in this vegetation', which, he says, 'becomes the companion of man', ministering to him 'through a veil of strange intermediate being; which breathes, but has no

voice; moves, but cannot leave its appointed place; passes through life without consciousness, to death without bitterness; wears the beauty of youth, without its passion; and declines to the weakness of age without its regret'. Within a matter of months after painting *Path through Wood*, Sutherland was dead.

For Bacon, by contrast, the 1970s were marked only by the restatement of well-established themes – figures seated in front of crucified carcasses; scenes of animal buggery; disintegrative portraits of self [*see plate 8b*] and others; and images of lonely and naked men seated on lavatories, beneath bare light bulbs or vomiting into sinks. Bacon's handling of his forms – though not of the paint materials themselves – became looser; stereotyping, mannerism and repetition held sway. His chronic inability (at once formal and psychological) to unite figure and ground became more pronounced. The only development was a movement away from reliance on the photographic image towards a new element of mythic symbolism, even if this often seemed arbitrary, almost absurd. It was as if the Eumenides, in forms resembling pink elephants, had returned to haunt the sordid events in hotel rooms, or the sphinx had materialised amidst the used dressings of a casualty ward. Bacon drew less upon his day-to-day life in the 'sexual gymnasium' of the modern city. The references to the recognisable circle of friends diminished, those to Aeschylus and Ingres increased. Although Bacon's painting was greeted with ever-greater acclaim, nothing reduced his relentless sense of surgical, but increasingly meaningless, despair; of paint thinned not so much with turpentine as formaldehyde.

How then ought we to assess the achievements of these two painters? It has been said of Sutherland that, in the 1930s, he owed much to the Surrealist movement, yet his roots lay in an older English tradition of imaginative transformation of the appearances of nature. (Sutherland's weakness perhaps, was a certain fatal facility, or a sense of graphic design which occasionally entered into his work. Such virtuosity could not substitute for emotional involvement.)

The personal and cultural events of the 1950s and 1960s alienated him from the common culture to which he belonged, with debilitating effects on his art. But he returned to it triumphantly in the 1970s, fortified by what he had learned from the European Modernist movement. Though neglected by the taste-makers of the art world, Sutherland's last pictures confirmed that his vision was not nostalgic; rather he was prophetic. Afer his death, there was much talk of a new 'post-industrial', 'post-modern' world, in which the restoration of a lost ecological harmony between man and nature had become essential for human survival. Sutherland's painting does not seem to demand that we share his belief in the Risen Christ. Rather he acknowledges that we live in a world in which there is, to quote the historian, Leo Marx, a 'machine in the garden', or a rusting industrial chain in the forest. He seems to affirm the intractable, unmalleable 'otherness' of the world of natural objects. And yet he insists, like Ruskin before him, upon the necessity of an imaginative, spiritual, and aesthetic response to nature, regardless.

Bacon's numerous critical supporters have repeatedly insisted that he is a great 'realist' who paints the world as it is. Michel Leiris has recently argued that Bacon 'cleanses' art 'both of its religious halo and its moral dimension'. Bacon himself has said that his paintings can offend, because they deal with 'facts, or what used to be called truth'. Yet Bacon is indifferent to particular truths concerning the appearance and character of his subjects. No one could accuse him of being a respecter of persons. In his view, men and women are raw and naked bags of muscle and gut, capable only of momentary spasmodic activity.

'Realism' in art inevitably involves the selective affirmation of values. Whether one accepts Bacon as a 'realist' or not will depend upon whether one shares his particular view of humanity. Bacon is an artist of persuasive power and undeniable ability, but he has used his expressive skills to denigrate and degrade. He presents one aspect of the human condition as

necessary and universal truth. Bacon's work is currently more highly esteemed than that of Sutherland, but this may merely tell us something about the values of those who express such a preference. Bacon's skills command our admiration, but his tendentious vision demands a moral response, and I believe, a refusal.

The very existence of a talent like Sutherland's indicates just how partial Bacon's 'realism' is. One might also ask, is his conception of human beings more 'realistic' than that of Henry Moore? Moore found no difficulty in affirming the possibilities of consoling relationships between mother and child, and even between adult individuals of the opposite sex. Like Sutherland's paintings, Moore's greatest sculptures also celebrate the potentialities of a human relationship with the natural world beyond the walls of the water-closet. It is tempting to end with the words of St Paul: 'Whatsoever things are lovely, whatsoever things are of good report; if there be any virtue, and if there be any praise, think on these things.'

1988

Ivon or Andy: a Time for Decision

> I've never been touched by a painting. I don't want to think. The world outside would be easier to live in if we were all machines . . . My work won't last anyway. I was using cheap paint.
>
> Andy Warhol, quoted in Victor Bockris, *Warhol* p.145

In one of his columns in *The Nation*, the New York critic, Arthur C. Danto, wrote that Andy Warhol was 'the nearest thing to a philosophical genius the history of art has produced'. I was surprised by this, not only because I found Warhol's art empty and banal, but also because I had read *From A to B & Back Again: The Philosophy of Andy Warhol*. The most profound statement in this book is probably, 'Diet pills make you want to dust and flush things down the john'. Admittedly, Warhol himself once said to a reporter, 'I don't think many people are going to believe in my philosophy, because the other ones are better'. But I knew that Danto was himself a distinguished Professor of Philosophy. How could he have reached such a judgement? It seemed to me that only in a culture which had lost sight of the perennial concerns of philosophy with the nature of the good, the true and the beautiful – a dying culture – would a leading philosopher wish to celebrate Warhol as 'a philosophical genius'.

After expressing such misguided sentiments, I received a helpful letter from Professor Danto exuding bonhomie and camaraderie, but firmly putting me straight. He found my 'curmudgeonly thoughts' about Warhol 'a lot of fun'. After all, he has always enjoyed 'cranky, quirky writing' and he can see 'there is a good heart beneath it all'. My error, however – and here I can almost feel him patting my unphilosophical English

head, just as he pats the snouts of his mad spaniels – lies in the
fact that I 'look at [Warhol] the wrong way'. Ah! So *there's* the
rub! 'In fact,' the good Professor continues, 'you are looking at
him as though he were trying to do what Veronese did, only
failing. Think of him instead as trying to do what Hegel did in
the medium of commonplace objects, and you will get closer to
the point.'

I fear that an awful lot of people are taken in by patronising
pundits of this ilk. Since his death Warhol's reputation has risen
exponentially. For months, book about Warhol succeeded book
about Warhol with a serial monotony he would have admired.
There was, of course, a monumental tome which accompanied
the retrospective, in which celebrities vied with each other in
the extravagance of their praise. 'There are the rocks, the sea,
and the sky, the days, the hours, the minutes; pain; the
temperature of a particular day – all permutations of reality –
and there is Andy Warhol.' Who else, but Julian Schnabel.

As if that was not enough, there was also a massive
monograph on the works by David Bourdon and sundry
specialist catalogues and studies, especially on the formative
years spent drawing fluffy show ads for I. Miller & Sons, Inc.
Victor Bockris's biography, published early in 1989, was soon
superseded by another, *Loner At the Ball: The Life of Andy Warhol*,
by Fred Lawrence Guiles. As editor of an art magazine, I was all
but submerged in a welter of *Diaries*, confessions and
photographic essays, published not only by the great philo-
sophical genius himself, but also by former members of his
entourage, whether superstars or mere Factory drones.

I attended to the soul muzak piped out through these tomes
of trivia and inanity, listening for just one indication that
Warhol possessed intentions of the kind Danto attributes to
him. I must admit that even if such a glint was forthcoming, it
would have counted for little, for I had already stood in front of
Warhol's works in his Museum of Modern Art retrospective,
and had been underwhelmed.

'If you want to know all about Andy Warhol,' Warhol said,

'just look at the surface: of my paintings and films and me, and there I am. There's nothing behind it.' This may be one reason why the pictures are so numbingly boring. A sidewalk or a supermarket has more to offer the eye. The surface of these pictures reveals that Warhol's imagination was negligible, his painterly skills nugatory, and his aesthetic sensibility non-existent. Hegel notwithstanding, there is nothing there except 'the evil of banality', *anaesthesia* itself. The real conundrum is why there are so many 'serious' people like Professor Danto, who are prepared to fritter away their time attending to such things; so many who seem willing to ignore the valiant endeavours of those who struggle to paint like Veronese – even if they often, or always, fail.

> He loved to see other people dying. This was what the
> Factory was about: Andy was the Angel of Death's
> Apprentice as these people went through their shabby lives
> with drugs and weird sex and group sex and mass sex.
> Andy looked and Andy as voyeur *par excellence* was the
> devil, because he got bored just looking.
> Emile de Antonio, quoted in Bockris, op.cit., p. 205

I remember reading a paper by a Freudian psychoanalyst who argued that if there was such a thing as 'libido' associated with Eros, or the Life Instincts, then, for the theory to stand up, there ought to be a hypothetical force, which he designated 'mortido', associated with Thanatos, or the Death Instincts. He suggested Narcissus as a prototype for a personality dominated by 'mortido'. Narcissus's infatuation with his own reflection in the still and silent waters of the pool was not so much a perversion of love as a manifestation of his longing for extinction. In love with himself, he was lost to 'the other'.

These days, I have less patience with Freudian psycho-analysis than I once had, least of all for those varieties of it which asssume the existence in all of us of a Death Instinct. And yet I must admit that consideration of the phenomenon of Andy

Warhol has provoked in me a wellspring of sympathy for such ideas. For Warhol's self-absorption was such that he seemed barely able to connect with others, or the world. ('The acquisition of my tape recorder,' he said, 'really finished whatever emotional life I might have had, but I was glad to see it go . . . I think that once you see emotions from a certain angle you can never think of them as real again. That's what more or less has happened to me.')

Warhol's 'affectless' way of looking at objects in the world had nothing to do with any heightening of the powers of the senses, although there are those who still try to see him that way. For instance, Robert Rosenblum makes much of the fact that Warhol worshipped regularly at the church of St Vincent Ferrer at Sixty-sixth Street and Lexington Avenue. According to Rosenblum, Warhol himself created 'disturbing new equivalents for the depiction of the sacred in earlier religious art'. His galleries of myths and superstars, Rosenblum says, 'resemble an anthology of post-Christian saints, just as his renderings of Marilyn's disembodied lips or a single soup can become the icons of a new religion, recalling the fixed isolation of holy relics in an abstract space'. Rosenblum sees in Warhol references to 'the mute void and mystery of death', especially in the blankness of *Blue Electric Chair*, and even 'the supernatural glitter of celestial splendor' in an image of Marilyn Monroe which he relates to 'a Byzantine madonna'. There is, he feels, 'an impalpable twinkle of sainthood' in Warhol's portrait of Joseph Beuys. Warhol, Rosenblum concludes, 'not only managed to encompass in his art the most awesome panorama of the material world we all live in, but even gave us unexpected glimpses of our new forms of heaven and hell'.

But this is nonsense. Warhol offers only a superficial vision of the material world, and the 'glimpses' of heaven and hell are no more revealing than those we can derive from plastic madonnas and two-dollar religious trinkets. The emptiness in his work was never even an analogue for that contemplative emptiness and silence which mystics have long associated with the

abnegation of the self and the enrichment of the soul. Rather, it reproduces the pornographic vacuity of a Jimmy Swaggart, or a Las Vegas Crematorium. Cheap nothingness, an oblivion of kitsch.

There is no indication in any of Warhol's painting that he ever glimpsed, say, the way in which the sun can touch the leaves of the trees and make them shimmer, or the glint in the wings of the dragon-fly as it hovers over the still waters of a pond. Warhol was too busy examining his own reflection. If he had been born in seventeenth-century Holland, when Vermeer was watching the way light modulated itself over the walls, Warhol would have been trying to use a camera obscura to photograph himself in the mirror.

Nothing reveals a painter's nature better than the way he paints flowers, and for Warhol, flowers meant painting by numbers. Apart from an Easter card for I. Miller & Sons, Inc., and an inconsequential floral cover for *Vogue's Fashion Living* in the early 1960s, Warhol's first painting of flowers was *Do It Yourself (Flowers)*, 1962. This consists of an enlarged and partially completed version of a 'painting-by-numbers' image in synthetic polymer. Warhol then plunged into his frozen images of death and disaster, wanted men, electric chairs and crashed cars. Bockris says that it was Henry Geldzahler who suggested to Warhol that it was 'time for some life', and showed what he meant by pointing to a magazine centrefold of flowers. Soon after, the Factory began to mass-produce flower paintings of every size from miniature to mural [*see plate 19b*].

Altogether, Warhol's assistants seem to have produced more than 900 flower pieces. Sometimes, there were fifteen people working on them at once. The images were reproduced on canvas by a photo-silkscreen technique. Unlike many of Warhol's pictures, these were not straightforward photo-graphic reproductions. The contours of the flowers were touched up by hand, though rarely Warhol's own. Whatever the size or shape of the canvases, they were mounted onto standard-size stretchers provided by a local art materials shop,

so the image is often cropped in peculiar ways or surrounded by a wide, white border.

In 1965, when Warhol held his first exhibition in France, he decided that he would show only flower pictures. 'I thought the French would probably like flowers because of Renoir and so on,' he said. 'They're in fashion this year. They look like a cheap awning. They're terrific.'

These synthetic flowers were as close as Warhol ever got to the idea of using his senses to attend to natural forms. Even so, any such allusions to nature as they may contain are purely coincidental. According to Rainer Crone, Warhol found the image in a women's magazine where it had won second prize in a housewives' photography contest. (The housewife in question later tried to sue and was paid-off by Warhol with two flower paintings, which she immediately sold through Leo Castelli, Warhol's dealer.) Crone says that, together with *Cow Wallpaper* and the *Silver Clouds*, the *Flowers* were unique 'by virtue of their meaningless image content'. But, he claims, the pictures were not entirely 'dehumanised' because 'their banal abstract form' was 'a gauge against which to measure Warhol's other work'. Warhol had created the form of the flowers solely as a means to carry colour which, in these works, he used 'strictly decoratively'.

Warhol's 'decoration', however, had nothing to do with aesthetic enhancement, nor yet with any longing for rarefied beauty and pleasure. Instead, he was interested in a sort of negative corollary of the decorative, a despoliation which bored and numbed. According to Peter Gidal, another Warhol hagiographer, this self-conscious cheapening of the image is what matters and makes Warhol's works worthy of attention. 'One accepts the flower pictures,' he writes, 'within one's taste even though beforehand one had the fine-art sense to dislike their cheapness . . . It's as if Warhol had managed to make "city flowers" out of real flowers, and that is part of his aesthetic; broadening the range of acceptability.'

There were also those who heralded the flowers as 'the ozone

of the future'. Small wonder that the more perceptive critics, when confronted with these works, have scented there the stench of the mortuary and of extinction. Much has been made of the fact that the flowers are poppies – though not, as Bockris points out, opium poppies. And yet death is present not so much in the imagery itself as in the way the flower paintings were made. They secrete the vile odour of 'mortido' unredeemed by any aesthetic consolation. As even one of Warhol's most sycophantic admirers, Carter Ratcliff, has put it, 'No matter how much one wishes these flowers to remain beautiful they perish under one's gaze, as if haunted by death.'

Now let us turn to the painting, *Flower Group* [*see plate 10a*], which Ivon Hitchens painted in 1943 – a picture which vibrates with light and life. It reminded me of that moment in 1858, when John Ruskin came to terms with the gorgeousness of the great Venetian painters, especially Veronese, and recognised 'a great worldly harmony running through all they did'. For a time, Ruskin came to believe that this 'worldly harmony' had more spiritual content than most religious painting.

In one sense, Hitchens's chosen subject matter was banal enough: a vase of flowers, including poppies, placed in an interior. His way of seeing, too, was unembellished. Patrick Heron once described him as engaged in 'the humble transcription, in terms of paint, of sensation itself'. As Heron points out, he eschewed the self-consciously 'symbolic' and 'poetic', even though these were much in vogue among his contempories. And yet, in pictures like *Flower Group*, the motif is not only fresh, but also transfigured – just as Van Gogh could transfigure a pair of boots and imbue them with the tragic sentiments of a *pietà*.

This transfiguration is not some kitsch 'added extra' like Warhol's sprayed glitter around the head of Beuys, rather it springs directly from Hitchens's consummate visual intelligence. 'A picture,' he said, 'is compounded of three parts – one part artist, one part nature, one part the work itself. All three

should sing together.' He looked with longing – love is not an inappropriate word – on the visible world, and he searched hard until he had found pictorial equivalents for what he saw, and, indeed, what he felt about what he saw. He tried to realise his truth to nature through composition rather than through imitation of the immediate appearances of things. He abandoned the focused perspective that had dominated Western landscape painting, and turned rather to a way of depicting which drew on his knowledge of Japanese pictorial composition, on Cubist space and on Fauvist colour. But, for Hitchens, all these things helped to provide him with the plastic and pictorial means through which he could express, with a striking freshness, an ancient yearning for a sense of unity with the world of nature. 'Art,' he used to insist, 'is not reporting. It *is* memory.'

The image of the landscape as paradise is always derived, in some sense, from memories of fusion with the mother. This, I think, may have been what Roger Fry was referring to when he talked about the dependence of the purest aesthetic emotion upon the arousal of 'some very deep, very vague, and immensely generalized reminiscences'. It was little short of a tragedy that all of Hitchens's paintings of the female nude were excluded from his 1989 retrospective at the Serpentine Gallery, for Hitchens's pictures of reclining women were deliciously free of those injured imagos of the fallen human body which haunt the paintings of the School of London today. Somehow, his fresh pictorial techniques allowed him to infuse the familiar symbolism of woman-as-landscape with a new life, in much the same way that Henry Moore's new sculptural forms enabled him to effect something similar in sculpture.

For Hitchens, as for so many of the great English landscape painters, landscape was more than the locus for sense experiences, more than a matter of topography. In those glimpses of paradise which he offers – especially in the marvellous series of paintings of a rather pedestrian view of Terwick Mill, which quite rightly formed the core of the

Serpentine exhibition – formal means have replaced the relics of religious iconography and the tired devices of picturesque pastoral poetry. The intimations of unity and transcendence in Hitchens's paintings are achieved through formal means. While not, perhaps, 'the ozone of the future', his pictures remain uncompromisingly secular and modern. Yet in another sense, they retain a strong if silent feeling of continuity with the aesthetic and spiritual truths of the past. As a painter of the common-or-garden, he is, one might say, on the side of the angels, or at least of life.

There are no doubt those who will say it is wrong to compare two artists whose work is so different in intention, but in a way, that comparison has already been made. 'At present,' writes Lynne Cooke, my weather-vane of art-institutional orthodoxy, 'there seems to be a widespread consensus that the recent artists who require most study are Warhol and Beuys.' It is this consensus among the historians and art administrators which dictates that Warhol should have a major exhibition at the Hayward Gallery while Hitchens received only a half-hearted showing, *après* Warhol's juvenilia, at the Serpentine. (Warhol, it should be said, last received a full-scale retrospective at the Tate Gallery in 1971; Hitchens has not had a major institutional retrospective since his Tate Gallery showing in 1963. I discount the small exhibition at the Royal Academy in 1979, like that at the Serpentine in 1989, as rather half-hearted affairs. Needless to say, Hitchens's work is practically unknown in the United States.)

A few years ago I tried to interest the major London art institutions, especially the Hayward Gallery, in a show about British landscape painting from the 1940s until the present day. My idea was to begin with the paintings of Hitchens, Paul Nash, Graham Sutherland, Victor Pasmore and others, from the war years, and to reveal how, contrary to the teaching of the 'consensus', the English landscape painting tradition had flourished right down to the present day. To take just two examples from among many, I would have included paintings

by William Tillyer and Derek Hyatt, two of the best living painters of the landscape. This was a project which I knew would have broken new ground, and I remain convinced it would also have been popular with British gallery-goers, who have always responded enthusiastically to English landscape.

There was, however, no interest among the institutions. Joanna Drew, director of the Hayward Gallery, has since found space in her programme not only for the Warhol retrospective, but for one by Gilbert and George. Drew told me that she would only give consideration to a landscape exhibition which contained work by Conceptualists, photographers and others using 'new media' – that is, the sort of landscape show which would have had no aesthetic value and would have been almost as successful in keeping the public away as the Hayward's recent exhibition of minor Latin American genre art. Landscape *painting*, as such, she told me, was a 'funny business' largely pursued by amateurs. Warhol, incidentally, could certainly not be accused of 'amateurism'. 'Business art,' he said, 'is the step that comes after Art. I started as a commercial artist, and I want to finish as a business artist.' And so he did.

On the other hand, what Ivon Hitchens had to say could only have been achieved through painting of the purest and most disinterested kind. In one sense Hitchens was a consummate professional, in another he was sustained by the conventions of amateurism – certainly by its obliviousness to fame and fashion. The same, I believe, is also true of many of the best landscape painters who have come after. Perhaps they don't paint as well as Veronese did; nevertheless, such work is more worthy of our attention and study, and, more importantly, more conducive to our *enjoyment*, than Warhol's ersatz petals of death or Beuys's deceased hares. And that would be true even if Warhol and Beuys were the greatest philosophical minds the history of Western art has yet produced.

1989

PART THREE

Contemporaries

Auerbach's *Kerygma*

In 1983, after seeing an exhibition by Frank Auerbach at Marlborough Fine Art, I wrote that 'Auerbach is one of the very few painters working in Europe or America today of whom it is possible to say with any degree of credibility that here . . . is a master in the making.' I remain convinced of the rightness of this judgement, and I applaud without qualification the decision that Frank Auerbach's paintings and drawings should have represented Britain at the Venice Biennale in 1986.

The British Pavilion contained twenty-four paintings and eight drawings, from the period 1977–85, all made since Auerbach's Hayward Gallery retrospective of 1978. Some, like the exemplary *Head of Julia II*, 1980, *Portrait of Catherine Lampert*, 1981–2, and *To the Studio II*, 1982, were included in his 1983 exhibition at the Marlborough Gallery. Others, like *Primrose Hill*, 1980, were exhibited in the gallery's New York space the previous year. Most, however, have not been previously shown in public. Nonetheless, the subject matter of the paintings was familiar to those who have followed Auerbach's work in recent years. There are heads of his, so to speak, long-standing sitters, like Gerda Boehm and 'J.Y.M.' [*see plate 15a*]; views of Primrose Hill and of the approach to his studios; and recent studies of a new model, Debbie Ratcliff. Each of the drawings is a large work in charcoal, or chalk and charcoal, of the head of a different sitter. In addition to studies of Auerbach's familiar circle there were drawings of his son Jacob, Charlotte Podro, and David Landau.

Yet I found myself wondering why no recent nude study was included in the Venice exhibition. The quality of the little *Reclining Nude* of 1984–5, exhibited in a mixed show at

Marlborough, was exceptional. I would also have liked to see the great charcoal head of Jacob, owned by Ron Kitaj, among the drawings. But these are mere quibbles. Since his retrospective, Auerbach has produced a body of work which should convince the most jaundiced sceptic that the best achievements of British art today require no apology and no cringing deference to New York or Düsseldorf.

The root of Auerbach's greatness lies in a quality which has long characterised the British tradition. I am referring to the value he places upon empiricism. Again and again, in interviews, Auerbach has drawn attention to 'this recalcitrant, inescapable thereness of what I call every-day objects'. His is an art which springs out of 'fact', which, he says, 'is a kind of sheet anchor' holding interior imagination to external reality. He has described his painting as 'the re-invention of the physical world', and insisted, 'everything else comes from that'. But his relentless commitment to the object denies neither imagination, nor the influence of a profound sense of tradition.

Auerbach was born in Berlin in 1931, but before his eighth birthday he was sent to safety in England. 'I . . . didn't in fact see again anybody who I had seen before, that I remembered,' he wrote. This is significant given his fidelity to his models, his dislike of any sort of change in his working habits or personal environment – he has painted in the same London studio since 1954. It also inflects his commitment to the present object and his yearning for a place within tradition. In 1947 he came to London without any clear idea of what he was going to do, although he fantasised about being an actor. After a time he began to attend art classes, first in Hampstead, and later those run by David Bomberg at the Borough Polytechnic. I do not want to down-play Bomberg's influence on Auerbach, but perhaps I, and others, have focused too exclusively on this association in the past. Auerbach was only a full-time student of Bomberg's for two terms, and also studied at St Martin's and the Royal College. He is, in fact, the heir to a wider and more generous tradition than that pursued within 'The School of Bomberg'.

It is worth looking back to that moment of Auerbach's first exhibition at the Beaux-Arts Gallery in 1956. That year was a turning-point in which the destiny of British art was determined for some time to come. The outward signs of change were the dissolution of the 'Kitchen Sink' school, after its showing at that year's Venice Biennale; the emergence of a degrading 'Pop' sensibility in the Whitechapel's exhibition, *This is Tomorrow*; and the arrival in Britain of Abstract Expressionism, first seen in the final room of the Tate Gallery's show, *Modern Art in the United States*. Auerbach may not have realised it, but these events heralded rapid cultural changes which ensured that his genius did not receive its due for more than twenty years.

Take first the demise of the 'Kitchen Sink' school. In the early 1950s, John Berger had been pressing the case for what he called a new 'realism' in English painting. Whatever he meant by realism, Berger clearly did not intend naturalistic involvement with appearances, nor was he interested in 'Socialist Realism'. He seemed to be in search of something much closer to Auerbach's 're-invention of the physical world'. Berger stressed that the emergence of a British 'realism' was a matter of potential, rather than realised achievement, but John Bratby was an early embodiment of his hopes. 'Bratby,' he wrote, 'paints as though he sensed that he only had one more day to live.' Berger felt that Bratby depicted a packet of cornflakes 'as thought it were part of a Last Supper', landscapes, 'as if seen from a prison cell', and his wife 'as though she were staring at him through a grille and he was never to see her again'.

By 1956, Berger had convinced the art establishment, and John Bratby, Derrick Greaves, Edward Middleditch, and Jack Smith – 'The Kitchen Sink School' – were dispatched to the British Pavilion for the Venice Biennale. But it was hardly a moment of triumph. The limitations of the work produced by this group became apparent even to its members. With the exception of Derrick Greaves – at best a mediocre painter – all underwent a dramatic change of direction. Berger promptly renounced Bratby and Smith: 'Once Bratby scrutinized his surroundings –

greedily – like a man under arrest being led down a street to the police station. Now he signs for things and it is the validity of his chits to which he clings.'

From this moment on, Berger became disillusioned with all British art. But Auerbach, holed up in his Camden Town studios, was beginning to realise that vision of the external world – born of despair, yet somewhere redolent with the glints and promises of redemption and release – which had eluded Bratby. Auerbach's early works were like those of a man thrown in a cell and left with only his own excrement out of which to create a vision of freedom.

Even so, Berger did not respond favourably to the encrusted and accreted paintings which Auerbach exhibited at the Beaux-Arts in 1956. 'They looked,' Berger wrote disapprovingly, 'as if they had been painted in the dark with a candle and a stick.' David Sylvester, probably the most visually perceptive of the critics of the 1950s, also stressed the 'morbidly tactile' qualities of Auerbach's pictures. But Sylvester saw that they gave expression to a sort of existential realism, and provided 'a sensation curiously like that of running our fingertips over the contours of a head near us in the dark, reassured by its presence, disturbed by its otherness, doubting what it is, and then whether it is'.

By 1959, Berger was more sympathetic: he argued that Auerbach's paintings themselves had changed. 'The inert deadness of the mud in Auerbach's earlier paintings becomes elequent now about the weather and the depth dug in building sites, just as in the nudes it becomes eloquent about the substance of flesh.' This capacity to speak eloquently of lived experience of physical reality was to intensify as the years passed. In the foreword to the catalogue of Auerbach's retrospective, nineteen years later, Leon Kossoff compared Auerbach's landscapes, heads and nudes to 'a gleam of light and warmth and life' in the darkness. He went on to say that, in spite of the excessive piling on of paint, 'the effect of these works on the mind is of images recovered and reconceived in

the barest and most particular light, the same light that seems to glow through the late, great, thin Turners'.

The comparison is just. Later Auerbach is not only a long, long way from the excremental rawness of his early vision; it convinces us with the authority of genius. But while Auerbach had been finding this light, Berger had fallen silent concerning his work, and contemporary art in general. Other critics, and the institutions of art, were looking elsewhere. The signing of chits, in preference to painting out of any sense of conviction or ethical commitment, was coming into vogue. If Bratby had any influence it was because he had painted cornflakes packets, not because of the heightened sense of reality, or existential despair, he may once have possessed. Between 1957 and 1976 the odious betrayals of Pop art, and the pursuit of empty American fashions proceeded apace. In 1957, the year that Richard Hamilton described art as 'popular', 'transient', 'expendable', 'mass produced', 'young', 'witty', 'sexy', 'gimmicky', 'glamorous' and 'big business', David Bomberg died in obscurity – unable even to secure a teaching post.

Auerbach was utterly unaffected by the new fashions. Like Bomberg before him, he stood for an older, and I would say *better* artistic ethic. None of the concerns of the moment seemed to interest him at all. His art sprang out of his immediate relationship to the persons, things and places who constituted his day-to-day London life. He has always regarded television as a 'barbarous invention', and there is no indication that things American have had the slightest effect on his development as a painter. He was indifferent to the stance of 'commercialism' and 'professionalism', so loudly vaunted by the shallow painters of the 'Pop' and 'Situation' tendencies. But Auerbach continued, daily, to grow as an artist, nurturing himself through his relentless fidelity to the practice of drawing, and through an ever-deepening, enriching and enabling sense of tradition.

In the past I have stressed the importance of drawing to what Auerbach does, and Kossoff, too, has rightly made note of the constant application of 'true draughtsmanship' in Auerbach's

work. Here I want to say something about the role of tradition in shaping his achievement. These days, the influence of tradition is something like that of a Protestant's God: the artist must seek it out (perhaps even invent it for himself), in a state of humility, before it can save him. Auerbach has accepted the redemption offered by the great masterpieces of the past. As he put it, 'Without these touchstones we'd be floundering. Painting is a cultured activity – it's not like spitting, one can't kid oneself.' One strand in the healing tradition he has chosen is that which runs from Hogarth's *The Shrimp Girl*, through Constable – especially the late Constable – and Sickert, into the later work of Bomberg.

Catherine Lampert mentions the Constable connection in her catalogue introduction for the Venice exhibition. She quotes Auerbach (who greatly esteems Constable) as saying that he wanted to make masterpieces out of the scenes, incidents and objects of his everyday life in much the same way that Constable turned to 'what they called at the time rotten tree stumps and old barges'. Similarly, Sickert relished the common-or-garden life of Camden Town, where Auerbach still lives. He insisted that the plastic arts 'flourish in the scullery, or on the dung-hill', but 'fade at a breath from the drawing-room'. Even so, Sickert sometimes seemed trapped. Though he refused 'the sordid or superficial details of the subject', what lay beyond them when one confronted the world without belief? This problem also dogged many of the followers of Bomberg. An abstract, philosophical belief in 'The Spirit in the Mass' was not enough. Auerbach remembers the 'anonymous cloudy pieces of paper' of the Bomberg School, 'which had absolutely nothing cheap or nasty about them'. But, he strikes a chord in my heart when he adds, 'In competition with the great paintings of the world, which also have a cutting image like superb posters, these drawings would seem like defenceless little molluscs.'

Painting in the illuminating shadow of Hadleigh Castle, Auerbach was possessed of grand ambitions which stretched beyond a vague 'adumbration of something . . . organic and

particular'. Recent taste has placed far too much emphasis on Constable's sketches and not enough on the soaring transformations of those sketches into 'The Grand Machines'. Claude was, after all, as important to Constable as the momentary effects of light to which he attended so scrupulously. Concluding his exemplary study of Constable, Malcolm Cormack writes, 'His method of working in oil with combinations of glazes and thick impasto, gave his works a richness of texture that took on a life of its own . . . He had imagined himself driving a nail to secure realism, but in the end he found himself constructing a "noble" art, concerned with the "beautifull" [sic], and "grandeur", in abstract terms.' Exactly the same could be said of Auerbach.

The relationship between memory, experience, and tradition is one which haunts Auerbach's work. It was vividly expressed in something he said to Catherine Lampert: 'I think that *Le bain Turc* is really much better than anything in one's memory but it isn't quite as good as a lot of people in a Turkish bath. But if you're actually in a room with a person you can have the Ingres, Michelangelos and Rembrandts round the walls, but the person will have something that they haven't got, and it's that something that's the next project for the painter.'

I do not know Frank Auerbach, but this is how I imagine him: I see him as a man alone in a room, filled with abundant evidence of the sordid and superficial facts of our material existence. Around him, on the walls, are the great masterpieces of Western art: the Michelangelos, Rembrandts, and Ingres. In front of him, on a stool, is a naked person, whom Auerbach is drawing with a scrupulous intensity. The moment is as intimate, immediate, and tentative as Constable's attention to the passage of cloud shadows across the fields. And yet, without allowing the fact to intrude bombastically into his consciousness, Auerbach is aware that what he wants to come out of the encounter is as aesthetically ambitious as those Michelangelos, Rembrandts and Ingres. Such desires are rare enough in art

today, but with these pictures he is on the way to realising those hopes.

There is more I want to say about Auerbach, much more. Some day, the contrast between his achievement and the injurious degradation proffered by Francis Bacon will have to be drawn more fully. Bacon, it seems to me, is incapable of bringing about the 'redemption through form' which springs out of every mark which Auerbach now makes. Bacon's art speaks of necrophilia and decay. In Auerbach, even a dung-hill or scullery sink of paint glimmers and flickers with a light which affirms the possibilities of life.

Once we have seen the greatness which is proclaimed through Auerbach's paintings, we find that, despite ourselves, we are involved in what theologians call a *kerygma* – or a call to a decision. For we cannot engage with Auerbach's achievement and then return to a celebration of anaesthesia, 'modernity' and 'relevance', without making fools of ourselves. If we profess to believe that Richard Hamilton, Victor Burgin, or Malcolm Morley are also good, in their own way, we have failed to confront the true stature of Auerbach's achievement. Of course, Auerbach is far from being blind to the modern world, but his stance towards it is anguished and critical, constantly informed by his awareness of the superior cultural achievements of the past. Indeed, it seems to me not unlike that of the historian Maurice Cowling, who has written, 'modernity is the practice we have and the life we lead, and . . . we have all to accept it and live as it commands us, even when we despise it'. Howard Hodgkin's Venice contribution in 1984 was in every way admirable, but Auerbach produced a body of work which was surely the finest Britain has sent to Venice since Henry Moore was shown alongside Turner in 1948, or Barbara Hepworth alongside Constable in 1950. Let up hope we have reached a turning point, and that the mistakes of the past will not be repeated.

1986

John Bellany

At forty-seven, John Bellany is emerging as the most outstanding British painter of his generation. That, at least, is the conclusion I have reached after seeing the works which he has been producing since the death of his mother in November 1989. Bellany's paintings have always been notable for their audacity and ambition, but these new works reveal an achievement commensurate with those high aims. [*See plate 11a*].

Inevitably, the themes of these paintings are often harrowing. Some concern themselves with the skull which waits to expose itself from beneath the veil of even the most lovely flesh. And yet the sheer radiance of Bellany's colours and the exuberance of his brush-work transform what might have been a requiem into a paean. In the presence of his mother's death, he comes to celebrate the life which she gave him, and in so doing, has produced some of his most moving and memorable paintings.

John Bellany was born in Port Seton, in Scotland, in 1942. His father and both his grandfathers were fishermen. His family, and indeed the whole community in which he grew up, was steeped in dour Calvinism – with its unrelenting emphasis upon toil, sin and the depravity of fallen man. When he was eighteen, Bellany went to study at Edinburgh College of Art. There he and his friends Alexander Moffat and Alan Bold came under the influence of Hugh MacDiarmid, poet and drinker, author of *A Drunk Man Looks at the Thistle*.

MacDiarmid believed in the renaissance and replenishment of Scottish national culture. He dreamed that Scotland might once again make a contribution to European high culture – on its own uniquely Scottish terms. Such ideas influenced the way in

which Bellany thought of himself as a painter. Although he came to respect the teaching of drawing he received at the Edinburgh School of Arts, he rejected what he considered to be the effeteness and parochialism of the still-prevalent traditions of the Scottish Colourists. MacDiarmid's well-known lines – 'I will have nothing interposed / Between my sensitiveness and the barren but beautiful reality' – might have been his motto. Bellany began to look for inspiration in the grand masters of European Realism – Velasquez, Goya, and Courbet. He became a frequent visitor to the Scottish National Gallery, being shaken and challenged by the realisation that Velasquez was only nineteen when he painted his great picture, *An Old Woman Frying Eggs*.

Beckmann became a major influence after Bellany saw an exhibition of his work at the Tate Gallery in 1963. Beckmann's pictures encouraged Bellany in his realisation that ambitious, contemporary realist painting of the kind to which he aspired could transcend the limitations of naturalism through drawing upon a world of potent symbols. All these influences were galvanised when, together with Moffat and Bold, Bellany visited East Germany in 1967. There he saw not only Dresden, Weimar and East Berlin, but also Buchenwald. This visit changed Bellany's painting. For him, Buchenwald became more than the site of an historic holocaust. The concentration camp re-emerges in his paintings as a symbol of humanity fallen irredeemably from a state of grace into desolation, cruel degradation and death.

From the mid-1960s onwards, Bellany's art began to depend more and more on an evocative and shifting cast of symbols – strange, palpable ancestral presences, whose 'meanings' could never be easily or definitively translated into words. Is it, I wonder, mere foolishness on my part to recall that, unique among Protestants, the Calvinists emphasise that the sacraments are much more than simple signs, being rather symbols which are permeated with the real presence of the body and blood of Christ? Certainly the most ambitious picture of this

period is the vast Gothic triptych, *Homage to John Knox*, which consciously evokes the claustrophobia of Port Seton's Calvinism.

In this painting, Beckmannesque imagery merges into memories of Port Seton's fish and fishermen and recollections of the anguish of Buchenwald. For much of the 1970s, Bellany's familiar iconography evoked ships of fools, and feasts of fate in which perception, memory, imagination, history and references to the great masterpieces of the past merged and mingled indistinguishably. I can think of very few contemporary painters who work in a comparable way. Indeed, the only one whose methods seem to me to be remotely comparable is the Australian artist, Arthur Boyd.

Bellany's iconography has been much discussed, with the religious, psychological, sexual and historic resonances of his imagery providing endless food for speculation. Bellany himself refuses to talk about the meanings of specific symbols as he does not wish to tie his pictures down to particular verbal interpretations. He prefers to confront the viewer with something visually engaging and open-ended.

But we should not neglect the other level at which symbolism operates in his paintings: that is through the forms and colours themselves. The way in which Bellany's paintings are actually painted is an inseparable part of their content. Bellany can represent the self-same image – say, a bloody skate or a fish-headed man – in a score of different ways. Sometimes, it may appear almost naturalistic, at others engulfed in a frenzy of expressionistic brush-strokes; or yet again, frozen in the bizarre and stifling stillness of psychotic detachment. The way in which the paint is put down contributes as much to the diverse 'meanings' of Bellany's paintings as the changing imagery itself.

This struck me forcefully when I reviewed Bellany's exhibition held in Birmingham in 1983. At that time, I was not greatly impressed by what were then Bellany's most recent pictures, works like *Confrontation* and *Time Will Tell*. It seemed to me that,

in such works, Bellany's vision was becoming lost in what I called an 'indulgent melange' of loose brush-strokes. I argued that Bellany was in danger of simply discharging inchoate emotions in a way which denied the possibility of bringing about that 'redemption through form' which is necessary to the creation of successful works of art.

I now feel that I was too dismissive of the works which Bellany produced during what were, for him, years of personal agony in the early 1980s. Certainly, when I saw a more extensive retrospective of John Bellany's work at the Serpentine Gallery in London in 1986, I revised my opinions about some of the pictures I had previously seen in Birmingham. *The Gambler*, in particular, struck me as a painting which was not only raw and loosely painted, but vivid and compelling – and, in its own way, entirely successful. *The Gambler* shows a hideous woman with a grotesque head almost like an inflated scrotum, or swollen fish-head, attached to her skull; her haggard breast is bare. She is seated alone at a table, playing cards. What makes the picture truly shocking is that this terrible image has its own undeniable beauty. The handling is so loose that, in parts, it borders on the slapdash, and yet it never goes over the edge. I doubt whether Bellany could have conveyed the feelings he wished to communicate through this painting in any other way. Image, symbols and brush-strokes all convey the idea of life on the brink, teetering close to that moment of loss from which there is no return, yet never quite succumbing to it. The image coalesces with frightening clarity out of the maelstrom of brush-strokes: the old hag has nothing but aces in front of her.

The circumstances of Bellany's life at the time he painted this picture are now well enough known. His first marriage, to Helen, had ended in separation. He married his second wife, Juliet, in 1979, but she suffered from an illness which affected her mind as well as her body. Bellany himself sought solace in drink. In 1984, the nadir of his fortunes, he became seriously ill and was hospitalised. The following year was marked by the deaths of his father and of Juliet.

Bellany's resurrection as both a man and a painter from this low point in his life has been remarkable. He managed to stop drinking and rediscovered his love for his first wife, Helen. They got married again. His work became much more controlled and precise. At times it seemed that his strange birds and fishes looked almost too much on their best behaviour. The versions of Russian roulette he played with his paint brushes began to disappear, but his life still hung in the balance.

The huge picture, *The Presentation of Time (Homage to Rubens)*, which Bellany painted in 1987, is a testimony to the continuing scale of his ambitions and the tenuous hold he had upon life at that time. In this complex painting, which still hangs in the artist's studio, he depicts himself seated, anxiously, at the head of a banqueting table, next to Helen, while Salome offers him a clock upon a platter. A herring gull overlooks the scene with the morbid menace of a vulture.

It was remarkable that Bellany could have painted on such a heroic scale given his physical condition. Even so, the mood of this picture is one of unrelieved apprehension. In 1988 that changed. Bellany was again admitted to hospital and Sir Roy Calne successfully conducted a liver transplant. Bellany realised, ecstatically, that he had been given a second chance at life. 'The day he came out of the intensive care unit,' Calne has written, 'he asked not for analgesics but for paper and paint.'

I am sure that when the dust has settled on the recent history of British painting, the oils and water-colours which Bellany produced as he recovered from his operation will come to be seen as among the most enduring works to be produced in England in the 1980s. They are an extraordinary testimony. It is not an exaggeration to say that paintings like *The Patient II* and *Bonjour, Professor Calne* show the victory of life over death. As always with Bellany, this is not just a question of the imagery and symbols used, but of the way the pictures are painted. A new, glowing lightness enters into Bellany's palette; colour itself becomes the symbol of a life snatched back from the grey silence of the grave. (Perhaps those teachers in

the Scottish Colourist tradition whom he had shunned as a student had taught him something after all.) His brush-strokes now show neither the frenzy of the pictures of the early 1980s nor the meticulous stasis of those painted in the middle of the decade. They flower into a confident exuberance which is not so much life-enhancing as life-proclaiming.

The paintings Bellany produced in the early months of 1990 strike me as even more powerful than those he painted immediately in the wake of his transplant. His mother's death unleashed in him a hymn of praise for the life which he still possessed. There is nothing sentimental in this vision. Indeed, some of the paintings, like those which deal with the familiar theme of Salome's dance, have subject matter which is in some respects even more grotesque than that offered in *The Gambler*. While Bellany never seduces us into feeling that death has lost its sting, the imagery of his *Ancestor* paintings seems to emphasise the continuity of life, passing on from one generation to the next. The shimmering beauties of these pictures celebrate the abundant potentialities of that life.

1990

Adrian Berg

Adrian Berg's 1986 exhibition at the Serpentine Gallery consisted of pictures of parks and gardens painted over the last decade. Many of them are of Regent's Park, as seen from the studio at the top of 8 Gloucester Gate, a Crown property where Berg lived from 1961 until 1985 [*see plate 16*]. Even before the Commissioners encouraged his move a little further south, Berg had been venturing beyond Gloucester Gate more than had been his custom for most of the seventies. In 1980 he was one of a group of artists invited to work in Israel; in 1981, he went to the Lake District where he produced a series of water-colours. He made more the following year, not only in Regent's Park, but also Hampstead Heath. He then started an ambitious series of large paintings based on some of the great parks and gardens in England. In 1983, he began working in the Punchbowl, in Windsor Valley Gardens. He has since made paintings of Kew Gardens, Sheffield Park, the Pinetum at Nymans, and Syon Park.

As I looked at Berg's vast, and, at the time, still unfinished painting of Sheffield Park stretched up in his studio, I was reminded of a remarkable claim made in a recent book on British landscape painting in the twentieth century. The author argued that Graham Sutherland's Neo-Romantic Pembroke paintings of the 1940s had 'brought down the curtain' on a 'long Age of Landscape', opened, apparently, by Constable. The implication was that, since the last war, landscape painting had been an activity suitable for Academicians and amateurs, but hardly for 'serious', or 'avant-garde' artists. Here, I want to argue a contrary view. As the Serpentine exhibition demonstrated, Berg has succeeded in producing landscapes which are original

but also exceedingly beautiful – no mean achievement after the curtain has come down! He has avoided the conspicuous limitations of both the academic and the avant-gardist positions. His landscapes helped me to revise my own views about what is, and what is not worth attending to. I hope these paintings will encourage others to do the same.

Adrian Berg was born in 1929. His father was Charles Berg, a psychoanalyst who wrote a number of books (including *The Unconscious Significance of Hair*), which are now largely forgotten, even within the psychoanalytic community. But Charles Berg seems to have awakened in his son an enduring love of English literature, especially poetry. Berg remembers weekends, during war-time, when, making use of his doctor's petrol allowance, his father would take the family on a drive into the countryside. On the way he would recite Victorian ballads and other poems. In 1930, the family lived in Ormonde Terrace, which overlooks Primrose Hill and is just visible from Gloucester Gate. While Berg was away at prep school he used to create imaginary landscapes in coloured crayons, based on the Park. His preferred subject matter in these early days included kings, playing cards, and Shakespeare.

At both his prep school, and his public school, Charterhouse, Berg won drawing prizes. But, although he always seems to have assumed that he would eventually become an artist, he did not immediately enrol as an art student. After leaving school he studied medicine at Borlands (Tutors) Ltd, but then went to Caius College, Cambridge, where he read English, and to Trinity College, Dublin, where he studied education. It was only after two years' National Service, and two further years teaching at a secondary modern school, that he became an art student at St Martin's. He went on to study at Chelsea and the Royal College of Art. Much of his work at this time consisted of sensitive life studies of naked negroes, which reveal an evident homo-erotic interest. At the College, Berg found himself painting back-to-back with Ron Kitaj, but he was a year ahead of the *annus mirabilis* of David Hockney et alia, which was to make

such a big splash in 1961. Indeed, that Christmas, while easels were going Pop everywhere, Berg moved into Gloucester Gate, where he was to live and work for almost a quarter of a century.

Recently, Berg has said that art students today do not need an *art* education so much as an education. The varied experience of his own formative years was reflected in his first exhibition, held at Arthur Tooth and Sons in 1964. (Even his two years of National Service were recycled in a grid painting called *Baden-Baden*.) Berg's early works have sometimes been associated with Pop art, but neither advertising, nor the mass media, nor 'popular culture' provided him with sources. Rather these paintings revealed an intuitive and imaginative involvement with the concepts of contemporary science. They indicate a critical and analytical concern with empirical experience, and what it tells us about ourselves and the world; an attitude which was to be carried over even into Berg's most intuitive land-scapes.

Like Constable before him, Berg might have complained that there ought to be room enough for a 'natural' painter. Some of his works, like *The Platonic Solids* and *Projective Configurations*, explored mathematical ideas. Others, like *Education*, offered almost an X-ray of the concepts and images within the brain tissue of an adolescent's head. Then, in 1964, Berg painted *This Island Now*, a picture named not not so much after the famous line from Auden's poem, as the title of the 1962 Reith Lectures, by Professor G. M. Carstairs. This Professor of Psychological Medicine had created a nation-wide storm when he suggested that pre-marital sexual experience could, on occasion, lead to happier marriages. But Berg's complex picture was based on a passage in which Carstairs argued that, in the future, computers would do all the tiresome storing of factual information and thereby leave men and women free to study scientific hypotheses, cultivate literature and the arts, and develop a deeper understanding of themselves.

Perhaps Berg was also influenced by a passage where Carstairs referred to the way in which, in the modern world,

even the arts were becoming 'stereotyped and internationally interchangeable'. He referred to the 'depressing uniformity' of American-inspired abstraction and argued that such art involved 'a sacrifice of emotional significance'. According to Carstairs, an artist was 'most effective' when his experiences were linked with a particular place and time. Berg's 1964 exhibition contained his first 'fragmented' images of Regent's Park.

Throughout 1962, while working on his paintings about science and ideas, Berg had struggled to paint the landscape he could see through the windows of Gloucester Gate, but he did not succeed. It was only the snow which fell in January 1963 that, in Berg's words, 'sorted everything out' enough for him to paint it. Berg's next show, in 1967, still contained more pictures that were based on maps, like *Europe by Rail*, 1966, than on perceived images of the territory, like the beautiful *Spring, Gloucester Gate* of the same year. Certain elements, like the grid, were carried through from the maps and game-board pictures to the landscapes proper. Thus Berg's pictures of trees and the Park were never ordered according to the received conventions of focused perspective, but rather through multiple imagery, which allowed for the inclusion of many experiences common in life, but rare in a single painting, such as the experience of the same landscape over a long period of time. In a brief catalogue footnote, Berg commented, 'Time was when a painter could with a title invoke whole mythologies, whether Christian or pagan. Now he has only fragments of a mythology, called art or science or in this green island, nature.'

Two years later, Berg had a second exhibition at Tooth's consisting of nothing but recent paintings of Gloucester Gate. In many of these, the fractured framing of the picture surface was more complicated, and more pronounced, than ever before. Some of these canvases contain their own time, in much the same way that, in certain medieval paintings, different episodes of the same story appear within a single landscape. Only in Berg's case there are no figures and it is the landscape which

changes. Perhaps we should not exaggerate the conceptual aspect of these grid divisions. One advantage of this compositional convention is simply that the grid enabled Berg to *assemble* a landscape in a way which did not exclude the immediacy and freshness of perceived moments. All this helps to explain one of the paradoxes of his Gloucester Gate paintings: although they seem to reflect that sense of fragmentation and transitoriness which we associate with modern consciousness, we also feel that Berg has somehow patterned his momentary perceptions into new and rhythmically satisfying wholes.

And now I fear the moment has come to declare a personal interest, for it was while Berg was working on these pictures that I moved into rooms below his, at 8 Gloucester Gate. At the time I was struggling to establish myself as an art critic, and the first piece of any length for which I was actually paid was a profile of Berg I wrote for *Arts Review*. Elsewhere, I have described the way in which this fact later made me wonder whether my response to Berg was not a sentimental one. After all, I, too, had been deeply affected by the same patch of Regent's Park, over which I had heard the wolves howling at night. That was also a time when influential writers, like John Berger, were encouraging impressionable and 'radical' young art critics to believe painting was dead.

I am sorry to say that, in those days, my taste was still too uncertain to escape the winds of fashion. It took me some time to reconcile what I felt I ought to believe, with the delight and instruction which I derived from Berg's painting. For me at least, the fashionable art of the 1970s eventually palled. But long after I had left Gloucester Gate, I found myself coming back, again and again, to look at what Berg was doing. He was working entirely within the traditions, disciplines, limits and skills of painting. His subject matter was, according to his critics, exceedingly narrow. And yet his work always seemed fresh, varied, and full of discoveries, whereas so much of the art which I was required to view was sterile and repetitive.

In 1973, Berg sent me a copy of something he had written in

which he tried to distinguish between 'critical' and 'creative' attitudes to thinking and looking. The problem for the latter, he acknowledged, was that, in the end, 'one's senses alone convey to one the significance of what one sees. This is reality, or the only reality one knows.' There was, however, a way out. 'The senses,' Berg wrote, 'can be shamed into conveying a more truthful account of the external world. Shown a picture of that world (their product, arrived at by skills they have developed), the senses are made to compare this artifact with nature, that is, with what they now make of that same world.' He added, 'A process which has to be repeated: comparing, correcting. It had better be if one is to continue to paint.' This characterised Berg's work throughout the 1970s, and beyond.

I remember that when I first saw the paintings for Berg's last exhibition at Tooth's in 1975, I was shocked. I had become used to the sophisticated conventions through which Berg fractured his surfaces, but most of his 1974 pictures were not like that at all. Berg had gone down into the landscape and painted pictures which were almost 'painterly' sketches. But I soon saw that, though very different from the grid paintings, these works, too, were intensely beautiful. They had about them a lushness, a celebration of the richness and abundance of vegetable growth, which had been only a muted accent in his earlier work.

His Serpentine exhibition opened with some of the paintings from the late 1970s, in which Berg successfully combined his techniques of multiple imagery with this sense of at times almost over-abundant growth. In works like *Gloucester Gate, Regent's Park, Autumn/Winter/Spring*, 1977, or *Gloucester Gate, Regent's Park, February, March, April, May and June*, of the same year, Berg's painting seemed to acquire a new authority. It was as if he was no longer inviting us to search the familiar landscape with him, yet again, but revealing to us all that he had already found there.

Yet Berg has never been able to rest content with such revelation for long. The process of 'comparing and correcting'

took over again. Several paintings he had produced in the early 1970s had shown a preoccupation with the spatial limitations of a single viewpoint, rather than with perception of the landscape *through time*. In 1978 these special concerns came to the forefront. Nowhere are they more evident than in *Gloucester Gate, Regent's Park*, of 1978, a picture which now hangs in the European Parliament. In this work, the view from the roof of the park is, as it were, splayed out around the four sides of the canvas, and we are reminded of the way in which Berg's familiar trees form part of the urban landscape. Another picture, *Gloucester Gate, Regent's Park, Autumn*, of 1980, now owned by the British Council, fuses together the view Berg obtained when he looked first to the west, and then to the north. About this time, Berg also produced his 'long' water-colours, stretched horizontally to take in far more than a single observer could ever see in a single gaze. The making of these water-colours helped to keep the spatial paintings fresh, and 'spontaneous', despite the elaborate compositional artifices.

Again, like the time-based pictures, Berg's ruptures of perspective are based as much on intuition as on calculation; on the demands made by the picture, as much as those posed by the world 'out there'. His visit to Israel, in the midst of these experiments, triggered off in him a sense of 'abstract' rhythm and pattern which, though always present in his work, had not been prominent since the mathematical pictures of the early 1960s. This can be seen in *Jerusalem* and *Marrakech*, of 1980, and also in many of the Gloucester Gate pictures of the early 1980s.

Berg vividly described this decorative sense in his self-interview of 1980. He spoke about the way in which the weather sometimes compelled him to ignore the external cycle of the seasons, and to look for other rhythms. 'On dull days,' he said, 'I don't look out, so I look in and attend to the formal problems of painting – what people who are not artists probably mean when they use the term "abstract". These get neglected looking only at nature . . . In repeating an image I've had on my hands not so much a composition as a pattern.' He went on to explain

that the flatness of most pattern, as in, say, a Persian garden carpet, was relieved by the perspective one made walking towards and across it, but the same carpet on a wall could be 'as boring as anything in the Tate'.

'Something designed to be seen on a wall,' he said, 'has to be supplied with its own perspective devices, and these have to be harmonious with the direct flatness of painting.'

Berg was not, of course, announcing a 'conversion' to abstraction. We need not be surprised to discover that in 1984 he plunged back into immediate perception of the landscape. Indeed, that summer, he took to visiting Kew, where, day after day, he forced himself to complete a small canvas. The effect on his work was similar to his decision ten years earlier to leave his studio window, and go down and paint in Regent's Park itself. The Kew paintings, shown at the Piccadilly Gallery in 1985, have a renewed intensity and vividness, especially in Berg's depiction of the blues of the sky and the lake.

A great strength of Berg's painting is that he never leaves go of any dimension of his work; he is always going back and reworking old pictorial conventions in the light of new experiences and discoveries. One of his most successful 1984 works was *Gloucester Gate, Regent's Park, May 1984*, a picture based on a three-way point of view, displaying an intensity of pattern beyond that which could ever be 'seen', but shimmering with the fullness of a glorious colour. Nowhere is this capacity for synthesis more evident than in the great paintings of the last three years. Berg is now prepared to take all that he learned through seeing and depicting the landscape of a section of Regent's Park – and on his occasional excursions – and to apply it in the painting of subjects before which any painter has a right to feel daunted.

How then are we to assess Berg's achievement? I began by suggesting that, in my view, his work evades the limitations of both the academicist and the avant-gardist positions. Academicians and amateurs have, by and large, followed the advice which Sir Alfred Munnings laid down in his notorious, if

inebriated, Presidential Speech at the Royal Academy Dinner of 1949, when he denounced 'this so-called modern art'.

'If you paint a tree,' Munnings said, 'for God's sake try and make it look like a tree, and if you paint a sky, try and make it look like a sky.' Since then, 'avant-gardists' have been prepared to do all sorts of things to the landscape – to walk through it, move stones about or tie up twigs within it; photograph it; map it – anything, in fact, except to paint it. And least of all, to paint it in such a way that a tree looks like a tree, or a sky looks like a sky.

I have to confess to an unfashionable preference for Sir Alfred Munnings rather than Richard Long. Even so, both their positions seem unnecessarily reductionist. I like to think that Berg's work confirms the view expressed by T. S. Eliot that there can be no originality except on the basis of tradition. (Berg himself once spelled out an important proviso to this: 'What one has to do, as T. S. Eliot nearly said . . . is to make up one's own tradition.') Berg's landscape painting is, I believe, at once traditional and original.

It is traditional in its affirmation of painting as a discipline worthy of a man's best efforts. Berg is a painter who knows the value of drawing as a way of seeing. His work is enmeshed with the painter's enduring concerns: the development of an awareness of colour, the understanding of natural forms, composition, and those formal or abstract dimensions of picture-making which are not 'given' in the view. It may sound at first like a paradox to say of someone who has devoted so much of his life to painting the same patch of landscape that his originality depends, in part, upon his rejection of specialisation; but I believe this to be true.

At a time when specialisation is the order of the day, Berg has refused to reduce his painting to any of its constituent parts. He is as involved with appearance as any follower of Munnings. Colour is as important to him as it is to those who have declared that colour is the only direction for painting today, and he is as deeply concerned with 'ideas' as any Conceptualist. Some

commentators have emphasised the analytic, even 'linguistic', elements of Berg's painting; others have written of the imaginative and intuitive aspects of what he does. Both are right. Berg's work shows an intelligence of feeling which is rare in contemporary art. He has held out for the distinctly unfashionable view that even in this island now, *painting* can be not only a source of aesthetic pleasure, but also a means to intuitive knowledge about the self and its relationship to the external world.

'A great deal of modern art,' Berg once said, 'looks to me like the end of an argument I was never in at the beginning of.' I have already admitted that his paintings helped change my own mind about what matters and what does not matter in recent art. But for many, Berg may still seem to suffer from parochialism. They should give themselves pause to consider whether – when combined with a stubbornly questioning way of seeing – parochialism cannot be a great source of strength. This would seem to have been the case for Samuel Palmer in Kent, Monet in his gardens at Giverny or Cézanne at Mont St-Victoire. Constable, too, eschewed the fashionable art of his own day, and indulged his 'overweening affection' for the banks of the Stour.

I am not trying to claim that Berg is necessarily a painter of this stature. Nonetheless, I would insist that in an era of widespread reductionism and false 'internationalism', his stance of 'informed parochialism' has served him well. It is possible that back in the 1960s, Berg, like Constable before him, believed that through his 'natural', or scientific, painting he was driving a nail to secure realism: that is, 'a more truthful account of the external world'. But Berg, again like Constable, ended up by producing paintings which are not simply 'objective' studies, but rather imply an ethical, even spiritual, stance towards the world they depict. Perhaps the curtain has not quite come down on the age of landscape painting after all.

1986

David Blackburn

It says something about that state of institutional taste in Britain that David Blackburn is so under-represented in the leading national collections of post-second world war art, and that his name hardly features in the standard art histories of the period. For Blackburn is, I believe, one of the most original landscape artists at work in Britain today. This was recognised by the Yale Center for British Art, who held a major exhibition of his work in 1989. [*See plate 10b*].

At least Blackburn's pastel drawings have never lacked influential supporters. Every article ever written about him reminds us that, in 1978, the late Kenneth Clark opened an exhibition of Blackburn's at York University and praised him as 'a great artist'. Clark also added that Blackburn had not 'yet received recognition'. A decade later, despite the fact that his work is sought after by a circle of discriminating collectors in Britain, America and Australia, this situation has not radically altered.

In part, this may be because Blackburn has always chosen to work in a way which is, as Clark himself put it, 'absolutely independent from all the tricks, mannerisms and fashions of the art of our time'. And yet, despite his stubborn refusal to toe the shifting lines of today's academies, Blackburn's images – like all works which are truly original, and not merely novel – belong to a definite, identifiable tradition. Patrick McCaughey has described this as 'the tradition of the landscape sketch'. I would prefer to define it as a tradition of higher landscape painting. By 'higher' I mean a way of painting landscape which, though it retains its roots in empirical perception, is concerned not so much with appearance as with symbol and sentiment.

In Britain, a tradition of work of this kind can be traced back through Samuel Palmer, Constable and Turner, into the late eighteenth century. Conventional wisdom argues that this line came to an end in the 1940s – usually, it is said, with the great, visionary landscapes of Paul Nash's last years. But I believe that this tradition has persisted and given rise to work of outstanding quality, of which Blackburn's is a pre-eminent example. This is not to say that Blackburn's work is 'nostalgic', in the negative sense of that word. His pastels are filled with a sense of freshness and wonder, as if, like a child, he is seeing everything for the very first time. But there is nothing 'infantile' or even Expressionist about his way of working. Blackburn's recent drawings are informed by a sense of order, serenity, and calm transcendence, which almost belongs to a classical rather than a Romantic sensibility.

These days, art historians are already beginning to reassess the art that has been produced in Britain in the last forty years. They are slowly realising that an indigenous higher landscape tradition was not wiped out by the advance of the twentieth century. Soon perhaps, they will come to accept that this tradition has, in fact, nurtured work of greater stature and beauty than that which was thrown up by the fashionable fads and fancies which have gained so much attention. In this situation, it seems certain that, sooner rather than later, the work of David Blackburn will be re-evaluated.

Blackburn was born in Huddersfield in 1939. His parents were devout Methodists, and from them he inherited a single-mindedness of purpose and a belief in the value of dedicated, even obsessive, work. I don't think it is just fanciful to suggest that from this background, too, he derived a spiritual feeling for the natural world which has survived the waning of his religious convictions.

The landscape in which he spent much of his childhood was certainly formative. Yorkshire has nurtured some of the most distinguished British artists of this century, including Barbara Hepworth, Henry Moore and David Hockney. Like them,

Blackburn widened his horizons through both travel and involvement in cosmopolitan traditions of art, but to this day he maintains a studio in Crosland Moor, a suburb of Huddersfield. There is an important sense in which he has remained a British, northern artist. The Colne Valley is a region where the industrial city and the rolling hills mingle and at times merge. Although Blackburn's primary interest has always been in the natural landscape, several of his drawings – especially a series made in the late 1970s – reveal that this fusion of man-made and natural forms possesses a peculiar poignancy for him.

From 1959 to 1962, Blackburn attended the Royal College of Art in London, making him a contemporary of R. B. Kitaj, David Hockney, Allen Jones, Peter Phillips, Derek Boshier and Patrick Caulfield – a generation of students who were associated with a much publicised new wave of British Pop painting. This period at the College is often regarded as a watershed in the history of British art. From this time onwards, American influences (both Abstract and Pop) and the mass media appeared to submerge the Romantic art which had undergone such a renaissance during and immediately after the second world war.

And yet the importance of 'Royal College Pop' may have been exaggerated. Many of the most talented painters, such as Hockney and Kitaj, were good *despite* their involvement with the new movements rather than because of them. Others, including Blackburn, were ignored, simply because they were relatively unaffected by all the razzamatazz of the new styles. Interestingly, Blackburn has often said that the most significant influence upon him while he was at the Royal College was Gerhardt Frankl, a Viennese artist from whom he learned the techniques of working in pastels which have been so important to him ever since. Such a way of working has nothing to do with the fascination with the mass media and its methods which was so prevalent at that time, and yet it eventually enabled Blackburn to develop techniques which are entirely suited to his aesthetic purposes.

Equally significant, however, was Blackburn's meeting with

Kenneth Clark, who was to become a friend and patron. Clark had been deeply involved in the British Romantic renaissance of the late 1930s and 1940s. He was, for example, behind the revival of interest in the late Turner, the reassessment of Constable (whom he saw as at once the most 'English' and 'universal' of artists), and the rediscovery of Samuel Palmer. Clark was also influential in the rehabilitation of John Ruskin as an alternative to the narrow aestheticism of Roger Fry and Clive Bell. Clark had done much to advance the reputations of a wide range of contemporary artists whose work could be understood in terms of a modern Romantic tradition, including Henry Moore, Victor Pasmore, John Piper and Graham Sutherland. Of these, Sutherland's spiky Pembrokeshire landscapes had the greatest effect on the young Blackburn.

Sutherland had always admired Palmer for his vision of a world metamorphosed through feeling. This imaginative approach to landscape was to prove vital to Blackburn, as well. Blackburn's art has always been an art of metamorphosis, transformation and allusion, as opposed to illustration, topography and illusion. Pastels may be so important to him because their dry fluidity allows him to engage in a process of metamorphosis through drawing in the most direct and immediate way.

By the time he met Blackburn in 1962, Clark's influence over the most prominent younger artists had already begun to wane. Clark stood for the idea of a developing, indigenous tradition, which formed part of a wider, evolving European civilisation. But this position seemed to be swept aside by an indiscriminate enthusiasm for new technologies, mass media and Manhattan. One of Blackburn's greatest strengths as an artist may be that he remained faithful to Clark's values. For example, in 1963, when most of the ambitious artists of his age were saving up to buy tickets to New York, Blackburn chose to make an extended tour of Europe. There he was especially moved by the idyllic landscapes of Claude, a major influence on his work ever since. Then, under Clark's influence, Blackburn made an inspired

decision which was to have even more far-reaching effects on his work: he went to Australia.

I have recently argued that the achievement of Australian painters in the 1940s and 1950s has been woefully under-estimated by art historians. I believe that the development of 'higher landscape' painting, which had become obscured in Britain, persisted there in compelling and original ways. Clark himself was very well aware of this. Before he visited Australia, he seems to have felt that this landscape tradition was coming close to extinction. Modern science, he argued, had exposed as an illusion the idea that nature was harmonious and beneficent. But, in Australia, Clark discovered a new landscape painting. The potent imagery of the desert, a literal wasteland, possessed a poignancy for the modern world simply unavailable to the exhausted English pastoral.

Blackburn was influenced by the Australian painters, Arthur Boyd and Sidney Nolan. He borrowed from Nolan the idea of working in sequential series of images, rather than through single works designed to stand entirely on their own. This idea of the sequence has remained important to Blackburn ever since, but he also seems to have found in Nolan the idea of the desert as Paradise, an idea which was later to become of central importance to him. Blackburn rediscovered this for himself through his own experience of the terrifying yet infinitely seductive landscape of Australia. At the core of his vision is an image of the wasteland transformed and transcendent, of the desert providing a glimpse of a promised land.

Between 1963 and 1966, Blackburn produced a series of twenty-one black-and-white chalk drawings on the theme of Creation. These drawings try to capture the way in which, in nature, light emerged out of darkness, order out of chaos, and natural forms out of formlessness. The series continues with the emergence of human forms, conspicuously absent from most of Blackburn's work. (For him, as for Sutherland, trees often play the parts of figures.) Despite the ambitiousness of the project, Blackburn's work is devoid of rhetorical distortion.

Indeed, in aesthetic metamorphosis, the key to these drawings, Blackburn seemed to find a convincing equivalent for the creative processes of nature herself.

Twenty years later, these works seem to possess a prophetic power. I do not think it is entirely fanciful to suggest that they point towards how, in the 1980s, science began to reveal the way in which the myriad natural forms, of infinite variety and complexity, emerged out of the combination and recombination of elements of great simplicity. Soon after completing these works, Blackburn returned to England and began lecturing at the School of Architecture at Manchester. There, he produced his *Metamorphoses*, another series in which the transformations have a more architectural feel. Façades shift and open up into ambiguous, illusory spaces and flat surfaces become great vistas.

In retrospect, it is easy to see how the formal devices explored in the *Metamorphoses* heralded a change which was taking place in Blackburn's sensibility. Hitherto, he had certainly retained something of the pessimism of the Neo-Romantics. There was a suggestion of primeval darkness in his work; a tortured and twisted vegetable life and a spiky wilderness. Many of his drawings echoed something Ruskin complained of in Constable: a persistent feeling of 'great-coat weather', no doubt exaggerated by Blackburn's preference for working in black-and-white. But from 1970 onwards, colour suddenly becomes the key to his work. Blackburn himself has described this change as walking out from the cave onto the plain. It is easy to see what he means. He loses his interest in depicting the world of darkness out of which light emerged, and concentrates on the light itself.

Australia once again seems to have been important in all this, for Blackburn kept up his association with this strange and alluring continent. It is almost a cliché to speak of the quality of light in Australia, but anyone who has experienced it will know that it is quite different from that which can be experienced in Huddersfield, or, come to that, anywhere else. Australian light

is uncompromising; it is a light which dispels the envelope of atmosphere and the nuance of shadows. We need not be surprised that, as Blackburn's association with Australia deepened, that sense of 'twilight', so vital to the English Neo-Romantics, disappears altogether from his work. Clarity of light becomes his literal and metaphoric goal. There is no doubt that the pictures of Fred Williams, perhaps the greatest post-second world war painter of the Australian desert, played a part in Blackburn's transformation. Williams's art was rooted in obser-vation of the Australian landscape, but he also drew heavily on the new ideas about abstraction which were emerging in America. Williams's example – and that of the Spanish Abstract painter, Antoni Tapies – encouraged Blackburn to try to find his own formal solutions to the painting of a landscape which offers no foreground, middle-distance and horizon, but only an endless vista of space.

Williams, like Blackburn, was also interested in oriental art. Blackburn has responded to Chinese ceramics and landscape painting, in particular, for their calm and harmonious sugges-tion of a transcendent reality. He has often said that he wants his pastels to have some of the quality of a Sung vase. His use of a surface calligraphy over a great expanse of coloured space is also derived from oriental painting. And yet, with Blackburn, this pillaging of Eastern painters rarely descends into man-nerism.

It is possible to exaggerate the importance of oriental in-fluences on Blackburn. There is also something very English, something which Ruskin would have approved, about his love of a beautifully crafted surface, a fine and detailed sense of 'finish'. In his little book *British Romantic Artists*, John Piper argued that Romantic art deals with the particular. He wrote that Bewick's particularisation about a bird's wing, or Turner's about a waterfall or a hill, was 'the result of a vision that can see in these things something significant beyond ordinary signifi-cance: something that for a moment seems to contain the whole world; and, when the moment is past, carries over some

comment on life or experience besides the comment on appearances'.

Blackburn's details – his leaf-forms and spiders' webs across the surface – evoke just such feelings in me. It is often as if Blackburn does not wish us to know whether he is painting a whole or one of its parts, an aerial landscape or a microscopic slide. But always in his work, we glimpse the universal through the specific. In his own poetic and metaphorical way, Blackburn appears to touch on something close to the principle of 'self-similarity' elaborated by modern mathematicians. For example, Benoit B. Mandelbrot has explored the fractal geometry of nature, and pointed towards the scientific truth of the Romantic insight that the whole world is contained in a grain of sand.

Paradoxically, this may be why a sense of place is not of ultimate importance to Blackburn. He becomes involved with the particular in order to reach beyond it. These days, it is the landscape of America which seems to be exerting an increasing influence over him. Certainly, the architectural lay-out of the great cities has affected him as it is said to have affected Mondrian, but he has responded most warmly to America as depicted by Albert Pinkham Ryder and Marsden Hartley. Some of the most recent paintings in this exhibition are inspired by the landscape of Maine, in the midst of Hartley country.

And so Blackburn's pastels involve a very personal synthesis of elements drawn from European classical landscape; oriental art; English, Australian and even American Romantic traditions. He brings all these things into a new and convincing unity through a confident, seemingly faultless, sense of plastic form, and a feeling for colour rare in anyone, but especially in a northerner. (In British art, perhaps, only Norman Adams can be compared with him in this respect.) What binds everything together in Blackburn's work is his longing to pass through the appearances of things and offer the viewer an imaginative vision of that harmonious and transcendent reality which lies behind them. In the end, we may want to admit that the idyllic world which Blackburn reveals is only an illusion. Even so,

these pictures belong to what Herbert Marcuse once called 'the cosmos of hope'. For the kind of illusions they encourage in us are those upon which spiritual life, perhaps civilisation itself, depends.

1989

Anthony Caro

'Anthony Caro,' writes Timothy Hilton, opening a review of Diane Waldman's monograph, 'is the most distinguished living British artist . . . By common consent, he is a master. The artistic justice of his innovation is unquestioned.' Judging by the bland orthodoxy of her text, Diane Waldman would agree. But the review, like the book itself, is typical of that tendentious dishonesty in which Caro's art institutional friends have indulged for years.

The promotion of Caro has always involved an implicit, if not explicit, demotion of Henry Moore, but beside Moore, Caro remains a mere upstart in sculpture. Moreover, I believe that far from being a 'master', Caro was a Judas among sculptors, the betrayer of the tradition he inherited. Indeed, though Waldman is careful to give no hint of the fact, 'the artistic justice' of Caro's innovations has never been more vigorously questioned than today. The facts about what Caro did have been repeatedly chronicled and are not seriously disputed. Caro studied engineering at Cambridge, and later learned the rudiments of sculpture under Charles Wheeler, a Royal Academician; between 1951 and 1953, he was an assistant to Henry Moore. For much of the 1950s, he was an Expressionist sculptor of moderate ability – just how moderate can be seen in such works as *Woman Waking Up*, now in the Arts Council collection. But, in 1959, Caro met Clement Greenberg, an influential critic of American Abstract painting. Thenceforth, by his own confession, everything changed.

That same year, Caro went to America where he met up with 'Post-Painterly' Abstract painters like Kenneth Noland and Jules Olitski. He also became acquainted, for the first time, with

David Smith's sculpture. When he came back from America, Caro demonstrated in *Twenty-Four Hours*, of 1960 [*see plate 19a*], that he had found a new set of stylistic clothes. This piece consisted of three flat steel planes set up in a relentlessly frontal arrangement. One of them, the circle, carried a specific reference to Noland's 'Target' paintings.

Caro demonstrated that he was determined to jettison the imaginative, or image-making, component of sculpture altogether. He went 'radically abstract' and eschewed all reference to anthropomorphic or natural form. He gave up drawing and traditional sculptural techniques, like carving and modelling, in favour of the placement of preconstituted, industrial elements (like I-beams, tank-tops, and sheet steel), which others joined together for him by welds. His work ceased to show any of the sculptor's concern with mass, volume, the illusion of internal structure, or the qualities of his materials. Frequently, his wife covered the steel elements with coats of brilliant household paint, so the metal appeared as weightless as plastic or fibreglass. He abandoned the plinth or pedestal, and engaged in a kind of three-dimensional drawing with lines and planes in space. The objects he produced bore precious little resemblance to anything which had previously been recognised as sculpture.

Perhaps because Greenberg had been so intimately involved in his 'conversion', Caro soon attracted the attentions of American academic and institutional Formalist critics. Greenberg had declared, 'He is the only new sculptor whose sustained quality can bear comparison with Smith's.' Michael Fried rubber-stamped this estimate in numerous catalogues and articles. Later, a book-length study by Richard Whelan appeared, to be followed soon after by William Rubin's monograph, issued at the time of the Museum of Modern Art's Caro retrospective in 1975. In 1982 came Diane Waldman's full-scale volume, lavishly illustrated with 300 plates. In addition, Caro's German dealer had recently issued a four-volume *catalogue raisonné* of his work, edited by Dieter Blume. Never before has so slight a sculptural achievement been so prodigiously documented.

Even in terms of existing Caro studies, Waldman's text is a shallow piece of work. It is hard to identify any facts or arguments in it which have not already been expressed in print elsewhere. The author has nothing new to say about how Caro's work developed from one piece to the next, even though this is the only subject she has anything to tell us about. Her descriptions of the sculptures themselves often read as if they had been taken from a Meccano instruction manual. Even when she strikes an evaluative note she remains unconvincing.

She writes of *Orangerie*, which is probably one of Caro's best pieces: 'This is a rare work indeed, in which perfectly conceived and executed parts are crystallized to form a breathtaking and culminating visual statement.' One feels, however, that her breath has not been taken. There is no indication that she has ever been moved by the work she is discussing. She writes as if she knows it is her duty to present the goods in this way. Her language has the tone of the motor-manufacturer's brochure, or the estate agent's hand-out. This does not incline one to accept her value judgements.

But very little that has ever been written about Caro has the ring of authentic criticism. With the exception of Greenberg, Caro's American protagonists all appear to assume that the aesthetic value of his work can somehow be equated with his novel devices. For example, Waldman constantly refers to what she calls Caro's 'advanced' style, whereas she criticises Charles Wheeler, Caro's academic teacher, for his 'reactionary forms'. Nonetheless, it remains a moot point who is actually the better sculptor.

The central question, which none of Caro's Formalist critics ever address, is 'What, in terms of sculpture, was the value of Caro's innovations?' It is no use saying, as Hilton does, that their 'artistic justice' is 'unquestioned'. It isn't. There are those, myself included, who believe that good sculpture depends upon the conservation of certain basic modes and practices. Caro violated the fundamental limits of this art form – with disastrous effects on his work, and that of his followers.

Nor am I alone in this view. Henry Moore certainly had his erstwhile assistant in mind when, in the early 1960s, he pointed out that 'a second-rater can't turn himself into a first-rater by changing his medium or his style'. The following year, Moore warned against 'change that's made for change's sake'.

'We're getting to a state in which everything is allowed and everybody is about as good as everybody else,' Moore said. 'When anything and everything is allowed both artists and public are going to get bored.' He added, 'Someone will have to take up the challenge of what has been done before. You've got to be ready to break the rules but not to throw them all over unthinkingly.' At this time, Moore repeatedly stressed that 'sculpture is based on and remains close to the human figure'. Work which just consisted of the arrangement of 'pleasant shapes and colours in a pleasing combination' (like Caro's) was just 'too easy'. Moore affirmed the 'full spatial richness' of true sculpture, and its rootedness in a 'humanist-organicist' dimension which could be opposed to the 'false and impermanent' values of a 'synthetic culture'.

Why, then, if Caro's innovations were bereft of any enduring sculptural or aesthetic qualities, did they attract so much attention, and exert such an influence? At the simplest level, they appealed to art world *cognoscenti* as literary and ideological exercises, or entertaining three-dimensional illustrations of what were once highly fashionable art-critical theories. Beyond that, however, the interest in Caro has always seemed to me (as it appears to have done for Moore) to have had a lot to do with the way in which his works simply mirror the 'false and impermanent' values of that 'synthetic culture'.

Elsewhere, I have tried to show how all manner of cultural factors led to the overestimation of Caro's achievement, from the time of his first one-man show at the Whitechapel Gallery in 1963. It was not just that Late Modernism's quest for stylistic novelty was reaching a peak. There was also a widespread belief in Britain that everything new (and therefore 'good') in art somehow had to originate across the Atlantic. Beyond that,

1963 was a year in which it seemed that some radical cultural transformation was about to take place in Britain. In the Profumo Affair, the old men of British politics were swept off their plinths. Harold Wilson, the Labour leader, spoke with enthusiasm about the 'scientific and technological revolution', and there was much talk of the nationalisation of steel. On all sides, one could feel this cult of newness. In Liverpool, the Beatles made their first appearances. The nation was shaken by the *Honest to God* affair, when the Bishop of Woolwich caused a national scandal with a popular book about 'Death of God' theology in which he argued against the anthropomorphic conception of the deity, and recommended bringing God down off his pedestal to reconstitute him as 'the ground of being'.

Now it has sometimes been said – not least of all by Caro himself – that I criticise him for his lack of 'social' or 'political' content. This is just nonsense. My point is quite the reverse. I believe that his work was much too timely. It is awash with the transient *Zeitgeist* of the swinging sixties; and, as it lacks any potentially enduring residue of real aesthetic or sculptural quality, I believe that it will, sooner or later, be quietly forgotten, like so much once-fashionable art of the past. Caro's work did not simply fade away as quickly as it had sprouted up, because Caro himself became something of an institution.

Unlike Henry Moore, Caro never commanded much of a following beyond the confines of the art world. Within that world, however, the emperor was widely believed to be wearing resplendent clothes. And Caro was able to reinforce his influence on a generation of younger sculptors through the pedagogic base he established at St Martin's School of Art in Charing Cross Road. What happened at St Martin's remains one of the saddest episodes in the chequered history of British post-second world war art education. Eager and talented sculpture students came to the school from far afield, but the rudiments of true sculpture ceased to be acknowledged there. Drawing, carving, and modelling fell into decline. Students were not encouraged to look at nature, or, for that matter, at

Henry's Moore's work. Welding, and steel construction, were taught as if they were the only way forward. There is no doubt that many talented students were effectively destroyed by this 'teaching'. Certainly, no sculptor of merit emerged from the school.

But the dogma spread, and became endemic in many British and American sculpture departments. It was even exported to the Antipodes by Ron Robertson Swann, who had met Caro when they were both assistants to Henry Moore. Swann's imitations of Caro's welded pieces, and those of his various pupils and imitators, now proliferate throughout Australian provincial art museums.

Caro's work and teaching, however, had effects he did not anticipate. By rejecting the image, mass, and volume, and throwing out carving and modelling, by deserting traditional materials in favour of prefabricated industrial components, and severing the relationship of his work to nature and the human body, Caro had abandoned almost everything that was truly sculptural. And yet he insisted on 'the onward march of art', the need for yet more stylistic reductions. Inevitably, many of his pupils at St Martin's felt encouraged to take things one stage further.

Some, like Barry Flanagan, began to present unworked substances and matter as 'sculpture'; others started to engage in activities like photography, and performance. Predictably, by the mid-1970s, William Tucker, a colleague of Caro's at St Martin's, was complaining that most students were so busy digging holes in the ground, or 'cavorting about in the nude' that it was impossible to get them to make anything at all. But, like Caro, Tucker seemed unaware of the fact that such antics were the inevitable outcome of that tragic reduction and dissolution of the truly sculptural which Caro had initiated. Indeed, it is becoming increasingly apparent to many younger sculptors and critics that there is an anti-aesthetic, anti-sculptural continuity which runs from Caro's *Twenty-Four Hours* of 1960, to the works of his pupils like Gilbert and

George, 'The Living Sculptures', who once made a video-tape of themselves getting drunk, which the Tate was foolish enough to acquire.

Although such considerations are not even reflected in Waldman's book, they are certain to have an effect on all future Caro studies. No serious critic will ever again be able simply to assume the sculptural value of what Caro did, since the orthodox, Modernist view of sculpture, which Waldman briefly sketches in the opening pages of her monograph, is becoming untenable. Waldman argues that sculpture could only realise itself by becoming free from representation, 'physicality', monumentality, and any association with architecture. For her, Renaissance sculpture is somehow inherently inadequate because it has not been cut loose from 'the prison of its own physicality'. Modernism emerges as the great redeemer which finally liberates sculpture from the unfortunate constraints under which it has laboured since the beginnings of human history . . . and Modernism achieves its apotheosis in Anthony Caro.

'In shedding his past with such conviction,' Waldman writes, 'Caro was able to make that extraordinary leap into his own time and to free himself to experiment with form as though he were seeing its potential for the first time.'

To me, this seems to misrepresent what sculpture is and what, at its best, it can be. Sculpture no more needs 'liberating' from representation and physicality than poetry needs 'liberating' from rhythm, meaning and language. Nor is it easy to see why the human figure, or indeed 'physicality' itself are things of the past, of no relevance to our time and place. Whatever it gains from its own time, good sculpture is always rooted in certain relatively constant elements of human being and experience which do not change greatly from one moment of history to the next. (This is one reason why the sculpture of the ancient Sumerians and Egyptians remains immediately accessible to us.) By stripping his work of such elements Caro handed it over to the transient ideologies and cultural epiphenomena of our contemporary 'synthetic culture'.

It is perhaps worth asking if, although Caro abandoned sculpture, he did not stumble upon some quite new art, worthwhile in its own right. The litmus test is always the yield of aesthetic pleasure one derives from a given work, and there is no doubt that, at times, some such pleasure is to be derived from a Caro piece. But since, as Waldman herself states, Caro's art is neither 'metaphorical nor descriptive', such pleasure is invariably slight to the point of triviality. It depends, as Moore saw, merely on the pleasing arrangement of certain shapes and colours in space. In this respect, Caro's art does not differ radically from that of a talented window-dresser, or pyro-technics designer.

Increasingly, however, younger sculptors are turning to what Moore called 'the challenge of what has been done before'. They are rediscovering imagery, the human figure, carving, model-ling, and traditional materials – like wood, marble, clay, and stone. These rediscoveries are not merely technical. Caro's forms of construction and collage involved the abandonment of imagination, and the replacement of physical handling by choice and arrangement. (Like the worst Victorian sculptors, Caro does not actually make his own works.) But as Ruskin saw, sculpture proper is an activity in which head, in the form of both intellect and imagination, heart, and hand combine together in transforming work upon materials as given by nature and tradition. Indeed, instead of mimicking the degradation of human work in the industrial era, as so much of Caro's sculpture appears to do, true sculpture affirms creative potentialities which are in grave danger of being lost. This rediscovery of what sculpture can do necessarily involves a rejection of all that has been done in the name of sculpture from *Twenty-Four Hours* to Gilbert and George.

In conclusion, I have often pointed out that, whatever Caro's inadequacies as a sculptor, he is certainly more impressive than his legion of followers. In what does this superiority reside? For all his changes of style, Caro has retained a small residue of what he learned – as even Waldman dimly perceives – from

Wheeler, and more especially from Moore. Caro is not as completely abstract as some of his commentators make out. As Michael Fried once admitted, Caro's works do not function through an 'internal syntax' of forms alone; rather, something about them continues to be expressive of certain experiences of *being in the body*. The followers, the sculptural Stalinists (or 'men of steel') who applied the dogmas so relentlessly in Stockwell and elsewhere, failed to recognise this fact. They assumed that it was the stylistic innovations which were the secret of Caro's qualities. But, in the end, even this differential judgement speaks against Caro, because it demonstrates that such sculptural qualities as his work possesses depend upon the residue of traditional, imaginative, figurative and physicalist sculptural concerns within them. Perhaps, if he had not jettisoned so much, he would have been a better sculptor. Or perhaps the change of clothes was necessary to disguise what was, from the beginning, a very slender sculptural talent.

Over the last ten years or so, in Caro's best pieces, he has simply reneged upon one after another of the 'revolutionary' innovations of the early sixties and reintroduced many of sculpture's traditional concerns. This has enraged his disciples, but it has produced some of the most convincing works of his career. *Descent From the Cross (After Rembrandt)*, 1988–9, seems to me a much more compelling sculpture than those thin and dated 'revolutionary' pieces. And yet it involves not only a direct appeal to the high sentiments of European art, but also a sense of mass and volume, and of upright, vertical forms, immediately suggestive of the figure.

Caro's starting point for this assemblage of rusted and waxed steel elements was a painting by Rembrandt in the National Gallery in London. His sculpture depends upon the contrast between the harsh geometry of the cross, with its supporting ladder-like shapes, and the soft, slumping and all-too-vulnerable forms grouped around its base. Nowadays, Caro frequently uses 'soft' forms alluding to flesh and organism. A few years ago, in New York, he even exhibited a number of

small, purely figurative sculptures, fashioned in front of the model, but his London dealers did not want him to show them in England. I cannot help wishing that Caro would complete his return to the mainstream of sculpture and fully embrace both image and figure.

1982/89

Alan Davie

Alan Davie's 1985 exhibition at the Gimpel Fils Gallery in London was called *Meditations and Hallucinations*, and consisted of a remarkable series of large oil paintings, and a few smaller works [*see plate 18*]. In the 'Meditations', mythic birds and beasts floated among strange symbolic and decorative devices, drawn from Indian, Egyptian, Mayan, Coptic and Celtic cultures – or even from the gorgeous textiles of Peru. By this stage, the intricate cosmology of the Jain sect had also begun to exert a special fascination over Davie. Rich patterns, cryptic calligraphy, distorted domes, temples, and palaces of all kinds, proliferated in the backgrounds of these pictures. Out of the 'Hallucinations', great eyes of the kind we find shooting through the art of the insane gazed back at the spectator from imaginary cephalopods, often with bared teeth and tentacles frozen in bunches.

Evidently, these paintings did not provide an image of the appearances of the world we see with our physical eyes, but neither did it seem that Davie was trying to communicate some private fantasy. His decorative references were too eclectic and his symbolic devices too universal for that. These haunting pictures seemed intended to provide glimpses into some remote and yet tangible world which can be reached neither through perception nor imagination alone.

Since the second world war, Davie has produced a continuous stream of paintings of exceptional consistency, and, I believe, growing strength. One of the most beautiful of these pictures was painted in 1985, *Meditation on Jain Cosmology, No. 4, with Dog and Fox*. In the late 1950s and early 1960s, Davie enjoyed tremendous exposure and public attention. Over the

last twenty years, however, interest from art critics and institutions has disappeared. Davie does not lack enthusiastic supporters. His gallery gives him a one-man exhibition almost every other year, and there is no shortage of collectors. And yet, since Davie's last retrospective in England, at the Whitechapel Gallery in 1958, there have been few serious evaluations of his work. Taste and fashion have changed a great deal in the art world in recent years, so the time may be ripe for a fresh appraisal.

In his brief autobiography, Davie writes of himself, 'The child born in Scotland in 1920 shared with all children the intense visionary powers, fears, fantasies and terrors of true knowing which is really of the animals and therefore nearer to God than to man. The child longed for some unknown adventure.'

His father was a painter and etcher who exhibited frequently in Scottish art circles. Both Davie's parents were musical, and music played just as important a part in his childhood experience as visual imagery. He began to paint seriously only when he was sixteen. His early pictures were of flowers and still lifes, in sumptuous colour, and a series of vivid self-portraits.

Davie possessed a natural creative talent and became a student at Edinburgh College of Art. He soon began to develop his idea that intuition was everything, or almost everything, in the creation of a good painting. 'Like a bird I shall take up my colours and my brush and I shall paint as the bird sings,' he later wrote. This sort of approach did not find much favour with his teachers, as Scottish art education was fiercely traditional. Davie was to develop a constitutional contempt for the life-class, painting from direct observation and 'good composition'.

'One must learn to have faith in the intuition which "knows" without knowledge,' he wrote. And yet his particular talent was recognised by the Scottish painter, John Maxwell, who taught at the school.

Central to Davie's belief is the idea that art comes naturally to

man, that it is, as he once put it, 'a fruit grown on the tree of man'. Predictably, given these views, it took him some time to find his own direction. After art school and the army, he took to writing poetry and playing the saxophone in jazz groups. He has never seen himself as belonging primarily to a tradition of painting. At various times, he has made jewellery, pots and textiles.

Davie seems to have 'found' himself on a European journey which he made in 1948 and 1949. Everything he saw, from the paintings of Uccello in the Louvre, to the Matterhorn, seemed to take on a marvellous, other-worldly quality. When staying in Venice, he produced pictures like *Pagan Music*, whose rhythmical, abstract forms indicate the direction of his mature work. Instead of painting the surfaces of flowers, Davie now made images like *Mechanism of the Plants*, of 1948, and *Birth of Coloured Organisms*, of 1950, in which he tried to express truths about nature which cannot be revealed through appearance alone.

While he was in Venice, Davie got to know Peggy Guggenheim and often visited her collection, where he saw Jackson Pollock's paintings for the first time. He immediately responded to Pollock's 'all-over' method. Indeed, he was the first British artist to recognise the significance of what the American had done, although I am convinced that Alan Bowness is right when he says that Davie's development 'would probably have been little different had Pollock never existed'. Not only was Davie apparently moving towards abstraction anyway, but his art was always very different from that of the Abstract Expressionists. If he was not interested in depicting appearances, neither was he concerned with the idea of art as a means of expressing the innermost feelings of the self. 'Self-expression,' he once wrote, 'is the antithesis of art. Expressionist painting or action painting can only be good if it achieves transcendence of the very expression.'

Unlike the Americans who tended to fetishise the substances and processes of painting, Davie was almost disdainful when talking about his materials and techniques. He spoke, with

distaste, about having to put on his painting boots, and insisted he wanted to convey something much more than the drama of the moment of creation. He criticised the critics who mistook the marks on the canvas for the image itself. Those marks, he said – apparently jibing at Clement Greenberg, the protagonist of Jackson Pollock – were merely 'the stuff through which the image is evoked'. The critic allowed himself to be enveloped by that image, and evaluated his experience of it.

Despite this, Davie acquired the reputation of being a Scottish Tachiste, or a sort of Celtic Abstract Expressionist. And, for all his stated intentions, it must be admitted that there is much of conventional Expressionism in those works of the 1950s which made him famous. The gestures, drips, flourishes and violence of the early pictures do refer us back to the subjective experience of the artist himself, to the movements he made, and the emotions he felt while creating them.

Davie came to resent this aspect of his own early style. He wanted to create images which were the result of that 'negative capability' of which Keats had written, rather than products of any conscious striving. In his writing he referred to 'the point of oneness, the abandonment of reason, desire, and ambition', and insisted that 'in the final moment, even the attempt to acquire enlightenment must be abandoned'.

From about 1960 onwards, Davie's painting and his aesthetic philosophy become increasingly close. There was a time when the path beyond self, for the artist, came through rituals, traditions and ornamental symbols. But when the dance has disappeared, how can the dancer lose himself? Davie tried to solve that problem by a pillaging of the decorative and ornamental symbols of other cultures. He tried to use his intuition to set in motion a strange process of cultural alchemy, whereby his personal mythology became the means to a more general revelation. His later works are certainly his most significant and compelling contribution, and yet they have been singularly neglected.

In part, this is the inevitable fate, in our culture, of the older

artist. Davie's reputation remains trapped within an Abstract aesthetic to which he never really belonged, and which, in any event, he has definitely deserted. The critics, journals and institutions of art have moved on to other enthusiasms, but they still think of Alan Davie as a 1950s Abstract Expressionist.

The problem is a chronic one and it does not beset Davie alone. It is wrong to think that the market determines the major interests of the art world. The prime mover is an insatiable quest for novelty, whether or not these novelties are immediately saleable. Despite high prices, satisfied collectors and a regular gallery, an older artist like Davie can be almost entirely ignored. Characteristically, the Tate mused for ages before buying their first late Davie from his 1985 exhibition. Tate representatives even asked Charles Gimpel, Davie's dealer, whether he thought they should buy one. Gimpel replied that he thought there was little point in doing so, as they already had eight major paintings by Davie stored, almost permanently, in their cellars.

The young Davie may have been more fasionable, but I believe that the older Davie is a better painter. In general, great painters and sculptors tend to be at their best in the latter part of their lives. Yet the system of institutional patronage and critical appraisal is so geared in this country that it tends to ignore an artist's 'late phase' – the phase in which artists such as Titian, Michelangelo, Turner, Rembrandt and Monet produced some of their greatest work.

Of course, Davie's refinement of the idea of art into a source of spiritual revelation can hardly be expected to be fashionable, or 'relevant'. Since the middle of the nineteenth century, such views of art have almost disappeared. Among major British artists, perhaps only Cecil Collins was close to Davie, in this respect, and he too was wilfully ignored until the last few years of his life. Davie likes to appeal to the art of Stone Age man. He argues that the first artists were not interested in communicating to others through imagery. They purposely chose the most inaccessible places in which to make their art. Though he feels

their works do communicate powerfully today, he says they do so not through depiction, nor through conveying anything of the artist's motives or emotions. He would like his own art, in this secular age, to be a comparable source of objective enlightenment, of realised communion rather than mere communication.

I feel that Davie's late paintings suggest a number of parallels. Some works, like *Meditations on Jain Cosmology, No. 4, with Dog and Fox*, have some of the appeal of, say, a great Mamluk carpet – whose attractiveness and sensual beauty is enhanced by the fact that its weaving is also expressive of a hermetic cosmology. But again and again, I feel as though I am looking into a series of illuminated aquaria, or, perhaps, untouched rock pools.

Edmund Gosse, son of Philip Gosse, naturalist, and student of seashore life, wrote about the rock pools of the British coast before they were 'profaned, and emptied, and vulgarised', by swarms of amateur beachcombers, whom his father's books had done so much to encourage. Gosse regretted that no one would see again round the shores of England what he had seen in early childhood: 'the submarine vision of dark rocks, speckled and starred with an infinite variety of colour, and streamed over by silken flags of royal crimson and purple'. Davie offers painted equivalents of these pristine pools.

In these late paintings, the brilliance of colours, abundance of ornamental devices and sense of the apparent weightlessness of forms – not much in a Davie painting is ever anchored to the floor – all seem to emphasise this submarine association. So, too, does the sense of impersonal intimacy which pervades so many of these works. But the aquatic parallel can give a wrong impression. Davie does indeed dive underwater with a mask and snorkel off the Cornish coast and near his home in St Lucia, in the Caribbean, but his imagery is not biomorphic. He says that he was painting that way even before he went under water. His diving, like his interest in gliding, provided a confirmation of something he had already discovered.

And yet the comparison with those Victorian rock pools

won't quite go away. Edmund Gosse believed that the unpro-
faned pools gave him access to 'a fairy paradise'. Philip, his
father, was convinced they were miniature paradigms of divine
creation. He thought they revealed the activity of a Great
Artificer, lying behind mere appearances of natural forms. The
home aquarium was a source of divine revelation. Davie may
not be interested in natural form, but he has always seen the
making of a picture as the elaboration of a personal mythology
which, he believes, can function as a source of spiritual
illumination, even in an age which has lost belief without any
hope of retrieving it. 'Art and religion,' he wrote, 'could be
conceived to be very much the same thing. What I have called
the Evocation of the Inexpressible by images, symbols, sounds,
movements, or rituals.'

1985

Lucian Freud

Whatever estimate may be placed upon Lucian Freud's 'naked portraits' by future generations, it is unlikely that they will ever be attributed to any time other than ours. Just as the regents and regentesses of Frans Hals (a painter with whom Freud has something in common) unquestionably belong to seventeenth-century Holland, so Freud's subjects seem indubitably to be children of this troubled century. Their modernity is not in question. [*See plate 17.*]

With Freud, this modernity is apparent not so much in telling appurtenances – nakedness strips away such clues as costume – as in the stance the painter adopts towards his subjects. An extensive literature has now gathered around Freud's celebrated scrutiny. Much of this emphasises the unflinching starkness of his gaze, which is not without overtones of the interrogator, even the torturer. He refuses to allow his looking to be deflected by compromise or accommodation. It is this unrelenting quality which recently led Robert Hughes to acclaim Freud as, quite simply, 'the greatest living realist painter'.

But like all 'realisms', Freud's is not without its own tendentious inflections. His pictures bring to mind the fascinated fears of Antoine Roquentin, the hero of Sartre's *La Nausée*, confronted in the municipal park by the intractable existence of the external world: 'All those objects . . . how can I explain? They embarrassed me; I would have liked them to exist less strongly, in a drier, more abstract way, with more reserve.' For Freud, as for Roquentin, what he might have 'liked' becomes irrelevant. He is driven by a sickening and ultimately terrible sense of the bruised and yet abundant otherness of the things

and persons in the world – that is what he wants to touch and to paint.

The critics have understandably seized upon Freud's obsession with particular imperfections, with faces and bodies pinched, slapped and swollen by life and worn down by their individual histories. We gaze at a succession of ruddy heads, flaccid bellies, and veins swelling just below the surface of the skin, like rivulets of ink. And yet we feel that, like Sartre's hero, Freud believes that 'the diversity of things, their individuality' is 'only an appearance, a veneer'. For Roquentin, this veneer 'melted, leaving soft, monstrous masses, in disorder – naked, with a frightening, obscene nakedness'. Freud seems to paint the moment before such disintegration occurs. Gathered together, his 'naked portraits' descend into it.

Here we are forcefully presented with the Existential angst, if not of the 1980s, then at least of the mid-century, yet when all is said and done, Freud's painting seems untouched by our century and its aesthetic concerns. Freud's ways of working – even in the much-vaunted fleshier and fattier modes of recent years – are redolent with a sense of the past, they bristle with the hogs' hairs of tradition. Certainly, his way of picturing has changed dramatically since the enamelled and coppery images of the 1940s and early 1950s, but the wrong conclusions have sometimes been drawn from this. For Freud's work is devoid of any sense of restless innovation or of experimentation with his chosen medium for its own sake. His innovations have never seemed to me to be about the liberation of the physical means from the burden of meaning. The changes in Freud's ways of painting have been strictly in the service of his Existential vision. He has sought out ways of making the images more mundane, meatier even, more tangible and sore. If Modernism is characterised by, as Clement Greenberg used to put it, an 'ineluctable quest' for the essence of the medium, then Freud is not a Modernist. Indeed, he is a deeply conservative, even reactionary painter. But he is so because he believes that only through such aesthetic traditionalism can he

speak most compellingly of our 'modern' condition.

Freud was born in Berlin in 1922, son of Ernst Freud and grandson of Sigmund, the founder of psychoanalysis. Freud has discouraged attempts to interpret his work in relation to his grandfather's achievement, and yet it must be admitted that the tastes of the two men have much in common. For, whatever Sigmund contributed to modern man's self-conception, he remained at bottom a nineteenth-century scientific rationalist. He endeavoured to understand the deepest psychological recesses of the human personality by approaching the human subject almost as if it were a specimen for dissection. In art he was dismissive of the Modern movement and his own preferences were classical, even academic. His one thorough examination of a major plastic work of art, *The Moses of Michelangelo*, relies on an unremitting scrutiny of physical detail. Freud's own collection of archaeological artifacts and antiquities reflected, as much as anything, an obsession with the subject matter of death – a theme echoed again in the work of his grandson, from the studies of dead cocks and monkeys to the splayed nudes of later years, revealed to us with the pallor of the grave already flickering across them.

Yet it must be said that Lucian Freud's work also reveals other, quite different associations. His family moved to England in 1933. Freud studied at the Central School of Arts and Crafts and, soon after, at the East Anglian School of Painting and Drawing in Dedham, run by Cedric Morris. He could hardly have chosen a path which brought him closer to the idiosyncratic centres of the British visual tradition, and, for all his German roots, Freud's attachment to Britain has proved as constant as anything in his life. John Russell has reported him as saying: 'All my interest and sympathy and hope circulate around the English.' And yet these differing cultural tendrils were not easily wound together. Freud responded intuitively to the empirical strand in British cultural life, but in the 1940s, when the effect of outside artistic influences upon him was at its greatest, British art was undergoing a Neo-Romantic revival.

Somehow, through his associations with Cedric Morris, his interest in Sutherland and his friendships with Craxton and Minton, Freud had stumbled into the very centre of this movement. However, he also knew he possessed an imagination stamped by what he has called 'my horror of the idyllic'.

His earliest works seem torn by these irreconcilable influences. They have been related by the critics to numerous sources: to the meticulousness of late Gothic painting, the smooth finish of Flemish miniatures, the electrified Protestant precision of Dürer, the linear classicism of Ingres, Surrealism, and the thorns and thistles of English Neo-Romantic contemporaries. Perhaps the truth is that Freud was still looking for the appropriate style and pictorial conventions through which he might express a vision as yet imperfectly formed. Anyone looking at the conté pencil drawings of 1944 like *Boy with a pigeon*, might have been forgiven for assuming that Freud would develop into an exquisite, if at times rather precious, lyricist. In the late 1940s, Freud struggled to veil these contradictions of vision behind an exquisite sharpness of technique, manifest in the meticulous images of his first wife, other women, and later in the decade, fellow artists such as Francis Bacon and John Minton.

It is easy enough to see why Freud rebelled against his own early achievement. For all the laborious transcription of skin, flowers, leaves and clothes, there is something ghostly and immaterial about these images; it is as if they are not of this world. Sigmund Freud had a horror of any association between his psychoanalytic method and those of poets, astrologers, and mystics. The paradox of *his* life was that he wanted psychoanalysis to be recognised as a branch of scientific thinking, even though its subject matter was precisely that terrain of human thought and feeling, which was, by its very nature, 'unscientific'. He 'solved' this dilemma by a life-long hope that the insights of psychoanalysis would eventually be corroborated by the physical findings of neurology. Similarly, the terrain his grandson had chosen for himself was that of the human

imagination, and yet he wished to express that imagination through works of uncompromised 'realism'. Poetry, fancy, dream and hallucination sprang up like thistles, making their insidious presence felt not only in his imagery, but even through his techniques. Freud found that his own work was beginning to arouse his horror of the idyllic.

The change of the late 1950s involved more than a loosening of the paint, the use of heavier brushes and fruitier qualities of pigment. Freud, too, wanted to see and to depict the human person as he or she really was. Despite the growing power of his imagination, the only way for him to do this was through a 'scientific' limitation of his subject matter to that which presented itself to the eye. In Freud's case, this is not a matter of some shabby fidelity to the surfaces of things, but rather it grew out of a belief comparable to that of his grandfather, that only through this sort of clinical realism can we hope to cut through the appearances of the other, to grasp at the meaning, even the truth of their otherness.

The objection has often been made to classical psychoanalysis that, despite the analyst's assumption of an 'objective' attitude to the patient as specimen, his analysis in fact involves entering into a relationship with another human being. Lucian Freud works within a similar paradox. The model (always someone well-known to the artist) enters his confined space. The conventions of sitting or sprawling for Freud demand a semblance of objectivity, an assumption that every vulnerability, however intimate and personal, may be exposed. And yet Freud is, in fact, no more a scientific realist than was his grandfather. For, insofar as his work rises above the decorative mortuary arrangements of a Pearlstein, or an Uglow, it is because this fiction of realism is made to serve a higher, if hardly softer, end: the exposure of a personality.

As with classical psychoanalysis, doubts remain. A room full of Freud's female nudes is chilling. The canvases hung together do not suggest a series of deep personal encounters of transcendent intimacy. Few viewers feel more than a sense of

revulsion, a vague sensation that they are witnessing some-
thing which degrades the persons depicted. The room is heavy
with the aroma of death, bringing to my mind uncomfortable
recollections of photographs taken at the liberation of
Auschwitz and Belsen. Perhaps scientific realism does not work
even as a useful fiction. Perhaps we can only find the other by
treating him, or her, as a person, whether in studio or
consulting room. It is not so much that too much reality is hard
to bear. Perhaps, after all, imagination, poetry, metaphor,
fancy, symbol – even idyll – are part of the reality that makes us
fully human. If we wipe them away, we risk losing the other at
precisely the moment when we seem about to reveal him, or
her, in nakedness.

Freud, I believe, knows this. Indeed, he seems constantly to
have to fight against symbolic or metaphoric expression. How
else are we to explain, for example, the mortar and pestle in
Large interior W9, the egg in a dish on the table in *Naked girl with
egg*, or the rat in *Naked man with rat*? If these are not symbols they
are something very like. They hover somewhere between the
psychopathology of everyday life and the poetic metaphors of
Neo-Romanticism. This, in a sense, is where Freud himself is
always trying to stand, and why his pictures – at their best –
have such a terrible, disconcerting power.

1988

Maggi Hambling

In *Minotaur Surprised while Eating* of 1986–7 [*see plate 11b*], the beast, half-man, half-animal, is shown devouring a joint of human flesh, morsels of which hang down from his bovine jaw. He glances out at us with a look of apprehension in his piercing eyes, which seem as human as his hands. This painting was among the most shocking and the most outstanding in Maggi Hambling's pictures of people, animals, landscapes, mythological and religious subjects shown at the Serpentine Gallery in 1987. Hambling has long displayed exemplary skill as a draughtswoman, but this body of pictures confirmed her as an artist of great imaginative depths and unexpected stature.

Hambling was born in Sudbury, Gainsborough's home-town, in 1945, and spent her childhood in Hadleigh, in Constable country. Her *Head of Christ* (1986) now hangs in Hadleigh church. While still at school, she took her paintings to the nearby 'Artists' House', home of Cedric Morris and Lett Haines. Soon she became one of their pupils. Haines, in particular, taught her to have confidence in her own imagination. Later, she continued her studies at Camberwell, under Robert Medley, and, for a short time in the 1960s, her figures resembled his fractured forms. Although Medley's stylistic influences were later much less apparent, he – like Haines – exerted a more general effect on her development as an artist.

Hambling went to the Slade School in 1967, where she reacted against the rich British imaginative and empirical traditions which had, in various ways, played their part in her early development. A confused period of environmental and conceptual work followed, but it was inevitable that an artist possessed of such considerable gifts would soon return to drawing and

painting. In 1972, she began to paint people. Her portrait heads of this time were reminiscent of those early pictures by David Hockney which contain traces of child art, combined with Francis Bacon's savage viewpoint.

Hambling moved towards a more personal vision when she focused on one sitter, Frances Rose, an elderly neighbour. The Frances Rose pictures began to address themselves to one of the central concerns of Hambling's maturity: the search for a way of painting 'fallen' modern men and women without resorting to the monstrous, but reaching beyond the limits of empiricism. Her paintings of the mid-1970s revealed a sympathy with human frailty and impoverishment, but they did not always escape a certain murkiness of colour and handling, as if the content was constraining the form. Her more visionary sentiments split off into fantasy and mythical subjects like the *Garden of Eden*, now at Petworth House.

A deepening and a broadening of Hambling's vision occurred in 1977, after she visited Madrid to study Goya. Her British roots were nourished by her sense of her place within a wider European culture. This was confirmed by the time she spent as the National Gallery's first 'Artist-in-Residence', in 1980–1. Her best-known works of this period were the series of paintings and drawings she made of the comedian, Max Wall, exhibited at the National Portrait Gallery in 1983. The Max Wall paintings combined a sense of the mundane – of the absurdity, sadness and vulnerability of human life – with vivid images of the transforming power of reverie, wit, illusion and imagination, suggested by the magical wreaths and wisps of cigarette smoke, like something from a genie's lamp, that appear again and again in these pictures. It was as if Frances Rose had strayed into paradise garden! And yet, despite the poignancy of these works, even the best of them seemed infected with a note of sentimentality. This was apparent as much in drawing and gestures (which sometimes veered towards caricature) as in the subject – the old, smoking clown whose heart bleeds.

The paintings Hambling produced in the four years leading

up to the Serpentine exhibition show a more confident fusion of imaginative and empirical elements than anything she had previously achieved. Some of her pictures of people, such as *Untitled* (1986), hark back to earlier modes. This harrowing work shows a tramp lying prostrate among the rubbish in the street. The awkward handling of the figure offers no glimpse of anything beyond the dreadful mortality revealed to us.

With Hambling's *Sunrises*, matters are different. These works stem from a small painting she made in Suffolk in 1984. For a long time the work hung at the bottom of her bed before she decided to make a much bigger version of it. This proved to be the first of a series of pictures of sunrises, painted with a brilliance, at times even a stridency, quite new in her work. They show the moment when, quite literally, night shrivels, and the living darkness is subsumed by light and colour.

A series of bull-fight paintings form the inverse of the sunrises – in both mood and form. In pictures like *Fallen bull* (1985), *Dead bull* (1987), or *Fifth bull*, the often bizarre location of the brute, black mass of the dead or dying creature threatens to swallow up all the colour and life around it. This repeated ritual of death becomes a pictorial 'negative' of the diurnal resurrection of the dawn.

It is not my wish to imply that Maggi Hambling is an artist of the stature of Bacon or of Rothko, and yet the union of natural and formal symbolism in these sunrise and bull-fight pictures suggests that she is looking for ways beyond the limitations of distorted physicalism or engulfing vacuity. Her most achieved pictures indicate that she is finding some sort of aesthetic solution in the replenishment of mythical painting. *Minotaur Surprised while Eating* and *Pasiphae and the Bull* (1987) are paintings of an exemplary strength which etch themselves immediately and indelibly into the imagination of the viewer. The poignancy of the pictures derives from Hambling's improbable union of the closest, and most obsessive, observation of bull and human bodies with higher aspirations. The monstrous creatures and acts depicted associate the carnal

appetites of men and women with the brutishness of the beasts, red in hoof and claw.

In *Minotaur Surprised while Eating*, 1986–7, the Minotaur turns his eyes on us with an alert and guilty look, as if we had interrupted him in the middle of his bloody meal. This terrible image is set against an almost abstract background of mingling green and gold, in which the sky and ground seem to merge.

When I first saw this picture in Hambling's studio, I was reminded of a little-known picture by George Frederick Watts [*see plate 4b*], the Victorian painter of mythic and allegorical subjects. Admittedly, there are many differences between the two works. Watts placed his Minotaur on the edge of a battlement, made him the predator not of huge joints of human flesh, but of a single tiny bird, and turned his monstrous features, discreetly, away from the viewer. Nonetheless, the two pictures have much in common; not least the abstracted background against which the bull-man is set. For Watts's Minotaur has been made to gaze out across the vast and enticing emptiness of an infinite sea.

Hambling had not seen Watts's picture before she painted hers, and yet the resemblances between these two works may be more than mere analogy. For one thing, they are both interpretations of the same Greek myth. According to the legend, the Minotaur came into being because Poseidon, the God of the Sea, caused Pasiphae, the wife of Minos, to become enamoured of a great bull which had been held back from sacrifice. Pasiphae told Daedalus, an exiled Athenian crafts-man, about her strange passion, and Daedalus made a fake cow for her constructed out of hide, cast over a wooden frame on wheels.

This contraption was placed in the meadow where the great bull grazed, and Pasiphae slid inside it, with her legs splayed out inside its make-shift hindquarters. The bull was deceived, and mounted her, and so she had her pleasure. Hambling has depicted their union in a shocking picture, *Pasiphae and the Bull*, 1987. This, of course, is not a subject Watts would have

attempted, and, even if he had, he would not have dispensed with the cowhide to bare Pasiphae's white and fragile flanks to our gaze, or contrived to place the bull's enormous black member as the very pivot of his picture.

The Minotaur was the monstrous progeny of this union. Minos gave orders that every ninth year seven young men and seven maidens should be sacrificed to the flesh-eating creature. The victims were released into the maze of the Labyrinth where the Minotaur waited to ensnare and devour them. And this is what we see him doing in Maggi Hambling's *Minotaur*. In Watts's version he is looking out for the boat from Athens which will come bearing fresh victims.

Whatever the Minotaur may have meant to the Greeks, he seemed to have a horrible poignancy for the Victorians. If nature had once appeared beneficent, almost a garden made by God for man, it was quite suddenly transformed, in the nineteenth century, into something savage and threatening. Charles Kingsley complained that he could no longer see spiritual truths or moral order in a natural world in which everything was always eating everything else. Simultaneously, belief in the Christ, or the incarnate God-man, who sacrificed himself to save man from sin, became increasingly difficult to sustain. Watts saw that the predatory, life-destroying bull-man was a more compelling symbol of modern man's self-conception, which was re-shaping itself more in the image of the brutes than of God.

If today there seems something a little comic – a touch, perhaps, of Bottom and *A Midsummer Night's Dream* – about Watts's Minotaur, it is perhaps because he reveals so vividly the aesthetic dilemmas which followed upon the heels of the Victorians' spiritual crisis. Watts's Minotaur gazes, forlornly, at a quivering, blue void – as if he and all his monstrous peers were about to become engulfed and subsumed by it. (Remember, 'A most rare vision . . . It shall be called Bottom's dream because it hath no bottom'?)

In a sense he *was* being engulfed, for many in the emergent

Modern movement believed that abstraction was the only means by which the vistas of spiritual truth might be opened up in painting, now that they could no longer be glimpsed through the features of men, animals, plants or landscapes. I like to think that if Maggi Hambling's Minotaur faces the other way, it is because he stands on the farther shore of the Modern movement. His back has been turned upon abstraction which can no longer provide a credible escape from our fallen condition in a seemingly godless world.

In one sense, Hambling confronts us with our brutish nature in a more relentless way than Watts would ever have dared. We sense that Goya must have been an important influence upon her. But if she repudiates the seductive blankness of the abstraction which lies behind the night-creatures in Goya's famous print, *The Sleep of Reason Begets Monsters*, she also struggles to offer something more than fallen 'realism'.

For a painter like Francis Bacon, the Victorian nightmare becomes reality. His evil genius depicts men and women as indistinguishable from the teeth, claws and raw sexual convulsions of the brutes and carnivores. Although Hambling's work is resolutely secular, she seems intuitively to want to find hints and traces of, if not redemption, then at least a kind of reconciliation. She does not deny our animal nature, but still finds hints of the great promises which religion once offered. This sense of transfiguration can be found in such things as the pathos in the faces of her clowns, the glory of the Suffolk sunrises, and even in the magnificent, sacrificial fall of her bulls.

Look again at the expression in the eyes of her Minotaur. Certainly, there is evil here. But is that all? The creature's gaze reminds me of something John Keats wrote in one of his letters: 'The greater part of Men make their way with the same instinctiveness, the same unwandering eye from their purposes, the same animal eagerness as the Hawk. The Hawk wants a mate, and so does the man – look at them both, they set about and procure one in the same manner. I go among the fields and catch a glimpse of a stoat or a field mouse peeping out

of the withered grass – the creature hath a purpose and its eyes are bright with it.'

We never see this glint of intention in, say, Bacon's monstrously pulverised faces. Despite all his malevolent grandeur, Bacon has been so overcome by the problem of evil that he loses all sight of purpose and intention. Hambling finds them again, even in the midst of evil itself. In Hambling's mythological works, the luminous and aureate backgrounds of burning gold verge on the numinous mists of abstraction, and yet also recall the redemptive splendours of the dawn paintings. Like Keats, she seems to be seeking a route which leads beyond Kingsley's dilemma, a route between the Scylla of Bacon's monstrous realism and the Charybdis of Rothko's abstract sea of silence.

Not surprisingly, one of her most remarkable paintings to date, *Christ in Venice* (1987), consists of a dramatic re-interpretation of a scene from the Passion. The sombre black and purple background recalls the void of Rothko's wine-dark seas, but the raised-up body of Christ suggests the harrowing and uneasy hedonism of later Titian, whom Hambling had been studying in Venice before she painted this picture. The frail body of Jesus rises above the grimacing crowd which bears him towards his death and reminds us of the fallen world of the modern grotesque – that caricatured and ignoble 'realism', through which, as unbelievers, we have hitherto seemed compelled to confront ourselves.

We might say that everything depicted is all too human, but it is not less than that. Hambling's painting offers hints if not of salvation, in any miraculous or other-worldly sense, at least of ethical and spiritual hope. With a growing confidence, she is finding original plastic and iconographic forms appropriate to this vision. Little wonder, then, that she has looked again into the eyes of the Minotaur.

1987

Patrick Heron: the Innocent Eye?

One of the paintings I most enjoyed in Patrick Heron's retrospective at the Barbican in 1985 was *December 4: 1983: II* [*see plate 9a*], a small but extremely beautiful gouache, no bigger than 18 x 20 inches in an exhibition where some canvases were 15 feet long. The forms in *December 4* are very fluid and the edges of colour areas generally fuzzy and indistinct. I doubt whether Heron would approve of the word, but the painting is vaguely 'biomorphic'. (Biomorph – 'Decorative form representing living object', *Concise Oxford Dictionary*.) It is suggestive of teeming life seen down a microscope after colour stains have been added.

And what colours! On the right of the picture, eight irregular, rose madderish, pink discs float in pools of deepening blues through which peep patches of white. These forms are insecurely contained by a branching, oval frame of red, which stretches across three quarters of the surface. On the far left are broken passages of green and illuminating spots of yellow. The picture gives rise to volatile sensations which are not easily pinned down in words. The meetings between the blue, the pink discs, and the surrounding red 'frame' are decisive. Often, these appear more as filigree or intricate tracery rather than as a line. We are a very long way from Heron's 'wobbly hard edged' effects of the 1970s. The blue seems to drift on top of the pinks and reds, and yet its darkest points form recessive foci which pull back into illusory depths in the painting.

This ambiguity forms a visual trigger which tears the skin of the painting, sets everything in motion, and gives rise to enticing new illusions of space, or, to use a favourite phrase of Heron's, of colour as space. The discs seem to release their colour and light, which not only flood out across the blues and

reds, suffusing the entire surface with rose madderish tints; they also seem to billow forth in front of and behind the picture surface creating an engulfing illusion of coloured space. As one continues to watch, the blues reassert themselves, seeming to police the dissolving picture. The pink space retracts into the flat, floating discs where it is contained and held once more.

But I don't want to exaggerate the experience of a single, small picture. This was a fine exhibition, beautifully selected, and intelligently hung. It provided an excellent introduction to the 'changing forms' of Heron's art from the 1930s until today.

Patrick Heron was born in Leeds in 1920, the son of Tom Heron, a socialist and manufacturer, who ran the textile firm, Cresta, which specialised in the production of silks. When Heron was five, the family moved to Cornwall, but about four years later, they went to live in Welwyn Garden City. The earliest exhibit in this show is *Melon*, a printed silk of 1934, which Heron designed for his father's firm from his school sick bay. This scarf shows precocity in both colour and decorative sensibilities. These were to be hall-marks of all Heron's work.

After leaving school, Heron studied part-time at the Slade. He was a conscientious objector and, on the outbreak of war, worked as an agricultural labourer. In 1944, he returned to Cornwall as an assistant to the great potter, Bernard Leach, who was based in St Ives. Although Heron moved back to London in 1945, regular visits to Cornwall were to continue until he moved there, definitively, in 1956.

Although English landscape was to play such a decisive role in Heron's life, and art, his intuitive love of colour drew his eyes towards paintings produced on the other side of the Channel. There were many within the English art education system who admired the draughtsmanship of Degas, but this did not interest Heron. What he liked about French painting is perhaps summed up in something Cézanne wrote in a letter to a friend: 'Shut your eyes. Wait, think of nothing. Now, open them . . . One sees nothing but a great coloured undulation. What then?

An irradiation and glory of colour. That is what a picture should give us, a warm harmony, an abyss in which the eye is lost, a secret germination, a coloured state of grace.'

Heron's earliest painting shows an impressionistic, or atmospheric, colour sense which perhaps owes something to the influence of Bonnard. This was soon to change and to stay changed. In 1943, with the world at war, Heron made repeated visits to the Redfern Gallery where he absorbed Matisse's *Red Studio*, which had been discovered in a Soho nightclub, and was on extended exhibition in the gallery. No single picture was to have a greater influence on him.

Much later, Heron was to explain, 'I dislike intensely the filmy, essentially unsubstantial, transparent, veil-like, revolving vapours of "colour".' He added that the sensation of space he valued was one generated by a plain, opaque surface placed at a measurable distance before his face. 'The contemplation of colour I refer to,' he went on, 'is something which heightens my accurate awareness of my own physical position in relation to such surfaces, and to my actual, physical environment.' Heron also valued the way of dividing up the picture surface he perceived in Braque's work.

By the late 1940s, Heron's love of colour, joy in decorative forms, and intense responses to French, Post-Impressionist painting, especially Matisse and Braque, had come together in a style which was very much his own. Within the limits of this style, he produced a number of remarkable portraits, including one of T. S. Eliot (1947/9) which now hangs in the National Portrait Gallery in London, and another of Herbert Read (1950). But many of his pictures at this time were explorations of the ambiguous relationship between depictions of indoor and outdoor space. Several were painted from the balcony window on those repeated visits to St Ives. Perhaps the most ambitious, and certainly the largest work of these years, was *Christmas Eve*, 1951, a large canvas made for the Festival of Britain exhibition, which loosely refers to a scene in Heron's parents' home in Welwyn Garden City.

As Heron looked around him in the years following the second world war, he must have felt a sense of aesthetic isolation. Perhaps he saw precedents for some of his concerns in, say, Matthew Smith, or more significantly, Ivon Hitchens. But neither geography nor cultural tradition appeared to predispose the English to an art of colour, decorative form and visual pleasure. To Heron, England seemed addicted to its 'great-coat' weather, its puritanical traditions, and what he took to be its 'literary' and 'linear' occlusions of vision. (Later, he was to pronounce anathema on 'the besetting sin of the British – the eternal dependence upon line, and an illustrator's rather than a painter's drawing'.)

'The puritanical English,' he said, when looking back in 1978, 'the whole Euston Road ethic, you know, everything about the bloody English except Turner and Constable, really, had been against actual pleasure. Yet I have always thought that to call a painting decorative was one of the highest possible compliments, because it means that the painting is giving pleasure through every millimetre of the surface, that its formal dispositions are perfectly ordered and balanced.'

In 1945, Heron began a critical crusade which was intended to open a nation's eyes and warm its heart with aesthetic pleasures, in the uniquely bleak years of austerity, rationing and post-war 'reconstruction'. Heron's most influential articles were published in *The New English Weekly*, between 1945 and 1947, and in *The New Statesman and Nation*, from 1947 to 1950. Much as he may have despised English puritanism and English pedagogy, the English, it seems, were to be taught to learn to see in the driest and most pedestrian manner. 'Criticism,' Heron wrote in 1949, 'should sacrifice pleasantries of style for a ploddingly careful analysis of what is there on the canvases under review. Criticism should have more in common with science than with poetry, for it is the subject you are discussing that is important and not the thing you write about it.' Just as Heron came to believe that 'concepts, and also symbols, are the enemy of painting, which has as its unique domain the realm of

pure visual sensation', he also believed that interpretations and 'any sort of verbal felicities' were the enemy of criticism, which he endeavoured to make 'as descriptive of the visual facts', that is, as formal, as he could.

Heron's criticism sprang out of very similar aesthetic beliefs to those which informed his painting. It is worth stressing at this point that, when working on a canvas, Heron made decisions about both colour and composition on the basis of imagination and intuition, rather than through reason or scientific analysis. However, his critical position was one which excluded imagination and intuition, in both theory and practice. Heron was sacked from *The New Statesman* in 1950 on the grounds that, as the editor put it, 'readers must have at least a *rest* from wrestling with the problems of new space'.

By the mid-1950s, Heron was clearly beginning to feel pinched by the self-imposed limitations of his chosen style of painting. A certain pleasing graphic facility often entered into his pictorial compositions at this time. Could he perhaps have perceived a resemblance between his own work and that of the quintessentially English 'linear' and 'literary' artist, John Piper? It was certainly there to be seen. Piper, too, had been influenced by French decorative traditions.

In 1956, Heron moved to Eagle's Nest, Zennor, near St Ives, where he has lived ever since. He was searching for a more 'gestural' way of painting. Under the influences of the American artist, Sam Francis, and the light and life of the Cornish landscape, Heron moved sharply away from explicit figuration towards abstract organisation of patches of colour across the whole canvas surface. When they were shown in London, the resulting 'Garden' pictures were widely derided by critics as being 'Tachiste'. Today, this label seems inappropriate. Not only are works like *Camellia Garden: March 1956* marked by that restrained taste and developed 'intelligence of feeling' which characterises all Heron's successful painting; their reference to the world of nature, beyond the canvas surface, appears self-evident. Though the colour may be based on

reminiscences of flowers and light, rather than on the immediate perception of them, it is most decidedly not the concocted 'studio colour' of London (or Paris). It was obviously more than a coincidence that Heron's decisive break with figuration coincided with his leaving of the metropolis to live in Cornwall.

For some time, Heron's sense of aesthetic isolation had been mitigated by the emergence of a so-called 'Middle Generation' of British artists, a good many of whom also lived in St Ives and shared at least some of his concerns. With the sad paling of the Parisian and Mediterranean suns, Heron had been looking to America, and attending to the achievements of the Abstract Expressionists. He was one of their first articulate and informed advocates in Britain, although, from the beginning, he stressed weaknesses in their colour. In 1955, Heron began to write for the American magazine, *Arts*, to whose readers he introduced Peter Lanyon, Alan Davie, William Scott, Roger Hilton, Ivon Hitchens, Bryan Wynter, Terry Frost and many others.

In 1956, the abstracted 'Garden' paintings began to be subjected to ever more pronounced vertical organisation, and a year later, Heron began a series of horizontal 'stripe' paintings. (A very beautiful example, *Green and Mauve Horizontals: January 1958*, was included in his retrospective.) In the 1970s these works were to become bones of contention in Heron's argument with the Americans over precedent. The crux of Heron's position was that, instead of having always been at the receiving end of ideas emanating from New York, several painters of his generation, himself included, had exerted 'crucial influence' upon New York painting from the late fifties onward. Heron established his case beyond any reasonable doubt – and it has never been answered. There have been those who have said that it just does not matter who did what first, but the truth always matters, in art, no less than in life. I would go further. I believe not only that Heron's stripe paintings preceded those of Morris Louis, but also that they are better, much better, in aesthetic terms.

Alongside the freshness and clarity of Heron's painting of
1956–8, there is a dowdy and depressing feel about even the
best Morris Louis canvases. With few exceptions, Louis's
paintings, today, have the look of last season's used and abused
fashions. Heron was always a painter of superior sensibility,
colour sense, and painterly intelligence. His work manifests a
love of tradition, a mastery of skills and techniques, which
Louis's lacked. In the end, originality always shines out over
second-hand novelty.

The greater sense of life in Heron's colour has to do with a
certain replenishment from landscape and natural form, how-
ever much he may consciously have tried to resist this.
Someone as visually sensitive as Heron could hardly not have
been affected by his move to Cornwall, especially when that
countryside was already redolent with childhood memories for
him. Louis, on the other hand, really only produced
Washington studio colour, plastic colour. Heron had an intui-
tive grasp of the importance of creating and crafting a surface
(residues of his denied English puritanism perhaps?) through
nuances of subtle brush-work which can imbue every square
inch with the variety and feeling of a fully human touch. Louis
poured his pigment out of buckets. Heron's oil paint is also a
more versatile and enduring medium than the slick, filmy
acrylics with which Louis worked. I have the gravest of doubts
as to whether those first acrylics were truly fast: if they were,
then Louis was an even worse colourist than I would otherwise
have given him credit for. Quite probably, many of his works
have physically deteriorated since the time they were made, but
the many collectors who still shell out large sums for Louis's
empty works are wasting their money. For a fraction of the
price, they could buy a Patrick Heron which would not only
antedate Louis's stripes by several years, but also be aesthetic-
ally superior, and, incidentally, a more conscientiously-crafted
object. They could also be sure – which they cannot when
buying a Louis – that they were buying a painting which the
artist himself acknowledged and approved of; one in which the

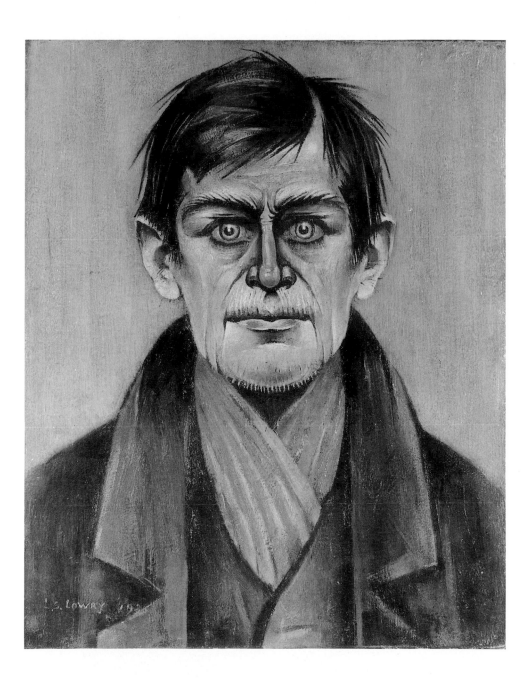

13 L.S. Lowry, *Head of a Man with Red Eyes*, 1938

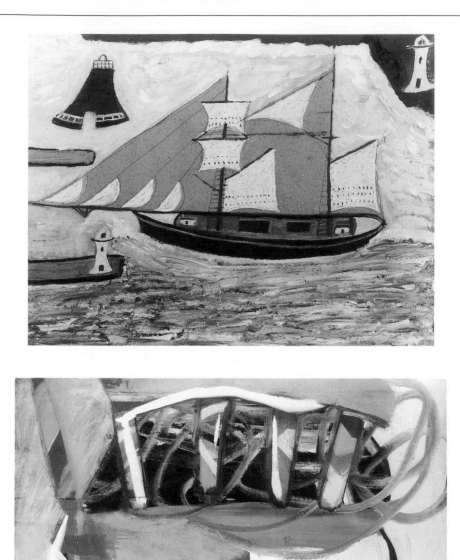

14a Alfred Wallis, *The Blue Ship (Mount's Bay)*, c. 1934
14b Peter Lanyon, *Tatra*, 1964

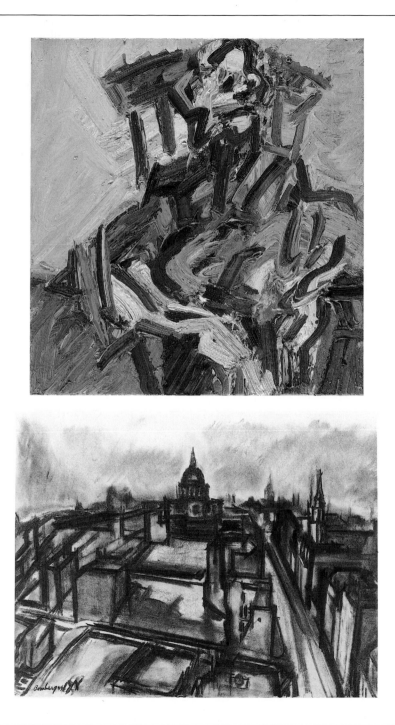

15a Frank Auerbach, *J.Y.M. Seated III*, 1992
15b David Bomberg, *Evening in the City of London*, 1944

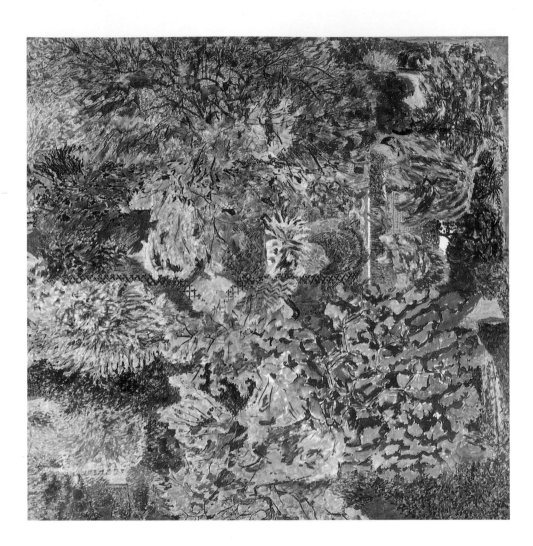

16 Adrian Berg, *Gloucester Gate, Regent's Park, June '83*, 1983

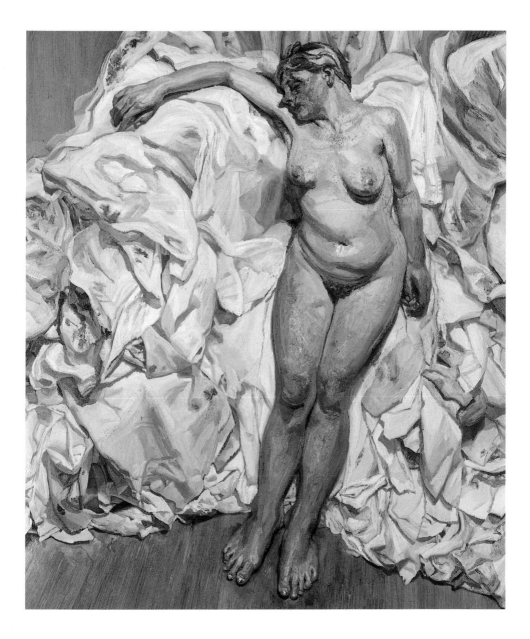

17 Lucian Freud, *Standing by the Rags*, 1988–89

18 Alan Davie, *Hallucination with Gold Pectoral*, 1984

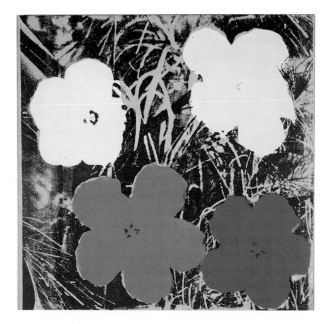

19a Anthony Caro, *Twenty-Four Hours*, 1960
19b Andy Warhol, *Flowers*, 1964

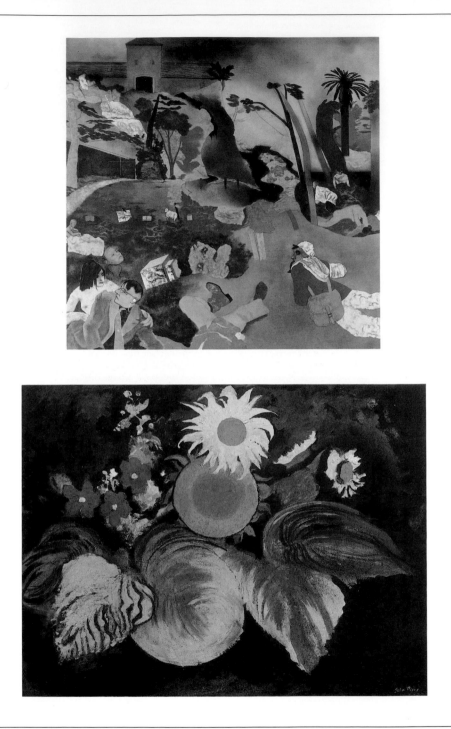

20a R.B. Kitaj, *If Not, Not*, 1975–76
20b John Piper, *Sunflowers*, 1987

artist, and no one else, had decided the crucial disposition of forms in relation to the canvas edge.

After his stripe paintings, Heron pursued a programme of 're-complicating the picture surface', spending much of the 1960s creating canvases in which discs and irregular rectangular shapes float across vast fields of colour. 'Colour,' he wrote in 1962, 'is both the subject and the means; the form and the content; the image and the meaning in my painting today.'

He also refused the central, symmetrical 'bunching' of his shapes, which – like Louis's vulgar colours – appealed to banal and unsophisticated tastes. The compositional drawing in a Heron is, I believe, more independent of colour than he likes to suggest. This drawing surely must be finished in the first minutes, perhaps seconds, of creating a canvas; long before the full weight of the colour values can be assessed. Such drawing seems to be derived from an intuitive sense of balance, which, unlike repetitious, mechanical symmetry, can also be related to natural form. Even in black-and-white photographs, it is easy to perceive just such a 'balance' in the disposition of the rocks and boulders in the Cornish landscape.

In the 1970s, Heron went on to produce what he calls his 'wobbly hard-edged' paintings. In these, the colour surface has become more opaque and resistant than ever. Everything depends on the juxtaposition of one area of colour against, or within, another. In these works, Heron makes full use of his observation that the shape of an area of colour, as defined by its boundary line, greatly changes its value and the nature of the spatial illusions to which it gives rise. As he once put it, 'Complexity of the spatial illusion generated along the frontier where the two colours meet, is also enormously increased if the linear character of those frontiers is irregular, freely drawn, intuitively arrived at.' Although these works can appear exceptionally flat and vigorously 'anti-atmospheric', they also give rise to intense, vibrating illusions of space which emanate from the densely painted picture surfaces.

The sheer expanse of canvas covered in the mid- to late 1970s

was daunting, but, occasionally, Heron did seem to be repeating himself. Perhaps he came to feel he was in danger of falling into American mannerisms. In any event, the 1980s saw another transformation in Heron's work. There is now a conspicuously greater freedom in his handling – a return to painterly gesture, rather than dependence on taut vibrancy. His colours are often softer and no longer necessarily fully-saturated. The great expanses are broken up, and there is no more than a whisper of a return to Bonnard, whom he deserted for Matisse, so many years ago. The references to natural forms and colours, which were never entirely eliminated from Heron's work, even when his rhetoric was at its most radically abstract, now seem undisguised and undenied. I can only presume that Heron himself endorsed the reproduction of a full-page colour photograph of the rocks, shrubs and flowers in his garden at Eagle's Nest towards the end of the Barbican catalogue.

Heron's life in art, hitherto, has shown an exceptional coherence and a single-mindedness of direction. For all the manifest transformations in his painting, he has dedicated himself to a particular set of aesthetic beliefs which involve the affirmation of certain dimensions of painting and the refusal of others. As I intimated earlier, however, his actual *practice* of painting involves faculties and qualities unaccounted for in his criticism.

Heron has set down his underlying aesthetic argument on numerous occasions, but perhaps nowhere more succinctly than in an article of 1969:

Because painting is exclusively concerned with *the seen*, as distinct from the *known*, pictorial space and pictorial colour are virtually synonymous. That is to say, for the human eye there is no space without its colour; and no colour that does not create its own space. When you open your eyes, the texture of the entire visual field (which opening them reveals to you) consists of one thing; and that thing is

colour. Variations in this colour texture (which sight reveals to us) are indications that *form* exists: but colour is there first, in that it is the medium through which form is communicated visually. And so, in manipulating colour, painting is organizing the very stuff of which sight or vision consists.

Again, in 1973, he wrote that painting had as its unique domain the realm of pure visual sensation. 'Painting,' he argued, 'should start in that multicoloured and at first amorphous texture of coloured light which is what fills your vision, from eyelid to eyelid, when you open your eyes.' He added that the finished painting 'should also end in pure sensation of colour – having passed into the realm of the conceptual in the process, and come out again at the other side'.

For Heron, the fact that the world is revealed to sight exclusively through colour is the foundation stone of an aesthetic which maintains that painting ought to concern itself, first and last, with colour. The pleasure to be derived from 'visual sensation', that is, the sensation of colour, and not lines, concepts, or symbols, constitutes painting's unique domain. His argument against the English tradition seems to be that because the English did not understand the primary importance of colour, they failed to grasp its exclusive claims over painting. Instead they fell into the trap of the linear, the literary, and the puritanical – or symbolic.

Given these beliefs it is easy enough to see why Heron separated himself from the harsh, deadening, linear empiricism of the Euston Road School, and from almost all varieties of Neo-Romanticism (Samuel Palmer he found guilty of both 'writhing detail' and symbolism); and especially from Social and Socialist Realism. Heron saw John Berger's criticism as posing 'the main threat to major painting' in Britain. 'Colour,' Heron wrote in 1962, 'is now the only direction in which painting can travel. Painting has still a continent left to explore, in the direction of colour (and in no other direction).'

One problem with Heron's line of argument, however, is that

it simply does not follow from the fact that the visible world is revealed to us exclusively through colour, that colour is the only way of creating space within the illusions of a painting. There was, of course, much more to the great French painting, which Heron loved, than 'pure sensation of colour'. Even if we had only Matisse's black-and-white drawings we would still recognise him as a great master of spatial depiction. Nor is the pursuit of a more depictive and less decorative linearity than Matisse's *necessarily* destructive of colour sense. Euston Road is one thing, but Degas was quite another. For me, he is a colourist second to none – not even to Patrick Heron! And, as I have already implied, there is more to Heron's painting, too, than 'pure colour sensation'. His compositional sense is not a derivative of his response to colour, but is, in a real sense, independent of it. Lines, especially outlines, may be fictions, but drawing remains one of the vital means through which the painter can create illusions and make them live.

I suppose that if one man embodies those English aesthetic values which Heron feels his colour sense means he must reject, it must be John Ruskin. Yet it seems significant that Ruskin's aesthetic was built on observations about colour almost identical to Heron's. Thus in *The Elements of Drawing*, Ruskin writes:

The perception of solid Form is entirely a matter of experience. We *see* nothing but flat colours; and it is only by a series of experiments that we find out that a stain of black or grey indicates the dark side of a solid substance, or that a faint hue indicates that the object in which it appears is far away. The whole technical power of painting depends on our recovery of what may be called the *innocence of the eye*, that is to say, of a sort of childish perception of these flat stains of colour, merely as such, without consciousness of what they signify, – as a blind man would see them if suddenly gifted with sight.

In Ruskin's case, these insights did not lead to an automatic rejection of the linear, the literary and the symbolic. They were

associated, rather, with a line even more 'writhing' than Palmer's, and a celebration of Pre-Raphaelitism – an aesthetic which, I imagine, Heron abhors. The reason for this was that although Ruskin realised that the experience of art (and also of nature) began in sensation, he also recognised that it did not end there. Even now, if we no longer hope that the artist will reveal to us the presence of God in his world, we want something more from him or her than merely optical effects.

Our response to, say, Matisse's *Red Studio*, or Heron's *December 4*, clearly begins in simple visual sensation, which is more or less susceptible to accurate verbal description. But the full appreciation of works of art, as much as the making of them, involves the imagination. Through the imagination, what began as a simple response of the senses enters into the whole terrain of feeling, differential value (quite simply, 'good' or 'not good') and High Sentiment. Simple optical sensations cannot reveal for us a work's place in relation to tradition and its affiliations with other works. They will not help resolve vexed issues of precedent and originality. All of these matters, as Heron well knows, are legitimate components in our response to a work of art.

I believe Heron's best paintings are not to be valued on the grounds of visual sensation alone, but because, through the successful creation of such sensations, he stimulates significant affects, or feelings, in his viewers. He uses all his skill, knowledge and sensibility, as one of the greatest living colourists, to re-create for us a fully adult version of that 'childish perception' to which Ruskin referred.

In her little book, *On Not Being Able to Paint*, Marion Milner, the English psychoanalyst, discussed her own recovery of the experience of colour. She writes:

Colour in painting had been a subject which for years I had been quite unable to think about. It was as if it had been so important that to think about it, to know just what one was trying to do with one's paints, had been to risk losing some-

thing; it seemed at first glance as if an experience so intimate and vital must be kept remote and safe from the cold white light of consciousness which might destroy its glories. In fact it was as if colour and the light of knowing were differences which must be kept firmly separate, just as objects had to be kept separated and not seen in their mutual effect upon each other.

Milner explained that when she finally risked not-knowing and gave herself up to colour, the common-sense world of objects separated by outline dissolved, and was transformed into 'a world of change, of continual development and process, one in which there was no sharp line between one state and the next, as there is no fixed boundary between twilight and darkness but only a gradual merging of the one into the other'. She insisted that this rediscovery, through colour, was not regressive. Rather, she associated it with the recovery of a spiritual, though secular, dimension in perception, or, as she put it, 'a re-emerging into a new division of the me-not-me, one in which there is more of the "me" in the "not-me", and more of the "not-me" in the "me" '.

Through his best colour paintings, Heron offers us intuitive experiences of both fusion and separateness, of space and the material facts of the painted surface. He thereby recovers something of the lost 'innocence' of infantile perception, although his vision is anything but regressive. Heron's paintings elevate, even exalt us, not simply because they provide pleasurable sensations, but because they suggest new kinds of integration between observer and observed, and indeed the whole world of nature, which cannot be revealed through logic, reason, nor even a conventional mode of seeing, which reads the world in terms of outlines and separate objects. This may not constitute the only direction for painting, but painting which ignores such a powerful means will certainly impoverish itself.

1985

David Hockney: All the World's a Stage

'Well, I'm not that interested in the theatre itself,' David Hockney said in 1970. 'I did one play. I designed *Ubu Roi*. When I was doing that, I suddenly realised that a theatrical device in painting is quite different to a theatrical device in theatre.' He added, 'I'm really not interested in theatre design or anything.'

Four years later, John Cox, a producer, invited Hockney to design a new production of Stravinsky's opera, *The Rake's Progress*, for Glyndebourne. Predictably, Hockney had profound misgivings, but he loved opera and he was experiencing a deep crisis of confidence about his own painting. The idea of working in a new medium appealed to him. So, too, did the subject matter. Hockney himself had made a 'modern life' version of Hogarth's famous series of prints in the early 1960s. He accepted Cox's offer, and the resulting designs were shown in the exhibition, *Hockney Paints the Stage*, at the Hayward Gallery in August 1985.

Hockney insisted that the opera should be set in the eighteenth century – as reinterpreted from a twentieth-century viewpoint. Even though the relationship between Igor Stravinsky's work and Hogarth's is tenuous, Hockney decided to make persistent reference not just to the subject matter but also to the pictorial techniques of Hogarth's prints. He made use of dramatic perspectival foreshortenings – especially in the Bedlam scene; and, improbably, turned even cross-hatching into a theatrical device. Intersecting lines covered not only the back-drops, but even the furniture and the costumes, creating the illusion that everything has been 'engraved' in three dimensions. The result proved so original and effective that

Hockney was immediately invited to design a *Magic Flute* which was staged at Glyndebourne in 1978.

During the year he spent working on Mozart's opera, Hockney produced no paintings at all. Again, his sumptuous sets captured the audiences' imagination. In 1981, he went on to complete two triple bills for New York's Metropolitan Opera House. The first of these included Satie's *Parade*, Poulenc's *Les Mamelles de Tirésias*, and Ravel's *L'Enfant et les Sortilèges*; the second, three works by Stravinsky.

Soon after, Martin Friedman, director of the Walker Art Center in Minneapolis, invited Hockney to make the exhibition, *Hockney Paints the Stage*. Friedman was concerned about the best way of displaying the sets in an art gallery. Sarastro's marvellous utopian kingdom in *The Magic Flute*, peopled with strangely costumed beasts, was one thing on an opera house stage, but it might be killed stone dead if it was presented simply as a stuffed menagerie against a static back-drop.

For a long time, Hockney appeared indifferent to these difficulties. He was deeply, even obsessively, immersed in his experiments with photography. He argued that the conventional photograph lacked time and therefore life. To overcome this, he started collaging together whole series of exposures and re-integrating them into single images which, he insisted, evaded the fatal photographic flaw.

At the eleventh hour, he managed to tear himself away from his Polaroids and decided to re-create seven stage sets especially for the Minneapolis exhibition. Working at extraordinary speed, on a gigantic scale, he produced what were, in effect, seven autonomous new works. He not only re-painted the props and back-drops himself, but fabricated his first sculptures to represent various characters from the operas and ballets. His esoteric researches into the photographic image exerted a powerful influence on what he produced. Tamino, the flute player in the Mozart opera, became, in Friedman's words, 'a picaresque abstraction of multi-coloured planes'. Hockney himself explained, 'a walking lizard might have twenty feet,

leaving a trail behind him to tell us where he has been'. He added that the lizard could have 'three heads in different positions and, as in the photographs, you believe it's one'.

Despite originally denying any interest in theatre design, Hockney's mastery of the medium was hardly surprising. Even when he worked in only two dimensions his principal means of expression had been the playful manipulation of depictive surface and spatial illusion. Behind all the wit and whimsy lay pressing psychological and aesthetic preoccupations.

As every art student knows, David Hockney was born in Bradford in 1937. At his local College of Art he learned to draw, and to paint after the manner of Sickert. He went to the Royal College of Art in 1959 and felt uncertain about what to do there. At first, he spent a lot of time making two painstaking drawings of a skeleton. From this time on, in times of doubt or confusion, he has often fallen back on the apparent certainties of naturalism.

Those were heady days in the College. Hockney's art soon reflected his espousal of homosexuality, pacifism, Cliff Richard and vegetarianism. His manner of painting now recalled the self-conscious infantilism of Dubuffet, or, closer to home, Roger Hilton. But there was always a sense of deliberate distancing in Hockney. Even at his most 'painterly' – as in *We Two Boys Together Clinging* – Hockney always held back, like a knowing child, and offered a kind of painted parody of his experience, replete with jokes and ironic references.

Although a gulf divided their sensibilities, Hockney also greatly admired Francis Bacon. Yet where Bacon seemed almost murderously intent upon exposing the post-operative entrails of his subjects, Hockney preferred to dress them up. Many of his early paintings, especially *A Grand Procession of Dignitaries in the Semi-Egyptian Style*, reveal his interest in the paradoxes of stagey space, performances, tassels and role-playing.

Hockney left the Royal College in 1962 with a gold medal and a ready-made success. He had his first one-man show at Kasmin's the following year. During the 1960s the nature of his

concerns became increasingly clear. He showed little interest in the expressive manipulation of his materials, nor did he want to use colour as a means of conveying intense emotion. Although he worked constantly with the male figure, he rarely showed much inclination to reveal character through attention to physiognomy or anatomical gesture. He showed no signs of wanting to involve himself with, say, the way in which natural light fell upon objects, nuanced and revealed them. For a while, at least, artifice was all.

At this time he became fascinated by a picture in the National Gallery by Domenichino, *Apollo Killing Cyclops*, in which the action is depicted through a painting of a tapestry made from a painting. The edge of the tapestry is carefully rendered; in the bottom right-hand corner it is folded back, revealing a 'real' painted dwarf. This picture inspired Hockney's painting, *Play Within a Play*, which shows his dealer, John Kasmin, with his nose pressed against a real sheet of glass laid across the picture surface. Kasmin stands in a shallow pictorial space behind which hangs the painted version of an illusionistic tapestry.

Soon after making this picture Hockney spent much of his time in California, where he was drawn to the imagery of showers, pools and jets of water. Curtains appear again and again in his work. 'They are always about to hide something or reveal something,' he said. There are also references to the reflective paradoxes the painter encounters when he seeks to represent water. These years, the early 1960s, were a period of high and confident conceit, when Hockney seemed content to remain trapped within a painted world in which illusion opened out onto illusion, revealing no ultimate reality.

The first hints of change came about in an awkward attempt to do a 'naturalistic' drawing of his father, associated with the painting, *Portrait Surrounded by Artistic Devices*. Here, a 'realistic' painted father sits beside a stuck-on heap of cubistic cylinders. Two years later, when working on *The Room, Tarzana* – a portrait of his boy-friend, Peter Schlesinger, laid out like Boucher's pink-bottomed Mademoiselle O'Murphy – Hockney suddenly

realised, 'This is the first time I'm taking any notice of shadows and light.'

He then plunged into a series of portraits and set-pieces, including the well-known double portraits of couples failing to relate, which showed a new reliance on the sort of appearances revealed by photography. Indeed, photography was coming to play an increasing part in Hockney's working methods. But this naturalism, too, he soon found cloying. In the early 1970s, he made a number of landscapes, effectively transcribed from photographs which had the dead and unappealing appearance of works by the American Photo-Realist school.

Neither the elaborate devices of Post-Cubism, nor an apparently straightforward naturalism, seemed sufficient to carry Hockney beyond that shimmering pool of narcissistic illusion and self-reflection in which he had imprisoned himself. Following the break-up of his relationship with Schlesinger, Hockney's picture-making entered a period of profound crisis, captured superficially in Jack Hazan's film, *A Bigger Splash*. He developed a new interest in Van Gogh, whom he regarded as an artist who had been able to deal directly with experience without being either aesthetically innovative or conventionally naturalistic. But Hockney could find no equivalent for Van Gogh's solution in his own painting. Perhaps he came closest to what he was looking for in the fine drawings he made of Celia, his only close woman friend. These possess an intimacy and a sense of otherness, conspicuously absent from so many of his male images.

The invitation to produce the designs for *A Rake's Progress* came in the middle of this crisis in his picturing. It provided him with an immediate solution: the chance to construct his artifices in real space, to make three-dimensional pictures which had an undeniable existence in a world beyond himself. The culmination of *The Rake's Progress* work was a painting based on an image by Hogarth, which Hockney called *Kerby* [*see jacket of book*]. In this piece, all the devices which should lead to a naturalistic image are reversed or inverted, and yet the picture remains legible.

Hockney tried to combine these discoveries with a replenished naturalism in the portraits of his parents that he produced in the mid-1970s. I remember visiting him at this time in his London studio. He told me, 'When you paint your parents, you paint an idea of them as well. They exist in your mind, even though they are not in front of you. And the problem is, is that part of reality?'

One cannot escape the observation that Mrs Hockney has the face of an ageing Celia, and Celia the look of a young Mrs Hockney. Perhaps he was no nearer an escape from narcissism? In any event, despite going through two versions, the double portrait of his parents was not a success. Hockney abandoned it and subsumed himself in the designs for *The Magic Flute*.

In the early 1980s he plunged into his critique of the photographic image. Though the 'cameraworks' are not, in themselves, an aesthetic success, they represent another stage in his struggle against being imprisoned within mere illusions of appearances. Once again, Hockney found it easiest to find his 'solutions' by transferring the problem into the third dimension – by making the exuberant, colourful and convincing set-pieces for *Hockney Paints the Stage*.

With Hockney, the shifting of levels is incessant and compulsive. Many years ago, when he had finished his complex picture of Kasmin trapped behind a sheet of glass, he added irony to irony by having a tapestry made of the image. Then a painter friend visited him and, to Hockney's delight, offered to make a painting from the tapestry.

At the same time as *Hockney Paints the Stage*, he also held an exhibition of pictures at Kasmin's Knoedler Gallery in Cork Street, called *Wider Perspectives are Needed Now*. In this show Hockney re-incorporated lessons he learned from his theatre work into enormous paintings which were like depicted images of those fanciful illusions which he had previously found he could only create in three dimensions on the stage.

There are those for whom all of Hockney's work will amount to no more than a kind of illustrational game-playing. Douglas

Cooper was not alone in his view that Hockney was an overrated minor artist. But this is to ignore both his manifest skills and his consistent capacity to entertain. I do not intend this word in any derogatory sense. Most art produced today lacks such a capacity to suspend our disbelief, to hold and engage us. At the very least, Hockney's achievement is comparable to John Fowles's in literature, or Hitchcock's in the cinema. He beguiles his viewers into a world of uncertainty and delightful paradox, but behind the façade, one senses the most serious intent.

Like his erstwhile hero, Francis Bacon, Hockney sees men and women as somehow trapped within their subjectivity. Perhaps this is where the vicissitudes of the homosexual imagination can appeal to a more general existential condition. For Hockney, as for Bacon, we are like caged animals: the jungle we see is just an illusion, painted on the concrete wall of our enclosure. Bacon's perception of this situation led him to claw his way through the skin into the splayed intestine. Hockney invites us to break through the wall – to confront another illusion, another depicted jungle, on the boundary beyond.

In some ways, Hockney may be a lesser artist than Bacon, and yet I have every sympathy with those who prefer the consolations of Hockney's mirroring artifices, his plays within plays within plays, to Bacon's dubious 'realism'. Bacon can only offer the ultimate presence of death, while Hockney invites us to celebrate the illusion of life.

1985

John Hubbard

John Hubbard's painting, *Tresco No.6*, 1984, is based on the sub-tropical Abbey Gardens at Tresco on the Scilly Islands. The picture is redolent with allusions to natural forms and the nooks and crannies of natural space. Its life and rhythm spring from a sense of twisting and trailing growth, of tangling fronds, swelling succulents and glinting petals, which almost dazzle the viewer with a superabundance of colour and a sense of swarming vegetable life. Hubbard describes these gardens as filled with livid geraniums cascading down the escarpment. There is, he says, a compelling 'vulgarity and a profusion' about the place.

All this is present within the painting. But although it contains more substantial forms than many of Hubbard's earlier pictures, *Tresco No.6* is not descriptive – at least not in the sense of seeking visual verisimilitude. It offers no illusion of recessive space, no identifiable horizon, no vanishing point. The forms of which it is comprised are infinitely suggestive, but it would be hard to identify, with certainty, any definite leaf, stalk, or rock shapes. It is as if Hubbard always wanted to remind us that his painting was just a mass of compact brush-strokes, rhythmically ordered across a two-dimensional canvas surface. The picture demands companionship. As we allow our eyes to sink deeper into it, we become increasingly certain that if what is on offer is not an attempt at the topographic recording of appearance, neither does it spring from purely formal, or narrowly 'aesthetic' concerns.

Hubbard once wrote that the purpose of his paintings was 'to relocate the familiar in an unfamiliar, personal way, so as to emphasize certain natural phenomena which possess a

metaphysical significance for me'. Or, as he put it to me, 'I try to find the places that reflect an inner consciousness I already have.' But we feel that through this strange vibration of space Hubbard is trying to do something more than to give expression to his subjective feelings about a place. Rather he seems to have created for us in Roger Fry's phrase, 'a new and definite reality'. He wants to introduce us to what Robert Lowell called 'The land that trembles to caress the light'.

In all significant landscape painting, as Kenneth Clark pointed out, 'the scenery is not painted for its own sake, but as the background of a legend and a reflection of human values'. But the problem in the twentieth century, as Clark also perceived, has been that scientific knowledge has tended to shatter the sense of unity which nature and the landscape once seemed to possess. Our growing knowledge that nature is, as Leonardo da Vinci perceived, 'full of an infinity of operations which have never been part of experience' has tended to alienate us from it. And so 'Higher Landscape', or the attempt to use landscape painting as a means for conveying moral and spiritual truths, is no longer fashionable.

The argument is that 'serious' or 'avant-garde' art since the last war has not been concerned with landscape and the exceptions have not been concerned with painting. Yet Kenneth Clark did not despair about the future of landscape painting. The fact is that even when some of Britain's greatest landscapes were being produced, theorists as astute as Joshua Reynolds referred to landscape painting as the most lowly pursuit in the artistic repertoire. It may well be that posterity will take a different view from that which is currently fashionable of what is, and what is not, of significance in today's art. Certainly, I believe that John Hubbard's remarkable landscape paintings will continue to be enjoyed and valued long after much of the art of the last three decades has been forgotten.

Hubbard's recent work has acquired a new authority and conviction. Like every major artist working today, he has had to re-invent tradition for himself. The sources which nurtured and

sustained him were diverse. They included American Abstract Expressionism; Chinese painting; early nineteenth-century English landscape painting – especially that of Samuel Palmer and Turner; late nineteenth-century French painting – particularly late Monet and Cézanne; and English post-war painting from St Ives.

John Hubbard was born in Ridgefield, Connecticut, in 1931. His father was a lawyer and a well-known local personality. Hubbard himself went to Harvard, where he studied English literature, but he was already turning towards the visual arts. His tutor, Benjamin Rowland, an expert on oriental art, did nothing to discourage this. Hubbard's own interest in the arts of China and Japan was not, of course, predominantly historical or scholarly. Bryan Robertson is guilty of only slight exaggeration when he writes, 'The key to all Hubbard's work, notably in its recent culminating phase of great authority, perhaps resides in the fact that his tutor at Harvard knew Morris Graves, Mark Tobey, and other West Coast painters with an awareness of Oriental art.' Like Tobey, Hubbard intuitively felt that the Chinese experience of landscape embodied something of that sense and symbolism of space which he was seeking.

It is, however, typical of Hubbard that he always prefers to incorporate rather than to oppose, and his interest in oriental traditions did not lead him to a reaction against Western art. He made his first visit to Europe while he was still a student in 1952. He was immediately attracted to the physical landscape of England, but also travelled extensively in France and Italy, perhaps only dimly intuiting the importance England was going to assume for his own work.

Two years later, he went to Japan where he served in counter-intelligence. Hubbard was to remain there until 1956, although most of his time was spent on the remote island of Hokkaido. The aesthetic coherence of traditional Japanese culture – which bore witness to a unity between ritual, ornament, horticulture, and social and philosophical attitudes – appealed to him. Something of this sensibility may have filtered

through into his later paintings, but the more powerful influence continued to be the art of China rather than that of Japan. His admiration for the great Chinese landscape painters remains undiminished today. 'They looked,' he explains, 'and then they thought. And when they came to paint, they knew exactly what they were looking for.'

Hubbard has never been interested in the idea of going to a strange place, setting up an easel, and simply painting what is in front of his eyes. He has always sought something much closer to the contemplative deliberation of the Chinese. He says, 'If landscape painting is too literal, for me it is too prosaic. But, of course, it can also be dull when memory has faded.'

Even when Hubbard's ostensible subject matter is the riotous writhing of vegetable growth, there remains an underlying stillness, a sense of being within a landscape (which is rare in Western painting), rather than of gazing or 'focusing' upon it from some external viewpoint. For Hubbard, as for the Chinese artists, pictorial space must be *felt*, rather than mathematically constructed. His painting declares its flatness, its disposition across a two-dimensional surface, before it offers us an illusion. And, when it does so, this seems to flow from an embrace, not emanate from a vanishing-point.

But all this was to come later. In 1956 Hubbard returned to America and began to study art at the Art Students' League, where his taste did not appear to be radically different from that of most young artists based in New York. He was an Abstract Expressionist, who admired and to some degree sought to emulate Pollock, De Kooning, Kline and Motherwell. In 1957 he studied with Hans Hofmann. David Elliott is surely right when he suggests that the principles which underlay Hofmann's colour theories and his concept of 'dynamic balance by opposing blocks of colour' were of importance in Hubbard's later working methods. But Hubbard differed from many painters of his own age group in that he was not concerned with the trappings of 'modernity', 'newness' and 'relevance' through which contemporary American painting presented itself to the

world. Clement Greenberg's concept of Modernist painting as being engaged upon a quest for its own essence had no relation to what Hubbard was attempting.

He likes to quote Hsieh Ho, who once wrote, 'In art, the terms ancient and modern have no place.' Hubbard is concerned with the nature of the experience which he derives from certain works of art of the past and of the present – and indeed from contemplation of landscape itself. His painting has always tried to focus upon aspects of the human condition which do not change greatly from one moment of history to the next. This was true even before his subject matter became stones, earth, vegetation, water, light and sky.

Here, perhaps, I risk becoming vague and pretentious, but it seems to me that even when Hubbard's painting was entirely abstract, he wanted to give expression to feelings which – though rare – remain a constant potential for us by very reason of the fact that we are human beings. When he changed from Abstract Expressionism to a related form of landscape painting, it was because he found that the latter provided a more effective way of realising this goal.

The decision he took in 1958 reflects these attitudes. At a time when New York painting was becoming intensely fashionable throughout the West, Hubbard forsook America and came to live in Europe. That same year he visited St Ives in Cornwall, where an exceptional colony of artists had established themselves during and after the second world war. All their work was transformed by their relationship to the local landscape.

Hubbard met Peter Lanyon, perhaps the greatest of the middle generation of St Ives painters. Although Lanyon's work had superficial affinities with the painting of De Kooning and Rothko, whom he knew well, the roots of his art were in the British empirical response to landscape. Lanyon was opposed to the idea of 'pure' abstraction. His mature painting reflected his desire to express a spiritual vision of union with nature. When Hubbard met him, his handling was loosening, and a new sense of light and airiness was entering into his work.

Hubbard felt he had found a kindred spirit. He felt that, eventually, he would have to reconcile what he had seen in St Ives with the legacy of his American experience. But perhaps he was not quite ready to do so. In any event, that year he went to Rome, where he remained until 1960. While he was there he painted mostly still life.

Hubbard returned to London in 1960. He began to teach at Camberwell School of Art. There was, perhaps, a fitting irony in this, as Victor Pasmore had taught there immediately before his momentous change, in 1948, from poetic landscapes of London parks to radical abstraction. While Hubbard was at Camberwell he was moving in the opposite direction. In 1961 he married and settled in the rolling hills of Dorset, close to the coast. No one could remain indifferent to the beauties of this place; but perhaps, for Hubbard, they merged with some emotional sense of having at last found a home. From this time on, intimations of external reality begin to play an increasing part in his painting.

Initially, Hubbard attempted to fuse an anti-illusionist conception of 'truth to materials' with Constable's concept of humble 'truth' towards nature. That is, he produced Abstract Expressionist 'landscapes' of Dorset, painted in broad, gestural strokes with a palette of earth and sky colours. But he soon found this way of working too solipsistic. He began to visit Greece where the Apollonian clarity of the landscape, and of white light on marble columns, impressed themselves upon him. Back in England, he looked again at the vertical forms of the cliffs of Dorset. They suggested a way of achieving a greater sense of continuity across the picture surface 'by means of a sample, or slice'. The painting called *Peloponnese* reflects these changes and reveals his desire to build a painting through tonal juxtapositions, rather than by reliance on the rhetoric of painterly gesture.

By the late 1960s, Hubbard began to feel the need for a more radical change. He felt that the way he was painting was limiting what he wanted to say. In particular, he wanted to reach beyond the blues, greens and browns of the English

landscape and experiment with ways of making marks which had less to do with the disposition of formal relationships. The turning-point came in 1968. That year he produced only two paintings and spent most of the year drawing with oil-based pastels. He became fascinated by the glowing, spiritual land-scapes of Samuel Palmer, where the English countryside seems transformed into a wondrous place. Hubbard even exhibited charcoal drawings after late Palmer water-colours in an exhi-bition at the New Art Centre in 1969. But the catalyst for the transformation of his own vision came from further afield.

He had often entertained the fantasy of going to Morocco, and, that year, he visited the country for the first time. Until the mid-1970s Morocco was to play a similar role in relation to his imagination as Greece had once done, but its effects on his painting were very different. For Hubbard, Morocco was a magical country, a land filled with the pungent smells of burning wood and strange herbs; mysterious passes and glittering, glistening mica. Even the soil seemed to glint with a myriad of sparkling hues. The leaves of the trees rippled, rustled, and quivered with a tremulous light and Hubbard gazed in wonder at the swirling colours which he saw in the streams. But it was not just a matter of new sensations. Hubbard found the Atlas mountains, in particular, to be a solemn and sacred place. A new note of symbolism, strangely reminiscent of Gustave Moreau, entered into his imagery. Indeed, his gorgeous Moroccan landscape, *Imlil*, based on a valley in the Atlas mountains, glows through all its glazes with an inner light which in mood, if not in technique, brings to mind the work of Moreau's pupil, Rouault.

Inevitably, given the direction his own work was taking, Hubbard was deeply impressed by the great Turner retrospec-tive held at the Royal Academy in 1975. The works there which spoke to him most were the 'Rivers of France' series, in which, after all his great discoveries, Turner seemed to resort to meticulous technique and a spirit of humility in the face of appearances. These studies had a direct influence over *Orange*

Water of 1976. The imagery in this painting recalls a moment when, on a drive down to St Ives, Hubbard stopped and watched the incoming tide in a small bay near Padstow. The movement of the water reminded him of the sight of Berber women washing their brilliantly coloured clothes in a Moroccan stream, but the burning colour could equally be a reflection of sunlight in water. Almost uniquely in Hubbard's pictures, the image in *Orange Water* is tilted away from the picture plane in a way which suggests one is looking down into it.

In Morocco, Hubbard had seen many strange caves. These provided the starting point for a series of works based on the imagery of caves, rocks, and stone groups. He began to visit Haytor Quarry on the south-east of Dartmoor. Although his beautiful charcoal drawings on stony themes have a strong sense of plasticity and three-dimensional form, the paintings do not. In works like *Yellow Facets*, the brush-strokes suggest light dissolving across the worn, worked and weathered surfaces of the stones. Other Haytor paintings, like the Tate Gallery's *Haytor Quarry* which was not completed until 1982, are more densely painted and embody a more sombre mood. Often, there are suggestions of lichens and seaweeds, of surfaces etched, encrusted and rubbed with a natural history – and the evocation of these seems more important to him than the suggestion of objects in physical space.

But Hubbard's stone studies are in no sense literal. Looking at them, I was reminded of the way in which John Ruskin argued that 'to the rightly perceiving mind, there is the same infinity, the same majesty, the same power, the same unity, and the same perfection manifest in the casting of the clay as in the scattering of the cloud, in the mouldering of the dust as in the kindling of the day-star'. Hubbard may not believe – at least not in the same literal sense as Ruskin did – that nature reveals the handiwork of an unseen God. Even so, his stone paintings seem to demonstrate that these weathered surfaces can offer us a spiritual and aesthetic experience of the same order as that which he had discovered in the Atlas mountains.

Something of this sense carries over into Hubbard's Vaucluse paintings. He went three times to the same little limestone valley, Les Seguins in Vaucluse, in northern Provence. On his first trip he made numerous studies in water-colour and pencil. On his second visit, two years later, even he seems to have been surprised at the degree of naturalism and definition of distinct features which he was now prepared to allow. He made a series of large-scale charcoal drawings. Back in the studio, he drew heavily on his pencil sketches to produce a series of sixteen major canvases. Les Seguins is close to Cézanne country, and Hubbard had Cézanne's late paintings very much in mind – particularly when he created the beautiful picture, *Pink Stones: Les Seguins*. Hubbard was intrigued by the way in which, in Cézanne's pictures, all the individual details seemed at once to cohere as part of the same living mass, and yet simultaneously could separate themselves and assert an identity. Conversely, his own forms appear to affirm their solidity and are much more plastic than ever before. And yet, as soon as the viewer tries to grasp them, they dissolve into the background. In Hubbard's painting this new relationship between objects and the ground which sustains them does not seem to be a merely technical matter; rather, through these pictorial means, he creates a space which is neither subjective nor objective.

One of the last of the Vaucluse paintings was *Vaucluse (Foliage)*, 1982, in which the imagery seems to refer to vegetable growth rather than to stones. This work heralded the explosion of garden paintings which has dominated Hubbard's imagination in recent years [*see plate 12a*]. These have been partly inspired by the sub-tropical gardens at Abbotsbury, near his home in Dorset; partly based upon Tresco, in the Scilly Isles, which he visited in 1984 and heavily transformed by his own imagination. It is perhaps tempting to interpret these works as images of superabundant vegetable growth and exuberant foliage. This element is certainly there, but the overall impression is of profound tranquillity. It is as if Hubbard was more interested in the relationship between forms than the

forms themselves. Pictures like *Woodland Garden*, of 1984, breathe with a gentle vibration of feeling which suggests the stillness of being beyond, or at least behind, the turmoil of desire.

Many of Hubbard's paintings in recent years are based on the conservatory in his house in Chilcombe. This beautiful farmhouse also possesses a magnificent walled flower and herb garden which Hubbard and his wife have raised from nothing over a dozen years. These days, Hubbard seems fully the master of his own means and is prepared to take greater risks. *Winter Conservatory*, in particular, involves not only substantial, broadly blocked, almost identifiable, leaf forms, but also suggestions of trellises and architecturally structured space. He allows a much greater degree of openness between and among his vegetable forms than ever before. None of this suggests that Hubbard is lurching towards naturalism. Rather, his confidence in his vision is such that he no longer feels it to be threatened by these more material presences.

There may be some who feel that Hubbard's 'garden' imagery is a form of escapism. They could even cite Kenneth Clark in support of their view. At the end of his great book, *Landscape into Art*, Clark tentatively speculated on the future of landscape painting in the modern world: 'Can we escape from our fears by creating once again the image of an enclosed garden? It is a possible way of life: is it a possible basis for art? No . . . The enclosed garden of the fifteenth century offered shelter from many terrors, but it was based on a living idea, that nature was friendly and harmonious. Science has taught us that nature is the reverse; and we shall not recover our confidence in her until we have learnt or forgotten infinitely more than we know at present.'

Clark goes on to argue that the best hope for the continuation of landscape painting is through 'an extension of the pathetic fallacy', and that our 'new and terrible universe' will eventually find expression in landscape in the same way that 'old forest fears' found expression in Northern art. Clark finished the revision of his lectures into book form on a voyage to Australia

in 1947; and, with his usual perspicacity, he was the first European to perceive how the great Australian desert landscapes of the post-war years reflected this new sense of an alien and intractable nature – inhospitable and threatening global destruction. This desolate image of nature is seemingly more appropriate to our times than the enclosed garden. And yet many writers in more recent years have stressed the need for an imaginative approach to nature which allows us, as it were, to go beyond that sense of 'alienness' with which modernity has lumbered us, to discover a new sense of unity with the natural world of which we are a part.

The biologist E. O. Wilson warns that we are near the end. 'The inner voice murmurs, *You went too far*, and disturbed the world, and gave away too much for your control of Nature.' We are presented with a dilemma he describes as 'the machine in the garden'. 'The natural world is the refuge of the spirit, remote, static, richer even than human imagination. But we cannot exist in this paradise without the machine that tears it apart. We are killing the thing we love, our Eden, progenitrix, and sibyl.'

Wilson points out that our suspension between the two 'antipodal ideals of nature and machine' has been restlessly seeking, in the words of the geographer, Yi-Fu Tuan, 'an equilibrium not of this world'. For the role of science, like that of art, 'is to blend exact imagery with more distant meaning, the parts we already understand with those given as new, into larger patterns that are coherent enough to be acceptable as truth'. Wilson argues that the injurious dilemma of the machine in the garden exists in the realm of the spirit as surely as it does in the shrinking natural world; and it is the unique province of the artist to offer images which represent a reparation in the spiritual, rather than the ecological realm.

In his paintings of the 1980s, Hubbard offers just such glimpses of an 'equilibrium not of this world' and he thereby enthuses the tired imagery of the enclosed garden with an unexpected strength. If Kenneth Clark had seen these pictures,

one suspects that he would have approved. The truth which Hubbard reveals to us he has found by looking into himself and through contemplating his own relationship to the living landscape. The space which he creates in his paintings is neither that of fantasy, nor yet an attempt to depict 'objective' appearances. His gardens are not a nostalgic escape, nor are they only the evocation of the sense of an existing place. Their insistence on movement, change, and becoming confirms that rather they are offering a kind of promise.

1986

R. B. Kitaj

In the catalogue to his 1985 exhibition at the Marlborough Gallery, Ron Kitaj wrote, 'Art "about" Jews does not appear much among painters, although a new "German" art has appeared with a bang, has it not?' Kitaj's recent paintings are a self-conscious attempt to redress this balance – to make art which is explicitly and unashamedly about Jews.

Kitaj confesses to being haunted by memories of the holocaust, and fears for the future. 'That epochal murder,' he writes, 'happened during my youth, and now, after the greatest trouble they were ever in, Jews find themselves in peril again.' Kitaj argues he could not proceed as a painter without a heightened sense of Jewishness. In a lecture he gave recently in Oxford, he explained that in him, the Jewish spirit was 'a long time in the forming and coming'. He told his audience it began to stir seriously about five years ago, 'although chimerical aspects of Jewishness had tempered my life and art for many years'. He recalled, 'One third of our people were being murdered while I was playing baseball and going to movies and high school and dreaming of being an artist.'

Nowhere are all these concerns more evident than in a painting called *Germania (The Tunnel)*, of 1985. In a self-portrait on the left-hand side of the painting Kitaj depicts himself wearing a vest and trousers splattered with blood and black arrows. He carries a stick because he is lame. One of his legs is caught in a chimney-like structure – a repeated iconographic device which runs through many of these works. In front of the painter is a boy child who has just learned to walk. He is bearing a book and pointing towards the printed page. Kitaj never allows us to forget that Jews are 'People of the Book'.

In the right foreground is a naked woman, seen from the back. She too appears ensnared within an evil chimney shape. Behind these figures stretches a long, arched corridor which has been borrowed in every detail from a Van Gogh painting of the Saint-Rémy asylum where he was incarcerated. This corridor immediately evokes the gas-chambers, and culminates in a small golden door. Kitaj recalls that the inscription 'Paradise Alley' hung above the entrance to one of the chambers of death in Auschwitz.

About a year ago, Kitaj's son, Max, was born. The theme of this painting then might be said to be, 'How do I, an artist and a Jew, bring up my son to know about things like the holocaust?' Minutes after Kitaj had told me this, in his gallery on the morning of the day on which his exhibition opened, I watched Max stand and take his first faltering unaided steps only a few yards away from *Germania (The Tunnel)*.

Another of the paintings in this exhibition was called, *Self-Portrait as a Woman*. This shows a naked, female figure, again seen from the back, and apparently wearing a placard. Kitaj lifted this image from holocaust literature which told how, during the Third Reich, certain women were taken and paraded naked in public with a sign round their necks saying, 'I slept with a Jew'. Kitaj identifies himself, as an artist and a Jew, with such a woman. S/He is transformed in his painting into a kind of hero/ine. Once again, the structure of the figure and placard suggests the recurrent symbol of the death-camp chimney. This is echoed in the church tower in the background, for Kitaj has set the lurid scene against the back-drop of a beautiful, almost magical, small German town. This contrast is reminiscent of the way in which certain 'Primitive' and early Renaissance paintings depict the Crucifixion as a glorious event which took place in front of a magnificent, fairy-tale city.

Many of these themes are also reflected in what is, perhaps, the finest single picture in the exhibition, *The Jewish Rider*, of 1984–5. The painting is a portrait of Michael Podro, the art historian, who is shown seated and reading – a text always

enters in somewhere – in a railway carriage. The chimney is
again conspicuous, this time in the corridor on the right-hand
side of the painting which is occupied by a menacing uniformed
figure who raises a lash high in the air. Through the window on
the left-hand side of the picture, one sees a bruised but beautiful
wasteland, in the midst of which a single tall chimney smokes.
Kitaj has long been fascinated by a newspaper report which
related that the trains of death on their way to Auschwitz
passed through an extraordinarily beautiful landscape.

In the painting called *Yiddish Hamlet (Y. Lowy)*, 1985, Kitaj
depicts Lowy, a member of a lowly group of Yiddish travelling
players. Lowy was a friend of Kafka's who lived a despised life.
'A Man of Sorrows', rejected of men, he died at Auschwitz.
Kitaj depicts him encased within that cylindrical chimney
structure.

The assertion of Jewishness, and the struggle for symbols
adequate to that assertion, have become the central preoccupa-
tion of Kitaj's painting. These pictures have already proved
something of a scandal and a stumbling-block. Other Jews,
especially other Jewish painters, recoil with embarrassment.
(Kitaj points out that there is much more coherent 'Jewish spirit'
among writers than among visual artists. No one hesitates to
call Philip Roth – of whom Kitaj has made some fine drawings –a
Jewish writer; but Auerbach, Freud or Kossoff are never
referred to as Jewish painters.) Gentiles, on looking at these
pictures, are likely to feel a sense of exclusion at the expression
of emotions with which they can sympathise but not empathise.

Conventional wisdom has long been that the Jewish ex-
perience in the Third Reich was so extreme and horrific that no
painting could ever encompass it. Ironically, one of the few
attempts to deal directly with the death camps in painting is a
Crucifixion by Graham Sutherland which now hangs in St
Matthew's Church, Northampton. Sutherland explained that
the whole idea of the depiction of Christ crucified became much
more real to him after having seen a book containing 'the most
terrible photographs of Belsen, Auschwitz and Buchenwald'.

For the first time, 'it seemed to be possible to do this subject again'.

For Kitaj, a Jew rather than a convert to Roman Catholicism, the treatment of Jewish experience required a symbol other than that of the Christian Cross. He admits, however, that it was the Christian Passion of Rouault which inspired him to embark on his Jewish Passion. 'I made a startling discovery,' he writes. 'There seem to be no representation of the Crucifixion itself in art for hundreds of years after the event.'

Peter Lasko suggested to him that the earliest known one may be on the wooden doors of Santa Sabina in Rome, which date from the fifth century. But Kitaj insists the subject was not a familiar one for hundreds of years after that. 'Anyway,' he adds, 'I thought – why wait 400 years after our (Jewish) Passion?' The appearance of his chimney form is, he suggests, 'my own very primitive attempt at an equivalent symbol, like the Cross, both, after all, having contained the human remains in death'.

But it seems to me that there are many queries and objections we ought to raise before we can accept this parallel, for the idea that the image of the Cross was expunged from the early history of Christianity will not stand up. Representations of the Cross (if not the Crucifixion) pervaded Christian culture long before the fifth century, let alone the eighth century.

In the second century, Justin the Martyr perceived the Cross everywhere, even where it was not. According to Justin, Plato believed that the Logos, the power next to God, 'was placed crosswise in the universe'. Justin also saw numerous 'types' of prefigurements of the ubiquitous Cross in classical literature. Homer describes how Odysseus asked his shipmates to lash him to the mast of his boat so he could hear the allurements of the Sirens and survive. Justin interprets the episode as a foreshadowing of the way in which the death of Jesus on the Cross enabled men and women to conquer sin and death.

Where the Cross could not be seen the early Christians readily re-created it for themselves. 'At every forward step and movement,' writes Tertullian, 'at every going in and out . . . in

all the ordinary actions of daily life, we mark upon our foreheads the sign.' According to Eusebius, when the Emperor Constantine was converted to Christianity, he saw the trophy of a Cross of light in the heavens above the sun, bearing the inscription: 'CONQUER BY THIS' (*Touto nika*). Lactantius tells us that Constantine was directed in a dream to cause the heavenly sign to be delineated on the shields of his soldiers, before proceeding to battle and to victory.

The Emperor's mother, Saint Helena, was believed to have found the true Cross in Jerusalem, allegedly establishing its authenticity by using it to raise the dead. Constantine himself forbade the continued use of crucifixion as a method of capital punishment because the Cross had now become a royal banner, or talisman – a symbol of 'Christ the King'. The Emperor Julian the Apostate forsook Christianity. 'You adore the wood of the Cross,' he complained of his fourth-century Christian subjects, 'and draw its likeness on your foreheads and engrave it on your house fronts.'

No one then can say that the Cross was an unfamiliar element in early Christian culture. As Augustine so vividly put it, 'The deformity of Christ forms you. If he had not willed to be deformed, you would not have recovered the form which you had lost. Therefore he was deformed when he hung on the Cross. But his deformity is our comeliness. In this life, therefore, let us hold fast to the deformed Christ.'

Why then, are there so few representations of the deformed Christ surviving from the early centuries of Christian faith? One simple reason, which Kitaj seems to ignore, is the fervour of the iconoclastic movements of the eighth century. So ferocious and fanatical were the image-breakers that it is more wondrous that *any* early Christian representations have come down to us, rather than so few. But this is not the only reason. We also have to take account of the process of 'elevation' of the Cross. That is, the way in which the sordid reality of a particular Roman execution became transmuted into a sign of magical power and of conquest.

That crucifixion was at first not even a speck in the tide of imperial history. The 'holocaust' of Roman crucifixion has been overlooked, as hundreds of thousands of men and women were crucified by the Romans, who used the cross as an instrument of terror, as well as of punishment. There were times when the arenas of the Empire bristled with crosses. After the defeat of the Spartacus uprising in 71 BC, almost 6,500 crosses lined the Appian Way from Capua to Rome. About *their* passion, the church is silent.

Kitaj also seems to be missing another seminal fact about the Crucifixion of Jesus. The Christian tradition subjected itself from the time of Paul onwards to a process of dejudification. Although the Jews were often accused of the 'Murder of Christ', little mention was made of the fact that Jesus was not a Christian but a Jew. He was, in fact, a Jewish prophet, who saw himself not as Messiah, but rather as playing some part in the imminent apocalyptic processes which could bring about the literal establishment of the Kingdom of God on earth – a Kingdom in which the Jews, as children of God, would be restored to their rightful place in the world order. Instead, the proclaimer became the proclaimed and the instrument of his absolute defeat and humiliation was elevated as the emblem of his divine, all-conquering power.

Kitaj, then, is right when he implies that Christianity found itself when it created the effective symbol for its passion, the Cross. He is wrong, however, to regard this as an unproblematic achievement – as one which Jewish art and culture should seek to emulate. For this process of the elevation of the Cross was one of the ways in which the Jewishness of Jesus (and therefore of Christian culture as a whole) was obscured, clearing the way for the persecution of the Jews and the holocaust itself.

Those who think this is an exaggeration should read the excellent book by Jaroslav Pelikan, *Jesus Through the Centuries*. Pelikan, an historian who believes that theology is too important to be left to theologians, points out that one

twentieth-century artist, at least, clearly perceived Jesus as, first and foremost, a Jew, rabbi and prophet. That artist was himself a Jew: Marc Chagall.

In his *White Crucifixion*, Chagall depicts Jesus as wearing not a nondescript loincloth but the *tallith* of a devout and practising rabbi. The pivot of this painting is a prophecy attributed to Jesus by John: 'They will put you out of the synagogues; indeed the hour is coming when whoever kills you will think he is offering service to God.' Chagall has seen this as having been fulfilled, in a supreme irony, when some who claimed to be disciples of Jesus regarded the persecution of Jews as a service to God. We should not allow ourselves to forget that, during the Third Reich, some Christian theologians elaborated the idea of 'Christ the Führer', the Leader or Ruler, and effectively identified the German Führer, with his swastika and intense hostility to Jews, with Jesus. Though the swastika dates back to the pre-Christian era, the Nazis recognised that it provided a parody, or approximation, for the triumphant Cross of Christ, as the very name, *Hakenkreuz*, implies.

'Would there have been such anti-Semitism,' asks Pelikan, 'would there have been so many pogroms, would there have been an Auschwitz, if every Christian church and every Christian home had focused its devotion on icons of Mary not only as Mother of God and Queen of Heaven but as the Jewish maiden and the new Miriam, and on icons of Christ not only as Pantocrator but as *Rabbi Jeshua bar-Joseph*, Rabbi Jesus of Nazareth, the Son of David, in the context of the history of a suffering humanity?'

I must confess my admiration for Kitaj's audacity, for his courage and ambition as a painter, and above all for the dazzling strength of his line, which seems to draw so much of its power from that of Degas – who, we should not forget, stood firmly on the wrong side in the Dreyfus Affair. Nonetheless, I believe that Kitaj was closer to a symbolism capable of expressing these themes when he was less self-consciously obsessed with the idea of replacing the emblematic cross with the

emblematic chimney; when his iconography was at once more particular and more universal.

When Marco Livingstone's monograph on Kitaj first fell into my hands, I turned eagerly to the series of 'Prefaces' to particular paintings by Kitaj himself which are published as an appendix to the book. I wanted to find out what Kitaj had to say about *If Not, Not*, of 1975–6 – a picture which I first saw in Timothy Hyman's *Narrative Painting* exhibition of 1979 [*see plate 20a*]. In a lecture called, 'Where was the art of the seventies?', delivered in 1980, I said that *If Not, Not* was one of the very best paintings of the last decade. That is a view from which I have never wavered – although I had never been able to unravel much of the picture's complex iconography.

What I read surprised me – for Kitaj relates this canvas, too, to what Winston Churchill called 'the greatest and most horrible crime ever committed in the whole history of the world'. He informs us that the great architectural structure which dominates the upper left-hand corner of the canvas is the Auschwitz gatehouse. In the journal he kept for the painting he first made notes about that train journey which a journalist took from Budapest to Auschwitz to get a sense of what the doomed could see through the slats of their cattle cars. As I have said, the fact that it was 'beautiful countryside' affected him deeply.

Kitaj also reveals that the references threaded through *If Not, Not* are literary and symbolic, as well as historical. The painting, he says, is permeated by 'a certain allegiance to Eliot's *Waste Land* and its (largely unexplained) family of loose assemblage'. Eliot, like Degas, was not uninfected with an unsavoury anti-Semitism, but Kitaj wanted to echo one particular eddy within the poem – the theme of the *Waste Land* as 'an antechamber to Hell'. He draws attention to the fact that there are passages in Eliot's masterpiece where drowning, 'Death by Water', is associated with the death of someone close to the poet – perhaps a Jew.

Now I have to admit that though I must have looked at my reproduction of the picture admiringly hundreds of times over a

period of several years, much of this simply passed me by. I had picked up that 'certain allegiance' to Eliot and even briefly wondered – wrongly, as Livingstone now tells me – whether the figure at the bottom left, wearing a hearing-aid and looking back through spectacles at a naked woman, was not meant to be a likeness of the poet who not only wrote *The Waste Land*, but had a lot of trouble with his women and his sexual drives. I even picked up a general likeness, which Kitaj acknowledges, to Giorgione's *Tempesta*; and responded to an image of a polluted and degraded paradise, the pool of which was 'stagnant in the shadow of a horror'. But I had never thought of *If Not, Not* as a Jewish holocaust painting.

Here was a particular symbol, which achieved the universal because it relinquished none of its particularity. The Auschwitz gatehouse was, indeed, the gateway to Hell, and this image of a soiled Eden – a promised land flowing with blood and bandages – reached me, a Gentile, touched me, and moved me deeply.

> Gentile or Jew
> O you who turn the wheel and look to windward,
> Consider Phlebas, who was once handsome and tall as you.

Something of this has gone in Kitaj's most recent paintings. The generalised chimneys are no longer representations of the gatehouse to Hell, but rather items of iconography. 'Maybe it's best not to paint about such things as Crucifixions and Passions in art,' Kitaj himself asks, 'because one is bound to fail?' But Pelikan comments on Chagall's rabbinical Jesus, 'the central figure does indeed belong to the people of Israel, but he belongs no less to the church and to the whole world – precisely because he belongs to the people of Israel'.

If Not, Not also seemed to me to approach the universal through an unremitting insistence upon the particular. But, ironically, Kitaj's more recent affirmation of his Jewishness through his painting seems to me to be painting conventional loincloths over forgotten *talliths*. The irony may be that these

paintings do not 'belong to the whole world' because they do not belong, sufficiently, 'to the people of Israel'. Not even Kitaj's chimneys can redeem him from the dilemma with which he has wrestled throughout his life. Those of us who lack faith must live without a guiding symbolic order. We inhabit the Wasteland. Like Phlebas, we are damned, Gentile or Jew.

1986

John Piper

'He was probably never better than at Bath,' John Betjeman wrote of Piper in 1944, 'because there is no city to which he is more attached.' It is impossible to say whether Betjeman would have held to this view if he had seen the flower and garden pictures which Piper has been producing over the last few years, for Piper's most recent paintings are surely among his best. But I know what Betjeman meant about the Bath works, because there is no city to which, I, too, am more attached.

The Germans blasted Exeter, Bath, Norwich, York and Canterbury with the explicit purpose of destroying historic buildings, thereby reducing national morale. But, as Malcolm Yorke reminds us in his book, *The Spirit of Place: Nine Neo-Romantic artists and their times*, we cannot afford too much nationalistic outrage at such vandalism. The 'Baedeker' raids were themselves a response to the fire-bombing, in March 1942, of the historic towns of Lübeck and Rostock by the British.

Even as the King and Queen toured Bath to inspect the damage in May 1942, Piper was drawing among the ruins as an official war artist. From Alexandra Park, you can easily pick out Somerset Place, of which Piper made an outstanding water-colour in 1942, now in the Tate Gallery, showing this Crescent crumbling and injured. Like so many of Piper's drawings done at this time, Somerset Place is not, as one feels almost that it ought to be, a depressing or pessimistic picture. On the contrary, it springs to life with a mysterious decorative hope – very like that found in such visionary late pictures by Paul Nash as *Pillar and Moon*, completed in this same year.

Stephen Spender captured something important about Piper's work at this time in his introduction to a book of war pictures by

British artists showing air raid damage, published in 1943. 'There is,' Spender wrote, 'something of release in the destruction of the greatest monuments, and what is released is the spirit which they enshrined.' Piper's portrayals of 'pleasing decay', even in bombed buildings, are almost like topographic or architectural crucifixions. But despite the cruel devastation they reveal, they also offer a kind of promise, a hope of reparation. Both Piper and Spender would, I think, feel it appropriate that the buildings Piper painted in ruins forty-six years ago are, today, the home of Bath's school of art and are filled with the studio spaces of young painters.

Not everything which has happened to Bath since Piper rummaged among its ruins can be seen as the liberation of a spirit trapped within its stones. You may remember Prince Charles's words, in one of his speeches on architecture: 'You have . . . to give this much to the Luftwaffe: when it knocked down our buildings, it didn't replace them with anything more offensive than rubble! We did that.' Indeed we did. Especially in Bath.

Adam Fergusson's chilling saga, *The Sack of Bath*, tells how, in the 1960s, architecture and planning in Bath lost all feeling for history and continuity. With it went all aesthetic judgement and any sense of creation of a living human environment shaped by more than the demands of the market-place. Ideas of care and renovation went out with the old buildings themselves, in those obscene years when the City Architect was reported as saying, 'If you want to keep Georgian artisans' houses, then you will have to find Georgian artisans to live in them.' Why did he stop there? Why not order the Roman baths to be pulled down because there were no Romans to bathe in them, or the abbey to be demolished, in response to the declining population of nuns and friars?

From Alexandra Park, you can see the crippling wounds such 'planning' has left on both the fabric, and indeed the nervous system, of the city. A swathe was cut into the historic heart of Bath to make way for a brutish bus station and a bland shopping

mall. The medieval church of St James, which happened to be in the way, was simply torn down. Similar violations occurred in every quarter of the city.

But the pillage of Bath is largely a thing of the past. Wiser councils have come to prevail. The planners and architects are still, of course, catering to a *modern* city, where the principal means of transport is the motor car, rather than the sedan chair, but they have become conservationists. They now seem to recognise that – even according to crude, economic criteria – it is simply inefficient to permit the commercial and technological dictates of urban life to overwhelm historical continuity and human scale. These things, after all, provide much of the present pleasure of living in, or even visiting, a great English city.

I like to think that Bath provides a kind of metaphor for the path beyond Modernism – not only in architecture, but in our wider, national cultural life. For that to happen on a more significant scale we must retrieve and develop something of the sensibility of John Piper who ought, at this moment, to be among the most influential of British artists.

Piper, who now ranks among Britain's most senior painters, was understandably insulted when the Royal Academy's 1987 exhibition, *British Art in the 20th Century: the Modern Movement*, included only one of his pictures: *Forms on Dark Blue*, 1936 – an abstract painting made before he had achieved his mature style. He withdrew the painting before the exhibition travelled to Germany.

Behind this incident lay a series of assumptions which have grievously affected Piper's reputation in the institutions of contemporary art over the last three decades. Charles Harrison spells out the case against Piper in his undeservedly influential book, *English Art and Modernism, 1900–1939*. Harrison describes the flurries of Modernist affiliation which ran through the British art communities in the 1920s and 1930s. He then refers to the growth of 'an insular and conservative tendency' in British art around 1937. He claims (pompously and improbably) that

this 'seems at least in part to have been due to a reaction against the elaboration of political considerations in discourse about and around modern art'. He goes on to say that 'those responsible for this reaction were critics and artists like the Pipers, who experienced such an elaboration as a threat to their own professional self-images and to their essentially superficial view of artistic practice'.

Needless to say, this conventional wisdom is wrong. Piper is not only an artist of far greater stature than such critics allow, but such a 'reading' of his work also distorts the nature of his shortcomings. The problem with Piper – if there is a problem – is not that he was somehow too 'conservative'. It can be more reasonably argued that his rehabilitation of a lost Romantic tradition was not pressed far or deep enough, and that his concessions to late Modernity were, in certain key respects, too great.

John Piper was born in Epsom in 1903, into a middle-class English family. His father was a solicitor, and, like Sutherland before him, and Peter Fuller after him, he attended Epsom College. Piper showed an early interest in archaeology, poetry and English churches. He was introduced to Ruskin by his father. In a letter to me, last year, he wrote that Ruskin's *Modern Painters* was 'my favourite book from early years'. After leaving school he reluctantly took up an appointment in his father's office in Vincent Square, visiting the Tate Gallery during his lunch breaks. He developed an early, and at that time highly unfashionable, understanding of the greatest painting of the English school – especially the work of Turner and other landscape artists of the late eighteenth and early nineteenth centuries.

We should not forget that, at this time, Bloomsbury was cultivating the idea that the first step in the acquisition of a serious artistic sensibility was the repudiation of all things English. Clive Bell believed that Girtin and Cotman were 'drivelling amateurs', and Roger Fry could not even stomach Turner. 'I wonder,' Fry mused, 'whether Turner ever did have

any distinctive personal experience before nature.' Turner's painting was, Fry argued, 'Poussin at second hand . . . Poussin filtered so as to strain off whatever in him makes that direct romantic appeal.' It was axiomatic, for Bell, that at any given moment, 'the best painter in England is unlikely to be better than a first-rate man in the French second class'. What, one wonders, would he have been arguing had he lived into the 1980s?

As for Ruskin, R. H. Wilenski, one of the pioneers of the Modern movement in criticism, wrote a character assassination in which he 'proved' that Ruskin was an indolent and arrogant old phoney whose ideas about art and architecture could be forgotten because he was completely mad. Such inverse xenophobia was, of course, to form part of the permanent intellectual and critical baggage Bloomsbury bequeathed to most would-be cultural 'progressives'. It can still be seen today in the posturings of art world intellectuals of every persuasion.

Despite a growing interest in the great achievements of the European painters of the 1930s, Piper, however, remained more open-minded. After his father died in 1926, he became an art student and quickly found himself absorbed by the work of Cézanne and Braque – whom he met. He even went to Paris to see an exhibition of Picasso's paper collages. In fact, the influence of Picasso over him at this time can hardly be exaggerated. Piper once showed me the famous scrapbook in which, as a young man, he had pasted his own copies and other reproductions of Picasso's works.

In 1934, Piper temporarily abandoned landscape painting and began to make his first abstract constructions, and later, large abstract paintings – like that which was shown in the Royal Academy exhibition. At this time he was also involved in commercial art, designing advertisements for Imperial Airways and other clients; and in proselytising for the Modern movement. In 1935, he moved to Fawley Bottom with Myfanwy Evans who, soon after, became his second wife. Together, they published *Axis*, a quarterly journal, which, for a short time, was

the most influential organ of the Modern movement in Britain. But, like Picasso himself and so many of those associated with the 7 & 5 Society, Piper never seems to have subscribed to those messianic or 'internationalist' interpretations of Modernism which were later to have such destructive consequences on our national cultural life. Rather, as Anthony West has put it, Piper saw that the French avant-garde was elevating painting 'to its own proper sphere of invention and visionary conception'. He came to believe that it was 'through a study of what the painters of the school of Paris were building on the foundations provided by the French classical tradition that the secret of the lost greatness of the English school of painting could be recovered and restored'.

It was in *Axis*, in 1937, that Piper published a text which, in retrospect, can be seen as seminal: 'Lost, a Valuable Object'. Piper could, of course, have been speaking of himself when he wrote, 'One thing is certain about all activities since Cubism: artists everywhere have done their best to find something to replace the object that Cubism destroyed.' Speaking of the Surrealists and Abstractionists, he wrote, 'one thing neither of them would dream of painting is a tree standing in a field. For the tree standing in the field has practically no meaning at the moment for the painter. It is an ideal: not a reality.' Piper argued that the object must grow again, 'must reappear as the "country" that inspires painting'.

For Piper, this recovery of painting's natural country also involved the recovery of that national tradition which had – with sad and enfeebling consequences – been forgotten by so many aspiring Modernists. Piper likened the Bloomsbury aesthetes' pursuit of a warm, aesthetic buzz to the taking of a holiday in the sun – fine in itself, but not the way in which British art was ever likely to be raised out of the doldrums.

But in 1942 (the year of the 'Baedeker' raids and his own best war drawings) Piper published *British Romantic Artists*, one of the first books to grasp the 'visionary, intense and prophetic power' of Turner's late works. Piper complained that the 'accent

on design, form, structure' emphasised by Britain's indigenous Post-Impressionists had led to 'the suppression of literary interest and atmosphere, . . . tended to squash all that was most natural to English painters, and produced a new and artificial academicism'.

Piper's little book was part of a much wider movement in British culture often referred to as 'Neo-Romanticism'. What happened in British art in the late 1930s, and throughout the war-torn 1940s, is only now beginning to be recognised. David Mellor's 1987 exhibition *A Paradise Lost: the Neo-Romantic Imagination in Britain*, 1935–55, at the Barbican, and Malcolm Yorke's book, referred to above, were a welcome beginning.

This much can be said with certainty: the peaks of the Romantic revival of these years were not a repudiation of European culture, but an informed response to Modernity. This involved a refusal of that kind of avant-gardist triumphalism one finds in Nikolaus Pevsner's diatribes on behalf of the only 'true and legitimate' style of the century, or in the battier utterances of Herbert Read. That sort of thinking is, in any event, almost universally discredited today.

Major British artists – not only Piper, but also Moore and Sutherland – came to see that, in Picasso, there was a new and original idea of *transformation* of natural form which could act as a trigger, or inspiration, for the invigoration of an indigenous Romantic tradition. As Sutherland put it, Picasso's *Guernica* drawings seemed 'to point to a way whereby – by a kind of paraphrase of appearances – things could be made to look more vital and real'.

Piper's own work in the 1940s was the most impressive of his career so far. 1942 was an extraordinary year for him. It included not only his outstanding work for the War Artists' Advisory Committee, but also the brooding studies of Windsor Castle, which produced the oft-quoted remark from George VI about Piper not having had much luck with the weather; and the marvellously melancholic and moon-lit works based on Osbert Sitwell's Renishaw. In the following years, Piper plunged

himself into British landscape. The cascading image of *Gordale Scar*, of 1943, and innumerable drawings of the Welsh mountains, throughout the later 1940s, confirm how deeply he had immersed himself in the doctrines of Ruskin. Piper's occasional studies of the female nude, like *Two Nudes*, 1942, reveal how (perhaps under the influence of Picasso's transformations) he had recuperated the image of the female body as landscape, which was so central to English Romanticism and especially to Ruskin's imaginings. Piper seemed to be moving from the thin and rootless streams of international Modernism into a much more rewarding terrain.

Nonetheless, it must be admitted that there is more than a little truth in the arguments of those critics who say that Piper's art was subject to a post-war decline. The intensity of Piper's sense of the spirit of a place began to elude him, and a certain theatricality – a fatal facility even – entered into his work. Shifts in his colour could be more arbitrary than revealing. His line sometimes fell into stereotyping.

And yet, when we look at these less-than-perfect Pipers, we should ask ourselves where these weaknesses are coming from. Do they – as Charles Harrison and Co. would have us believe – issue forth from his retrieval of a 'conservative', or sentimental, Romantic sensibility? Or do they, rather, spring from the scope and the extent of those accommodations which Piper proved willing to make with the later, post-second world war manifestations of Modernism?

I have no doubts that the latter question points towards the answer. The matter was brought home to me with clarity when, at Fawley Bottom Farmhouse, Piper revealed that Richard Hamilton was a near-neighbour and friend, with whom he had had many discussions on the subject of print-making. It will not come as a surprise to those acquainted with my writing that (unlike Piper) Richard Hamilton is not among those artists whose work I greatly revere. Indeed, I have often had occasion to criticise what I see as his sacrifice of aesthetic value and the spiritual dimensions of art, in favour of a vacuous

preoccupation with technical means and photographic devices. In the 1970s, Hamilton (a former commercial artist) began to produce flower paintings incorporating images of human excrement and toilet tissues, and wrote of his desire 'to defile a sentimental cliché'.

Piper is never so spiritually bankrupt, but there have been echoes of similar vices in some of the work he has done since the war. Take his occasional depictions of the female nude. In the *Eye and Camera* series the evocations of Ruskin, Romantic transformation, Moore, and Picasso often appear, at best, muted. Indeed, such works sometimes reveal a banal occupation with 'girlie' imagery and the technical means of reproduction. Similarly, his colour can sometimes seem closer to that of the colour supplements than to nature, transformed.

The weaknesses of Piper in the post-war period have more to do with his urbanity than with his Anglicanism, with his proximity to Pop art rather than the Romantic revelation he recovered from Turner. Piper, like Hamilton, has always admitted an interest in modern technologies, such as motoring and photography. (See, for example, John Piper, *A Painter's Camera*, published by the Tate Gallery.) Such concerns have sometimes given a brash freshness to his work, but have also been allowed to substitute for its content.

At the very least, one can say that if Piper sometimes does not succeed, the lack of success rarely seems to derive from an aesthetic 'conservatism', an over-burdening of spiritual content, or an excessive fidelity to Romantic tradition. On the contrary, if only Piper had pressed his recuperation of such themes more deeply, his painting might have been all the richer. For me, Piper's pictures of the last few years prove the point. They are, quite literally, a coming home, since advancing years and occasional illnesses have led him to ease up considerably on his tourism, motoring and photography.

Many of the paintings which he showed at Waddingtons in 1986 and 1989 are based on the flowers and walled garden round his home at Fawley Bottom [*see plate 20b*]. They are, I

believe, among the finest pictures he has done since the 1940s. Certainly, there has been no relinquishment of the search for a modern means of depiction. The bright, brash colours, and the bold design, bear witness, unashamedly, to the times in which they were made. But they do not simply mirror these times, they also resist them. Unlike his friend, Richard Hamilton, Piper has been moved by something more than the desire to 'defile' the beauty of flowers. He has re-created in a secular, yet spiritual way the mysteries of the *hortus conclusus*, or enclosed garden, which has, since medieval times, always been at the centre of an important strand in European landscape painting.

By now it may be evident why, at the beginning of this essay, I laid such heavy emphasis on the example of Bath, in ruins and after. Certainly, I would like to think that Piper's *Summer Gardens*, and his living pictures of the flowers and blossoms around Fawley Bottom, have a greater part to play in the education of desire than uncritical and spiritually-empty instances of Late Modernism, or indeed, its continuation in today's arid Post-Modernism. Nor do I consider this a 'nostalgic' or an escapist view. 'The role of science, like that of art,' writes the biologist E. O. Wilson, in his book, *Biophilia*, 'is to blend exact imagery with more distant meaning, the parts we already understand with those given as new, into larger patterns that are coherent enough to be acceptable as truth.' This, I suggest, is what Piper's recent pictures do, and what – rather than 'deconstruction' – a true 'Post-Modernism' in art and architecture ought to be about.

1988

William Tillyer and the
Art of Water-Colour

Nothing frightens a modern painter more than the
challenge of exterior appearances. Sooner or later he will
have to find a mode of 'study', a means of communing
direct with nature. When this moment arrives we shall see
the re-birth of landscape painting and portraiture.
 Patrick Heron, *The Changing Forms of Art*, 1955

Contemporary art criticism is notoriously wary of that which
cannot easily be pigeon-holed. William Tillyer's work has
received less attention than it deserves because he draws upon
two quite different traditions. He breaks the conventions of
both, and so seems to belong to neither.

Tillyer's paintings depend, for their aesthetic effects, upon
his responses to the world of nature, but his pictures do not
offer a reproduction of the appearances of that world. Indeed,
they seem to be deeply involved with questioning the nature
of the medium itself – a typical late Modernist concern. Tillyer's
painting in oils shows a characteristically self-critical doubt
about the validity of illusion and representation, and a restless
preoccupation with the nature of the picture plane, the support
and the framing edge. Tillyer often seeks 'radical' solutions,
assaulting the surface, tearing, reconstituting and collaging.

Although Tillyer's water-colours – my principal concern here
– invariably spring out of his response to particular places, they
are in no sense topographic. Indeed, we might imagine Tillyer
making the same retort as his predecessor, David Cox, when
the committee of the Water-Colour Society criticised the vague-
ness of certain of his paintings. 'These,' wrote Cox, 'are the
work of the mind, which I consider very far before portraits of

places.' Instead of trying to tell us what a scene looks like, Tillyer seems to be engaged in a search for what Roger Fry called 'Significant Form'; that is, for 'lines and colours combined in a particular way, certain forms and relations of forms' which arouse aesthetic emotions through formal means. Yet Tillyer's water-colour paintings are not abstractions, even though their relationship to the visible world of nature may be oblique.

'Good water-colour drawings,' wrote John Ruskin, '. . . are pleasant to everybody. Not so pleasant as bad ones to the general mob; but never offensive, and in time attractive.' Tillyer's best water-colours are not only good, they are also exceedingly pleasant and attractive. When I look at a great one like, say, *The North York moors, falling sky* [*see plate 12b*], I find that my eye is drawn easily into its shimmering veils, membranes and pools of pure, vibrating blue. And yet, in terms of critical response, this visual seductiveness has hardly worked in Tillyer's favour. One of the legacies of the recent history of painting is a belief that 'serious' art must be 'difficult'. It ought not to please too easily. Instead, the viewer should feel affronted, or at least offended. In this critical climate, water-colour has tended to be regarded as the choice of amateurs, *Country Life* readers, members of the Old Water-Colour Society and other aesthetic recidivists or dilettantes. Water-colour is 'not serious'.

Here, however, I wish to argue an alternative view, for I believe that water-colour possesses possibilities which other media do not. When fully realised, these delicate qualities touch upon some of the most intimate and nuanced dimensions of aesthetic experience. Moreover, I believe that Tillyer has not only mastered the potentialities of this subtle medium, but has also developed them in a thoroughly original way.

Water-colour, as a substance, is simply pigment ground up with a water-soluble gum, like gum arabic. Such techniques are very ancient. The Egyptians used them, and so did the illustrators of medieval manuscripts. In more recent times

water-colour has been displaced by the more gestural, durable and theatrical properties of oil-based paints, and has survived largely as a secondary medium. For example, some painters would enhance their preliminary studies in ink or pencil with monochrome sepia washes. Alexander Cozens, an artist to whom Tillyer appears to owe much, was perhaps the first to see how water-colour presented an opportunity for imaginative expression which other media did not. He developed a system for inventing imaginary or ideal landscapes from washes and 'blots'.

When the full range of hues returned in eighteenth-century England, this was due to a vogue for drawings of Gothic ruins and other architectural features. Water-colour provided a quick and convenient way of tinting these studies. But the history of art is full of examples of processes and materials being developed, or revived, for 'functional' reasons, then revealing quite new aesthetic and imaginative possibilities of their own. (Etching is another good example. It was originally developed as a convenient, if rude, means of reproduction.)

I am sure that art historians know better, but I like to think that the awakening to the possibilities of water-colour occurred in Dr Thomas Monro's workshop, where Girtin and Turner worked alongside each other filling in the skies on architectural and topographic drawings. Was there a moment when Girtin suddenly came to feel that his living pools of colour contained more trembling aesthetic potential than the illustrations and reproductions to which he was applying them? At least he must have wondered whether more immediate and sensuous responses to the world of nature might not embody spiritual values as significant as those found in the detailed, linear depictions of the relics and ruins of medieval Christendom, at which he and Turner were so proficient.

It was not immediately clear what contribution water-colour might make to this emerging landscape aesthetic. The early practitioners were often successful in forcing the medium to do that which did not come 'naturally' to it. Ruskin recommended

the use of 'body colour', or water-colour mixed with white to make it opaque, like gouache. Turner liked to enhance textures and effects by roughing and scraping the surface of the paper. David Cox, too, rubbed, scrubbed, scratched and sponged. In the hands of these masters, such techniques often led to works of undeniable richness and strength, but they are rarely recommended by teachers of water-colour today.

It was, perhaps, Girtin who first sought to 'purify' the practice of water-colour, and, in a rather 'modern' way, endeavoured to isolate that which was peculiar to his chosen medium. Girtin transformed the practice of water-colour. He abandoned the idea of monochrome underpainting. He made use of thick, off-white cartridge paper, and relied increasingly upon the whiteness of the surface instead of added highlights or body colour, to indicate areas of heightened light. With his translucent washes of vibrating, thinly-applied colour, offset by darker, denser patches, Girtin established water-colour techniques which are still in use today, notably in a good deal of Tillyer's work.

This sense of precocious modernity is intensified in the early work of John Sell Cotman, who painted in large areas of flat washes and clearly-defined planes, orchestrated into strongly decorative patterns. It is hard for us to look at these works without thinking that they anticipate Cézanne. There is something almost shocking about Cotman's resort, later in life, to thick and gaudy rice impasto, for it seems that in the rhythmic washes of his early works there is a complete union between the desired effects and the means used to achieve them.

This, I think, is what Ruskin was getting at when he wrote that Girtin's work was often as impressive to him as Nature itself. I feel Ruskin was right when he claimed that water-colour looks much more lovely when it has been laid on with a dash of the brush and left to dry in its own way, than when it has been dragged about and disturbed. He argued that it was 'always better to let the edges and forms be a little wrong, even if one cannot correct them afterwards, than to lose this fresh quality of the tint'.

As a lesser critic put it, writing in the *Edinburgh Review* of 1834:

The dewy freshness of a spring morning – the passing
shower, – the half-dispelled mist – the gay partial gleam of
April sunshine – the rainbow – the threatening storm – the
smiles and frowns of our changeful sky, or their infinite
effects upon the character of the landscape – the
unsubstantial brightness of the grey horizon – and the fresh
vivid colouring of the broken foreground – all these
features in the ever-varying face of Nature can be
represented by the painter in water-colours, with . . . a
day-like brightness and truth, which we will not say *cannot*
be produced in oil-painting, but which we at least have
never yet witnessed . . . All that we have yet seen inclines
us to think, that, in the representation of land, sea, and
sky, the art of water-colour painting which has so recently
begun to be cultivated, and is probably so little advanced
towards the possible perfection, is superior to the long-
established art of painting in oil.

These judgements point towards an intriguing conclusion
which neither Ruskin nor the anonymous critic of the *Edinburgh
Review* was able to draw: namely that in water-colours, and
perhaps *only* in water-colours, the great cry of the Romantic
aesthetics, ('Truth to Nature') and that of emergent Modernism
('Truth to Materials') were, in effect, one and the same. When
used in a way which preserved the particular qualities of the
medium (even at the price of losing immediate resemblance to
the appearances of things), water-colour painting seemed to
come closest to embodying the fragility and spontaneity of our
perceptions of nature itself. I think it is this unique property of
the medium that Tillyer has understood so fully.

During the nineteenth century, a great split began to appear
in aesthetic life, a split between those who believed in the
pursuit of 'Natural Form', as the means to spiritual truth, and
those who, in the phrase later made popular by Roger Fry and
Clive Bell, set out in quest of abstract 'Significant Form'. Walter

Pater was perhaps the first critic to elaborate a critical response which radically rejected mimesis – or imitation of appearances – as a means to truth. Pater argued 'art comes to you professing frankly to give nothing but the highest quality to your moments as they pass, and simply for those moments' sake'.

Whistler took these ideas and wittily vulgarised them in a thoroughly American way. 'Art,' he declared, 'should be independent of all clap-trap, should stand alone, and appeal to the artistic sense of eye or ear, without confounding this with emotions entirely foreign to it.' He went on to explain that he insisted on calling his own works 'arrangements' or 'harmonies' – whatever their depicted subject matter.

It was in America that such aesthetic ideas were to be pushed to their ultimate conclusions, most nobably in the writings of Clement Greenberg. These days Greenberg insists that his critical counsels have always been descriptive, not prescriptive, but in 1944 he wrote, 'Let painting confine itself to the disposition pure and simple of color and line, and not intrigue us by associations with things we can experience more authentically elsewhere.'

The painter, he said, 'may go on playing with illusions, but only for the sake of satire'. Greenberg believed the best art was launched on an 'ineluctable' quest for its own essence. Avant-garde painting and sculpture, he maintained, had attained a thorough-going purity. They were in the process of becoming 'nothing but what they do; like functional architecture and the machine, they *look* what they *do*. The picture . . . exhausts itself in the visual sensations it produces.'

Greenberg's aesthetic corresponded with Post-Painterly Abstraction, as practised by Morris Louis, where thin films of paint applied to the canvas surface produce vibrant, if slight, aesthetic sensations.

In England such goals were never pursued with the reductionist urgency of the Americans. The intellectual heritage of empiricism and perhaps even our native geography and weather, combined to encourage the belief that aesthetic values

could be rooted in some sort of imaginative experience of the natural world. There were many different ways of doing this, and the old Romanticism persisted in increasingly exhausted guises. I'm thinking of the pastoral tradition which passes through John Linnell into the 'Romany' paintings of Augustus John, to Alfred Munnings and Russell Flint.

Far more radical was that 'Neo-Romanticism' of which I have written so much elsewhere. Graham Sutherland, Henry Moore, and John Piper were among those who tried to confront an injured nature as a wasteland from which God had departed. They struggled to depict landscape in a plastic, rather than a scenic way. Predictably, Greenberg made Neo-Romanticism a polemical target. But there was also a third route: that which tried to explore landscape in a way which remained compatible with the peculiar quests of Modernity for an art of sensations, 'truth to materials', and restless questioning of the conventions of illusion.

This was more successful than has often been admitted, and, predictably, water-colour has played a very important and still underestimated part in the development of this tradition. I am thinking, especially, of those magnificent paintings which Wilson Steer produced on his painting trips in the 1920s and 1930s – works like *A Calm of Quiet Colour, Totland Bay*, 1931, or *Showery Weather, Mill Beach*, 1933. Here we find that fusion of truth to nature, and to materials and techniques, which lies in direct continuity with the achievement of Girtin.

It was such a quest which animated Ivon Hitchens and so many of the St Ives painters in the immediate post-second world war period. Some, most notably Peter Lanyon, were clear about what they were doing. Lanyon always resisted the idea that he was painting absolute abstractions; and I have always suspected that, notwithstanding his critical views, Patrick Heron's sensibility, too, owed a great deal to his response to nature. Others, however, were seduced into the American belief that *thoroughly* Modern work must dispose of any Romantic residues, that is, of any resemblances, however slight,

to natural form. This may account for all the confusions and contradictions that swept through the St Ives aesthetic in the late 1950s, and early 1960s – all the hostility to horizon lines, to 'natural' colours, to any trace of Neo-Romanticism, or a quest for spiritual values. Indeed, the next generation of London-based 'Situation' painters conducted a puritanical purge of any such features, reducing their work to an anaemic reflection of the American Late Modernist aesthetic.

William Tillyer, who was born in 1938 and studied at the Slade in the early 1960s, was of this generation. He is, I think, as questioning as any of his contemporaries about the nature of plastic form, and painting itself. And yet he did not believe that the argument had been definitively 'resolved' in favour of the formal and physical dimensions of picture-making. Tillyer seems to me to have gone back to the point where Lanyon and Heron left the argument. Despite his firm grasp of Modernity, he was to revive even older ways of working and replenishing his work.

In 1981, Tillyer took up a post in Australia as artist-in-residence at Melbourne University. We cannot be sure why, but the vastness of Australia's inhospitable terrain always challenges and unsettles a sensitive European's response to nature. In 1982, Tillyer held a major exhibition at the university gallery. Soon after that, while working on his 'Yorkshire Bridge' paintings, he decided that he wanted to establish the Romantic, illusionistic, and indeed, spiritual dimensions of his painting more unequivocally, without sacrificing his self-conscious concern with the physical and the formal. To this end, Tillyer turned to water-colour, becoming as diligent as Wilson Steer in seeking out new locations. He moved restlessly from one painting venue to another in France, Italy, Switzerland, America and, most recently, the north-east of England. Far from seeking to purge his painting of intimations of nature, Tillyer seems to want to find a new (and Modern) vision of the natural world. I believe this is why his art is attaining a new beauty and subtlety at a time when so many of the 'Situation' generation have entered a fatal cul-de-sac.

I hope that enough has been said about the nature of water-colour to indicate at least part of the reason why it was appropriate to Tillyer's aesthetic needs. With his best water-colours we find ourselves delighted by works which declare their Modernity, originality, plasticity and topographical scepticism, while simultaneously affirming that they are part and parcel of a particular English tradition which may be traced back as far as Dr Thomas Monro's workshop.

Not surprisingly, Tillyer has tended to agitate 'informed' critics who react to what they perceive as his fidelity to anachronistic practices and techniques. Today the artist is not expected to pack up his water-colours, pick up his painting stool, and journey to inaccessible places – in short, to behave like Edward Lear. Even if he does, he ought to have the good grace to return with readily identifiable, topographic studies, so that we can all see just where he has been and how quaint and old-fashioned his outlook is.

And yet slowly the tables may be turning. For Greenberg, one of the virtues of thoroughly Modern art was that it refused any appeal to spiritual values, resting upon sensation alone. But Fry could never have been content with such a position. His only interest in 'Significant Form' was as a vehicle, or avenue, to the realm of the spirit. 'Art,' he wrote, just before he died, 'is one of the essential modes of our spiritual life.' Whatever American critics have taught and American artists have done, a large part of the British public have held fast to Fry's belief. Today, the severance which Late Modern art seemed to demand from the realms of illusion, spirit and nature is beginning to be seen as its greatest weakness. An abstract 'art of the real', which excludes such concerns, leads to inevitable aesthetic failure. The search for spiritual values in some kind of imaginative, if secular, response to nature is becoming almost respectable again.

The great strength of Tillyer's water-colours is that although they are unequivocally Modern, they are the kind of 'pure' works of art which, as Fry put it in his *Last Lectures*, 'set up vibrations in the deeper layers of our consciousness and . . .

these vibrations radiate in many directions, lighting up a vast system of correlated feelings and ideas'. Tillyer's water-colours invite us to share with him a tentative and tremulous sensation of physical and spiritual oneness with the natural world.

These are not experiences of a kind which photographs or annotated Ordnance Survey Maps could ever provide. Richard Mabey, one of the most perceptive writers on rural themes, has bitterly criticised 'that glib blurring of meanings, that appropriation not just of the whole countryside but the whole nation to a single point of view about our proper relationship with nature', so characteristic of the contemporary world. By contrast, he stresses the 'immense range of experiences of natural life and landscape reaching back through our history and often beyond any narrow definition of rural traditions', which, he insists, 'is part of a *common* culture'.

I believe that Tillyer's enticingly beautiful water-colours reunite us with that 'common culture' in a way which does not compromise our Modernity. Beautiful in themselves, true at once to nature and to materials, Tillyer's gentle washes of colour have a wider meaning. They remind us that if we divorce our highest aesthetic emotions and perceptions from the world of nature, we will be more inclined to injure and to exploit the natural world – and indeed, each other – than if we perceive ourselves as being part of it.

1987

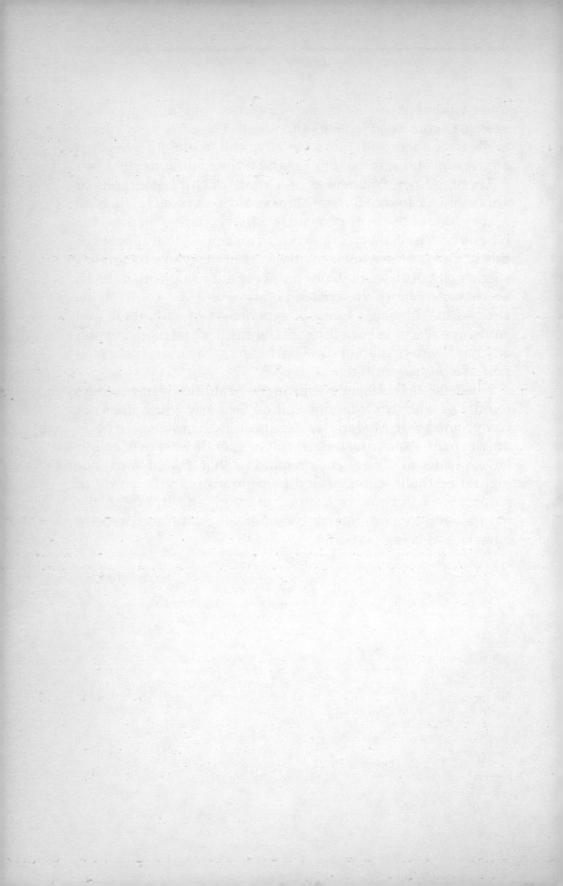

Index